ENCOUNTERS
NEW ART FROM OLD

Sponsored by
MORGAN STANLEY DEAN WITTER

ENCOUNTERS
NEW ART FROM OLD

RICHARD MORPHET
Introduction by
ROBERT ROSENBLUM

Contributions by
JUDITH BUMPUS
KEITH HARTLEY
ANDREW LAMBIRTH
MARCO LIVINGSTONE
CHRISTOPHER RIOPELLE

National Gallery Company Limited

SWINDON COLLEGE REGENT
CIRCUS

Cypher	17.10.02
	£25.00

CONTENTS

This book was published to accompany an exhibition at
The National Gallery, London
14 June – 17 September 2000

© 2000 National Gallery Company Limited

First published in Great Britain in 2000 by
National Gallery Company Limited
St Vincent House, 30 Orange Street, London WC2H 7HH

ISBN 1 85709 294 5
525460

British Library Cataloguing-in-Publication Data
A catalogue record is available from the British Library
Library of Congress Catalog Card Number 00-102773

Managing Editor Caroline Bugler
Editor Paul Holberton
Designer Chloë Alexander
Assistant Editor Tom Windross
Picture Researcher Xenia Geroulanos

Printed and bound in Great Britain by Butler and Tanner,
Frome and London

Sponsored by
MORGAN STANLEY DEAN WITTER

Detail from Anthony Caro *Duccio Variation 6* 1999–2000, Cast iron, 165 x 173 x 99 cm, courtesy Annely Juda Fine Art, London

SPONSOR'S PREFACE

Morgan Stanley Dean Witter is very pleased to be supporting the National Gallery by sponsoring this highly original exhibition, *Encounters – New Art from Old*. It is the first exhibition of its kind and we are glad to be associated with what the National Gallery thinks is its most unusual exhibition ever.

It is a fascinating look at how some of the world's greatest artists have reinterpreted works from one of the world's greatest collections, and we believe its central theme mirrors our own philosophy of continually striving to reinvent ideas and provide new solutions to our clients' business challenges.

As a global investment banking firm, we support an extensive arts and education programme. We are working closely with the National Gallery on its education programme for young people and adults with a special focus on schools close to London's Canary Wharf, where we have our European headquarters.

We congratulate the National Gallery on mounting this highly imaginative exhibition and hope that our support will enable many people to enjoy the unique perspective of *Encounters – New Art from Old*.

Sir David Walker
Chairman
Morgan Stanley Dean Witter (Europe)

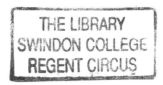

This is an exhibition of snatches of dialogue. We invited, a few years ago, twenty-four great artists of our time to converse with the greatest artists of all time, and the fruits of those conversations are the works of art now on show, and this is the catalogue. The result is, we hope, a striking exhibition of contemporary art, and a celebration of what the national collection of paintings means to artists worldwide in the year 2000, but the phenomenon that it captures is, of course, by no means new.

Every day, in the rooms of the National Gallery, similar conversations go on. Rembrandt talks to Titian, Velázquez looks at Rubens, Seurat nods to Piero della Francesca, and Turner, by his own express wish, hangs forever beside the artist whom he revered and admired above all others, Claude Lorrain. The collection in Trafalgar Square, as nowhere else in the world, makes it clear that the European tradition is just that: a tradition, in which each generation draws on an ever richer inheritance, as it sets about tackling, in truth, the business of painting. This is no coincidence, for the Gallery's Collection was put together precisely to allow us to eavesdrop on these dialogues across the centuries that have criss-crossed Europe since the Renaissance. And indeed the Gallery was founded in part at least so that artists in London could at last join in the talk.

When the National Gallery opened its doors in 1824, it aimed to offer the pleasure of pictures to the public at large, rich and poor, believing that this shared delight would inevitably foster social harmony. But the founder had from the beginning one particular public in mind: artists. By comparison with their continental colleagues, before 1824 artists in London were starved of great pictures from the past. In every other capital city of Europe, royal and princely collections had been opened to the public, allowing living artists to study the greatest achievements of their predecessors. In London, by contrast, the royal collection, which the King considered his own, remained firmly closed. There were of course great private collections, but they were mostly in the country, so artists wanting to look closely at the Old Masters had to rely to a disconcerting extent on the fleeting chances of the sale room. The decision by Parliament to buy pictures for everybody changed that situation forever, and since 1824 artists from London – and around the world – have been able to use the National Gallery as their own study collection. They have done so with verve, considering the Old Masters, in Reynolds's words, 'as models … to imitate, and at the same time as rivals with whom … to contend'.

The artists taking part in this exhibition are not just letting us see the work they have produced as a result of our invitation to respond to a painting in the National Gallery. In the process they allow us all to look again at pictures we thought we knew well. And to look at a painting through the eyes of an artist is, in many cases, to discover a new painting or perhaps, more accurately, to be reminded that great paintings are inexhaustible, and always have more secrets to yield.

The making of art is always an act of generosity. The making of exhibitions no less. Our thanks go first to the artists who have entered so enthusiastically into the spirit of the venture. The whole enterprise has been masterfully steered to completion by the tactful energy of Richard Morphet, former Keeper of the Modern Collection at the Tate Gallery, to whose unfailing good cheer we owe a great debt of gratitude. Our thanks also go to the excellent team of writers who have made such important contributions to this catalogue.

None of this would have been possible without the great generosity of our sponsors, Morgan Stanley Dean Witter, who have supported us unstintingly and imaginatively from the first. On behalf of all who work at the National Gallery and of all who will see the exhibition, may I say thank you.

Neil MacGregor
Director of the National Gallery

REMEMBRANCE OF ART PAST

Robert Rosenblum

OF THE ABIDING MYTHS about modern art, one of the most stubborn would tell us that artists of the last two centuries kept unburdening themselves of the past, hoping forever to wipe their eyes clean of history. Like many grand generalisations, this one is both true and false as well as something in between. If the history of modern art is taken to begin with such masters as David and Goya who, born in the mid-eighteenth century, responded to the irreversible upheavals that marked the next revolutionary decades, then this precarious balance between respecting and destroying tradition is at the very roots of our heritage. The swift changes of modern history demanded constantly new solutions; yet to step into an uncertain future, one foot had to be kept in a secure past. David, no less than his radical political colleagues of the 1790s, was determined to annihilate inherited traditions of Church and State, but he also believed in timeless, ideal beauty, learned the old-fashioned way by making copies of antique statuary and Old Master paintings, the kind of education shared, a century later, by another artist-revolutionary, Picasso. Goya, the very model of an artist who seemed to see facts as a photo-journalist *avant la lettre*, not only made drawings in the 1770s of such icons of antique sculpture as the Belvedere *Torso* and the Farnese *Hercules*, but also respectfully copied in a series of etchings of the 1780s (**1**), the most famous of Velázquez's portraits in the royal collection, including *Las Meninas*. Without conscious allusions to these ancestral images of absolute, un-troubled authority, how could he have had such success in dethroning pictorially, as definitively as the guillotine, the feeble members of the Bourbon court who, decade after decade, employed his services?

For an ever growing audience of ordinary spectators and, of course, artists, the art of the past would become more and more accessible in the proliferating public sanctuaries which now sustained visual culture outside the world of kings and wealthy collectors. To be able to see countless originals long hidden from view was a thrilling boon to the welling population of artists.

It is telling, for example, that when the egalitarian dream of a Muséum Central des Arts (what we now call the Louvre) finally materialised on 10 August 1793, in the midst of the Reign of Terror, it was available to the public for only three days of the ten-day week of the new revolutionary calendar, with five days put aside for the copyists who rushed to study what was formerly walled up in private collections. To be sure, artists had always copied earlier art – Rubens, for example, copied Leonardo's cartoon for *The Battle of Anghiari* and Caravaggio's *Entombment* – but as one public museum after another opened in the early nine-teenth century (Amsterdam's Rijksmuseum in 1815, Madrid's Prado in 1819, London's National Gallery in 1824, Berlin's Altes Museum in 1830), the availability of these time-capsules of beauty and history kept expanding, the visual equivalent of the vast new libraries opening to the growingly literate public.

1 Goya *Philip III of Spain on horseback, after Velázquez*, etching inscribed in pen and ink, 370 x 310 mm, Boston, Museum of Fine Art

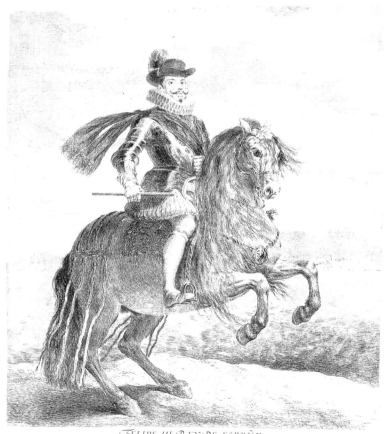

FELIPE III. REY DE ESPAÑA.
Pintura de D. Diego Velazquez, del tamaño del natural, en el Rl. Palacio de Madrid, dibujada y grabada por D.n Fran.co Goya, Pintor, año de 1778.

2 Samuel Morse *Gallery of the Louvre*, 1831–3, oil on canvas, 187 x 274 cm, Chicago, Terra Foundation for the Arts

Within these new sanctuaries contemporary artists would learn from the past as well as rivalling it. So it is that in the nineteenth century British painting kept reflecting, as it still does today, what there was to see in Trafalgar Square. Most famous of these responses, both competitive and humble, was Turner's specification in his will that two of his paintings (*Dido building Carthage* and *Sun rising through Vapour*) be hung in the National Gallery side by side with two paintings by Claude Lorrain, purchased in 1824, a compare-and-contrast installation still respected today and one that continues to provide a lesson in the shifting sands of tradition versus innovation. (In this exhibition, we will see how Louise Bourgeois and Cy Twombly responded, in turn, to two major Turners.) As for another generation of British artists fired by the Old Masters seen at the National Gallery, there is the case of Holman Hunt – beloved, like Turner, by John Ruskin – who himself made scrupulous copies of Renaissance painters working in styles as contradictory as Botticelli's and Tintoretto's. Could Hunt, in 1853, have painted *The Awakening Conscience*, a hyper-realist drama of illicit love in a domestic interior, without the inspiration, right down to the mirror, of Van Eyck's Arnolfini double portrait, a supposed paragon of Christian marital harmony that entered the National Gallery collection in 1842?

It was above all the Louvre, however, that offered in its vast, palatial galleries a St Peter's for art, in which visitors and artists

3 Paul Cézanne *After Titian's Concert champêtre*, c. 1878, watercolour, Paris, Musée du Louvre

challenge the Old Masters, artists like Ingres, who was always ready to kneel at the altar of Raphael, copying both the whole and the parts of his canonic masterpieces. But the same would become true of the now honoured sequence of aggressively modern rebels, from Manet to Matisse, who are famous for constantly flouting tradition. We all know that in the *Déjeuner sur l'herbe* Manet satirised, as Offenbach was to do in his operettas, inherited pieties from the shrines of culture, transporting the ideal past of Giorgione and Raphael into the present tense, much as he might have thought that Titian, were he painting a Venus in Paris in the 1860s, would have done something as shockingly contemporary as *Olympia*. But in order to juggle past and present, new experiences and timeless pictorial values, Manet had first to immerse himself in lessons that could be learned at the Louvre. Perusing a catalogue of Manet's work, one

alike could immerse themselves in an environment that often seemed to usurp the authority and the congregations of established religions. In a large canvas of 1831–3, the American painter (and inventor) Samuel F.B. Morse pinpointed the populist magic of these museum spaces with what appears to be a documentary record of the wonders preserved in the Louvre's Salon Carré, but is actually his personal selection of forty-one masterpieces he felt could provide the firmest foundations of visual culture for a New World still starving for European art (**2**). In fact he deleted contemporary French painting, which he disliked, and, for the sake of this fictional installation, often altered relative sizes. For a new transatlantic audience, Leonardo, Raphael and Titian were to become the equivalents of the Bible, Homer and Shakespeare. His didactic ambitions were further underlined by the presence in the painting of copyists – Americans in Paris? – men and women who drink from the well of beauty, truth and history, occasionally even echoing in their postures figures in the paintings above them.

We might assume that these humble worshippers of past achievement were artists who would never have dared to

4 Thomas Struth *National Gallery I, London 1989*, 1989, photograph on paper on perspex, image 134 x 152 cm, Tate, London

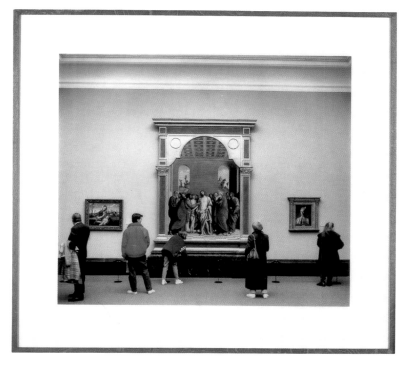

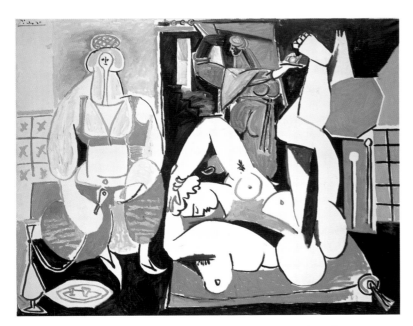

5 Pablo Picasso *Final Version after Delacroix's Women of Algiers*, 1955, oil on canvas, 130.2 x 162.3 cm, private collection, courtesy Helly Nahmad Gallery, London

Louvre, copying, as a teenager, such complex figural paintings as Veronese's *Calvary* and *Feast in the House of Simon*.

Given this tradition, it is hardly surprising to learn that Matisse, beginning in 1893, spent eleven years making several dozen copies of paintings in the Louvre, ranging from Annibale Carracci and Poussin to Chardin and Fragonard; and that when Delacroix's *Abduction of Rebecca* was acquired in 1902 he must have been excited enough by its half-century-old explosion of pigment to draw a free copy of it in inky blacks that juggled (as he was later to do in his mature art) a complementary mastery of colourless drawing and colour-shot painting. His alternation between tradition and audacious experiments that most spectators viewed as untutored kindergarten painting can be discerned by the way he returned, in 1915, to a seventeenth-century Dutch still life by

quickly discovers that in the 1850s, when he was in his twenties, he copied famous paintings by Titian, Tintoretto, Brouwer, Velázquez and Delacroix, among others, and that on a visit to The Hague in 1856 he copied Rembrandt's *Anatomy Lesson of Dr Tulp*, all works that, in various ways, nurtured both the rebellious and the respectful aspects of his awareness of his place in history. As for Cézanne, like Antaeus touching Mother Earth, he constantly looked back to museums and reproductions for inspiration and courage to continue his adventurous quests (**3**). His famous statement, that he wanted to redo Poussin after nature, has considerably more reality when we learn that in 1864 he was registered at the Louvre in order to copy the master's *Shepherds in Arcadia*, or that, like Manet, he copied Delacroix's *Bark of Dante*, or that, from youth to old age, he filled his sketchbooks with drawings after venerable geniuses, using figures from Michelangelo or Van Dyck in the Louvre collections as the basis for exploring his own radical vision of tautly energised anatomies. One may remember, too, Fantin-Latour's advice to Renoir, 'There is only the Louvre! You can never copy the old masters enough'. That Renoir took this advice is apparent when we see his reincarnations of Veronese, Rubens, Boucher or Ingres in paintings which, in their new colours and brushwork, nevertheless seemed to many the equivalent of torching the Louvre. Even Berthe Morisot, an Impressionist of far more modest ambitions, had her turn at the

6 Roy Lichtenstein *Women with a Flowered Hat* 1963, magna on canvas, 127 x 101.5 cm, private collection

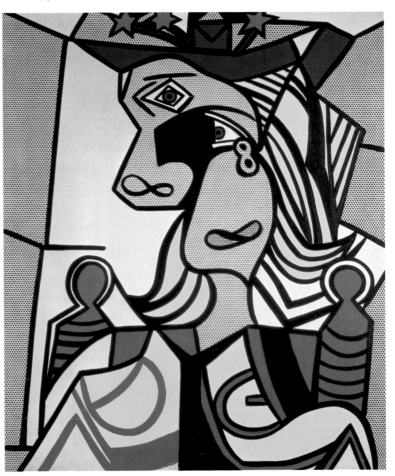

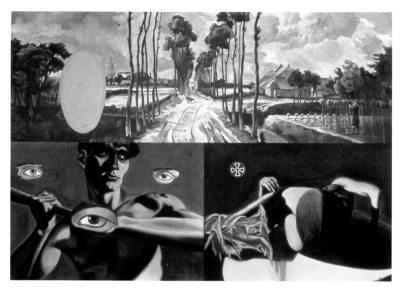

7 David Salle *Landscape with Two Nudes and Three Eyes*, 1986, acrylic and oil on canvas, 260 x 353 cm, private collection, courtesy Gagosian Gallery, New York

Jan Davidz de Heem, a work that in 1893 he had copied quite literally, but would now translate into his own shockingly unfamiliar language, as if to reaffirm his closeness as well as his distance from the world of the Louvre. Such ritual immersions in the art of the past, whether through would-be exact replicas or free variations, were the bread and butter of artistic training well into the twentieth century. Indeed, the ghosts of the Old Masters presided over the education of even the most innovative rebels of the New York school. The sketchbook drawings of Jackson Pollock, for instance, contain one turbulent confrontation after another with famous works by the likes of Michelangelo, El Greco and Rubens; and in the case of Arshile Gorky, the Old Masters usually meant saints recently canonised in the religion of modernism. As a young immigrant, Gorky haunted the public spaces of New York's new shrines to the contemporary, the Museum of Living Art and the Museum of Modern Art, and with this exciting nourishment he dutifully educated himself for more than a decade by making virtual paraphrases of works by the century's new ancestral figures – Cézanne, Picasso, Braque, Léger, De Chirico, Miró – not to mention the portraits and nudes of Ingres, which, with De Kooning as a companion, he would scrutinise at the Metropolitan Museum.

Of course, there is ample contrary evidence that, beginning in the late eighteenth century, one generation after another of artists

wanted to create the world anew by burying what they considered the moribund relics preserved in museums. Writing to his brother Daniel in 1802, the German Romantic painter Philip Otto Runge bewailed the folly of imitating earlier art, yearning to start from infantile scratch with an immersion in the beauty of nature and claiming that 'we must become children again if we want to reach perfection'. Or listen to the account of Monet by the American painter Lilla Cabot Perry, who recalled the artist's saying in 1889 that 'he wished he had been born blind and had suddenly gained his sight so that he could have begun to paint in this way without knowing what the objects were that he saw before him'. Or remember the Futurists' more aggressive assaults upon the conventions of earlier art, pinpointed in Marinetti's manifestos proclaiming that 'a roaring motorcar ... is more beautiful than the Victory of Samothrace' and that his revolutionary

8 Andy Warhol *The Disquieting Muses (after De Chirico)*, 1982, synthetic polymer paint and silkscreen ink on canvas, 127 x 106.6 cm, Pittsburgh, The Andy Warhol Foundation for the Visual Arts

goals were to destroy the cult of the past, to sweep art clean of all subjects used before. The visual evidence of this recurrent impulse to annihilate tradition and invent new visual alphabets is overwhelming. Picasso's brutal assault upon Western conventions of female beauty; Malevich's re-creation of the cosmos with pure squares and circles; Pollock's pursuit of a language of chaos; Lichtenstein's use of cartoon imagery and commercial printers' vocabularies – such a familiar pattern would seem to confirm the legend of modern art as a sequence of progressive rejections that faced only forward, a scorched-earth policy that would leave museums in ashes. From this vantage-point, who could ever have guessed that, by the end of the twentieth century, museums would become the equivalent of shrines and spectacles for both artists and the general public, providing for modern

9 Malcolm Morley *The School of Athens*, 1972, acrylic on canvas, 176 x 247.5 cm, Stefan T. Edlis Collection

tourists the equivalent of medieval pilgrimage routes to be visited with ritual devotion? Museums themselves, as proved in a recent (1999) exhibition at the Museum of Modern Art in New York, *The Museum as Muse*, could become subjects for many later twentieth-century artists. The German photographer, Thomas Struth, for one, recorded the throngs of international tourists who, just in from, say, the streets of London, might cluster in a Venetian room at the National Gallery to gaze in awe at a Cima da Conegliano altarpiece as if it were a holy vision (**4**), offering an update to such images as Morse's painting of copyists at work in the Salon Carré (**2**).

As the twentieth century becomes the past, not the present, and as museums and historical exhibitions proliferate with seemingly endless vitality, our own angle of vision has become more retrospective, making it apparent that all the revolutions of modern art faced backwards as well as forwards. For example, Impressionism, despite its search for childlike immediacy of perception, now seems haunted by the ghosts of Rococo pleasure and spontaneity, with the modern Parisian garden scenes of Monet freshly recycling the *fêtes galantes* of the *ancien régime*, and the outdoor nudes of Renoir reincarnating the bathing nymphs of Fragonard.

Picasso, once heralding everything new in the twentieth century, has slowly been transformed into the guardian of the past, as we discover that his terrorist attacks on tradition turn out to be a way of rejuvenating, not destroying, our heritage, even preserving for us the conventional subject hierarchies of ambitious figure paintings, ideal nudes, portraiture, landscape and still life. As for such voyagers into extraterrestrial worlds as Kandinsky, Mondrian, Malevich and Pollock, they, too, have become tethered to a more earthbound art history. Some of Kandinsky's most apocalyptic explosions, for instance, may have been triggered by Bruegel's fantasies of Hell's chaos; Mondrian's skeletal blueprints of a Utopian world order have begun to reveal their seventeenth-century Dutch roots, whether in the rectilinear structures of genre painting or the diamond-shaped funerary plaques found in churches; the original installation of some of Malevich's geometric icons cutting diagonally across the upper corner of a room can now evoke the traditional Russian placement of domestic holy icons in the same position; Pollock's plunges into the abyss can also be read as the conclusion of a tradition launched

scale homages, witness his 'Masterpiece Theatre' productions of variations on Delacroix's *Algerian Women* (1954–5) (**5**), Velázquez's *Las Meninas* (1957) and Manet's *Déjeuner sur l'herbe* (1959–62), not to mention his invocations of El Greco, Rembrandt, Ingres, Degas and others to haunt the etched plates of his poignantly retrospective *Suite 347* (1968). Much younger generations quickly caught up with him. An *enfant terrible* like Lichtenstein, who, to many viewers in 1962, looked so ugly and so illiterate, began in the same year to offer his own knowledge-able variations on Cézanne, Picasso, Mondrian and De Kooning,

11 Cindy Sherman *Untitled 216*, 1989, colour photograph, 170 x 142 cm, private collection

10 Joshua Reynolds *Portrait of the Artist*, 1780, oil on panel, 127 x 101.6 cm, London, Royal Academy of Arts

by Turner's worship of the vortex, just as the catch-phrase used for Pollock, 'energy made visible', might equally apply to the older master. Even Lichtenstein's insolent adaptations of the lowest-budget techniques of commercial artists now look like a replay of Seurat's fascination with the flat primary colours and the clear, impersonal contours of the cheap chromolithographic images of his day.

If the ghosts of tradition hovered over even those pioneering modern artists who would slam the doors firmly on the past, the story of that uneasy dialogue changes drastically in the second half of the twentieth century. By the 1950s, Picasso was offering not only occasional quotations from the Old Masters, but full-

eventually producing an entire encyclopedia of modern styles and artists translated into what once seemed his own anti-art vocabulary (**6**). It was a spirit rising on both sides of the Atlantic: witness Patrick Caulfield's 1963 variations on artists as diverse as Delacroix and Juan Gris, or Sigmar Polke's deathblow to modernism, a painting of 1968 that reproduces a cluster of signs familiar to abstract art — splatter, spiral, swath on a flat black ground — and inscribes below this glossary a verbal tombstone, *Moderne Kunst* (modern art). Another iconoclast of hallowed art, Andy Warhol, who, in the 1960s, first revived the tradition of bowing to (or perhaps defiling) the sanctity of the *Mona Lisa*, ended up in the 1980s making countless signature-style reproductions culled from images taken from the pantheon of art history — Uccello, Botticelli, Raphael, Munch, Matisse, De Chirico, Picasso were all grist for his mill. Moreover, towards the end of his life, Warhol even began to recycle the differing vocabularies from the historic dictionary of abstract art, making camouflage paintings, for example, that looked like Arp and Miró; tangled yarn paintings that rejuvenated Pollock; cross paintings that paid homage to Mondrian and Malevich. A younger generation of artists compiled another eclectic anthology of famous quotations. Philip Taaffe, for one, turned from one mid-century signature style to another — Clyfford Still, Bridget Riley, Barnett Newman — in a new kind of decorative art that wilfully transformed the seriousness of the quoted artists' original intentions. David Salle broadened this range of visual paraphrases still further to include everything from Caravaggio, Géricault, Kuniyoshi, Giacometti, Johns and even the National Gallery's well known Hobbema to a virtual showroom of samples from the design studios of the 1950s — furniture, fabric patterns, lighting fixtures that by then had acquired the period nostalgia of antiques (**7**). Such sweeping art-historical time capsules were expanded, too, in the work of Polke, who could offer fragments of Renaissance prints, Rococo fabrics or Goya etchings buried, like archaeological strata, in his image-layered canvases.

In fact, by the 1960s, the once revolutionary artists of the twentieth century had settled peacefully into great museums all over the world; and some, like Matisse, Brancusi, Chagall, Dubuffet and Pollock, would eventually receive the ultimate populist accolade, their art enshrined on a postage stamp. Instead of emphasising the heroic innovations of modern art, interpretations began more

12 Carlo Maria Mariani *Lepeletier de Saint-Fargeau on his Deathbed,* 1980, oil on canvas, 185 x 140 cm, private collection

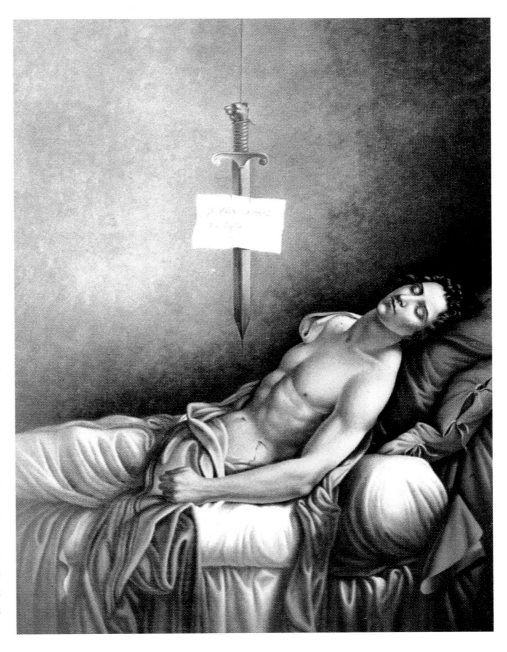

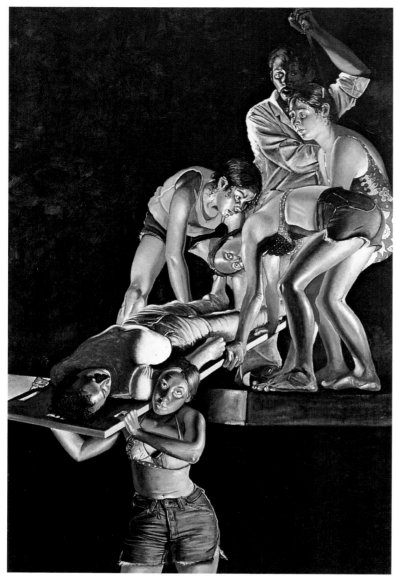

13 Alfred Leslie *The Killing of Frank O'Hara [The Killing Cycle (#5):The Loading Pier]*,1975, oil on canvas, 185 x 140 cm, St Louis, The Orchard Corporation

often to face backwards, revealing more clearly how the venerable heritages housed in the Louvre, the Prado, the National Gallery were perpetuated. So it was that Picasso's *Demoiselles d'Avignon*,instead of looking like the first day of creation, putting to death centuries of Western ideals of beauty and launching a disquietingly original language of fractured spaces unique to the new century, started to resemble a synthesis of familiar masterpieces, with reincarnations of everything from El Greco's apocalyptic imagery to *Las Meninas*, Goya's *Naked Maja* and

Ingres's *Turkish Bath*.As artists, art historians and ordinary viewers became more and more exposed to an infinitely expanding image bank of reproductions on the printed page or on the screen, the art of the past, though its original incarnations were preserved behind museum doors, began to lose its often oppressive authority. Endlessly mirrored in the prosaic fragments of everybody's visual environment – films, magazines, posters, T-shirts, shopping bags – these images became facts as commonplace as soup cans in a supermarket.With the triumphant story of modern art safely turned into a catechism endlessly repeated in textbooks and lecture courses, artists of the later twentieth century could relax again and look back not only at the Old Masters but at the early twentieth-century revolutionaries who had become Old Masters themselves. It now seems predictable that, as the twentieth century drew to a close and its inherited myths of progress turned into naive anachronisms, artists became, like everyone else, more retrospective, contemplating the known and more comforting terrain of history rather than the scarier prospects of the future. It is telling that the late work of artists who had fallen out of the forward march of history began to be resurrected and admired in the century's last decades. For example, De Chirico's work from the 1920s on, once banished from serious art history because of his defection from modernism and his conscious counterfeiting of his own earlier work, began to be looked at afresh.Not only did it become possible to relax and enjoy his neo-traditional art inspired by antiquity or Venetian painting, but it was also found that his self-replications were in tune with the conveyor-belt reproductions of modern art that now pervade our lives. It is no accident that Warhol once had an entire show based on the classic early De Chirico images the older master himself had later replicated (**8**). Francis Picabia, too, who had traditionally been scratched out of history after playing a central role in New York and Paris Dada, began to be re-examined, with the ironic discovery that, for the late twentieth century, his return to a slickly commercial realism,traditionally construed as treason to the modern movement,might turn out to be even more heretical than his achievements as a card-carrying Dadaist.André Derain, who used to be esteemed only for his vigorous foray into Fauvism and his more cautious experiments with Cubism, was also reconsidered, with many converts admiring his later efforts to turn the clock back to a pre-Fauve world, an ambition that today takes on a piquant historical flavour evoking the inter-war years of aesthetic conservatism,when the French hoped to revitalise what

syndrome launched in the late eighteenth century in efforts to reconstruct the past, a passion for historic revival temporarily buried by modern art's counter-efforts to live only in the present and the future, has turned out to be alive and well once more. It may even have already reached its extreme in the effete eccentricity of the real lives and fictional works of David McDermott and Peter McGough, an artist couple who wear period clothing from the turn of the last century and who paint and date pictures from earlier time periods, recreating, for example, a damaged fragment of a Victorian landscape inscribed 1883, vintage tinted photographs of c.1900, Jazz-Age Art Deco fantasies of the 1920s, and even manifestos and paintings for 'Dandyism', an imaginary

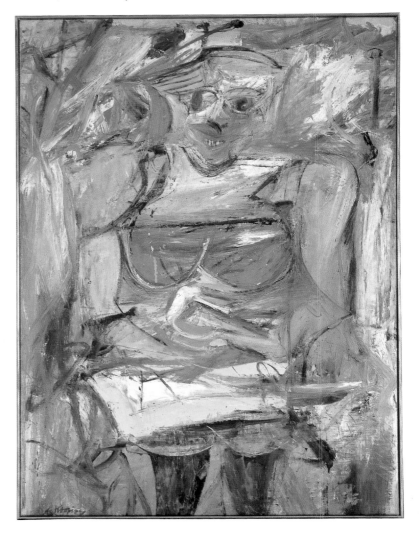

15 Willem De Kooning *Women V*, 1952–3, oil, charcoal on canvas, 154.5 x 114.5 cm, Canberra, National Gallery of Australia

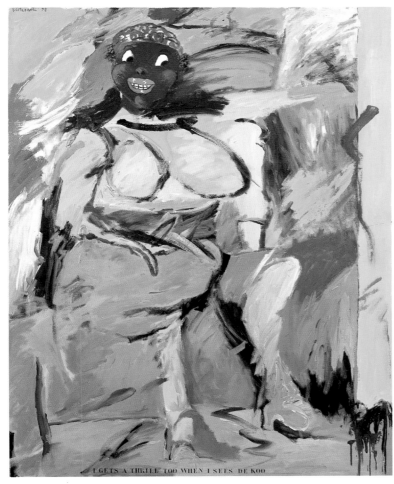

14 Robert Colescott *I Gets A Thrill Too When I Sees De Koo*, 1978, acrylic on canvas, 213 x 167.6 cm, Waltham, Mass., Rose Art Museum, Brandeis University. Gift of Senator and Mrs. William Bradley, 1981

they considered their indigenous classical tradition. Picasso's late work, which once seemed irrelevant to the history of art made by his younger contemporaries in Europe and America, was also due for a new wave of enthusiastic spectators who, as suggested in the London exhibition, *The New Spirit in Painting* (1981), could reconsider this superannuated modernist as a father-figure for younger artists who also enjoyed wallowing in energetic eruptions of pigment.

The late twentieth century marked a revival of that very historicism detested by the early heroes of modern art and architecture. From the ubiquitous glut of art images, quotations of everything from Georgian pediments (Quinlan Terry) to the *School of Athens* (Malcolm Morley) could be made (**9**). The once scorned 'neo'

16 Pablo Picasso *Woman pissing*, 1965, oil on canvas, 195 x 97 cm, Paris, Musée national d'art moderne, Centre Georges Pompidou. Gift of Louise and Michel Leiris

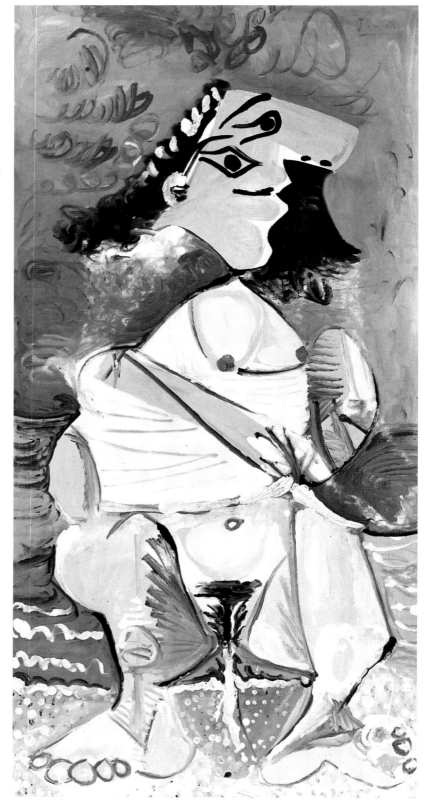

'ism' from the heyday of Apollinaire's and Marinetti's explosive typography. Amazing how the once vigorous efforts to annihilate past traditions can become, by the late twentieth century, as quaint and antiquated as Victorian embroidery!

Such an about-face has had a domino effect on not only the making of contemporary art but upon our own ways of re-reading the art of the past. It is now possible to reconsider even such a presumably old-fashioned painter as Sir Joshua Reynolds in a new context, as a forefather of the current passion for famous art-historical quotations. Plucking motifs from the venerable canons of Renaissance and Baroque art, Reynolds would re-create one sitter in the guise of Francesco Trevisani's *Cleopatra*, another in the role of a Michelangelo *Prophet*, a third as a Correggio *Madonna*, and even himself as a Rembrandt self-portrait that now hangs in the National Gallery (**10**). Although this might once have seemed a still-born display of academic learning, it may now look startlingly up to date as we consider, say, the way in which so many contemporary artists have re-created their own images in the theatrical guise of art history. Unwitting disciples of Reynolds include such photographers as the American Cindy Sherman, who re-creates her own persona as a series of charades that run the art-historical gamut (Fouquet [**11**], Holbein, Caravaggio, Ingres, among others); or the Japanese Yasumasa Morimura, who can populate with his own face and body everything from Cranach's Munich *Crucifixion* and Rembrandt's *Blinding of Samson* to Goya's *Executions of the Third of May, 1808* and Burne-Jones's *Golden Stairs*.

Such private art-historical costume parties reflect only one facet of the infinite ways contemporary artists re-create the past. A particularly telling symptom of the ubiquitous phenomenon which, in 1978, was called *Art about Art*, the title of a prescient exhibition at New York's Whitney Museum, may be found in works that could be awkwardly dubbed 'neo-neo-classicism'. The original Neoclassicism of the late eighteenth and early nineteenth century used to be anathema to modernist taste, for it seemingly revived given forms rather than forging new ones; but in the historicising climate of the late twentieth century it was this very aspect of the movement that switched from

negative to positive. So it was that the Italian painter Carlo Mario Mariani turned with love and passion to the marmoreal figures of the first waves of Neoclassicism, re-creating once more the chilly statuary style embraced by the likes of Mengs and David. Mariani even went so far as to re-create in 1980 a lost painting by David, the corpse of the revolutionary martyr Lepeletier de Saint-Fargeau, now known only from a drawing and the fragment of a print (**12**). The result cuts through layers of history, offering not only an exercise in archaeology that may actually bring us closer to David's painting than any documents surviving from his own time, but an original work of art that proclaims its unique authorship as clearly as would a work by David. It becomes a homage to an historical style that itself was a homage to the look and feel of a buried classical past. Such a sophisticated revival of Neoclassicism can be found, too, in the imaginary voyages taken by the Scottish artist, Ian Hamilton Finlay, who has re-created at Little Sparta, south-west of Edinburgh, the kind of eighteenth-century garden in which classical monuments prompt meditations on the antique past, a realm of memory that is now given a newly nostalgic dimension by being reconstructed yet one more time.

Our penchant for nostalgia, for resurrecting history, has become much more of positive than a negative force, carrying with it a new fascination for earlier 'neo' movements, such as Neoclassicism, once scorned by modern prejudice. From this post-modern vantage-point, many aggressively innovative enthusiasms for earlier, usually non-Western and prehistoric art have begun to seem like variants on the nineteenth-century tradition of revival styles. When Picasso and Derain, Nolde and Kirchner zealously embraced the grotesque and magical character of tribal art, or when Henry Moore sought to purge sculptural decadence by turning to models from Pre-Columbian civilisations, were they not looking backwards to remote ideals in the way that earlier artists used Greco-Roman antiquity or the Middle Ages to nourish their visions of a new art? Even prehistory could become a site of nostalgic revival, witness earthworks like Robert Smithson's *Spiral Jetty* or James Turrell's *Roden Crater*, both of which offer a kind of fantastic time-travel to imaginary archaeological sites from a neolithic era. Similarly, Richard Long's hand-laid arrangements of uncut stone fragments stir up indigenous British memories of Stonehenge, a talisman that also inspired many Romantic artists to regress to primordial roots.

Such voyages to other worlds of art and civilisation can often be replaced by respectful or comical quotations or by poignant contrasts between now and then, especially when contemporary artists look at the hallowed past through the lenses of the real-life world we live in today. For example, Alfred Leslie, a disciple in the 1950s of De Kooning's abstractions, began to reconsider, in the 1960s, such venerable realist masters as Caravaggio and David, trying to paint as they did from unedited direct observation and even re-experiencing famous paintings in the present tense. Thomas Cole's unpolluted view of the Oxbow in the Connecticut River, lovingly recorded in 1836, was revisited by

17 Otto Dix *Vanitas (Youth and Old Age)*, 1932, mixed media on wood, 100 x 70 cm, Friedrichshafen, Zeppelin Museum

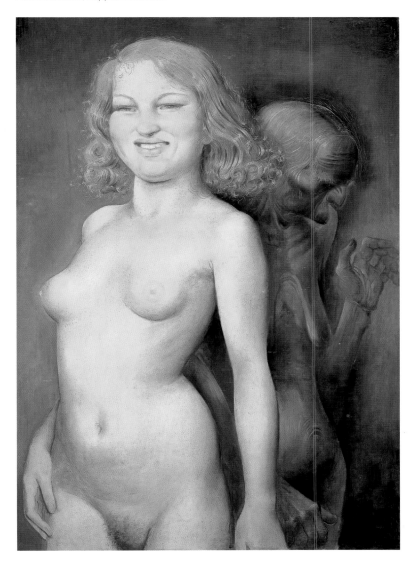

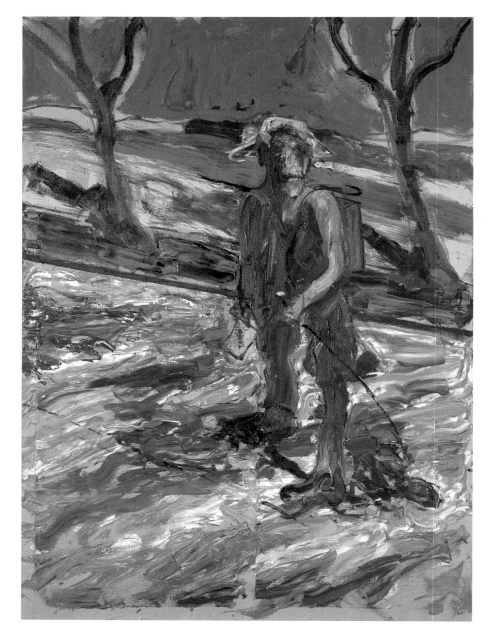

18 Francis Bacon *Study for Portrait of Van Gogh III,* 1957, oil and sand on linen, 198 × 142 cm, Washington, D.C., Hirshhorn Museum and Sculpture Garden, Smithsonian Institution. Gift of the Joseph H. Hirshhorn Foundation

martyrdom of General James Wolfe to a loftier plane). Consider, too, how the black American painter Robert Colescott commented on the ugly facts of American race relations by confronting one of De Kooning's women and turning this frenzy of paint into a politically incorrect caricatural head of an old-fashioned Aunt Jemima, complete with bandanna, bug eyes and toothy smile, and then titled the result, in imitation of Southern American patois, *I Gets a Thrill Too When I Sees De Koo* (**14**). The result, rather than being incendiary, is hilarious, calming troubled waters with its comic art-historical irony. And what about De Kooning's own mix of past and present in the *Woman* series (**15**)? In the 1950s, these horrendous icons came across as both a post-apocalyptic volcano of reckless paint and a celebration of such brashly contemporary feminine lures as fiery rouge and lipstick, broad exposures of pink skin, and cornucopian breasts – in other words, the pin-up ideals of the period as embodied by Marilyn Monroe (whose face, in fact, appeared in one of these images). But this sense of mid-century New York now also looks rooted in this Dutch-born artist's own indigenous traditions. Looking at the *Woman* series today, we think of De Kooning's past – not only of Picasso's hideous witches, but of Frans Hals's slashing evocation of cackling whores or of Rubens's alchemy in transforming pink pigment into succulent flesh. Indeed, in the 1950s and 1960s, De Kooning and Picasso almost converged in their homage to such great ancestors from the Low Countries, with both of them offering variations on the National Gallery's Rembrandt of a clothed, but bathing woman, ankle-deep in a stream (**16**), a canvas reconsidered again for this exhibition by Antoni Tàpies. Looking at such marriages of present and past, one sees

Leslie in 1971–2 and re-recorded as a blighted, industrialised landscape in Western Massachusetts; and the premature death in 1966 of the New York poet Frank O'Hara was ennobled by translating it into a pictorial template provided by Caravaggio's Vatican *Entombment* (**13**, a new version of Benjamin West's successful use of Van Dyck's *Lamentation* to elevate the military more fully the way in which twentieth-century art revitalised the constant see-sawing between the contemporary and the historical. For De Kooning, as well as for countless other artists, the sheer technical wonders of paint, not to mention the perennial magic of the Old Masters' skills in mirroring the seen world, might well be enough of a reason to visit and re-visit the museums. The irony of witty quotations is one thing, but there are more visceral marvels to learn from: the layerings of paint that evoke the muscle and bone beneath the flesh, the rounded high-

light that reflects a window, the streaks of colour that produce a radiant sky, the dappled brushwork that can turn into rain on leaves. Such abundant miracles can nurture all artists, but are essential models for that endangered species of passionate realists who, like Lucian Freud, remain convinced that the unmediated replication of the seen world is their central calling.

Still, works of art always reflect more than what even the most dogged realists hope to record, and can often be savoured in national terms, a point made clear by the National Gallery's familiar division of its catalogues and galleries into national schools. Although the mission of many adventurers in the domain of Cubism and abstraction was to create a universal art, the equivalent of a visual Esperanto that would announce a Brave New World, the rekindling of national hatreds and prides that marked the First World War often re-directed artists to search the museums for their own pictorial roots. In the wake of the war, French artists, for example, as well as expatriates in Paris like Picasso and Gris, felt the need to heal the shattered present with quotations, both solemn and comical, from their own national pictorial ancestors, a lineage that ran from Poussin and the Le Nains through Ingres, Corot and Seurat. East of the Rhine, German artists who, before and during the war, had pushed the cosmic potential of abstract art to apocalyptic extremes soaring high above Western history reverted to much earlier German traditions that now had a specifically nationalist character. During the war, for example, Otto Dix's paintings looked as if they had just been detonated on the battlefields but, soon after, he tried to revive, in his own grisly way, the spirit of Dürer, Grünewald and Runge (**17**). At the end of the century, Georg Baselitz reincarnated the by now historic style of the first German modernist group, Die Brücke, and Anselm Kiefer invoked the phantoms, both exalted and nightmarish, of German culture and history – Friedrich, the Ring cycle, the neo-classic and neo-Gothic architecture of the Nazi era. British art, too, after the first shockwaves of modernism had been followed by the far

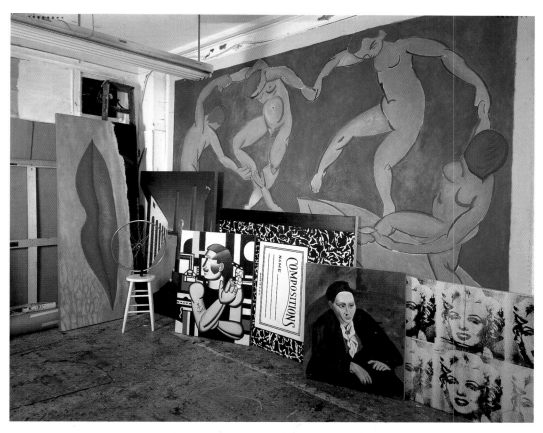

19 Mike Bidlo *View of Mike Bidlo's Studio in New York* (showing paintings by him after Matisse, Picasso, Léger, De Chirico, Warhol and Lichtenstein), 1987, private collection, courtesy Bruno Bischofberger, Zürich

more shocking reality of war, began to burrow into the healing security of its native heritage. The airborne spirit of William Blake seems to have been launched again in the art of Cecil Collins; the Pre-Raphaelites' hard grasp of visual and palpable truth was reincarnated in the earthbound visions of Stanley Spencer; the enchanted, minuscule landscapes of Samuel Palmer were born once more in the nature fantasies of Graham Sutherland. The very name, 'neo-Romanticism', with which these trends were dubbed in 1942 by Raymond Mortimer reflects not only the welling desire to return to an historical past but also a nationalist awareness of what was most characteristic of British culture. With comparable retrospection, Italian artists, after Futurism had met its corollary on the battlefields, also embraced their own Mediterranean heritage, with De Chirico's re-creations of Greco-Roman subjects and imagery, Severini's paraphrases of Quattrocento painting, or the ambitions of a group of artists in the 1930s – Carrà, Sironi, Campigli, Funi – to revive the

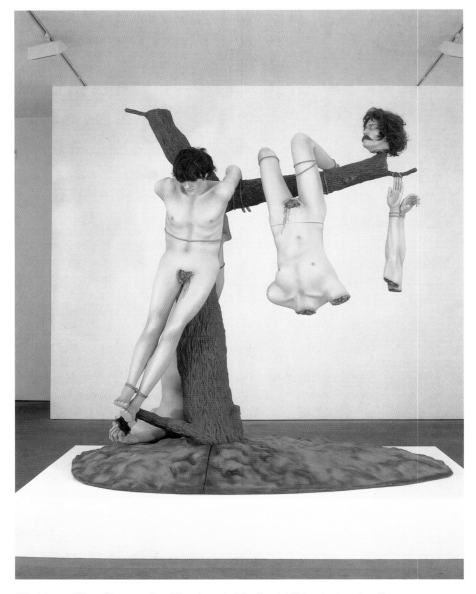

20 Jake and Dinos Chapman *Great Deeds against the Dead*, 1994, mixed media with plinth, overall dimensions 277 x 244 x 152 cm, London, The Saatchi Gallery

for another, carried on a long infatuation with the works of Poussin, making his own variations on works always accessible in the National Gallery as well as those originals he could study in temporary exhibitions. Such uses of the past quietly perpetuated what Cézanne himself had always done. By the end of the century, however, such borrowings from Old Master sources took on a quite different inflection, reaching almost mechanised extremes of veneration. For several artists, these images required duplication with minimal changes or, in some cases, none at all. Sherrie Levine, for instance, copied book-size reproductions (sometimes in black and white) of works by artists and even photographers – Cézanne, Monet, Giacomo Balla, Kandinsky, Léger, Walker Evans – familiar to the standard histories of modern art. Mike Bidlo has devoted his entire career to copying, in exact dimensions, famous works in the classic pantheon of modern masters, from Matisse, Duchamp and Picasso to Pollock, De Kooning and Warhol (**19**), at times even exhibiting as retrospectives his handmade facsimiles of these masters' works. As usual, the proportions of innovation and respect for authority keep shifting, so that, looked at one way, such replications seem totally subservient to history, a catechism of venerable images, like the copies of sacred manuscripts made in a medieval scriptorium. Looked at another way, their fascination with virtual reality, with reproductive images, seems to embrace fully the visual environment of the late twentieth century. When Ingres copied Raphael or when Cézanne copied Michelangelo, this was one kind of link to tradition. When artists today replicate as exactly as possible a Matisse or a Lichtenstein, they may be telling us about something uniquely related to contemporary experience, that we are living in an age of second-hand realities, a world of faxes, xeroxes and computer screens.

Today the burden of art history, globally disseminated through permanent collections, travelling exhibitions, publications both weighty and portable, classroom lectures and textbooks, can become so overwhelming that the very idea of youthful innovation risks being stifled by our ever accelerating knowledge of the past. So it is that even those artists in the much publicised

monumental mural style of the Italian heritage, born with Giotto and lost by the nineteenth century.

But artists hardly need a nationalist programme to select the art that fires them. Just to think of two internationally acclaimed masters of post-war British art, Francis Bacon, for one, ransacked images from such diverse sources as Velázquez and Van Gogh (**18**), Eadweard Muybridge and Sergei Eisenstein; and Leon Kossoff,

Sensation show, which, surprisingly, triggered even greater outrage in Brooklyn in 1999 than in London in 1997, can often be given respectable pedigrees by our awareness of their debts to art history. Dinos and Jake Chapman may create a science-fiction race of sexual mutants in humanoid guise, but they also can resuscitate in three polychrome dimensions the initial shock of two-dimensional horror to which we have become inured in one of the most famous etchings from Goya's *Disasters of War* (**20**). Ron Mueck's eerie body-doubles first startle us in the present tense, but then the Muse of History locates them not only in the twentieth-century tradition of Duane Hanson's waxworks people but also, even farther back, in the domain of hyper-realist Spanish Baroque sculpture. Damien Hirst's tanks of preserved animals, sliced or whole, while instantly unnerving in an art context, have now begun to recall both the respectable conventions of educational display in nineteenth-century museums of natural history and the wondrous biological specimens collected in the *Wunderkammer* typical of the sixteenth and seventeenth centuries. Jenny Saville's Gulliverian travels in the mountains and valleys of all too blemished flesh update an earlier British dynasty of Stanley Spencer and Lucian Freud. Mark Wallinger's stable of racehorses in perfect profile on a white ground (**21**) instantly proclaim the authority of their eighteenth-century pedigree in George Stubbs, as if *Whistlejacket*, also the source for a quite different interpretation by Jeff Wall in this exhibition, had been reincarnated. It is telling that, in New York, the informed art-world response to Mayor Giuliani's outrage at the ostensible heresy of Chris Ofili's image of the Holy Virgin Mary in *Sensation* was to summon up the lessons of art history, reminding the mayor and his pious supporters that Caravaggio's *Death of the Virgin* was at first deemed blasphemous because Mary

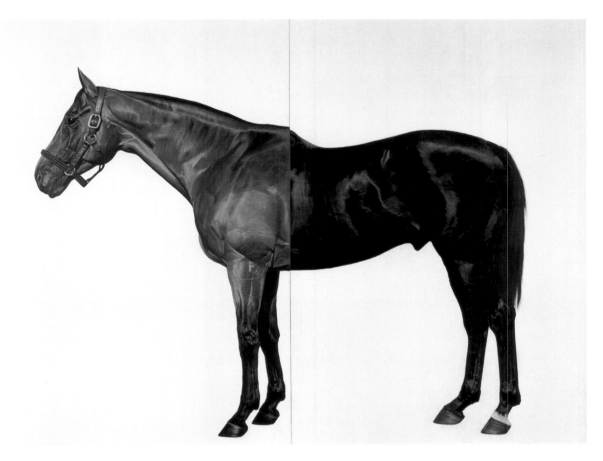

21 Mark Wallinger *Half-Brother (Exit to Nowhere/Machiavellian),* 1994–5, oil on canvas, 230 x 300 cm, Tate, London

was modelled after a whore, and that Manet's *Dead Christ with Angels* was thought offensive because Jesus looked like a dead coalminer brought up from the pits. Artists, like the rest of us, walk in the long shadow of history, to which an entire century has just been added. Given the evidence of the infinite ways in which artists today have rejected, absorbed and quoted this ponderous past, we can be sure that the next century's dialogues with the Old Masters, who will soon include the once young masters of the late twentieth century, will keep us more than alert. Only a decade ago, could anybody have imagined that a major video artist, Bill Viola, would use this new medium to re-enchant us with the mysteries of Pontormo's *Visitation* or Bosch's *Christ Mocked*?

USING THE COLLECTION:
A RICH RESOURCE

Richard Morphet

THE NATIONAL GALLERY'S Collection has long been of compelling interest to artists. Nine of the twenty-four participating in *Encounters* have previously exhibited here in direct connection with the Collection, and twenty-one works in the present exhibition (by two artists) were executed in the Gallery. However, alongside new British art it is a fresh development for the Gallery to be showing work by eleven artists from abroad. In the context of a collection that shows masterpieces of both foreign and British art, this seems only natural. It is also appropriate in a period in which global links are easier and more multiple than ever, even though art's regional identities remain pronounced.

Many works in *Encounters* reflect frequent study of their National Gallery sources. Others are a response to intense experiences on specific visits. With still others, the acquaintance is less close but the source image nevertheless fundamental. This, too, is indicative of the way images are transmitted in the contemporary world. It corroborates the importance of the art museum's dual capacity as a place of display and the propagator of visual information about its works by many additional means, all of which have the purpose and effect of attracting people to view the actual works of art. Even a glancing encounter can be the catalyst for remarkable work that could not otherwise exist. As Keith Roberts wrote in the catalogue of an earlier related exhibition, 'Works of art become part of the imaginative landscape of the artist'.[1]

Both the Gallery and its immediate environs are a compelling site for fantasies by artists, or by others about their works. The subject of Richard Hamilton's painting in this exhibition is the building itself. Over three decades ago, another participating artist, Claes Oldenburg, depicted the Gallery in his visualisation of the replacement of Nelson's Column by a giant gear-lever, the motion of which would reflect the halting movement of the dense traffic that still afflicts Trafalgar Square (**1**). Anthony Caro's exhibition at the National Gallery in 1998 inspired the conception of a novel way to display his sculpture (**2**).

Encounters makes no claim to present an overview of contemporary art practice. With only twenty-four participants this is inconceivable. Furthermore, shortage of space inevitably compels the absence of work by innumerable artists who respond intensely to great work from the past. Many of these were born within the forty-four years that separate the birth of Balthus, the oldest artist in *Encounters*, from that of the youngest, Francesco Clemente. Among younger generations, animated engagement with the art of the past continues unabated. *Encounters* is thus in every way open-ended. Nevertheless, despite the exhibition's unavoidable limitations, the work shown is strikingly diverse in approach. It is worth exploring both the differences between the twenty-four artists' visions and some of the qualities their works have in common.

In inviting twenty-four artists to make new works for the exhibition, the National Gallery was stepping into the unknown. The first imponderable was which source works they would select. In the event the works chosen cover a wide spread of the Collection. At least one source work was painted in each of the six centuries covered. The artists stretch from Duccio, born in the mid-thirteenth century, to Monet, in whose lifetime the oldest participating artist, Balthus, had already painted a reclining nude after Poussin, the very category of motif he has painted again for this exhibition. The living artists' selections show two points of particular concentration, the seventeenth and the nineteenth centuries. No two artists have chosen the same work. Only two (Bourgeois and Twombly) have chosen the same artist (Turner), with predictably contrasting results. Many participating artists have in the past made works that relate to National Gallery pictures other than those they have selected now, and this process continues.

Only four of the artists, Freud, Hodgkin, Kossoff and Oldenburg/Van Bruggen, have made works that resemble their source works at a glance. A fifth case, that of Auerbach, is complex in this respect, as explained in the essay on his picture. In a further two works, those by Caulfield and Kitaj, the source can be identified

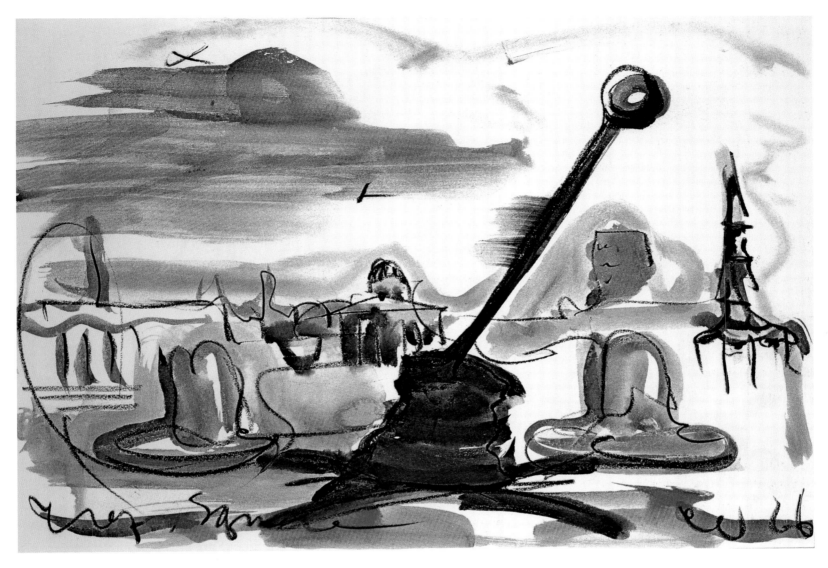

1 Claes Oldenburg *Sketch of Gear-lever to replace Nelson's Column, Trafalgar Square,* 1966, crayon and watercolour on paper, 48.2 x 66 cm, private collection

reasonably quickly by sight. That leaves as many as seventeen works that appear independent of their sources. Such a balance is in marked contrast to the close attachment to the source image evident in the great majority of the works in a major recent exhibition which, like *Encounters*, depended on the collection of a great museum. This was *Copier Créer: De Turner à Picasso: 300 œuvres inspirées par les maîtres du Louvre.*[2] The reason for the difference is, of course, that the works in *Encounters* were commissioned. Nevertheless, when one knows why each work in the current exhibition takes the form it does, the degree of engagement with the source work is striking in almost every case. Intentionally or not, the works also communicate a sense of the time taken in their conception and realisation. The latter is part of the very subject of several. The majority of the works not only direct attention to their own physicality but use their materials in an actively sensuous way. All these features, which imply a savouring of continuity and of making, are to some extent under threat today in a culture that lays emphasis on speed and simplicity in the consumption of information, and limits the opportunity to concentrate, or to explore anything in depth. These developments are combined with an information overload compounded by the speed and technological sophistication of its transmission. The pressure on artists to produce is a related

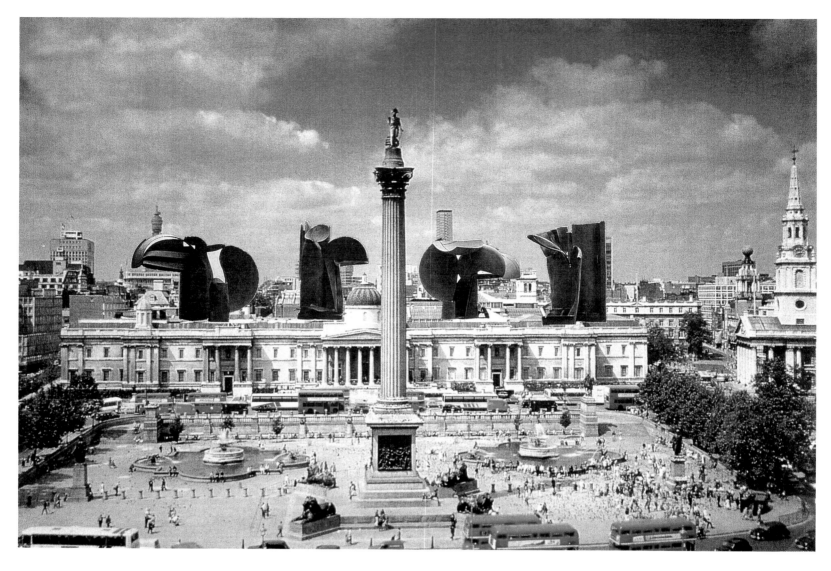

2 Andy Bow, Catherine Ramsden and Ken Shuttleworth, image sent to Anthony Caro in celebration of the exhibition *Caro at the National Gallery*, 1998, showing an imaginary scene of an enlargement of Anthony Caro's *Night Movements*, 1987–90, installed on the National Gallery roof, photographic collage, 15 x 20 cm, collection Anthony Caro

problem. Not surprisingly, therefore (as Robert Rosenblum's essay shows), much new art quotes and combines available images from both the recent and the farther past with promiscuous abandon, in the process creating effective markers of contemporary existence. The works in this exhibition connect with their heritage in a slower way. They also lack the sense of irony and the detachment that are widespread in art today. Nevertheless, many on today's 'cutting edge' would agree with the exhibition's implicit assertion of the inseparability of living art from the great art of the past. The constantly increasing scale of the interest shown simultaneously today in the very new and in the National Gallery's Collection is not evidence of conflicting phenomena.[3]

A large number of the works in *Encounters* suggest an analogy with the stage, and in making them several of the artists worked like directors, manipulating cast, lighting or performance. The final form of many works either resembles a stage or is a box-like interior in which something is either happening or latent. Into such spaces, unexpected figures or their substitutes can be inserted (Hamilton, Kitaj, Oldenburg/Van Bruggen). Though over half the works openly represent the human figure, a frequent

subtext is the implied presence of people they do not depict, underlining that every work is about more than we are literally shown.

These themes of revelation and implication connect with artists' impulse, evident in the great majority of works in the exhibition, to evoke a world other than that of contemporary actuality. In this, they continue a principal theme of the National Gallery's Collection. Some evoke a condition of dream or reverie, while others develop a rich fantasy. Several inhabit a world of myth and others recall long distant times. Indeed, duration across the centuries is a second way in which time is a subject of many of these works. Some of them take the viewer back, stage by stage, through a long perspective, as in Finlay's journey from the 1950s to the 1880s to the 1620s to the first century before Christ and thence to a still more distant era in ancient Greece, or Kiefer's from recent insights regarding space-time to the persecution and genocide of the 1930s and 1940s to ancient Mayan civilisation to the creation of the galaxies. In the continuously recycled water of her sculpture, Bourgeois represents time as a thread that never ends.

Those artists associated with the Mediterranean (Clemente; Tàpies; Twombly; Kiefer, who lives and works near it; and Cox, whose work in Encounters was made in Italy and Egypt, of materials found in those countries) form a sub-group whose work combines strong materiality with reaching simultaneously back into a distant past and out to extra-European cultures. But a majority of the works in Encounters give evidence of an impulse to be elsewhere, and in most of those that do not the artists create distinctive imaginative environments of their own, which may amount to the same thing. Yet, however persuasively any work in the exhibition transports us elsewhere in time, place or state of mind, each also recalls the viewer insistently, in one way or another, to the here and now. Some works that most strongly evoke the ancient also insist powerfully on modern realities that are at times uncomfortable.

A characteristic of most of the new works is the multiplicity of opposites that each embodies and the flagrancy with which it does so.[4] Head-on oppositions within a single work are a particular feature of much modern art. They evince the complexity of the development of art in combination with that of artists' own experience in a world that, while knowing and information-saturated, is also uncertain and full of ambiguities. As Keith Hartley states in his essay on Kiefer, 'It is … the ability to hold two or more contradictory ideas in one image, without their cancelling each other out, that makes art so unique and precious.' In the great majority of cases, shifting meanings interact for the viewer as the work is experienced. This is so whether alternative readings are openly proposed (as with Caro's variations, Finlay's free word-structure or Johns's enigmas of image and space) or (as with Hamilton and Le Brun) the very firmness of the image leads us to question what can be taken for granted.

In every work in the exhibition, either the imagery or the work's own physical appearance (or both) prompt the viewer to ask exactly what is going on. One enquiry may be how the work was made and why it took this form, but in many cases another concerns the narrative that the new work may propose. Balthus, Clemente, Cox, Finlay, Kitaj, Le Brun, Oldenburg/Van Bruggen, Rego and Viola all place the initiative in the viewer's court to determine either the meaning or the outcome of a sometimes ambiguous or interrupted image, story or state of affairs. Even images so dissimilar as those of Caulfield, Twombly and Wall seem like stages of a narrative. As half the artists' source works remind us, the same is true of innumerable works in the National Gallery, yet taken as a whole the new works are differentiated from the old by their characteristically modern interest in fragmentation, changeability and open-endedness. This is expressed in a wide range of ways.

A key part of Johns's subject is the dismemberment of a master image, while in Tàpies's painting the human body is dismembered and further violated. Clemente's warning of the perils of life calls across to Rego's demonstration of the disasters than can follow human machinations. Hodgkin's replacement of a scene of extraordinary calm by one of mysterious turbulence is in some ways an outdoor parallel to the subversion by Oldenburg/Van Bruggen of a no less supremely orderly interior. In Kitaj's picture we see an icon of modern art turned almost brutally into a trophy. Kiefer links ancient ritual killings to modern genocide. Caulfield, Finlay, Hamilton and Oldenburg/Van Bruggen all transform the very nature of something previously settled and known, while Le Brun cautions against regarding his insistent and archetypal image as the subject of his work.

The exhibition abounds in themes that are shared between different combinations of works, not always in obvious ways. Those by Finlay and Kiefer present groups of stars and this motif links to the importance of light, which in different ways plays a crucial role also in the works by Balthus, Bourgeois, Caulfield, Cox, Hamilton, Le Brun, Oldenburg/Van Bruggen, Twombly, Uglow and Wall. In varying ways, love is a central theme in the works by Bourgeois, Caro, Clemente, Oldenburg/Van Bruggen, Rego, Tàpies, Viola and Wall. The idea of a picture within a picture is present in those by Caulfield, Clemente, Finlay, Hamilton, Kitaj, Johns, Oldenburg/Van Bruggen and Rego.

The works of five artists, Freud, Hockney, Kossoff, Rego and Uglow, consist of marks made in the presence of the motif, as the outcome of direct looking (in one instance through an optical device). With a sixth artist, Auerbach, the position is a little different, though closely related. He looked insistently at his motif in a London street but painted it in the studio, from drawings made shortly before. Three of these cases involve mark-making from direct observation of pre-existing works of art and three from a figure or figures placed as the artist determined. In every case, however, the artist's visual engagement was enriched (and the form of the resulting work affected) by their extended experience of art, as well as by their experience of life.

In an exhibition of responses to earlier art each new work naturally effects some kind of conjunction between the visions of two quite distinct artists. But bringing unlike things together to make something new is characteristic of much of today's art, and the majority of the artists in *Encounters* do this. We see it in Bourgeois's mirrors and water, Hamilton's modernism and Postmodernism, Kiefer's rat-trap and stars. Caulfield's location of an antique silver plate in a trendy bar is a parallel, in reverse, to Oldenburg/Van Bruggen's introduction of a work by Rietveld into a seventeenth-century interior.

A peculiarly modern way in which unlike things are joined is in the merging of disciplines. Thus painting is extended by Kitaj and Twombly into drawing, by Viola into video and by Wall into photography. To create a painting, Hamilton uses the computer as a vital tool. Finlay extends painting into poetry. His word-centred work links to the incantatory sequence of names stencilled along the bottom of the Johns. When Clemente, Kiefer

and Tàpies inscribe words (and Kiefer numbers, as well) the effect, in their wall-like works, is akin to graffiti. The comparison signals a close connection with the work of Twombly, whose paintings frequently include scrawled words, strong both in cursive vitality and in associative intensity. While no words are present in his paintings in *Encounters* the pictographs in these canvases nevertheless partake of the urgency and immediacy of marks drawn on urban walls in both modern and ancient times. What might once have been considered a low form of expression has for some decades been fused with the highest art.

Almost all the painters of the source pictures would surely have found the responding works in *Encounters* shocking or incomprehensible in form, content and feeling, and not only because they make allusion to their own art. This is the historical norm, for what might Piero have made of Tintoretto, or Chardin of Monet? Not only would lettering on glass or backlit transparencies seem inadmissible to the source artists as art, but the work of Auerbach or Kossoff, which we know to be rigorous and the result of engagement of a high order with each given motif, would probably appear indulgent and careless of all acceptable norms. Even the works of Balthus, Freud and Uglow would seem puzzling.

Yet the new works, for all their strangeness in terms of the criteria of earlier ages, are examples of a natural continuity in art. An aspect of this continuity is the unpredictability of the connections it reveals. Artists respond to the down-to-earth as much as to the elevating qualities in their sources, and often to their factuality and practicality. When Kitaj selected works from the National Gallery's Collection for the 1980 exhibition in the series *The Artist's Eye*, he prefaced his catalogue introduction with these words of Walter Sickert's: 'And this, gentlemen of the press, curators, critics, experts and others, is the claim we painters make in regard to the Old Masters. They are ours, not yours. We have their blood in our veins. We are their heirs, executors, assignees, trustees. We are the pious sons, but henceforth it is we who are the interpreters of their wishes, with full power to set them aside, and substitute our own, whenever and wherever it seems fit for us to do so. They would have wished it so.'

The National Gallery's Collection makes artists aware of the gulf in time and (as many of them feel) also in quality, which divides

them and the artists whose work they come to admire. But it also makes evident the living reality of these works, through which time is collapsed, as if these paintings were made by contemporaries. As each new work in *Encounters* is a kind of dialogue it is not surprising that in many cases its starting point is not the source work but some pre-existing preoccupation of the living artist's. Yet in each case the result is a surprise; in many instances the encounter has opened up new territory for the responding artist.

Frank Auerbach has expressed well the interdependence that exists between living artists and masters of the past. On the one hand: 'It would be ludicrous to imagine that paintings come out of thin air and the people who attempt to keep themselves innocent, I think you'll find, do paintings that look tremendously like pictures that already exist. I think one's only hope of doing things that have a new presence, or at least a new accent, is to know what exists and to work one's way through it and to know that it is not necessary to do that thing.

'... I find that towards the end of a painting I actually go and draw from pictures more to remind myself of what quality is and what's actually demanded of paintings Painting is a cultured activity – it's not like spitting, one can't kid oneself.'[5] And: '... if you see a picture of yours reproduced across the page from one by Monet, you feel so miserably inferior. I mean, a Monet seems so grand and one's own painting so jejune and papery. Sooner or later you're going to see something that makes you feel a dwarf. And that keeps one going.'[6]

Yet on the other hand: 'I don't think you can understand the art of the past until you understand the art of the present.'[7]

What the living artists in *Encounters* have found through the source works they selected is themselves, their own vision. This is what determined their selection of source works, then, as each new work developed with its source in mind, invariably it took on a life of its own and this momentum determined its final form. The source works were, however, anything but incidental to the outcome, as the essays that follow make clear in detail.

The works in the National Gallery are a source not only of nourishment for artists but also of constant surprise. Great art of the past means one thing to one artist or generation, another to another. What is derived from it on a given occasion is unpredictable, but the nature of a great work of art is continuously to impart its exceptional concentration of idea and appearance. For artists from Britain and throughout the world it is impossible to imagine a time when a collection as astonishing and abundant as the National Gallery's will cease to be a fundamental resource.

Notes

1 In the catalogue of *Art into Art: Works of Art as a source of inspiration*, an exhibition at Sotheby's, London, September 1971, organised by *The Burlington Magazine*.

2 Paris, Musée du Louvre, April–July 1993. The exhibition and its 480-page catalogue were reviewed by Merlin James in *The Burlington Magazine*, August 1993, pp. 580–2.

3 Cf. the opposition implied by Lynn Barber, who wrote recently, 'I used to consider myself an art-lover because I was happy to spend a day in the National Gallery, or to drive round the back roads of Tuscany in search of another Piero. I now feel that sort of art-love is necrophilia. If you care about art at all, then you *must* engage with contemporary art, however difficult or irritating you find it Art is too important to consign to the heritage cupboard: we need it *now*' ('Art Struck' in 'This is British Art', 4-page special feature in *The Observer*, 19 March 2000, pp. 4–6).

4 Cf. the penultimate paragraph of the essay on Twombly, on p. 294.

5 Catherine Lampert, 'A conversation with Frank Auerbach' in exh. cat. *Frank Auerbach*, Hayward Gallery, London, May–July 1978, pp. 10–23.

6 Michael Peppiatt, 'Talking to Frank Auerbach', in exh. cat. *Frank Auerbach*, Marlborough Gallery, New York, September–October 1998, pp. 4–7.

7 Ibid.

ENCOUNTERS **ARTISTS**

CONSTABLE
The Hay Wain 1821

NG 1207 Oil on canvas, 130.2 x 185.4 cm

JOHN CONSTABLE (1776–1837) took as the subject of some of his most ambitious, large-scale paintings the countryside of his native Suffolk. His father operated a mill at Flatford on the river Stour and the young artist roamed the nearby fields and lanes, observing the evanescent effects of nature through the seasons and the changing patterns of light and shadow during the day. He made swift oil-sketches of scudding clouds and drawings of prosaic farm-yard motifs as, largely self-taught, he prepared himself to be what he called a 'natural painter'. From such homely studies he advanced, step by step through preparatory studies and roughly brushed-in sketches on the same large scale as the finished works, to the elabo-rately worked, so-called 'six-foot' canvases (more than 180 cm high or wide), that he submitted for exhibition at the Royal Academy. Constable's subtle, specific and minutely observed depictions of the local landscape, animated by the timeless rituals of agricultural labour, expressed the passionate engagement he felt with the English earth and sky, and with the slow, salutary rhythms of country life.

This 'six-footer' was completed and exhibited at the Royal Academy in 1821. It depicts a bend in the Stour at the cottage of Willy Lott, nestled in the trees adjacent to Flatford Mill. A horse-drawn wagon fords the stream while in the distance workers can be seen cutting the hay they will soon load on to the wagon. Clouds roll across the sky and sunlight glistens on the water. The highest note of colour comes at the vertical centre of the canvas with touches of bright red on the horses' blankets. (The six-foot sketch for this painting is today in the Victoria and Albert Museum, London.)

As fresh and direct as Constable's depiction is, as unmediated as his gifts of observation appear to be, the painting is in no sense 'artless'. Rather, the artist studied the works of other painters assiduously, learning from the Italianate landscape compositions of Claude Lorrain, the massing of forms in Gainsbor-ough's rolling landscapes, and the work of his contemporaries, which he followed with a competitive eye. And Constable's works in turn proved influential on other artists as well, in the case of *The Hay Wain* in a very specific way, as it soon became a point of reference in the history of modern French art. Little remarked when shown in London in 1821 and again the following year, the painting was sold to an Anglo-French merchant, John Arrowsmith, who submitted it in 1824 to the Paris Salon. There, it was awarded a gold medal and, far more important, attracted the attention of Eugène Delacroix, among others, who recognised Constable's novel mastery of naturalistic light effects and immediately sought to emulate them. The direction of French landscape painting was deflected towards naturalism by this fortuitous encounter of a French master with an English painting in the galleries of the Louvre.
Christopher Riopelle

FRANK **AUERBACH**

born Berlin 29 April 1931

A UERBACH HAS LIVED in England since 1939. In the late 1940s and early 1950s, while studying at London art schools, he attended the classes of David Bomberg at the Borough Polytechnic. These strengthened his lasting conviction that a painting must convey a sense of the tangible reality of its subject. In each work afresh he seeks a structure that combines being a new and self-sufficient thing in itself with truth to his experience of what he has seen. He prefers familiar subjects, especially people he knows well and streets and public spaces near the studio in London's Camden Town in which he has worked since 1954.

Drawing is fundamental to Auerbach's method. His large, densely worked portrait drawings require many sittings. Paintings of outdoor subjects depend on many smaller individual drawings, made daily from direct observation and intended above all to capture and recall visual facts. Though often in progress for months, a painting consists only of the marks made in the final day's session. These replace marks made earlier, on the same support. The sudden realisation, 'a unity one had not predicted', is made possible by Auerbach's accumulated experience of the subject.

For decades, Auerbach has drawn from National Gallery paintings (and occasionally made paintings from such drawings). He has said: 'Without these touchstones we'd be floundering'.

© Julia Auerbach

Park Village East 1997–8

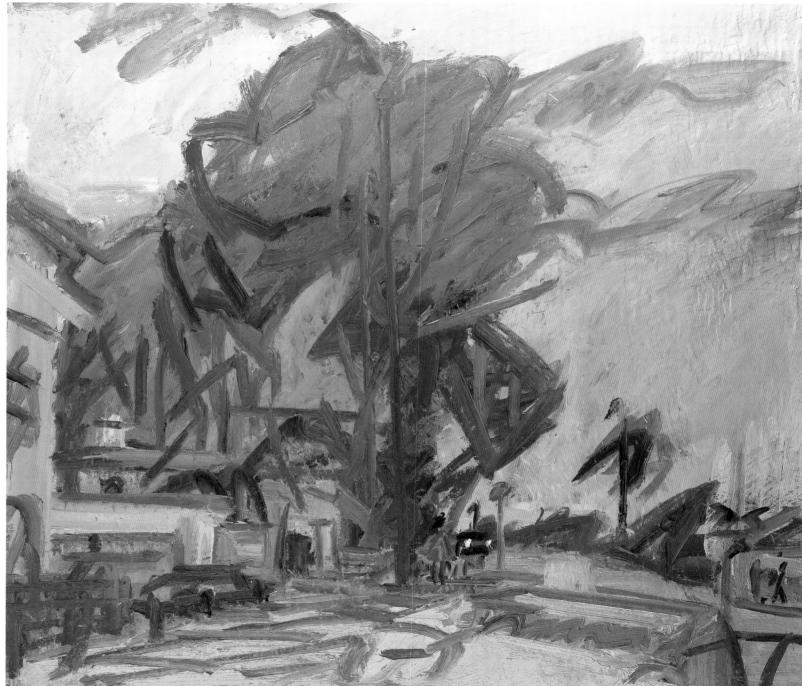

Oil on canvas, 122.5 x 137.2 cm, Ivor Braka Ltd., London

FOR MANY decades Frank Auerbach has engaged with the National Gallery's collection unusually closely. An exhibition at the Gallery in 1995 provided vivid evidence of the intentness (coupled, at times, with an almost dramatic invention) with which he had long made drawings in the Gallery.[1] In a surprising range of materials, he had worked from pictures by artists as dissimilar as Signorelli and Goya, Cuyp and Seurat, Veronese and Hals. The exhibition also displayed paintings made in the studio using such drawings. These included some of Auerbach's best known images, *After Rembrandt's 'The Lamentation over the Dead Christ'*, 1961, *After Titian's 'Bacchus and Ariadne'*, 1971 (**1**) and *After Rubens's 'Samson and Delilah'*, 1993.

As a student, Auerbach drew in the National Gallery almost daily. Later he did so two to three times a week. By the time of the 1995 exhibition he was accustomed to doing so weekly. Though he still draws in the Gallery often he does so less frequently now, partly because the focus placed by the 1995 exhibition on his working there had the effect of pushing him towards still greater involvement with his motif in nature. However, this adjustment in his practice does not imply any reduction in his concern with the work of the great masters, about which he has said: 'Without these touchstones we'd be floundering. Painting is a cultured activity.'[2]

Constable is one of the National Gallery's artists whose work has unusual importance for Auerbach, who has stated: 'I think I have a sort of penchant for the whole of English painting. It is as though it isn't held up by a scaffolding of theory or of philosophy … that it was arrived at empirically, out of sensation, as though there is a sort of fresh wind blowing through a room of English painting, that is nowhere else in the National Gallery. I find myself at home here.'[3]

Despite its range of artistic reference, this passage reads like an accurate description both of Constable's landscape painting and of Auerbach's rootedly English landscape in this

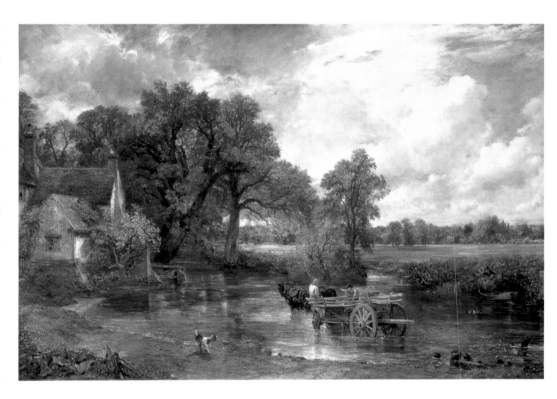

John Constable *The Hay Wain,* 1821

exhibition. Indeed, Robert Hughes has described Constable as Auerbach's 'great exemplar', drawing attention to 'his obstinacy and wildness: the ambition of his pictorial structure … and the determination to butt through his experience of Claude to a way of landscape painting that had *not* begun on the Continent among the props of antiquity'.[4]

Among the Constables in the National

Gallery at least two[5] mean still more to Auerbach than does *The Hay Wain*. Nevertheless, over the decades he has found himself drawn repeatedly to this Constable picture in particular. On his visits to the gallery he has rarely had a given picture in the Collection in mind from the outset. Instead, he has wandered through the rooms with his own work in progress unavoidably in his thoughts. The choice of National Gallery picture from which to draw has been determined not by aesthetic or art historical considerations but rather by his needs in relation to whatever is currently on his easel. That Auerbach has used *The Hay Wain* so often is due not to its imagery of trees and

1 Frank Auerbach *After Titian's 'Bacchus and Ariadne'*, 1971, oil on board, 153 x 122.3 cm, Tate, London

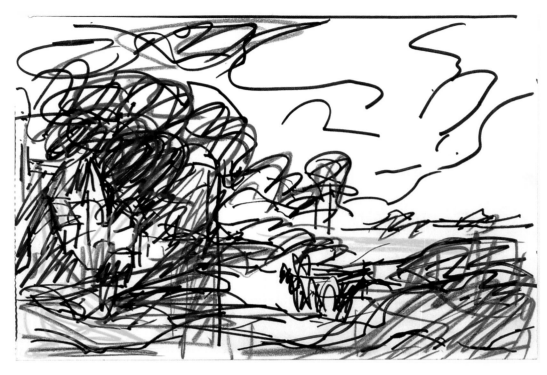

2 Frank Auerbach *Drawing after Constable's
'The Hay Wain'*, c.1989, felt pen and crayon,
28.1 x 41.2 cm, private collection

country life but to the strength of its pictorial structure.[6] Though it has many additional qualities that interest him, it is this that his numerous drawings made in front of the work itself assert (**2**,**10**).

The Hay Wain, therefore, has been of great importance in Auerbach's work over a long period. Moreover, *Park Village East* is one of the very few works in this exhibition that bear a striking resemblance to the National Gallery picture to which they relate. It is thus a paradox that *The Hay Wain* had no conscious causal role in the genesis of *Park Village East*. Furthermore, once Auerbach recognised the visual affinity between the two paintings, he resisted it actively as work progressed. Nevertheless, as he himself asserts, the visual likeness cannot be denied.[7] In fact the works' affinity also goes deeper than what we see. The unexpected yet intimate relationship between these pictures is explored below.

Auerbach lives and works in Camden Town, an inner suburb of London. Most of his outdoor subjects nowadays are pronouncedly urban; they represent scenes in the local streets, ranging from the entrance to his studio to busy nearby intersections and tower-blocks seen in the middle distance. Camden Town adjoins Regent's Park, but is divided from it by one of the principal railway approaches to the capital, which is many tracks wide at this point. The park itself is ringed by grand terraces, designed by John Nash, which back on to adjacent streets. Among those occupying the narrow terrain between terraces and railway is Park Village, itself divided by a declivity into the smaller Park Village West and the longer, sloping road which, at the point where it gives Auerbach's picture its title, runs beside the shrub-fringed wall of the railway embankment. Pevsner has recorded that these streets 'were laid out and begun by Nash in 1824 …. In the two Park Villages Nash established the tradition of the small urban villa …. Picturesque model villages had existed before … but the application of the village idea to the suburb was new and had a universal future.'[8] These developments near Regent's Park must have been witnessed by Constable, who painted *The*

3 Park Village East (motif of Auerbach's *Park Village East*), photographed October 1999

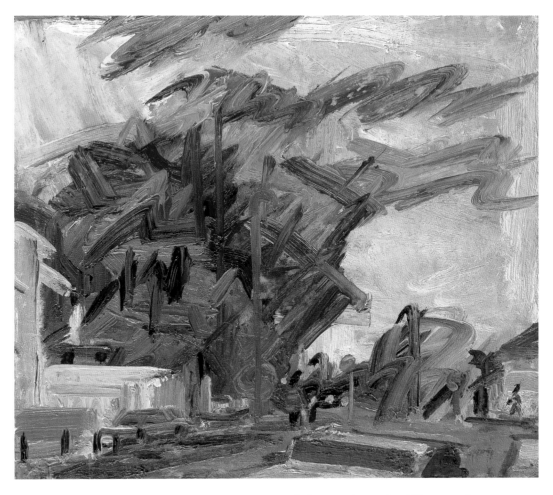

4 Frank Auerbach *Park Village East*, 1998, oil on board, 50.8 x 55.9 cm, Louisiana Museum of Modern Art, Denmark

Hay Wain in the same decade.

In the picture now exhibited, Auerbach's standpoint (**3**) is on the pavement beside the wall beyond which lies the railway. The chiefly yellow form in the foreground represents a passing car. At lower right is the near end of a bridge over the railway, on to which, beside one of the distinctive trident-like finials[9] of the bridge ends, a figure is walking. Between a distant smaller tree at the right and the dominant clump of trees in the centre, the roadway of *Park Village East* snakes up the hill. A black taxi cab advances towards the viewer. It is early morning, so its headlights are on. Near the foot of the tallest lamp-post

a lady exercises a dog. The complex structure at the left of the picture represents parts of two houses, the nearer with a garage extension. Behind bollards, a car is parked, off the road, just beyond cross-hatched road-markings, which continue the woven configuration where architecture and foliage meet.

Park Village East is one of five larger paintings of this subject made by Auerbach between 1994 and 1999. Though the viewpoints were all close, each produced a quite different composition. Of these pictures the first, third (the present work) and fifth all look uphill along Park Village East, from the same pavement. The other two look along it downhill, the second from the pavement opposite and the fourth from the farthest uphill position of the whole group. During this period Auerbach also made five smaller paintings,

which are versions of four of the larger pictures (one of which has two such 'offshoots'). The single smaller version (**4**) of the work now exhibited was probably finished after its larger companion. In Auerbach's studio there is not enough space for more than one large painting at a time. When he feels the need to break off work on the current picture for a day or so, he usually works on a smaller painting in the same space, and this tends to be of the same subject. Though each picture depends on its own separate set of drawings from the motif, the two paintings often feed off each other as work progresses. As a result the smaller picture is sometimes completed first.

When viewing all ten *Park Village East* pictures, one is struck by the extraordinary range of expression in these streetscapes, which, at even the farthest distance between the viewpoints, cannot be more than a hundred yards apart, and which represent a scene that is in many ways quite mundane. For all its radical reformulation of the motif, the present work is perhaps the most naturalistic of the group. They range from an intimate image painted in a kind of liquid freedom peppered with dark abruptnesses (**5**) to a giant surging arch of foliage further animated by an irregular, almost harsh progression of zigzags (**6**). Just over a year after the work now exhibited, virtually the same viewpoint (but with a significant leftward extension) produced an all-over image in a rich yet cooler palette (**7**), in which the fall of leaves reveals more of the architecture lying beyond the central clump of trees. The smaller version of this latest treatment (**8**) is the wildest of all these pictures. It demonstrates how, even at an extreme of painterly looseness and lack of restraint, Auerbach is concerned to convey a profusion of visual fact (here including another pair of illuminated headlights).

Auerbach began painting *Park Village East* when he wished, in his outdoor subjects, to counteract the unavoidable insistence of straight lines in paintings of the wholly urban scene. For almost three decades from the early

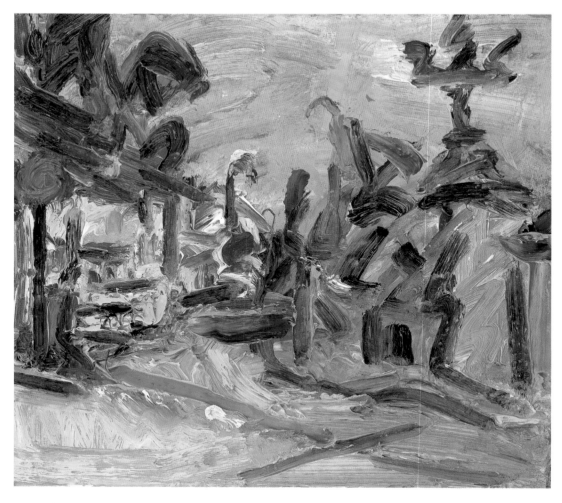

subject he might make six or eight drawings. Now he finds the idea of something familiar (and loved and cherished) more attractive as the starting point of a picture. It seems paradoxical, at first, that he feels the need to make many more drawings for each painting of such a motif. For the present picture he made perhaps two or three hundred, of which some thirty survive (**9, 11**).

Asked by Catherine Lampert whether he felt he had a better chance of arriving at something incredible if he began with something familiar, Auerbach replied: 'I think so, simply because one knows more about them. The thing is after all done from the mind, and the accrued information enriches the content to an extraordinary degree'.[10] This explains the seeming paradox of his need to draw so often from a motif he knows well. The drawings trap information. In the same interview, he explained: 'I don't visualise a picture when I start. I visualise a piece of recalcitrant fact and I have a hope of an unvisualised picture which will surprise me arising out of my

6 Frank Auerbach *Park Village East – Autumn*, 1998, oil on canvas, 128 x 153 cm, London, Marlborough Fine Art

5 Frank Auerbach *Park Village East*, 1994, oil on board, 40.6 x 45.7 cm, private collection

1960s this need had been answered chiefly by the relative proximity of Primrose Hill, a northern extension of Regent's Park, but now Auerbach required somewhere less distant. Choosing Park Village East, only three minutes' walk from his studio, as the closest available instance of something sylvan, Auerbach repaired to it 'as to a healing stream'. In doing so, he declined the possibilities of his own now abundantly tree-lined street, which is more shut in. Park Village East offered stronger visual antiphonies. From the viewpoint chosen for the present example Auerbach was challenged by the need to accommodate in a single picture the angularity of the buildings at the left and the complex of the central trees, with their curves, rhythms and luxuriant growth.

These features were *found* in a motif that might not particularly catch the eye, but which, in terms of Auerbach's requirements, was simply there, at hand. In earlier decades he consciously sought motifs which offered extraordinary compositions more obviously. From such a

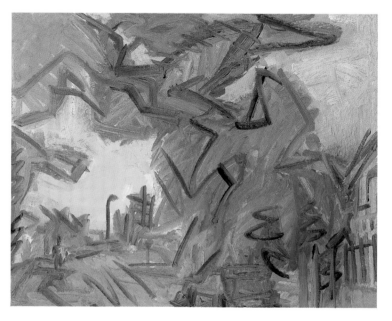

confrontation with this fact.'

Most of the sheets on which Auerbach has drawn from different positions in Park Village East bear two drawings on a single side of paper. He first draws the view in pencil, then later (sometimes on a later day), when the first drawing has, as he puts it, 'manured' the sheet, he makes a black felt-tip drawing over it from the same spot, then works on the painting from that. Sometimes a further reason for overdrawing in ink is to correct errors he perceives in the pencil notations. Usually, only one drawing of the motif is made per day.

Auerbach works from several days' drawings pinned beside the easel. These are succes-sively replaced as new ones are made, though individual drawings that are specially sugges-tive can be retained in the group. The finished painting can incorporate incidents observed on different days, or a particular earlier drawing can be decisive, but more frequently the last drawing, made on the day the painting is finished, is instrumental in bringing it to completion. As Auerbach explained to Robert Hughes when discussing his draw-ings of Primrose Hill, looking at them back in the studio: 'What I see is what I was looking at when I did the drawing and it reminds me of it. That's what it was for. I see the sunlight and the trees and the hill so I paint from these by looking at the drawing I'm looking at black and white drawings and the lines signal colour to me.'[11]

The painting from a given motif may be in progress for months, more or less daily. Yet the marks we see in the finished picture were all made on the last day Auerbach worked on it, preceding marks having been scraped off. Catherine Lampert has well described his oils as 'amazingly fresh one-day paintings … imposed on the site of months or years of unresolved attempts'.[12] The work ends when Auerbach has achieved what he calls a

7 Frank Auerbach *Park Village East – Winter,* 1998–9, 1999, oil on canvas, 101.6 x 153 cm, London, Marlborough Fine Art

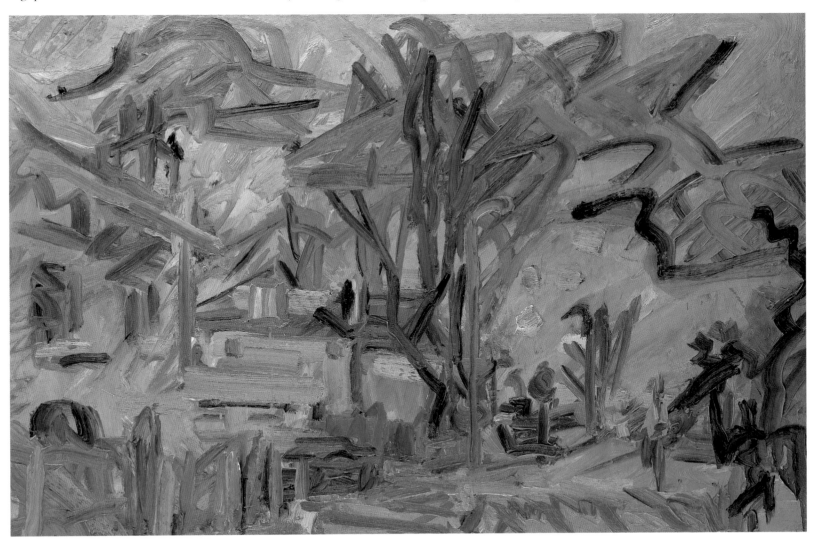

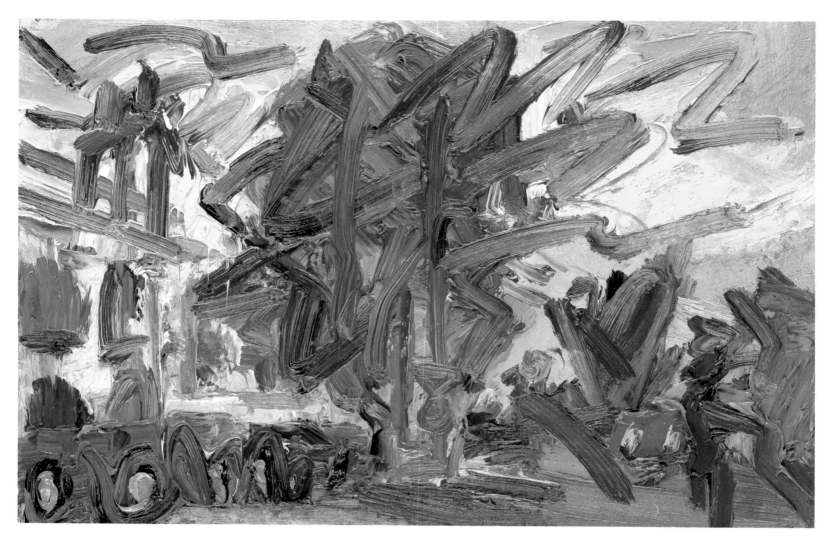

8 Frank Auerbach *Park Village East*, 1999, oil on board, 40.6 x 61 cm, London, Marlborough Fine Art

'reinvention of the physical world'[13] that has its own equal reality. The extraordinary and demanding activity that has led to this outcome is really quite extreme in nature, yet the strength and richness of the finished work would be impossible without it.

When visitors to the studio began to see the drawings Auerbach was making in preparation for the present work, they at once assumed they had been made from *The Hay Wain*. To Auerbach, however, 'the early drawings for "*Park Village East*" were almost embarrassingly similar to my drawings from the Constable, this was unpremeditated and something of a surprise' (**10**, **11**).[14] He proceeded consciously to try to distance the appearance of the developing picture from that of *The Hay Wain*, but 'I think there are still traces of the compositional connection in the finished painting'.[15]

The way Auerbach chose his viewpoint for *Park Village East* demonstrates how fortuitous is the two paintings' visual likeness. Once the broad location of the 'sylvan' motif had been established, he was not seeking a particular type of view. His exact position was chosen because a lamp-post enabled him to pinpoint it immediately each time he returned to the scene. Moving only a few yards along the pavement gives a quite different composition, as the paintings of Park Village East other than this one and its small version make clear. Nevertheless, it is not only in respect of composition that the present work connects with the Constable. It is notable how many parallels there are in specific details. These include not only the grouping of the central clump of trees, with a separate smaller tree to their right, the buildings at the left and the eye-catching clouds, but also a foreground wheeled vehicle, additional vehicles (note the boat in *The Hay Wain*), human figures and a dog. In each work, moreover, the gaze is drawn strongly along the principal 'thoroughfare'.

Such parallels were unintentional on Auerbach's part; his picture's kinship with *The Hay Wain* is on other levels.

When Auerbach started to draw from *The Hay Wain* it had long had such an entrenched a position in public affection that it might have been difficult to see it afresh. For Auerbach, however, this was not an issue and he is sure the same is true for most professional painters. The standpoint from which he approached the older work was his own total

9 Frank Auerbach *Drawing for 'Park Village East'*, 1997–8, felt pen over pencil, 21 x 23.5 cm, collection of the artist

engagement in painting and drawing. This enabled him to identify directly with the sense of rawness and indigestibility that *The Hay Wain* embodied in its day, and with Constable's willingness to accord to what then seemed the shockingly unsuitable subject-matter of rotted stumps and wrecked barges a size and grandeur that conventionally were the province of history painting. On this perspective the work's subsequent history, in terms of public standing or art historical theory, was irrelevant. He describes it as 'all gloss after the event'.

A further quality to which Auerbach

responded directly on the evidence presented by *The Hay Wain* itself was the completeness with which Constable addressed a landscape with which he was closely familiar. This was a matter not so much of the particular details Constable introduces, such as the turning dog, Hay Wain or harvesters, as of the sense the picture as a whole gives that it is true to the actuality of a working environment. Real, everyday life is going on, a quality that Auerbach sought likewise to catch in *Park Village East*. Among other masters of English landscape painting Auerbach admires Turner intensely and has drawn from his work often.

He points to Turner's extraordinary brilliance in turning effects into structures that are wholly convincing both as abstract form and as experience of nature. But he misses the feeling, given by Constable's landscapes, that the painter has tramped the terrain and that the scene recorded is also haptically felt. These qualities, too, are an aim in *Park Village East* and in paintings like it. They are realised strikingly in a pictorial language that could only be of the present time.

With reason (considering that a day's work in the studio habitually followed), the drawings of *Park Village East* were made at first light. The painting now displayed was completed in autumn. As usual, the light and weather of the final day's drawing are caught in the picture, despite the absence of any programmatic intention. The image is of a radiant fullness, at once of colour

10 Frank Auerbach *Drawing after Constable's
'The Hay Wain'*, felt pen and crayon, 28.5 x 41.2 cm,
private collection

than that visible from the pavement where he stood. Very strangely we are able, as we look, to walk simultaneously through an actual streetscape in the late 1990s, through a landscape that is somewhere else – in Auerbach's fantasy – and through a panorama of the immediate and vehement gestures of his hand.

It is extraordinary that a process in many ways so dogged can yield an image that is so variously alive. But, as Auerbach commented when being asked about *Park Village East*, 'I like complete abandon in painting, but not when it is like someone whirling their arms around, in which case the magic of painting disappears. One wants immensely complex material, digested to such an extent that one can write it down as though it was one's own signature, yet without losing the complexity of the material. That is what I see in all the paintings I admire. I want to do something that feels a hundred per cent specific. If it is not that, it is just decorative. I also want to

11 Frank Auerbach *Drawing for 'Park Village East'*,
1997–8, felt tip and chalk over pencil, 21 x 24.2 cm,
collection of the artist

and of growth. Despite broad agreement between the proportions of the elements in the composition and those in the actual motif, the finished picture has the effect of accentuating both the low horizontal reach of the view into the distance and the exhilarating ascent of the central structure to what seems like a magnificent height. Important in the latter effect is the elision of the vertical of the central lamp-post with one of the lines that describes foliage.[16] Like the majority of Auerbach landscapes, this picture is a system of strong vectors. The clouds here seem like exuberant out-flingings from the furious and festive ferment of intersections by which the scene is dominated. A great admirer of the landscapes of Koninck and Ruisdael (**12**), with their abundance of clouds, Auerbach observes: 'Before abstraction, landscape was the abstraction of painting, the field where artists had freedom to release their formal

impulses', and 'the sky is the abstract element of the landscape'.

As Auerbach stated in 1978, 'People have said that modern painting has a shallow space Maybe it has, but I've never seen it as such'.[17] Paradoxically, through the obsessive acts in which, day after day, he seeks to pin down the particulars he observes, Auerbach opens and expands the scene that is his source. Devoted to a specific reality, and remaining faithful to it in the finished work, he yet creates a surprising new space for the imagination, a 'place' that seems no less actual

Notes

1 Exh. cat. *Frank Auerbach and the National Gallery: Working after the Masters*, National Gallery, London, July–September 1995. The exhibition was supported by an important catalogue by Colin Wiggins.

2 In Catherine Lampert, 'A conversation with Frank Auerbach', in exh. cat. *Frank Auerbach*, Hayward Gallery, London, May–July 1978, pp. 10–23.

3 Quoted by Colin Wiggins in the catalogue cited at note 1.

4 Robert Hughes, *Frank Auerbach*, London 1990, p. 170. Hughes also notes Auerbach's admiration for Constable's rejection of '"the seeming plausible arguments that subject makes the picture" …. If it did not make the picture, what did? Nothing but paint, in its relation to what Lawrence Gowing called "the momentum of the real".'

5 *Salisbury Cathedral from the Meadows*, 1831, and *The Cenotaph to Reynolds' Memory, Coleorton*, 1833.

6 The painting which a given drawing from *The Hay-Wain* serves is as likely to be a street scene or an interior as one that shares any imagery with the Constable.

7 Interview with the author, 15 October 1999.

8 Nikolaus Pevsner, *The Buildings of England: London except the Cities of London and Westminster*, London 1952, p. 373.

9 Obscured from view in (**3**) by subsequent growth of intervening foliage.

10 Interview cited at note 2.

11 Hughes 1990, cited note 4, p. 166.

12 Catherine Lampert, 'Frank Auerbach', in exh. cat. *Frank Auerbach Paintings and Drawings 1977–1985*, British Pavilion, XLII Venice Biennale, June–September 1986, pp. 6–16.

13 In interview cited at note 2.

14 Letter to the author, 8 January 1999.

15 Ibid.

16 This elongation is accentuated by Auerbach's also continuing the line of the lamp-post downwards in such a way as to place it in front of the traffic signs (triangle above circle) attached to it, which in fact are on the viewer's side of the post.

17 In interview cited at note 2.

18 Ibid.

make something which, like Euclid's theorems, is like some nugget of unrepeatable, unique knowledge or sense, a knot of invention, like a new geometrical structure. It must not be made with arbitrary formal components, but with specific, varied, unpredictable material. If it's simply schematic you can chuck it in the dustbin. The same applies if it's simply reactive. It has both to be architectural and to be receptive and sensitive. If it is not both things, it's not art.'

Or, as he said to Catherine Lampert in 1978, 'All good painting looks as though the painting has escaped from the thicket of prepared positions and has entered some sort of freedom where it exists on its own, and by its own laws, and inexplicably has got free of all possible explanations.'[18]

Richard Morphet

12 Frank Auerbach *Drawing after Ruisdael, 'Extensive Landscape with a Ruined Castle and a Church'*, c.1982, black and yellow felt pen on paper, 20.6 x 27 cm, private collection

POUSSIN
Sleeping Nymph surprised by Satyrs 1626–7

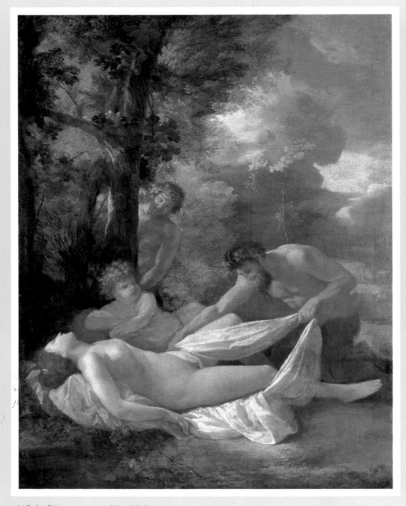

NG 91 Oil on canvas, 66 x 50.8 cm

BORN NEAR ROUEN in north-western France, from early in his career Nicolas Poussin (1594–1665) longed to travel south to Italy, and to immerse himself in Antiquity and the masterpieces of Renaissance art that he knew he would find there. After two failed attempts, in 1624 he reached Rome and was immediately at home. With the exception of two unhappy years when he was summoned back to work for Louis XIII in Paris, Poussin remained in Rome all his life, creating erudite, elegant and ever more deeply felt paintings on religious and mythological themes, paintings informed at every level by the Italian milieu in which he worked. He found avid patrons for his paintings in a small, sophisticated group of connoisseurs, Italian and French, noble and bourgeois, many of them, like Poussin himself, learned men, or hungry for learning, who were attuned to the complexities of theology and classical literature. We know from a diary of the day that, when the great sculptor and architect Gianlorenzo Bernini visited France in 1665, one of his pleasures, both intellectual and aesthetic, was the intense study and discussion of the Poussins he saw in private collections there. Such was the influence Poussin exercised during his lifetime that even *in absentia* he was recognized as the indispensable exemplar of French academic painting, the linchpin in that endlessly fertile relationship by which French painting drew – draws to this day – renewed life from Italian art.

Poussin's paintings were never dry exercises in erudition. Rather, early on, he found himself profoundly moved by the colouristic intensity and emotional and sensual charge of Venetian painting, especially the work of Titian and Veronese. During his first years in Italy, it can be said that he saw Antiquity through their eyes, illuminated by a shimmering Venetian light. The golden tonalities of this painting reveal that Venetian debt. No specific literary source can be identified for the subject. Like Titian's *Bacchanals*, it is imbued with the sense of a timeless ancient past, when nymphs and satyrs, and mischievous putti, frolicked and gambolled in an Arcadian dream. Here, in a verdant, sun-drenched forest clearing a satyr spies on a sleeping nymph, abandoned in her sensuality. He pulls back a sheet to appreciate her perfect nudity. By this point, still relatively early in his career, so deeply imbued was Poussin with the spirit of Antiquity, and of the Italian achievement in painting, that he was able to conjure such an evocative scene, so foreign to the wet, grey Normandy of his youth, with consummate and compelling ease.

Christopher Riopelle

BALTHUS

born Paris, 29 February 1908

© S Martin Summers

THE FATHER OF Count Balthazar Klossowski de Rola (Balthus) was a German art historian and painter of Polish ancestry. From 1914 to 1924 Balthus lived in Berlin and Switzerland, then from 1924 to 1961 for varying periods in Switzerland and France, crucially in Paris for most of 1924–39 and 1946–53. From 1953 to 1961 he lived in a château in the Morvan and from 1961 to 1977, as Director of the French Academy, in the Villa Medici, Rome (which he restored). He and his wife, the painter Setsuko, have lived in Rossinière, Switzerland, since 1977.

Encouraged to paint by Bonnard and the poet Rilke, Balthus also had close friendships with André Derain, Antonin Artaud and Alberto Giacometti. He was influenced decisively by early study of the work of the great masters, notably Piero della Francesca, Poussin and Courbet. In the heyday of competing Surrealism and abstraction he forged a style combining arresting realism with a sense of dreamlike strangeness. From 1933 to 1954 some of his largest works were monumental figure groups set in streets or amid mountains, but he is specially known for paintings of figures in interiors, particularly adolescent girls. Controlled and searchingly observed, these have a heightened atmosphere, at once sensual and otherworldly. Balthus's central purpose is the revelation of beauty. This is seen in his nudes, still lifes and landscapes, in his sensitivity to light, and in the refined facture of his paint.

BALTHUS

A Midsummer Night's Dream 1998–2000

Oil on canvas, 162 x 130 cm, collection of the artist, courtesy of Alex Reid & Lefevre Ltd., London

IN *A MIDSUMMER NIGHT'S DREAM* Balthus pays homage to a painter of figures in landscape who he has admired for more than three quarters of a century. Developing a motif that has long been at the centre of his own art, he focuses on the principal figure of *Sleeping Nymph surprised by Satyrs*, her nudity accentuated by vestigial drapery. A major difference between source and responding picture is the absence from the Balthus of additional figures. This removes from the new painting the theme of discovery which is so marked in the Poussin. The sense of encounter is, however, transferred to the viewer, who lights upon the sleeping figure with a pleasurable shock in its revelation of beauty.

One of Balthus's most famous paintings, *The Mountain* of 1937 (**1**), is a figure group, yet figures in the setting of landscape (as opposed to the city, or interiors) are rare in his work. Though Balthus has often painted the nude, his contribution to this exhibition is his first painting of a female nude in an outdoor setting. The unexpected conjunction is occasioned by the source in Poussin. The conven-

Nicolas Poussin *Sleeping Nymph surprised by Satyrs*, 1626–7

tion links back to the very beginning of Balthus's career when, in 1925, he copied Poussin in the Louvre. As his friend and commentator Jean Leymarie has explained, Poussin was a deliberate choice for Balthus's initiation into the art of the Old Masters.[1] The work he copied, *Echo and Narcissus* of c.1629–30 (**2**), was painted close in time to the National Gallery's *Sleeping Nymph surprised by Satyrs* and is likewise dominated by a reclining semi-nude. In contrast to the National Gallery's picture and Balthus's response to it, the central figure in the Louvre's painting is dying. The uninstructed viewer could be forgiven, however, for mistaking his situation for sleep or reverie, two conditions Balthus has often depicted.

A key source of the eloquence of Balthus's art over the decades is the intensity of his inspiration from the work of great masters of the past, conspicuously including Piero della Francesca, Courbet and Seurat. Balthus's art has been widely admired for its fusion of such influences with a sensibility very much of his own era. On the other hand, proponents of successive waves of avant-garde art have often been made uneasy by the openness of Balthus's affinity with the art of the past. He believes, however, that cutting out tradition leads to a kind of blindness and that this condition is exacerbated by the plethora of images with which we are bombarded in the contemporary world, not least through television, and often at high speed. Conversely, there is a link between Balthus's slow savouring of the past art by which his own is nourished and the slow gestation of each of his own pictures. These, in turn, reward extended contemplation of

1 Balthus *The Mountain*, 1937, oil on canvas, 248 x 365 cm, New York, Metropolitan Museum of Art, Purchase. Gifts of Mr. and Mrs. Nate B. Spingold and Nathan Cummings, Rogers Fund and The Alfred N. Punnett Endowment Fund, by exchange, and Harris Brisbane Dick Fund, 1982

2 Nicolas Poussin *Echo and Narcissus*, c.1630, oil on canvas, 74 x 100 cm, Paris, Musée du Louvre

family friend, the poet Rainer Maria Rilke (1875–1926). Rilke wrote to Balthus from Muzot on 26 June 1926: 'Do not leave without sending me your Poussin (mine: I say this proudly). It is as if my walls had changed their clothes to receive it fittingly: it will probably be their only adornment.'[7] Five years earlier, the first publica-

tion of any work by Rilke originally composed in French, namely his preface to Balthus's *Mitsou*, a pictorial narrative told in forty images, was also the first publication of any work by Balthus (then aged thirteen).[8] Balthus was present at the final meeting between Rilke and their mutual friend André Gide;[9] as he painted *A Midsummer Night's Dream* for this exhibition Balthus referred continually, at the easel, to the fine black and white reproductions in Gide's monograph on Poussin, published more than half a century before.[10]

In the new painting the posture of the

their form, their facture and the mood they distill. *A Midsummer Night's Dream* is no exception.

In Balthus's art from the 1930s to the 1960s Leymarie and others[2] have pointed to parallels with particular imagery in Poussin, among them the fact that, more than a decade after copying Poussin's *Echo and Narcissus*, Balthus transposed the posture of Narcissus into the contemporary scene of *The Mountain*.[3] Poussin painted *Sleeping Nymph surprised by Satyrs* in Rome, his home for some forty years. From 1961 to 1977 Balthus was Director of the Académie de France in the same city. His successor in that post has recorded how the exhibition of Balthus's own work that had been proposed to mark Balthus's retirement was replaced, at the artist's request, by a retrospective of Poussin, as this meant much more to him.[4] That exhibition was dedicated to Balthus. In the same publication Anthony Blunt explained the astonishing fact that 'it is no exaggeration to say that this exhibition represents [Poussin's] first public appearance in the City [of Rome]'.[5]

Balthus's early copy of *Echo and Narcissus*,[6] which frustratingly is lost, was inscribed by him, in the image, to a close

3 Balthus *Golden Afternoon*, 1957, oil on canvas, 198.5 x 198.5 cm, private collection

4 Balthus *A Midsummer Night's Dream* in progress, March 1999 (photograph by Desmond Corcoran)

5 Balthus *A Midsummer Night's Dream* in progress, June 1999 (photograph by Richard Morphet)

nymph, her head to the right, reverses that in its Poussin source. The reason is that the image started out as a picture of an odalisque in an interior. She was seen reclining on a *chaise longue*, her head resting on its raised, right-hand end, in front of a window giving a view of the garden of Balthus's home in Switzerland. The conception may be compared with that of *Golden Afternoon* of 1957 (**3**), a scene at an earlier home of Balthus's, in the Morvan. In the light of his decision to work with Poussin's sleeping nude in mind, Balthus re-visualised the odalisque as a nymph and transposed her to an outdoor setting. In the painting's early stages (**4, 5**)[11] this was dominated by a tree, in reference simultaneously to the splendid trees outside Balthus's

windows and to the tree that dominates his Poussin source (as does another in *Echo and Narcissus*). By early 2000, however, the nymph's setting had unexpectedly become a rocky outcrop in a hilly location, with trees only in the distance. The picture continues to relate to Balthus's surroundings, a valley in the Swiss mountains, in which just this mixture of forest and rock is familiar. As in *The Mountain*, the exposed rock also shows affinities with Courbet.[12] However, a specific source for part of the landscape in this painting is Corot's picture *The Cascade of Terni*, 1826 (**6**).[13] The sharp diagonal that helps define the central ravine in the Corot is similarly prominent in Balthus's painting, above and

6 Jean-Baptiste-Camille Corot *The Cascade of Terni*, 1826, oil on canvas, 36 x 22 cm, Rome, Banca Nazionale del Lavoro

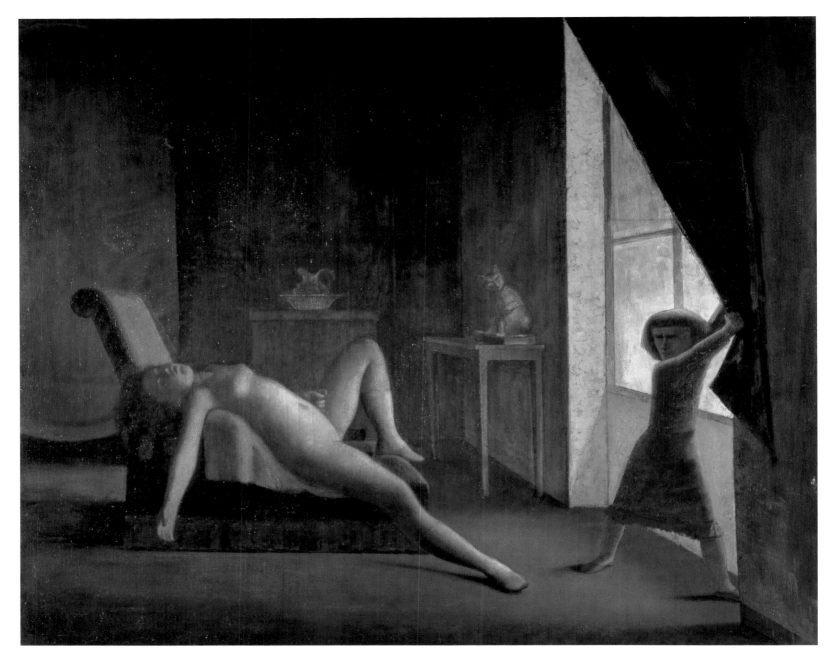

7 Balthus *The Room*, 1952–4, oil on canvas, 270.5 x 335 cm, private collection

beyond the body of the nymph.

At an early stage Balthus crowned the nymph with flowers. Her golden hair now spreads over the green surface of the rock on which it rests. The model, Anna, who lives locally, had posed for the last (**13**) of Balthus's remarkable trio of paintings *The Cat and the Mirror, I, II* and *III*, completed in 1994.

One indication of the appeal of Poussin's nymph for Balthus is the frequency with which the female figure asleep has been the subject of his own art – in every decade, in fact, since the 1930s. In the long history of this motif in Western art, Balthus's realisations show close sympathy with many paintings by Poussin and by earlier and later artists, from Giorgione's *Sleeping Venus* in Dresden to a variety of treatments of the subject by Courbet. The sleeping head leaning (in some cases thrown) back is a striking feature of Titian's *Bacchanal* ('*The Andrians*') in the Prado and of Poussin's *Nurture of Bacchus* and *Venus surprised by Satyrs* (the latter two works are familiar to Balthus, the first being in the

Louvre and the second – a larger version of the present source painting in the National Gallery – in the Kunsthaus, Zurich).

In any painting by Balthus of a sleeping nude it is impossible, even in the absence of specific pointers, not to recall the importance in his work of the theme of the sleeper surprised. When, as in this instance, his painting is inspired by another on that very theme, the association is irresistible. Here, again, there is a long pre-history. Sleeping nudes surprised were painted memorably by Titian in his Pardo *Venus* (Louvre) and by Van Dyck in his *Cupid and Psyche* (Royal Collection), as well as by Courbet in *The Awakening* or *Venus and Psyche*, which is in the Kunstmuseum, Berne, close to Balthus's home. In Balthus's own work, the classic example is the monumental *The Room* of 1952–4 (**7**). In common with the new painting, this shows a nude with head thrown back and one arm falling downward. The fall of light through the large window into a predominantly dark room is strongly reminiscent of that in the studio in which Balthus painted *A Midsummer Night's Dream.*

The combination of passivity with vulnerability in these sleeping nudes of Balthus is complicated by a certain ambiguity as to their state of consciousness, for it is possible to interpret several of them as daydreaming. Whether dream, as suggested by an image by Balthus, is semi-waking or is an experience of real sleep, its intimation enriches a painting's meaning. The theme is central to three major pictures by him in which a recumbent dreamer is surprised by a figure who enters swiftly, bearing flower or fruit. These are *The Dream I*, 1955 (**8**), *The Dream II*, 1956–7 and *The Golden Fruit*, 1956. All three of these dreamers are young girls. Their conjunction with beautiful, almost hallucinatory objects seen in an interior links them with Balthus's fascination with the imaginative world of Lewis Carroll. Like *A Midsummer Night's Dream*, their setting relates to Balthus's surroundings at the time they were painted.

Almost slipping from the loose grasp of Balthus's sleeping nymph is a mandolin. The painting closely followed one in which a related figure in a canopied bed holds the same object (**9**). In each case the source is an antique instrument which Balthus owns (**10**). The conjunction of woman with stringed instrument has, again, a long history. It speaks strongly to Balthus in paintings by Poussin, such as *Bacchanal with a Guitar Player* in the Louvre, which is contemporary with his National Gallery source. Paintings by Ingres, notably *Odalisque with Slave*, 1839–40 (Cambridge, Mass., Fogg Museum) and *The Turkish Bath*, 1862–3 (Louvre), conjoin sensuous nudes with the playing of long-stemmed mandolins. Balthus was photographed by Cecil Beaton with Picasso in front of the latter's magisterial *L'Aubade* of 1942 (Paris, Musée national d'art moderne), in which a reclining nude is serenaded by a mandolinist,[14] while Max Beckmann's

8 Balthus *The Dream I*, 1955, oil on canvas, 130 x 163 cm, private collection

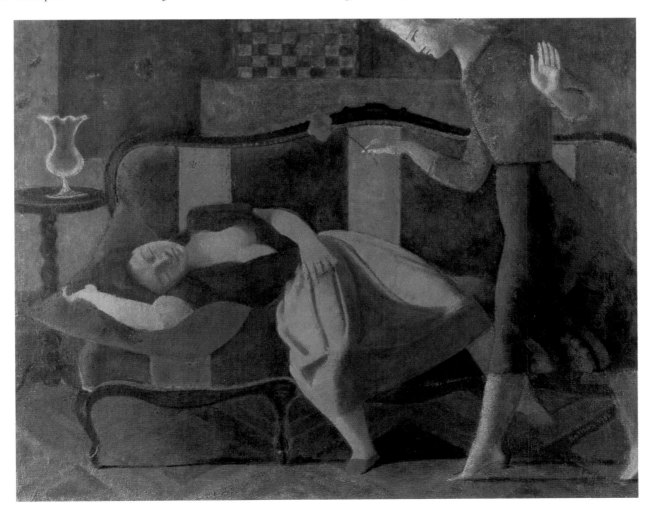

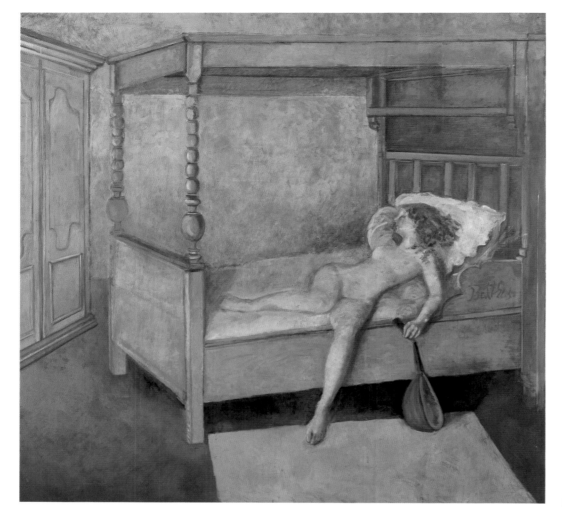

The Guitar Lesson of 1934. In *A Midsummer Night's Dream* the interpretation is closer to that favoured by Braque. Balthus delights in the beauty of form of nymph and mandolin alike, but even though the instrument is not being played its very image here evokes both its touch and the music it has just made, and will make again.

This painting cannot be understood without reference to the importance to Balthus of music, so memorably conveyed by Mark Kidel's film about him of 1996. It also compounds the link with Rilke, to whom the origin of Balthus's admiration for Poussin is so closely tied. For the catalyst in the creation of Rilke's *Sonnets to Orpheus* (1923), written only a short distance from Balthus's present home, was a reproduction, bought by Balthus's mother, Baladine, of a drawing by Cima da Conegliano of Orpheus making music.[16]

Balthus transformed the character of his image when he changed the sleeping nymph's setting from daylight to moonlight, thus creating his first painting of a night scene. At every stage of the picture's progress the body of the nude had radiated an almost

10 Balthus holding a mandolin at his home in Rossinière, Switzerland, 9 June 1999 (photograph by Richard Morphet)

9 Balthus *Reclining Odalisque*, 1998–9, oil on canvas, 225 x 232 cm, London, Alex Reid & Lefevre Ltd.

sleeping *Woman with Mandolin in Yellow and Red* of 1950 (Munich, Bayerische Staatsgemäldesammlungen; **11**) makes the mandolin itself, even without a player, a principal protagonist in the scene.

John Richardson has recounted[15] how Picasso was intrigued, from 1901 onwards, by the allegorical possibilities of musical instruments, which became a thread through his work of subsequent years. 'Braque, too,' he adds, 'liked to paint guitars, not only for their allegorical or anthropomorphic possibilities but because, unlike Picasso, he loved music For Braque painting and music partook of

each other He said ... "I was drawn to musical instruments because they have the advantage of being animated by touch". For Braque a principal purpose of cubism ... was to bring figures and objects within reach; to make us feel that it would be pleasurable to touch them.' Both themes are extended in Balthus's art. His *Nude with a Guitar* of 1983–6 (**12**), in which the instrument 'reclines' with a presence almost equal to that of the adjoining sleeping nude, gives a more benign interpretation to the theme of woman and guitar which Balthus established so memorably in

unearthly illumination. This beautifully lit body was the one constant during the painting's extended development. Everything around it changed a number of times. It was the special quality of the light that finally led Balthus to identify the moon as its source. The choice augmented the sense of mystery and possibility in the scene. It was at this point, in response to the painting itself, that Balthus changed the title from *Sleeping Nymph* to *A Midsummer Night's Dream*.

The whole action of Shakespeare's comedy takes place during a single night. The text makes repeated reference to the moon and its light, ranging from the famous line spoken by Oberon, king of the fairies, to his wife, 'Ill met by moonlight, proud Titania',[17] to Hippolyta's anticipatory 'And then the moon, like to a silver bow/ New-bent in heaven, shall behold the night/ Of our solemnities'.[18] In many of these references the moon is linked to the play's central themes of love and magic. In Balthus's picture, as in the play, the moon is 'like to a silver bow'; the motif connects the picture with the lines 'Cupid all arm'd: a certain aim he took/ At a fair vestal throned by the west,/ And loosed his love-shaft smartly from his bow'.[19] Moreover, despite the absence of supporting figures in the new painting, Balthus's change of its title to *A Midsummer Night's Dream* links its atmosphere to that of the Poussin. In the latter we see imaginary creatures, half animal and half man, while in Shakespeare's play a man is turned into an ass and transformation is a continuous theme.

Balthus's title makes it natural to speculate that the sleeping nymph might be under the influence of a spell. His interest in the vision of Lewis Carroll has been mentioned and the figure here, like others in Balthus's art over the decades, shares a quality of the adventures of Carroll's Alice, that of seeming simultaneously to occupy our own world and another reality. Indeed, Balthus's affinity with Shakespeare[20] is one of many examples of a concern with English culture that includes

the debt of his art to Hogarth, his powerful and disturbing illustrations, in 1933–5, to Emily Brontë's *Wuthering Heights*[21] and his self-portrait *The King of Cats*, 1935,[22] boldly titled in English in the picture.

Though delighting in palpable appearances, which his paintings make us view afresh around us, Balthus's art cannot be described as realism. In more than one way it embodies a yearning for states other than

11 Max Beckmann *Woman with Mandolin in Yellow and Red*, 1950, oil on canvas, 92 x 140 cm, Munich, Bayerische Staatsgemäldesammlungen

present reality. Exemplified by *A Midsummer Night's Dream*, this yearning is so strong as to be experienced by the viewer as part of the painting's very subject.

Contemplating the paintings of Poussin, Balthus laments the fact that the techniques he used are now lost. When copying Poussin in the Louvre he longed to be able to question him 'about his pigments, his touch'.[23] Balthus attaches special importance to the craftsmanship of painting. He states: 'I am not an artist, but an artisan Artists [i.e. in recent years] have poisoned painting by their pretentiousness.'[24] He admires Poussin's dedication to the practicalities of his method as the means of realising images of lasting

resonance. In the catalogue of the Villa Medici exhibition dedicated to Balthus, Anthony Blunt wrote of Poussin's painting in terms which, though describing his later work in particular, illuminate the link between technique and vision that makes the French master's art so compelling in terms of Balthus's own aspirations: 'His colour enchants the eye, and one could almost say that his handling of paint stimulates the sense

of touch. Even when the colour is at its quietest ... and even when the touch is at its most restrained ... the sensuous appeal is there; but it is now used not for its own sake but to give perfect expression to a theme, to make manifest the ideal of beauty which Poussin had formed in his mind.'[25]

As with much of Balthus's work, the evolution of *A Midsummer Night's Dream* was driven by a conviction of the primacy of beauty as the goal of art, regardless of prevailing fashion or theory. While fidelity to

Morandi, a master of simplification whose works, likewise, not only depict but powerfully evoke.

Like these earlier artists, Balthus accords major importance to light – to its intrinsic beauty and to its property of revealing form. Both in Poussin's *Sleeping Nymph surprised by Satyrs* and in Balthus's painting in response, the reclining nude is bathed in light. In each case the erotic charge of the revelation is thus heightened and the notion of surprise reinforced. But here, as in many paintings by Balthus of the nude, the erotic imperative evident throughout much of his work is at once asserted and transcended. The vision that light reveals arouses desire but also represents pure beauty. Indeed, as Balthus observed in 1996 when discussing related examples of his art,[26] he is moved by what he describes as 'the divine aspect of reality'. In *A Midsummer Night's Dream* the figure's radiance combines with the sureness of the composition and with the life and refinement of the painting's facture to situate the depicted scene in the domain of a kind of multiple enchantment. Responding to the observation that the light that falls on this sleeping figure seems not quite of this world, Balthus replied, 'So much the better!'

Richard Morphet

the picture's main idea was constant, the introduction or elimination of particular imagery was driven by formal considerations, rather than by any implicit narrative. Even in the most richly patterned of Balthus's paintings, such as *The Cat and the Mirror III* (**13**), where every finely judged detail locks into place, the urge towards simplification that runs through his art is evident. This instinct, which links his approach to that of Poussin, is at work in *A Midsummer Night's Dream* and helps explain Balthus's admiration for

13 Balthus *The Cat and the Mirror III*, 1989–94, oil on canvas, 220 x 195 cm, London, Alex Reid & Lefevre Ltd.

Notes

1 Jean Leymarie, *Balthus*, London 1982, pp. 10–11.

2 Especially John Russell in his Introduction to *Balthus*, exh. cat., Tate Gallery, London, October– November 1968, pp. 7–29.

3 As explained by Sabine Rewald in *Balthus*, exh. cat., Metropolitan Museum of Art, New York, February–May 1984, pp. 16 and 82.

4 Jean Leymarie, in introduction to *Nicolas Poussin*, exh. cat., Villa Medici, Rome, November 1977–January 1978, pp. 10–11.

5 Anthony Blunt, 'Poussin and Rome', ibid., pp. 26–34.

6 Balthus's painting is no. 19 in Jean Clair and Virginie Monnier, *Balthus: Catalogue Raisonné of the Complete Works*, Paris 1999, p. 104, where letters by Rainer Maria Rilke and Baladine Klossowska are quoted.

7 Present author's translation; Rainer Maria Rilke, *Lettres à un jeune peintre*, Paris (Archimbaud), n.d. [1994 or 1995], p. 30.

8 *Mitsou: Quarante Images par Baltusz* , Erlenbach-Zürich and Leipzig 1921. On the publication of Rilke in French, see Ralph Freedman, *Life of a Poet: Rainer Maria Rilke* , New York 1996 (paperback edition, Evanston 1998, p. 505).

9 Alan Sheridan, *André Gide: A Life in the Present*, London 1998, p. 388.

10 André Gide, *Poussin*, Paris 1945.

11 Figure 5 shows the ground of *rosso* Pozzuoli that underlies this Balthus picture and many of his recent works.

12 Also beside Balthus as he painted this picture was a book on Courbet. Most of Courbet's rocky landscapes do not include nudes, but in *La Source* of 1868 (Paris, Musée du Louvre), which by contrast is set beside water, the dominant nude rests directly on moss-covered rock.

13 Balthus adapted this from the colour reproduction in the French edition of Peter Galassi, *Corot in Italy*, New Haven and London 1991.

14 The photograph is reproduced in Claude Roy, *Balthus*, Boston, New York, Toronto and London, 1996, p. 229.

15 *A Life of Picasso,* II, London 1996, pp. 149–50.

16 Freedman, cited note 8, pp. 482–3; the drawing by Cima is reproduced on p. 480; the origins of the *Sonnets to Orpheus* are recounted on pp. 480–5.

17 Act 2, Scene 1.

18 Act 5, Scene 1.

19 Act 2, Scene 1.

20 Balthus designed productions of *As You Like It* in 1934 for Barnovski and *Julius Caesar* in 1960 for Barrault (see Clair and Monnier 1999, cited note 6, pp. 504 and 528–30).

21 Reproduced ibid., pp. 485–98.

22 Reproduced ibid., no. P 84, p. 126, and in colour as frontispiece.

23 Quoted by Roy 1996, cited note 14, p. 252.

24 In the film on Balthus directed by Mark Kidel (1996).

25 'Poussin and Rome', cited note 5.

26 In the film cited note 24.

TURNER

Sun rising through Vapour: Fishermen cleaning and selling Fish before 1807

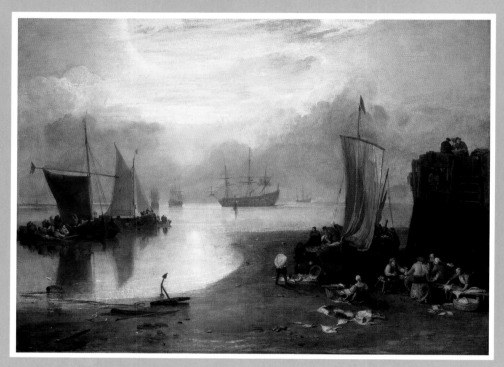

NG 479 Oil on canvas, 134.6 x 179.1 cm

WHILE MOST PAINTINGS have come to the National Gallery by gift or bequest, few were accepted into the Collection with conditions attached as to where or how they might be shown. The Trustees, however, made a notable exception in the case of Joseph Mallord William Turner (1775–1851). In a will that he drew up in 1829, the artist requested that two of his many paintings that he proposed to leave to the nation 'be placed by the side of Claude's "Sea Port" and "Mill" [as he called them] ... to hang on the same line same height from the ground and continue in perpetuity to hang'. Like many Englishmen before him who made something of a cult of Claude, Turner admired the seventeenth-century French landscape painter's skill in investing his works with a sense of ambient atmosphere, and a poetic mood achieved through the manipulation of light. Turner hoped that his own works would be admired in terms of that accomplishment. In a second will of 1831 the artist specified that the present painting and another work in a contrasting mood, his *Dido building Carthage*; or *The Rise of the Carthaginian Empire* (NG 498), were the canvases that he meant to have hung side by side with Claude's *Seaport with the Embarkation of the Queen of Sheba* (NG 14) and his *Landscape with the Marriage of Isaac and Rebekah (The Mill)* (NG 12). They do so to this day, in Room 15.

At first sight, Turner's *Sun rising through Vapour* would seem to have little to do with Claude's Italianate scenes, redolent of ancient grandeur and Arcadian peace. Rather, the inspiration for the work, first shown at the Royal Academy in 1807, resides in more homely Dutch and Flemish painting traditions of the seventeenth century. The fishing boats and ships at the left recall marine paintings by Van de Capelle and Van de Velde, while the fisherfolk at right, who have laid out their catch on the ground for sale as the sun rises, might be at home in a genre scene of peasant life by a painter such as Teniers. Simply enough, Turner sometimes called this picture '*Dutch Boats*'. Like Claude, however, he was anxious to explore the play of light across land and water. Here he examined the diffusion of sunlight in a moist atmosphere as the sun begins to burn through the mist of early morning. The cool, silvery luminosity of the moment suffuses the entire composition. Sold to a collector in 1818, the painting was bought back by Turner at auction in 1827 and he kept it by his side for the rest of his life.

Christopher Riopelle

LOUISE **BOURGEOIS**

born Paris, 25 December 1911

© Claudio Edinger 1988

LOUISE BOURGEOIS rejected an academic art education for independence and the private painting studios of, among others, Fernand Léger, who insisted she was a sculptor. In 1938 she married the American art historian Robert Goldwater (1907–1973) and left Paris for New York, where she associated with successive waves of the avant-garde without formally aligning herself with any group or movement.

Her abiding theme is the human condition, explored over a long career in painting, writing, drawing, printmaking and, prominently, sculpture, for interior and public spaces. Drawing deeply on personal experience, her startling visual metaphors succeed in tapping into the psychological anxieties of her public.

Bourgeois first attracted notice as a sculptor in 1949, exhibiting alienated wooden figures. As she experimented with latex and other materials in work suggestive of strong emotional and sexual states her reputation grew through the 1960s, culminating in her inclusion in Lucy Lippard's ground-breaking exhibition *Eccentric Abstraction* (1966), and her adoption in the 1970s by emerging women artists. In the 1980s and 1990s her iconography of mirrors, body parts, spiders, needles and glass vessels, particularly when combined in her dramatically conceived *Cells*, won world acclaim. Recognised as one of the most original minds of the century, she has been engaged since 1982 in a ceaseless round of national and international touring retrospectives, and in 1993 represented America at the Venice Biennale.

BOURGEOIS

LOUISE **BOURGEOIS**

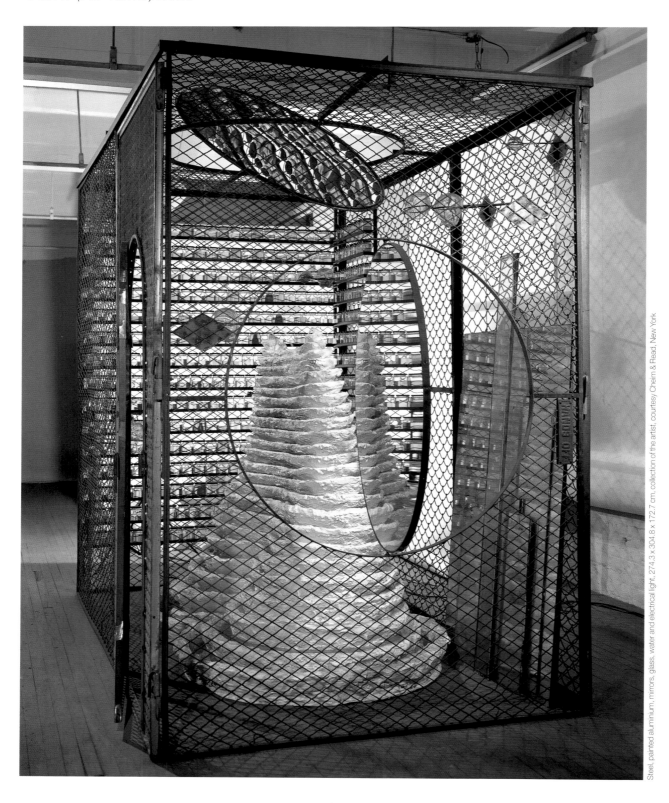

Steel, painted aluminium, mirrors, glass, water and electrical light, 274.3 x 304.8 x 172.7 cm, collection of the artist, courtesy Cheim & Read, New York

TURNER WAS OBSESSED by nature, and I am obsessed by human nature. Turner saw himself defined by capturing nature – nature, perhaps as something larger and uncontrollable, outside of himself. In his *Sun rising through Vapour* one sees the over-powering presence of nature and the inconsequentiality of human existence. My work is the exact opposite. It is the relation-ship to the Other person that motivates me. The human condition is what I sculpt and my forms emanate from within my body.

'The air, light and water that Turner portrays in his paintings become abstracted because of their elusive quality. But our emotions are equally elusive. A person can oscillate between calmness, like the setting of the sun, and turbulence, like the raging of a storm at sea. Though my art is different from Turner, I am able to identify with his work and to fully appreciate him.'[1]

The sheer visual charge of Louise Bour-geois's sculptural response to Turner's painting is electrifying. Seen in a darkened room the suffusion of light changing from tones of blue to grey and the dazzling texture of reflective surfaces have a mesmerising effect, drawing the eyes of the spectator towards two gleaming white, intersecting cones flowing with blue liquid. Such is the subtle relationship between the different elements that form, colour and light dissolve into an abstract radiance. It is precisely this abstract quality in Turner that Bourgeois admires and finds so remarkable. *Cell XV (For Turner)* is the most serenely beautiful and, certainly in Bourgeois's mind, one of the most powerfully abstract *Cells* she has created.

Cell XV (For Turner) is essentially a conceptual piece. Through the symbolic fusion of its elements the artist expresses an idealistic desire for a state of human harmony, while conscious of the difficulty of achieving it. The intersecting cones and the merging streams are Bourgeois's equivalent of 'a couple whose lives mesh'. Blue liquid springs from two separate sources at the top, then

flows into a single runnel that encircles the cones in a tight spiral. The gradient is barely perceptible, but the water tumbles unevenly on a downward course, bouncing over tiny, rock-like obstacles. At the foot it flows out into a basin, to be pumped up again to the

J.M.W. Turner *Sun rising through Vapour: Fishermen cleaning and selling Fish*, before 1807

summit. 'The continuous and unbroken thread of blue water winding its way down and then back up is a metaphor for time and the unbroken thread of time,' Bourgeois says.

The distinction Bourgeois makes between 'time' and 'the unbroken thread of time', in other words between the subjective and objective experience of time, between events of finite duration and infinity, is instructive. Caught up in time's ineluctable momentum, the couple perceive events from a purely personal perspective of lived moments as they aspire to overcome imped-iments to their union. 'To remain constant represents an ideal form of human relation-ship,' Bourgeois says. 'If you're united, there are moments of trust, but also of mistrust and jealousy. You can feel threatened and insecure,

but there is no real pain or tragedy.' Thus the thread of water represents both continuity and constancy, the continuity of time and the continuity of a relationship dependent on the constancy of two people in their day-to-day existence within the larger framework of eternity. We can understand *Cell XV (For Turner)* as a strikingly symbolic combination of Louise Bourgeois's central themes, the human condition and the concept of time experienced simultaneously as a universal and as a subjective experience.

Time is an obsession with Louise Bour-geois, crystallising into certain recurring images in her sculpture. The most frequent and potent are to do with weaving, threads and spirals, and with fluidity and flux, notably of water and light. These are all ancient, universal symbols of life and creative energy, which are closely associated with her own experience. Revitalised by Bourgeois, they

1 Louise Bourgeois *Fountain and Benches*, 1999, (fountain) bronze, fibre optic lighting and water; (three pairs of benches) black Zimbabwe granite; collection of Pittsburgh Cultural Trust

find particular resonance in *Cell XV (For Turner)*. The motif of thread, for example, recalls her parents' workshop practice, repairing and restoring tapestries. Of special significance are memories of the way thread was dyed, then looped and twisted into skeins, and of how the tapestries were twisted after being washed in the River Bièvre flowing past her home in Antony, Hauts-de-Seine. Such recollections could be obliquely connected to the spiral form of the cones in the *Cell* and to its 'thread' of blue water. Bourgeois is conscious of the power of symbol and myth, of traditional connections between different images, and of the way one can dissolve into another, and she frequently amplifies these shifting images with her own symbolism. Thus thread can refer to weaving, a stream of water, a spider's web, a drawn line or a line of thought and, even, by way of her idiosyncratic association of ideas, to the design of a safety pin and, back again, to the fabric it holds together. In the *Cell* the thread

of water round the cones is related to the cyclical nature of time and to the flow of light as it passes from day through night.

The scale of the meshed cones in *Cell XV (For Turner)* originated in a plaster maquette for a twenty-five-foot-high bronze fountain,

commissioned for a public plaza beside a new theatre in Pittsburgh (**1**).[2] As in the *Cell* the two merging streams represent the threads of a relationship, which here takes shape in the open, under public scrutiny. In front of the fountain are three pairs of massive granite benches in the form of eyes, whose gaze is diverted away from the private communication taking place on the seats. Unlike *Cell XV (For Turner)*, in which the entire journey of the blue stream is visible, only the two springs emanating from the top and the flow of water near the base are clearly seen. 'In Pittsburgh, it's a more secretive voyage, in the *Cell*, it's more open.'[3] The fountain takes on a life of its own in the evening. The running water is caught in the light of a fibre optic display, which moves the sculpture through a spectrum of slowly changing colours designed, as Bourgeois said, 'to reflect the changing mood of a relationship from hot to cold'.[4]

Cell XV (For Turner) extends the theme in a different direction and, significantly, the

2 Louise Bourgeois *Articulated Lair*, 1986, painted steel rubber and stool, 335.2 x 335.2 x 335.2 cm, New York, The Museum of Modern Art

cast cones retain the human dimensions and hand-built texture of the original maquette. The cones are, after all, Bourgeois's height – five feet, one inch – a reminder that, as she says, 'my forms emanate from within my body' and are identified with it. The wire cage isolating the vision of human communion may suggest the disquieting prospect of imprisonment, but Bourgeois intends it to be seen as a small, enclosed space, analogous to a biological, rather than a prison, cell. The smallest living structure houses, metaphorically, the smallest human relationship, a couple. Bourgeois liked the *HANDS OFF* sign she found attached to one of the cell walls because it warned of 'the fragility of human relationships'. Her sense of what should, or should not, be touched bars us from physically entering the cell. This is a private attachment. Yet everything is visible through the wire mesh and on one side, where a mirror pivots open like a window, we can look directly through a large circular aperture. Another mirror is suspended over the sculpture, angled towards the floor. The cones appear diffused in the light, but, as we approach, the mirrors frame a view for closer inspection, thus doubling the image. Each mirror offers multiple readings, which 'symbolise the various realities and perspectives of the situation. They also allow Louise to be included.'[5] We, too, become involved through the vertical layers of glass and mirror leaning against the back wall, forced to confront our own fractured reality in dealing with the elusive nature of the Other person, the 'you'.

The cell, which for a decade Bourgeois has used as a generic form in her work, had its genesis in a large steel piece, *Articulated Lair*, of 1986 (**2**). The lair, she said, was a refuge, not a trap or a prison. Once you had squeezed inside the piece and found yourself utterly alone, an escape route was always at hand. *Lair* was followed in 1989 by two frighteningly isolated situations, *No Exit* and *No Escape*. There is no escape, either from ourselves or others, Bourgeois told us in her

germinal piece on this theme, *Confrontation* (1978). This work consisted of bulbous bodily organs 'laid out' on a long table. Round it *A Banquet / A Fashion Show of Body Parts*, or, as Bourgeois saw it, a moral tale of unrequited passion and death, was performed by models parading in visceral costumes made of latex. While actors improvised their crazy scene of

seduction, an unwitting audience sat on what Bourgeois described as funeral caskets, forced to face the human comedy.[6]

The *Cells*, the first of which was made in 1991, were originally devised as a means of focusing these situations by creating her own architectural structures in the gallery. Each one offers a different case-study, as it were, examining the nature of human relationships. 'It is a closed world that is isolated in an attempt to understand the mechanism of the problem,' Bourgeois says.[7] 'The *Cells*,' she wrote elsewhere, 'represent different types of pain: the physical, emotional and psychological, and the mental and intellectual. Each *Cell* deals with fear. Fear is pain. Often it is not perceived as pain, because it is always

disguising itself.'[8] At one end of the spectrum of human travail are works such as *Confrontation* and *The Destruction of the Father* (1974) : 'Both come from emotional aggression, dislocation, disintegration, explosion, and total destruction or murder.'[9] At the other end are pieces such as *Partial Recall* (1979), 'pieces that are peaceful. After so much

3 Louise Bourgeois *The Puritan*, text 1947, engraving 1990, suite of 8 hand-coloured engravings and text; 66 x 100.3 cm, courtesy Cheim & Read, New York

emotion, they represent a search for, if not peace, actually forgiveness or forgetfulness. They are a plea for a peace and that is all … peace with oneself.'[10] *Cell XV (For Turner)* suggests apprehension, regarding the volatile nature of our emotions, resolution and harmony. 'No real pain' is experienced, only feelings of vulnerability and insecurity regarding the strength of our relationship with another person. Since Bourgeois has stated that her life is the source of her art, it is worth noting that she and her husband, Robert Goldwater, sustained a very

4 Louise Bourgeois *The Destruction of the Father*, 1974, plaster, latex, wood and fabric, 237.8 x 362.3 x 248.6 cm, courtesy Cheim & Read, New York

close and happy marriage for thirty-five years until his death in 1973. He was, as she said, 'a completely rational person. He did not betray me.'[11]

The sensation of blue in Bourgeois's *Cell XV (For Turner)* is startling. One side of the cage and a corner are lined from top to bottom with shelves of hundreds of empty marmalade jars part-filled with blue liquid, like a three-dimensional tapestry of light.[12] Six large glass spheres of blue glass, and three smaller ones of a darker blue, project hazardously from the walls of the cage. The symbolism of the colour blue is important to Bourgeois. 'Her own eyes are blue, and she looks at sky and water to give her relief when relationships cause her tensions.'[13] Louise Bourgeois adds that blue means 'sky and freedom', and clearly the coloured elements in the cell generate reflective calm. An early prose piece, *The Puritan* (**3**), written in 1947, perfectly described her sensitivity to

atmospheric mood: 'Do you know the New York sky? You should, it is supposed to be known. It is outstanding. It is a serious thing. Can you remember the Paris sky? How unreliable, most of the time grey, often warm and damp, never quite perfect, indulging in clouds and shades; rain, breeze and sun sometimes

managing to appear together. But the New York sky is blue, utterly blue. The light is white, a glorying white and the air is strong and it is healthy too. There is no foolishness about that sky. It is a beautiful thing. It is pure.'[14]

Bourgeois's consciousness of the sky as a working environment dates from her first 'studio' space for making sculpture on the roof of a tall apartment block in New York. There she carved wooden figures, *Personages* as she called them, painted in a pure and 'immaculate' white. Apart from their vulnerable nature, these figures were essentially 'stiff with fear, rigid and upright'. Though installed in many configurations they never touched each other. As Louise Bourgeois once said, 'Skyscrapers reflect the human condition because they do not touch.'[15]

By contrast, the cones in *Cell XV (For Turner)* both touch and merge. But the material she uses for the other elements in the cage – glass – adds another layer of meaning, evoking for Bourgeois 'the infinite fragility of the human person'. Its characteristics are, she

5 Louise Bourgeois *Couple III*, 1997, fabric, leather and steel arm brace, 71.1 x 99 x 180.3 cm, private collection, courtesy Cheim & Read, New York

feels, analogous to human relationships. A crack or a break is permanent. It can never be mended, never hidden. Bourgeois likes the transparency of glass for the very reason that 'nothing is hidden and there are no secrets'.

The brilliant illumination of *Cell XV (For Turner)* heightens this sense of clarity. Light in Bourgeois's work is more than a symbol. It is its central metaphor, whether we interpret it morally, spiritually, psychologically, or in terms of colour symbolism. All the mirrors and other translucent and reflective surfaces intensify the luminous effect of the piece. Light activates the cell as it strikes, and is deflected off, glass, liquids, mirrors and metal. It is in itself emblematic of the insubstantial and elusive nature of the relationships Bourgeois is examining. She has always perceived light as an active component in her installations, making it operate imaginatively, as well as formally. In the gallery she likes to control the environment herself, manipulating the notion of light and shadow: 'It is not the light of the real world, but the light of remembering something in the distance.'[16] Light for Bourgeois operates in a Proustian sense as a key to the past. 'Time is a tributary of light, of twilight, of the night and dawn. And full daylight. That's my *madeleine*. That's what I say to myself when time has passed. It's mostly a function of the eyes, of light.'[17]

Turner's miraculous inventions with paint turn the key of memory again, offering, besides, a fascinating comparison with Louise Bourgeois's own explorations of the abstract qualities of light and water. For her, Turner is a 'quintessentially British' artist. His atmospheric paintings, such as *Sun rising through Vapour*, or the later *Rain, Steam and Speed*, where the light is diffused in cloud and mist, water dissolved into vapour, and transformed into the material of paint itself, are

'quintessentially England'. In particular, Turner's calm painting *Sun rising through Vapour*, which she selected as a stimulus for her new work, characterises a country which she identifies with grey, watery dampness. These associations derive from her earliest

6 Louise Bourgeois *Toi et Moi*, 1997, cast and polished aluminium, 480.1 x 1249.7 x 208.3 cm, Paris, Bibliothèque nationale

memories of visiting London in the late 1920s and early 1930s, but her peculiar sensitivity to climate and weather originates in her childhood concern for her mother, whose health was kept in balance by trips to the South of France and to spas. Bourgeois may well have seen the Turners in the National

Gallery before the Second World War, but her most vivid recollection stems from a visit in 1951 with her husband, Robert Goldwater.

Some time during these trips she recalls seeing Mortlake tapestries in the Victoria and Albert Museum, a memorable experience for someone who, from a young age, had helped with the repair of fine French tapestries in her parents' workshop. In Turner's *Sun rising through Vapour* the fishermen in their boats, and particularly the cluster of men and women gathered on the shore on the right of the canvas, reminded her of the genre scenes she was familiar with in tapestry. 'She liked the idea of fish being opened up, gutted and cleaned. There is a parallel here to Louise's bronze sculpture *Rabbit* (1970) in terms of the way the body is opened up and exposed, although the connection is probably subliminal.'[18] In a later, extraordinarily visceral piece, *The Destruction of the Father,* 1974 (**4**), Bourgeois expressed her interest in 'body language and the mechanism of how the body operates'.[19] The children, exasperated by the tyrannical behaviour of their father, finally wreak their revenge by chopping him up and eating him.

On Turner's *Sun rising through Vapour* Bourgeois projects her own symbolism of water and light. Aspects of his painting are distinctly, if not consciously, echoed in her own abstract preoccupations in *Cell XV (For Turner)*: the morning sun refracted through cloud and mist, the patch of blue sky and, most obviously, the still sea in the curve of the shore, which creates a circular mirror of water, but also suggests the base of a cone rising through a pillar of light to the glare of sunlight. In the gleaming surface of sea Turner pushes the reflected light to a further level of abstraction, which she greatly admires. The debt to Turner in her own work should not, however, be stretched too far. 'Turner was a

point of departure.' As her own idea took shape 'Turner was forgotten'.[20]

It is striking how much Louise Bourgeois shares with the English artist. Like Turner she is acutely aware of climate and weather. Mountains (particularly the French Alps), rivers and seas all retain significant associations for her.[21] The rivers Bièvre, Seine and

from which all my work grows,' she said.[22] Contradicting Jean-Paul Sartre's famous conclusion in *No Exit*, 'Hell is other people', she asserts: 'I say that Hell is the absence of others – that's hell'.[23]

'Art is interesting,' she said in an interview in 1996, 'but for me people are more interesting – people, friends, personalities.'[24] More

Her early wooden *Personages*, each of which represented a real person, were the first sculptures in which she worked through remembered emotions associated with the tangled, 'twisted' relationships in her family. Since then her work has continued to deal with her childhood experience of psychological abuse and humiliation, the emotional extremes it provokes, and the problem of human relationships. A number of pieces in the 1990s were called variously *Couple* (**5**), *Single* and *Toi et Moi* (**6**), the familiar French form for 'you' and 'me' used between friends and intimates. All engage specifically with these issues with the aim of re-establishing a sense of equilibrium and self-worth.

The meanings in Bourgeois's work are continually resurfacing, merging, changing subtly and evolving. The theme of '*Toi et Moi*' goes back to a suite of ten drypoint engravings she made in 1992 called *Homely Girl, a Life* (Volume I). It begins with a single chrysanthemum-like flower, and the accompanying text is: '*Toi* and *moi* … a love affair. This beautiful thing is the consequence of the encounter of two people. One says to the other: "Look what we can do together."' Other stems appear, bifurcate and wilt. One breaks, but the flower survives, pushing out a new shoot. For Bourgeois, this new growth represents regeneration and expresses the extreme optimism and faith depicted in the final image, where clouds metamorphose into petals on a jagged mountain slope. Bourgeois writes: 'After an accident or a difficult episode, faith comes again … the sky is the limit … no danger is perceived. This is the energy of the morning.'[26]

7 Louise Bourgeois *Untitled*, 1990, drypoint, 30.1 x 37.7 cm, courtesy of Peter Blum Editions, New York

Hudson, and seas, especially the Mediterranean but also the Atlantic, have always been important features in her physical and mental landscape. We might even see, in her love of New York, something of the special attraction Venice had for Turner. Her profound sense of isolation and loneliness, which, she says, she was made to suffer from birth, finds its equi-valent in Turner's experience, particularly in his later, reclusive years. But unlike Turner, who became increasingly unsociable, Bourgeois is preoccupied with the relationship of one person to another. 'This is the soil

tellingly, she said on another occasion that it was not portraiture that interested her, but 'the portraiture of a relationship, how a relationship can be twisted, the effect people have on one another'.[25] A brilliant, four-sentence parable, written by Bourgeois in 1947, evokes the tragic consequences of deceit:

A MAN AND A WOMAN
LIVED TOGETHER. ON ONE EVENING
HE DID NOT COME BACK FROM WORK.
AND SHE WAITED. SHE KEPT ON WAITING
AND SHE GREW LITTLER AND LITTLER.
LATER, A NEIGHBOR STOPPED BY OUT OF
FRIENDSHIP AND THERE HE FOUND HER,
IN THE ARMCHAIR, THE SIZE OF A PEA.

Life is a journey of self-discovery in which people are fated to live, and come to terms, with themselves, as much as they are fated to work with, and adjust to, others. *Toi et Moi* (**6**), a wall-piece commissioned for the entrance hall of the new Bibliothèque nationale in Paris, explores this experience. Its curved corrugated surface in aluminium is polished to a mirror finish. But, like an antique mirror, the metal is not crystal clear.

What it throws back is an impression, further distorted by the folds. We can only sense the spectral presence of an Other.' The title refers to the double reflection, what one really seems to be and the other image which is its double, the image that cannot be recognized immediately,' Bourgeois said.[27] It is difficult, she also seems to be saying, to capture anything as tenuous and changeable as a human relationship, even with ourselves. It threatens always to slip out of control.

One way of coping with the chaos of the human condition is to devise an aesthetic of survival, and Bourgeois has found a powerful as well as pleasing, motif in the spiral. The significance of the spiral, an ancient, universal symbol, is most closely associated with the spinning of the earth in space in relationship to cosmic motion. For Bourgeois, the image offers a strategy of human action, which she has demonstrated in a video fragment of a figure descending a spiral staircase. In her sculpture, too, she describes the spiral as 'the beginning of movement in space. As opposed to the rigidity of the monolith, the subject is exploring space.'[28] The spiral assumes various, often contradictory, meanings of tension and relaxation, of creativity (spirals

which turn clockwise) or destruction (spirals which turn anti-clockwise), of power and vulnerability. So her wooden *Spiral Women* of the 1950s stand, uncommunicative, firmly on the ground, while her bronze *Spiral Woman* of 1984 spins helplessly in the air.

The spiral lends itself particularly well to the drawn line and has featured in a number of Bourgeois's prints, one of the most exuberantly energetic of which, *Untitled* (1990) (**7**), plays with fourteen and a half interrelated spirals. An accompanying text in the book *The Prints of Louise Bourgeois* reads: 'Bourgeois gets a ball of twine to demonstrate the concept of these spirals. "This is a way of going on ... it is like a thread of thought ... or a dance ... you go here, you go there ... you keep reaching out to others. It is wishful." '[29] On another occasion she explained: 'The spiral is an attempt at controlling the chaos. It has two directions. Where do you place yourself, at the periphery or at the vortex? Beginning at the outside is the fear of losing control; the winding in is a tightening, a retreating, a

compacting to the point of disappearance. Beginning at the center is affirmation, the move outward is a representation of giving, and giving up control; of trust, positive energy, of life itself.'[30] In 1962 Bourgeois made *Lair* (**8**), a small, 22-inch high single-cone spiral in bronze with a white patina, which relates very directly to *Cell XV (For Turner)*. But *Lair* proposes a retreat . The spiral path round the double cone in *Cell XV (For Turner)*

8 Louise Bourgeois *Lair*, 1962, bronze, white patina, 55.9 x 55.9 x 55.9 cm, courtesy Cheim & Read, New York

moves outwards from the top, a sign of 'giving, and giving up control; of trust, positive energy, of life itself'.

Bourgeois put a slightly different spin on the theme of relationships in *Les Bienvenus à Choisy-le-Roi* (Welcome to Choisy-le-Roi; **9**), a public commission she undertook for Choisy-le-Roi, just outside Paris, where she spent her early childhood.[31] From a tree in the park beyond the Town Hall, where marriages are conducted, she suspended two large visceral forms, a male and a female element, cast in aluminium. Slowly they turn in the wind addressing their message to the newly-weds. Bourgeois explained: 'A marriage is a fragile thing which hangs on a thread. This object has the look of a big heart; it implies a certain attitude, an attitude of pure and simple love. All marriages need balance, tenderness, and confidence It's an entity of two human beings who look at each other

9 Louise Bourgeois *Les Bienvenus a Choisy-le-Roi*, installed in the Parc de la Mairie, 1996, at Choisy-le-Roi, France, aluminium, unique variant, 1st element 154.9 x 109.2 x 81.2 cm, 2nd element 160 x 111.7 x 76.2 cm

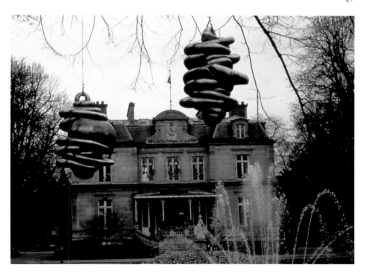

sometimes, who turn around, just as we all turn around psychologically throughout each day. We have moods, we have degrees of affection, degrees of revolution, but we're always there together. We spend our lives together, we spend our lives with the possibility of looking at each other and loving each other.'[32]

In a spectacular commission to celebrate the opening of Tate Modern on Bankside Bourgeois makes another direct appeal to the

10 Louise Bourgeois *I Redo*, 1999, steel and stainless steel, 124.5 x 61 x 53.3 cm, collection of the artist, courtesy Cheim & Read, New York

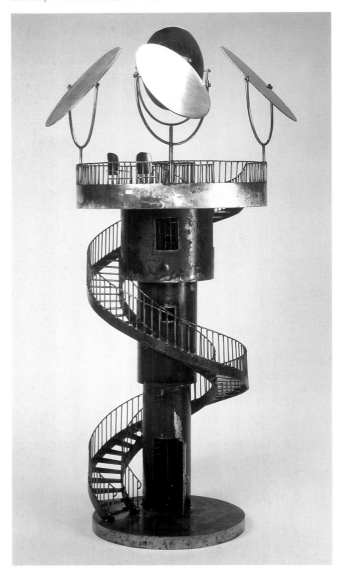

public, this time to take positive action and engage with other people, partners, friends and, possibly, strangers. Three giant steel towers, the tallest of which is sixty foot high, entitled *I Do*, *I Undo* and *I Redo*, combine many of her familiar elements in an inventive and ingenious way. They deal not only with adult relationships, but, quite specifically, with a predominant issue in Bourgeois's life, parental behaviour. Each tower, with its winding staircase and secret chamber, contains a sculpture examining the bond between mother and child. The large tower, *I Do*, has a single spiral staircase on one side which ascends externally directly from the floor to a platform at the top. There, a single chair is placed beneath five giant oval mirrors in polished stainless steel. Bourgeois prefers the oval form because its two centres refer to '*toi et moi*'. This tower contains the 'good' mother, nurturing and caring. *I Undo* consists of a rectangular tower ascended by an external staircase to an enclosed space on top with high sides where the 'bad mother' and a punishment chair can be seen through two small windows. From this, the visitor enters a door and descends a spiral staircase into a central cell, a single chair, a small mirror and nineteen red glass elements. In *I Redo* (**10**) a double spiral staircase, enables two people to ascend at once and meet at the top, where a pair of chairs await beneath four mirrors. An inner chamber contains an image of a mother whose baby is still attached to her by the umbilical cord, which, for Bourgeois, who had a strong relationship with her own mother and became a mother herself, is 'the most significant thread'.[33] She is optimistic that

the platforms 'will become the stage for significant conversations and confrontations', where people will come face to face with the reality of a relationship and, through their reflected images, with themselves.

Bourgeois's preoccupation with the need to face up to oneself and others once prompted the following disclosure on the consequences of evasion: 'In a refusal to come to grips with the problem you project yourself at the horizon. The landscapes explode in a desire to escape, to distance yourself and dissolve the anxiety. Terror is turned outward toward the understanding of the universe. The introjection of the landscape is the lair.'[34]

Landscape, sky, blueness, the infinity of the horizon provide an escape hatch. The landscape of the mind offers an alternative refuge. None produce a solution to 'the problem', which, she seems to be suggesting, Turner, the landscape painter, avoided altogether. Bourgeois observes that Turner projects himself on to the world through his paint, but that we never see the effect of the world on him. 'While there is an incredible beauty, in Turner it is not an erotic world.'[35]

For Bourgeois self-knowledge, the aim of all her work, is inseparable from consciousness of the body and its sexuality. Her sculpture is an extension of her body, a passionate expression of the turmoil of physical and psychological feelings generated inside her in relation to another person. Turner's understanding is directed towards the universe. He painted the sky, air, wind, moisture. In her sculpture Bourgeois depicts the liquids of the body and the elemental forces of its passions and desires, as in *Precious Liquids* (1992), *Cell (Arch of Hysteria)* (1992–3; **11**), and, more obliquely, her blood-red rooms of 1994 and her intersecting cones running with water to the active hum of the pump.[36] Just as Turner captured the fugitive magic of nature, so Bourgeois seeks in *Cell XV (For Turner)* to grasp the elusiveness of human nature in an image of water and light.

Judith Bumpus

Notes

1 Louise Bourgeois, 20 March 2000. The author would like to thank Jerry Gorovoy, assistant to Louise Bourgeois, for his generous help in the preparation of this essay. Gorovoy, an artist, met Louise Bourgeois in 1979 and has been her full-time assistant since 1982. As Bourgeois is no longer giving interviews in person, I put my questions to her in letters to Jerry Gorovoy, who answered either with a distillation of her intentions or with quoted replies from her. Unless otherwise referenced, this essay is based on conversations and correspondence with Gorovoy, and quotations from Louise Bourgeois dated 1999 or 2000 received through Gorovoy. It should be borne in mind that *Cell XV (For Turner)* was in the process of creation while the author was writing and remained unfinished when the catalogue went to press.

2 The fountain, unveiled in 1999, was commissioned by the Pittsburgh Cultural Trust for the Agnes R. Katz Plaza and stands in front of the new O'Reilly theatre, designed by the architect Michael Graves.

3 Jerry Gorovoy, letter to the author, 16 April 2000.

4 Louise Bourgeois, April 2000.

5 Jerry Gorovoy, letter to the author, 16 April 2000

6 The one-off performance took place on 21 October 1978, the closing day of her exhibition of new work, which included *Confrontation*, at the Hamilton Gallery, New York. See 'Self-expression is Sacred and Fatal', in Marie-Laure Bernadac and Hans-Ulrich Obrist, editors, *Louise Bourgeois: Destruction of the Father, Reconstruction of the Father. Writings and Interviews*, 1923–1997, London 1998, p. 224.

7 Louise Bourgeois, April 2000.

8 Louise Bourgeois, 'Symbolic Architecture', from an unpublished interview with Deborah Wye, 11 July 1981, in Bernadac and Obrist 1998, cited note 6, p. 136.

9 Ibid.

10 Ibid.

11 Robert Goldwater (1907–1973), American art historian, best known for his pioneering book *Primitivism in Modern Art*, 1938.

11 Louise Bourgeois *Louise Bourgeois with Cell (Arch of Hysteria)*, steel, bronze, cast iron and fabric, 302.3 x 368.3 x 203.4 cm, Seville, Centro Andaluz de Arte Contemporaneo

12 Louise Bourgeois eats marmalade every day. The empty jars, reused in *Cell XV (For Turner)*, therefore have a special significance for her.

13 Jerry Gorovoy, in conversation with the author, December 1999.

14 See Deborah Wye and Carol Smith, *The Prints of Louise Bourgeois*, New York (The Museum of Modern Art) 1994, p. 194.

15 Louise Bourgeois, 1999.

16 Louise Bourgeois, April 2000.

17 Louise Bourgeois, cited in Paulo Herkenhoff, 'Louise Bourgeois, Femme-Temps', in Jerry Gorovoy and Pandora Tabatabai Asbaghi, editors, *Louise Bourgeois: Blue Days and Pink Days*, exh. cat. Fondazione Prada, Milan 1997, p. 269.

18 Jerry Gorovoy in conversation with the author, December 1999.

19 Louise Bourgeois, March 2000.

20 Jerry Gorovoy, in conversation with the author, December 1999.

21 Bourgeois visited Chamonix in the French Alps in 1929 when she was eighteen.

22 Louise Bourgeois, source unknown, 1992, cited in Rainer Crone and Petrus Graf Schaesberg, *Louise Bourgeois: The Secret of the Cells*, Munich and New York 1998, p. 91.

23 'Meanings, Materials, Milieu', republished in Bernadac and Obrist 1998, cited note 6, p. 143.

24 'Interview with Michael Auping,' 25 October 1996, in Bernadac and Obrist 1998, cited note 6, p. 351.

25 Louise Bourgeois, source unknown, 1992, cited in Crone and Schaesberg 1998, cited note 22, p. 49.

26 *Homely Girl, a Life* Volume I, reproduced in Wye and Smith 1994, cited note 14, pp. 216–19.

27 Louise Bourgeois, in Manuel Calderón, 'Louise Bourgeois. La Dama del alba', *ABC de las Artes*, 22 November 1996, quoted in Gorovoy and Asbaghi 1997, cited note 17, p. 260.

28 Louise Bourgeois, 'The Passion for Sculpture: A Conversation with Alain Kirili', in *Arts*, March 1989, vol. 63, no. 7, pp. 68–75, republished in Bernadac and Obrist 1998, cited note 6, p. 182.

29 *Untitled* (1990), in Wye and Smith 1994, cited note 14, p. 165.

30 Louise Bourgeois, 'Self-expression is Sacred and Fatal', in Bernadac and Obrist cited note 6, p. 223.

31 Louise Bourgeois was born in Paris on 24 December, 1911. The family moved to Choisy in 1912 and remained there until 1918. In 1919 they moved again, to Antony. See 'Interview with Jerry Gorovoy and Marie-Laure Bernadac', April 1996, in Bernadac and Obrist 1998, cited note 6, p. 349.

32 Ibid., p. 348.

33 Louise Bourgeois, April 2000.

34 Louise Bourgeois, in Christiane Meyer-Thoss, *Louise Bourgeois: Designing for Free Fall,* Zurich 1992, republished in Bernadac and Obrist 1998, cited note 6, p. 223.

35 Louise Bourgeois, 14 April 2000.

36 I am grateful to Jerry Gorovoy for suggesting this analogy.

DUCCIO
The Annunciation 1311

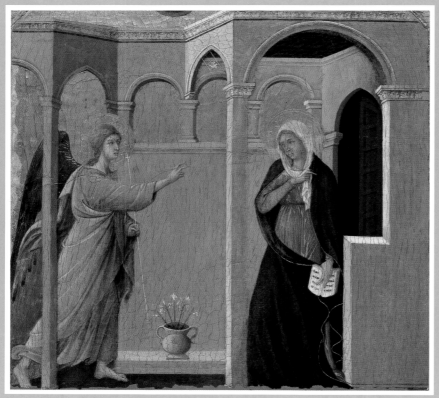

NG 1139 Egg on poplar, painted surface 43 x 44 cm

THIS SMALL PANEL is a fragment of a very much larger work, a monumental two-sided altarpiece comprising some ninety separate images that the Sienese artist Duccio di Buoninsegna (active 1278; died 1318/19) and his assistants are recorded as painting as early as 1308. Three years later, in 1311, the *Maestà*, as it is known – the word means 'majesty' – was carried in solemn procession through the streets of the city to the Cathedral, where it was installed on the high altar. The front of the altarpiece was dominated by the Virgin and Christ Child, enthroned in glory and surrounded by the heavenly host. That large panel rested on a predella with narrative scenes from the life of the Virgin, beginning, at the left, with this depiction of the Annunciation. The work remained in its place of honour in Siena Cathedral until 1506. As befell countless early Italian altarpieces in the eighteenth and

nineteenth centuries, in 1771 the *Maestà* was dismembered. While most of the pieces remain in Siena, several panels were dispersed and have found their way into collections around the world; in addition to *The Annunciation*, two other panels from the altarpiece are today in the National Gallery.

Here, the artist depicts the moment described in Luke I: 28 when the Archangel Gabriel, arm outstretched in greeting, approaches Mary with the news that she will bear the Christ Child. Simultaneously, the Holy Spirit, borne on three golden rays, enters her from heaven. Mary seems to tremble and draw back not so much in fear as in wonderment that Isaiah's prophecy (7:14) – that a virgin will bear a child; it is written in the book she holds – is indeed coming to pass. Mary's anxiety is underscored by the sudden agitation in the folds of her gold-trimmed cloak just below that book. It is as if the very words have caused a disturbance in the air. The elegant movement and counter-movement of the two figures is enframed within a complex, pavilion-like structure in tints of lilac and salmon, at once open and enclosed, receding and advancing towards the viewer. Set against a gold background, the three-dimensional space in which the mystery unfolds is established by the arches that step gracefully across the upper third of the picture, round-headed when shown frontally, but slightly pointed when Duccio means to indicate recession into depth. Such crispness and architectonic clarity is a foil to the tremulous delicacy of the emotions aroused in the Virgin. Oddly enough, beneath the angel's wing and rear foot at left, an area of bole has not been gilded like the rest of the background, leaving an irregular patch of red. It was an oversight, no doubt, in the rush to complete a hugely complex commission. And yet modern eyes might see in that inexplicable patch of red a subtle balance to the Virgin's gold-striated red dress at right. Even if unintentional, it functions pictorially, beyond the constraints of representation, in a way that, centuries later, Cézanne would have understood implicitly.

Christopher Riopelle

ANTHONY **CARO**

born New Malden, Surrey 8 March 1924

© Hugo Glendinning

A KEY FIGURE in modern British sculpture, Anthony Caro studied at the Royal Academy Schools, London (1947–52), was an assistant to Henry Moore (1951–53) and an influential teacher in London (1953–79) and in the USA over many years. Exposure to new American abstract art in the late 1950s was decisive in his developing a personal language of constructed sculpture. From 1960 he made abstract sculptures in painted steel, placed directly on the ground, which exposed the interplay of form and space with a new directness and freedom from hierarchy. From 1970 he also made works in unpainted steel, later enlarging his range of materials (both fashioned and found) to include bronze, iron, ceramic, wood, paper and stone.

Caro works across an enormous range of sizes, from intimate-scale table and 'writing' pieces to 'sculpitecture', which is comparable to small houses, and can be entered and explored. From the mid-1980s his sculpture responded openly to art of the past, from that of ancient Greece to figurative painting by great masters. In recent years his work has shown increasing emotional complexity, conspicuously in major sculptural sequences representing *The Trojan War* and *The Last Judgement*. The vitality of Caro's work and its wide influence relate to his continuous questioning of what sculpture can be. Knighted in 1987, he was awarded the O.M. in 2000. Married to the painter Sheila Girling, he lives and works in London.

THONY CARO

Duccio Variations 1999–2000

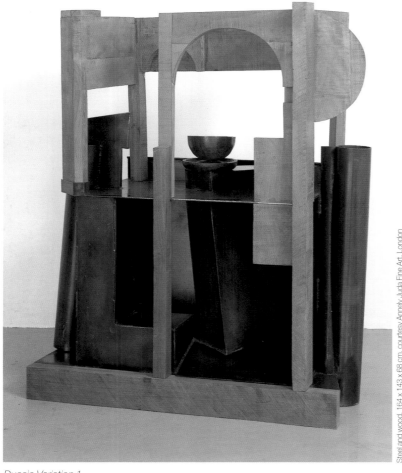

Duccio Variation 1

Steel and wood, 164 x 143 x 68 cm, courtesy Annely Juda Fine Art, London

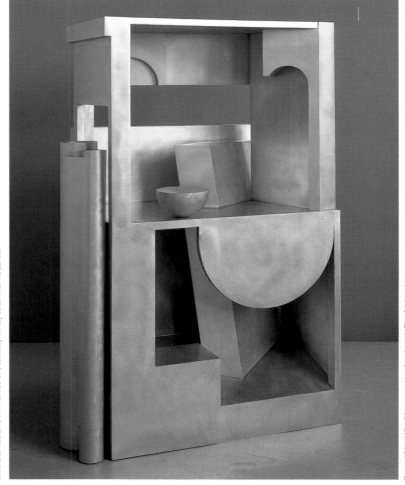

Duccio Variation 2

Brass, 164 x 119 x 64 cm, courtesy Annely Juda Fine Art, London

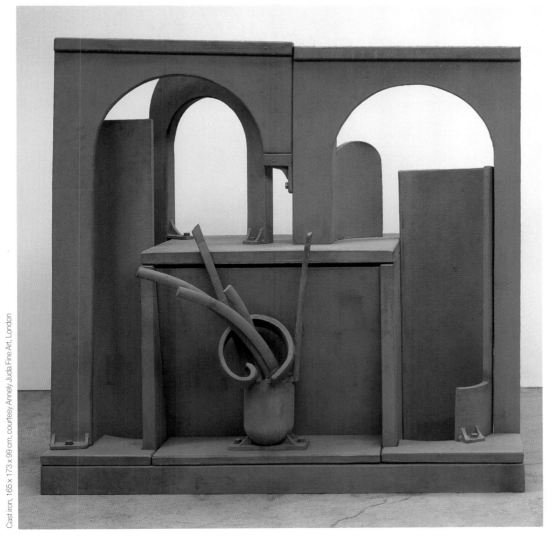

Cast iron, 165 x 173 x 99 cm, courtesy Annely Juda Fine Art, London

to mind the processes by which each was made. They assert the continued relevance of the tradition of constructed sculpture of which Caro has been an outstanding exponent for forty years. At many points they echo the architecture shown in Duccio's image; they do so in the service, above all, of the vitality of abstract relations within each individual sculpture.

In responding to the Gallery's invitation Caro intended to make a single sculpture, but as work advanced the process itself provoked additional variations, eventually numbering seven in all. For reasons of space, it is possible in *Encounters* to show only three, but this essay discusses the group as a whole, which refers back to its point of origin in multiple ways.

As Caro puts it, 'The first variation comes ... closely from the painting, the second comes both from the picture and Variation One and so on The painting is the taking-off point, like the original theme in a set of musical variations.'[1] Eventually the process developed into a dialogue between independent pieces, all well established. As they evolved, the works criticised each other continually, without poaching one another's territory. Each new variant explored

D UCCIO'S PAINTING of the Annunciation is a small, perfectly organised contrivance. Though it abounds in detail, the paraphernalia of an inhabited interior has been pared down so as to enhance both the disclosure of the parts shown and the lively tension between them. These means communicate, above all, the reality of the spiritual and psychological encounter that is the work's chief subject, but the concentration with which this is realised animates all the pictorial elements, not least the strongly articulated setting. Shallow though this setting is, the viewer perceives it as a space to be explored. We look into a box-like enclosure, but in our

imagination we also enter it, experiencing its apertures, its levels, its compartments and the way these are occupied by what they contain.

Anthony Caro's sculptures inspired by this picture are not depictions of the Annunciation, but like the Duccio they invite exploration of the interplay between container and contained. While they retain in some degree a sense of human habitation, the close attention they encourage is much more to their own component materials. In exposing these frankly, these works also call

Duccio The Annunciation, 1311

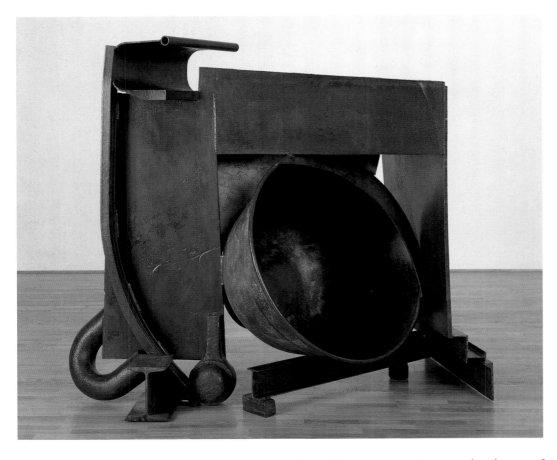

1 Anthony Caro *The Soldier's Tale*, 1983, painted steel , 183 x 208 x 134.5 cm, Tate, London

possibilities unavailable within the materials and structures already employed. The series became, among other things, an examination of the different properties sculpture can have, contrasting heavy with light, opaque with reflective, rough with smooth. Thus, despite relative similarity of dimensions and a shared point of origin, the differences between these seven works are striking. But every sculpture declares at once a common preoccupation, namely the exploration of degrees of openness and of enclosure. Announced, as we have seen, by the Duccio, this is, formally, these variations' central theme. Ultimately, however, it is a theme that takes the works beyond formal considerations to ones of an emotional nature.

Variation 1 is the most readable in terms of the Duccio image. It states the theme of containment with particular clarity; the principal object contained sits at its still centre and seems almost to invite the viewer to reach in and lift it out. Its pure though unexpectedly sealed bowl-form echoes the curves of five of Duccio's arches, which themselves run throughout the group as part of its architecture, now large, now small, now solid, now void, and variously resembling doors, wings or table-like flaps, as well as often remaining natural arches.

This bowl looks back to the vase in the Duccio. Though it rests, in the picture, at the lower centre, for Caro the vase is very significant pictorially and holds the whole painting together. As he observes, 'Architecture is very abstract and it is difficult to put something so "thing-like" as a vase into this framework. This gives focus and physicality to the abstraction of the sculpture.'[2] The idea of

a focal point which Caro establishes with this bowl/vase can also be identified, in changing guises, in *Variations 2* and *6*. In other variations from which it is absent, either it appears in transmuted form or its very absence becomes a preoccupation of the work.

Caro's use of the bowl/vase motif extends an interest in vessels that recurs in his work of recent decades. An implicit theme of the *Duccio Variations* is the sensation of putting an object into a container or of taking it out (this was, indeed, a central aspect of the process of creating these works, as their forms changed over the months). But another is the simultaneous thickness and hollowness of containers themselves. And although the objects these structures protect are eminently tangible, they themselves are not solid. An important part of their sculptural interest is the way they, in turn, raise the issue of inside and outside. Caro dramatised this in earlier works such as *The Soldier's Tale* of 1983 (**1**), in which the chief contained object presents empty space at the heart of the sculpture it so emphatically occupies.

The division of the first sculpture into the dissimilar materials of steel and wood echoes, in a sense, that of Duccio's architecture into partitions of different hue. The work began with steel, but the warmth of the Duccio spoke to Caro of wood. Rejecting mahogany as too hot and red, he opted for walnut, which he had never used before. Its greyish brown seemed suitable to the subject. At a late stage the walnut was waxed, but Caro deliberately preserved a natural rawness in the wood.

Where Caro's first *Duccio Variation* has a quality of quietness and privacy, the second is boldly declaratory and, as Caro puts it, 'there with a bang'. Its gleaming radiance picks up on a further feature of the Duccio, parts of which are gilded. For Caro wood, and even steel, were unable fully to bring out the crisp clarity that is one of the chief features of the Duccio. For *Variation 2* he therefore chose brass, for its hardness and rigidity and the decisiveness of its angles (emphatic in the Duccio wherever planes change direction,

and especially in the right angle beside the Virgin). At its heart stands a brass equivalent of the dark steel bowl in the first variation.

In *Variation 3* (**2**), Caro reacted away from *Variation 2* in several ways. From the latter's coldness he returned to the warmth of wood and from its planar clarity and classicism he moved to a world both looser and more impure. The profusion of uprights in *Variation 3*'s highly partitioned interior creates the effect of a kind of labyrinth. Compared with

Variation 1, the near ubiquity of wood also yields a quite different expressive effect. Where in the former variation the viewer feels the central vase might be picked up, here (where there is no vase) there are two trays, at top and bottom, which give the feeling that they might quickly be put to practical use.

This sense of usability is a function of these works' human scale. They seem accessible, part of our own space, and this quality, too, expresses something of the intimacy of the Duccio. It relates closely to another feature linking these Caros with the Duccio, that of directness. Caro began the first variation with unused material from his ambi-

tious, twenty-five part suite *The Last Judgement* of 1995–9 (**3**, **9**). It was no accident that this was steel, a material Caro prizes for its straightforward immediacy of working and for the freedom it gives as work is in progress. One of the challenges of the *Duccio Variations* was how to maintain the sense of directness when moving to wood, which for Caro is always more indirect, and then to the less tractable materials of brass, fibreglass, perspex and cast iron.

2 Anthony Caro *Duccio Variation 3*, 1999–2000, walnut, 162 x 180 x 120 cm, courtesy Annely Juda Fine Art, London

3 Anthony Caro *Torture Box* from *The Last Judgement*, 1995–9, stoneware, jarrah wood and steel, 208.5 x 110.5 x 95 cm, Künzeslau, Museum Würth

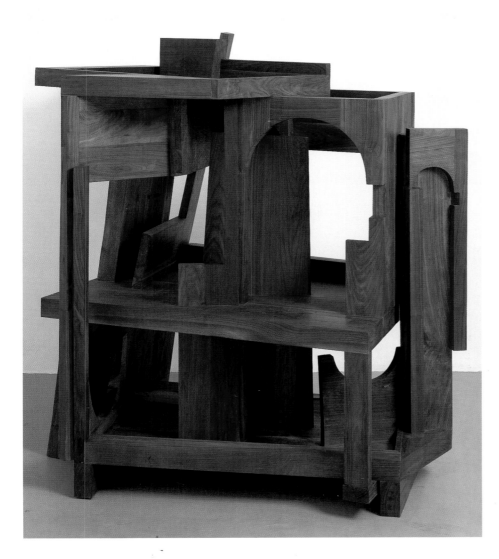

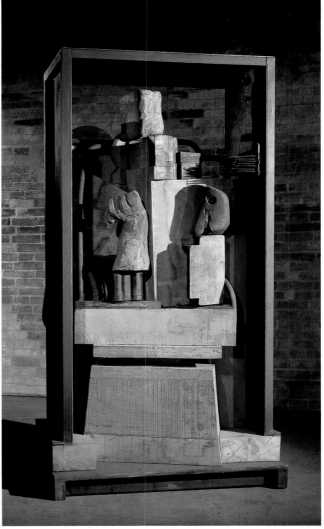

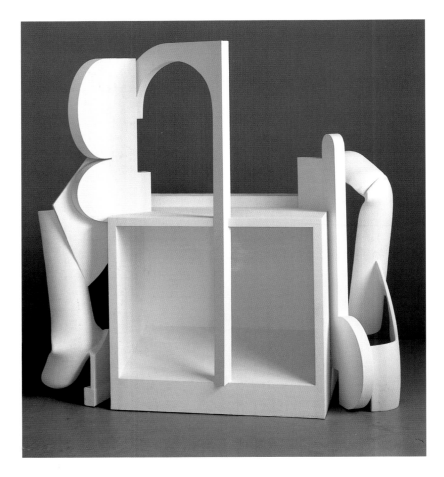

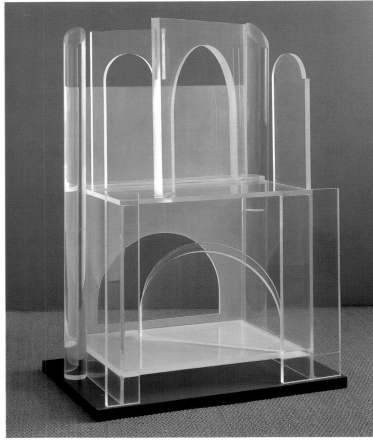

4 Anthony Caro *Duccio Variation 4*, 1999–2000, medium-density fibreboard and glass fibre painted white, 165 x 163 x 82 cm, courtesy Annely Juda Fine Art, London

5 Anthony Caro *Duccio Variation 5*, 2000, perspex/lucite, 168 x 122 x 66 cm, courtesy Annely Juda Fine Art, London

The viewer of *Variation 3* is not acutely aware of the absence of a 'vase' because the sculpture's interior is so full. At its centre is a vector which, as in the first two variations, links the work's upper and lower levels, seeming, in each case, to push through cleanly from one to the other. The force of this thrust, combined with its slightly off-vertical direction, invests these rooted-seeming complexes of form with a dynamic quality which, in an interesting analogy with the subject of the Duccio, conveys a sense of change no less than one of finality. Moreover, the idea of active vectors also works like a relocation of the lines of psychological and spiritual force that in Duccio's painting are directed towards the Virgin by both the angel and the Holy Spirit.

Variations 4 and *5* (**4, 5**) not only lack a focal object but, in their very openness, highlight the container motif which links all seven sculptures. The *Duccio Variations* have something of the character of cabinets. Normally a cabinet displays one or more objects, but here it is sometimes as though structures that conventionally play a supporting role have themselves become the subject. If so intriguing an effect is unintended, an element of paradox is nevertheless in keeping with a creative quality of ambiguity that pervades these sculptures. They are about enclosure yet, as Caro observes, 'the Duccio is a very transparent painting, and it's a thin kind of enclosure'. As we look at (or for) the contents of each of these seven enclosures we also look *through* the overall structure. Each work presents an interplay of apertures as much as of solids. Though in some variations we focus on one particularised object, the contained subject can equally be perceived as being internal space.

In *Variation 4* it is as though the contained object has been displaced from within the enclosure to its two sides. A pared-down centre is flanked by a double rococo flourish. Fibreglass is employed to approximate Caro's original concept of making this work in plaster, which was suggested by the seeming fragility of the pale structure that encloses the Virgin in the Duccio. *Variation 5*, in perspex, is like a drawing in space. It is the emptiest variation and its polished surfaces deflect the viewer's gaze. Its bare enclosures

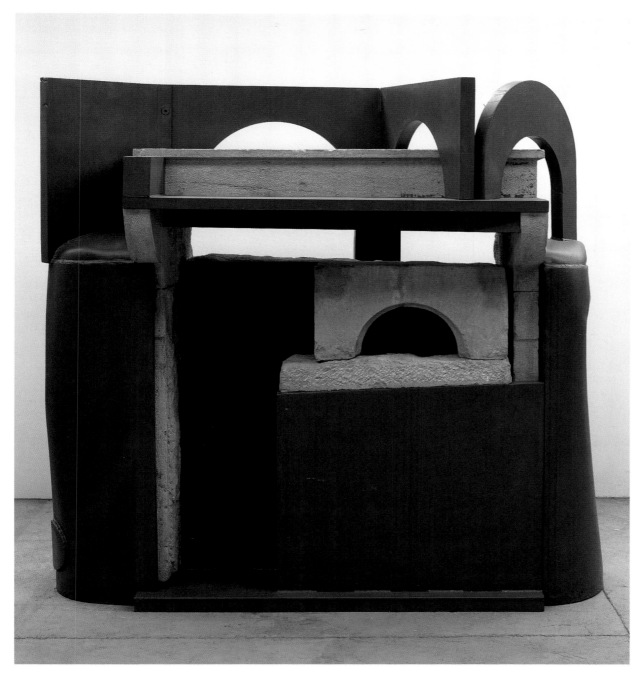

6 Anthony Caro *Duccio Variation 7*, 1999–2000, sandstone and steel, 164 x 143 x 79 cm, courtesy Annely Juda Fine Art, London

seem to await some human drama, but their very spareness directs attention to other acts – those of cutting and of connecting, which are particular to the constructive mode.

Reacting against the relative insubstantiality of *Variations 4* and *5*, the final two sculptures form the group's rich climax. *Variation 6* is suffused by the intense glow of rusted cast iron. It presents a box within a box. On its 'front' side the box's outer frame partially encloses the third bowl or vase to appear in the group. This contains flowers,

most of which shoot exuberantly upwards, while one coils round to enclose two others in a circlet that echoes the form of the vase's rim. On the 'back' side of this variation the curved contour of Duccio's largest arch is inverted, as it is on the 'front' of *Variation 3*. This device resembles the flap of a table, a reading supported by the bowl above it in the latter work. The 'displacement' of the vase from table-top to floor in *Variation 6* echoes the displacement to the edges seen in *Variation 4*. Nevertheless, here again the vase is the artistic and emotional heart of the work.

The construction of *Variations 6* and *7* is particularly frank. In *6*, the heavy parts are openly bolted in place, while in *7* they are held in position by a combination of visible balancing with steel clamps. Despite the absence of a vase element, *Variation 7* (**6**) concludes the sequence with perhaps the most emphatic statement of the group's theme of enclosure. The warm, honey hues of the vulnerable, worn sandstone glow within the harder casing of the painted steel. Although the two structures interpenetrate, the effect is of one building within another. Each structure reveals marked internal contrasts, between clarity of line and plane and evidence of destructive force. The twin steel uprights at either end of the sculpture are formed of two halves of an imploded boiler. Their seeming pliability echoes that of the scrolling flanks of *Variation 4*. Strongly reiterating the series'

7 Anthony Caro *Menelaos* from *The Trojan War*, 1993–4, stoneware, steel and jarrah wood, 169 x 49 x 34 cm, private collection

also brings the variations full circle by being made of two materials, steel juxtaposed with a substance found in nature.

Caro is famous for the non-referentiality of the sculptural idiom he developed from the very late 1950s, but consideration of his work suggests, in every phase, abundant analogies with the forms of the natural world and with our sensory experience of it. Starting thirty years ago and gathering pace progressively, Caro has increased his work's outward connections by making many sculptures that respond explicitly to great works by earlier masters. The figurative dimension was strengthened when in 1993–4 he unexpectedly created a 38-part suite of sculptures, *The Trojan War*, most of which represent individual participants, both gods and mortals, in the conflict recounted by Homer (**7**). Soon afterwards, his still larger ensemble representing *The Last Judgement* (**3**,**9**) developed the earlier suite's concern with using a range of contrasting materials in a single piece. As in the present group, these included steel, brass and wood.

Caro's creation of sculptures after earlier artists' paintings was the focus of the exhibition *Caro at the National Gallery: Sculpture from Painting*, held in 1998.[3] Among the works shown were derivations from Mantegna, Rembrandt, Goya and Matisse and the catalogue reproduced another after Rubens. In all these cases the works referred to were in collections other than that of the National Gallery, but the exhibition highlighted the distinction between two types of sculpture by Caro relating to past art. Those already mentioned were after paintings from which, over the years, Caro had spontaneously chosen to work, owing to a pressing wish to discover more about

them in his own terms. But other sculptures were made following the invitation to respond to paintings selected by him from a particular collection. The latter category was represented by three sculptures in stoneware and rusted steel from a larger number Caro made after the National Gallery's own painting *Van Gogh's Chair* of 1888 (**8**).[4] As is always the case when Caro is *asked* to choose a past painting to work with, he selected this picture because its imagery exemplified a major current concern in his own work. This was an interest in enclosure. As we have seen, the same interest led to his choice of the Duccio for the present exhibition, even though the nature of the enclosure that interested him on this occasion was quite different, in both the painting and the sculptures that resulted.

8 Anthony Caro *Van Gogh's Chair III*, 1997, stoneware and rusted steel waxed, 86.5 x 58.5 x 81.5 cm, private collection

concern with containment and revelation, this final sculpture also evokes the display of archaeological material in a museum. The stones appear specially preserved and protected. This focus seems perhaps to bring us back, across the centuries, to the once pristine structure that Duccio shows. The sculpture extends the sense of reverence that is common to the group as a whole but which is most marked at its beginning and its end. It

Caro was drawn to Duccio's *Annunciation* because of the strongly organised nature of the image and the prominence it accords to architecture. At the heart of his work as a sculptor is a concern with structure. For all the boldness of Duccio's structure, however, Caro did not aim to adopt it for his work in response, any more than he had done with Van Gogh's image of a chair. Rather, he went to this image from a radically different time and place for thought-provoking suggestions of approaches he might explore for his own needs, working with a third dimension. He was also stimulated by the challenge of the National Gallery's invitation. Once selected, the Duccio was a given, in relation to which he needed to conceive something new.

Throughout his career Caro has been more inspired by past painting than by sculpture. Paradoxically, this is because the discipline within which he constantly seeks new forms of structure is itself that of sculpture, which has its own structural repertoire. By contrast, painting – another world – abounds in hints for structures unexplored in three dimensions that he can develop and make his own. The need to make it his own is the key. All artists draw on past art at will for their own work but those who make something distinctive assimilate the earlier material, transforming it into their own fabric and communicating their own vision, rather than the earlier master's. Thus the importance of the Duccio for Caro's work should not be understood in terms of one-for-one correspondences between the painting and its variations.

Immediately preceding the *Duccio Variations*, Caro's work on the major ensemble of *The Last Judgement* was an enormous under-

taking, not only physically and organisationally but also in its emotional demands. Caro was simultaneously reading Dante's vivid evocation of the horrors of Hell and being confronted daily by raw reports of new mass suffering in Kosovo, and his feelings about Kosovo entered into his treatment of the timeless theme. By contrast with the grandeur, in every sense, of *The Last Judgement* the *Duccio Variations* are like chamber music. Each piece is a contained, carefully constructed mechanism which in no way insists on the subject of its point of departure. Moreover, many of the 'stations' of Caro's *Last Judgement* make evident a certain harsh forcefulness in the creation of form, not least in the gruesome kneaded and branded representations of heads in stoneware (**9**). Nothing of this kind is involved in the *Duccio Variations*, which for Caro not only afforded a welcome

9 Anthony Caro *Sacrifice* , from *The Last Judgement*, 1995–9, stoneware, jarrah wood and steel, 126 x 150 x 109 cm, Künzeslau, Museum Würth

shift in sculptural process but were also a counterpoint to misery.

Many of the *Last Judgement* sculptures are boxes of human images. Comparison is therefore unavoidable both with Duccio's painting, which likewise encloses a figure group suffused by emotion, and with Caro's box-like variations from it. Caro's *Last Judgement* was driven by its subject. Its spiritual and psychological import is insistent for the viewer. With the *Duccio Variations* the emotional charge is less immediate in impact but grows steadily the more the works are viewed. Strangely, for Caro the emotion inherent in the Duccio was not active in the process of the works' design and construc-

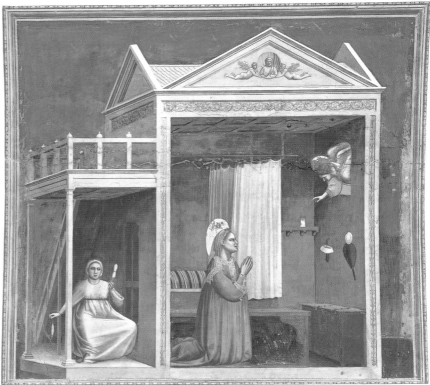

10 Anthony Caro *Arena Piece, 'Visit'*, 1995, wood and steel painted, 58 x 60 x 56 cm, courtesy Marlborough Fine Art, New York

11 Giotto *The Annunciation to Anna*, 1303–6, fresco, 185 x 200 cm, Padua, Cappella degli Scrovegni all'Arena

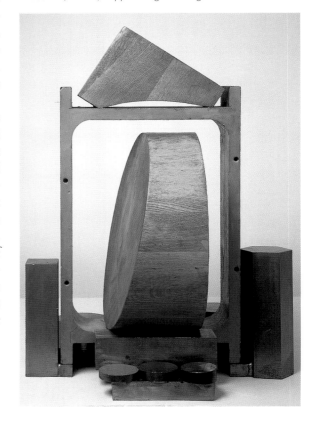

tion, despite the fact that the quality of love that pervades the Duccio was eloquent for him.[5] For the viewer, it cannot be imagination alone that makes each variation seem to embody a related emotion. Indeed, Caro regarded these sculptures as charged spaces from the first, and the very insistence of the first two on the enclosure of a vessel carries an implication which, going beyond any particular faith, gives a sense of the safeguarding of something precious, and this carries through the group as a whole.

In recent years Caro has worked extensively from images by Giotto in the Arena Chapel at Padua. One of the resulting sculptures (**10**) derives from the image of an earlier Annunciation, that to the Virgin's mother (**11**). While the Giotto and Duccio's near-contemporary *Annunciation* both represent figures, Caro's concern in each case is with the spatial division of an interior, within which his emphasis is above all on relationships of form. In the same year a very different Caro sculpture inspired by Giotto (**12**)[6] focused on the enclosure of a single form – thus, for all the sculptures' visual unlikeness, anticipating a leading idea in his *Duccio Variations*.

A marked feature of the *Duccio Variations* is the degree to which they assert a frontal view. Caro insists that his work has always been frontal, but many would regard dynamic all-roundness as one of his distinctive contributions to sculpture of the last forty years. Typically, a Caro induces an irresistible wish to view it from all directions. As one does so the sculpture re-creates itself in ways that often seem mutually contradictory, yet exciting. But an increase in the relative importance of the frontal aspect is undeniable in recent work; it is a particular

12 Anthony Caro *Arena Piece, 'Beginning'* ,1995, wood and painted steel, 72 x 54 x 38 cm, private collection

feature of most parts of *The Last Judgement*. Moreover, as Caro stresses, frontality is as much a property of sculpture as all-roundness.

How we should read the sculptures in terms of scale is productively ambiguous in all the *Duccio Variations*. This quality comes straight from Duccio's *Annunciation*, which combines psychological credibility with a curious, though effective, sense of uncertainty about the scale of the setting in relation to the figures it contains. A similar quality is present in the National Gallery's other two Duccios. Caro observes that in many Early Renaissance pictures one receives a pleasing jolt from the relation between the seeming inaccuracy of the depicted scale of towns in a scene's background and their rightness in terms of the works' effect.

A feeling of intimacy in *Variations 1, 2* and *6* is a result of the presence of the vase. The theme of an object placed on a shelf is a constant reminder that the work is on the viewer's own scale. Yet the strongly architectural character of all the variations leads the viewer naturally to read each as in some degree representing rooms on two floors. In the first five it is also irresistible to see the whole as having the character of a stage set, with all its implications of impending or imagined action. The analogy returns one to the drama of the Annunciation as Duccio visualised it.

Architectural readings cannot but asso-ciate these works in some degree with the side of Caro's work he has termed 'Sculpitecture'. His largest-scale works are actual buildings, which viewers can explore quite literally (**13**). With their steps, their storeys and their openings the *Duccio Variations* invite a similar experience in imagination. These sculptures do not represent figures overtly, but they act as a meeting point between our own sense of body and the potent occupation of defined space that Duccio depicts.

Richard Morphet

Notes

1 Letter to the author, 25 November 1999.

2 Ibid.

3 25 February–4 May. It was supported by an informative and well illustrated catalogue by John Golding.

4 Cf. the painting by Kitaj in the present exhibition.

5 'What a wonderful painting it is, so full of tender feeling' (Caro in letter to the author, 25 November 1999).

6 After the *Madonna in Majesty* (the Ognissanti *Madonna*), Florence, Galleria degli Uffizi.

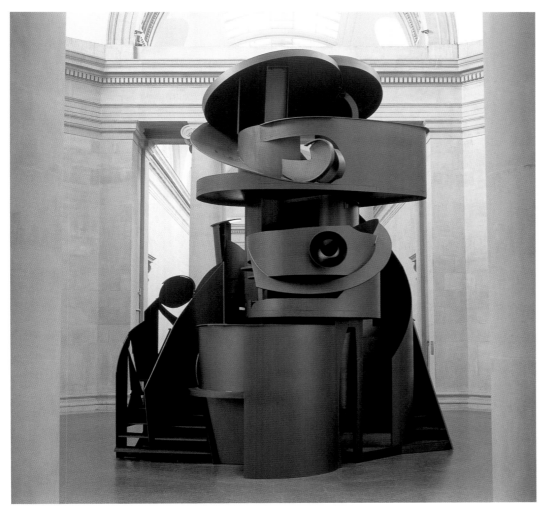

13 Anthony Caro *Tower of Discovery*, 1991, painted steel, 671 x 554 x 554 cm, Tokyo, Museum of Contemporary Art (Photograph shows installation in Tate, London)

ZURBARÁN
A Cup of Water and a Rose on a Silver Plate c.1630

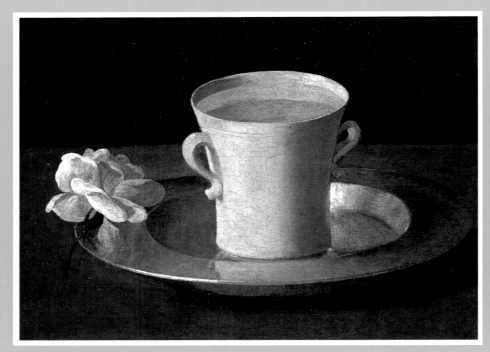

NG 6566 Oil on canvas, 21.2 x 30.1 cm

FRANCISCO DE ZURBARÁN (1598–1664) was the leading painter in Seville around 1630, the author of monumental paintings on the life of Christ and of the saints. He was also an innovative master of still-life painting, which was emerging in those years as a distinctive achievement of Spanish art. Despite the humble motifs he treated in such works, it does not seem that Zurbarán conceived of still life as a secular genre in any way independent of the concerns that animated his grander religious art. Rather, his depictions of ordinary objects in simple groupings carry within themselves an implication of the divine presence, which reveals itself almost imperceptibly and only with long looking.

Here, the image could not be more austere. A silver plate carrying a water-filled ceramic cup and a single rose stands on a table-top. The cup is Sevillan in origin, the plate probably Peruvian; while elegant in form, neither is ostentatious, both are like

sacramental vessels. Set against a dark background, the objects emerge into the light and authoritatively inhabit and structure their space. The eye is drawn to the play of ever smaller curves and counter-curves in the edges of the plate, the rims and handles of the cup and the petals of the rose. The latter is itself palely mirrored in the silver surface of the plate. Light, falling from the left, glints off its outer edge and again from the inner rim of the cup, while a shadow, cast to the right by the broad brim of the plate, gives weight and structural support to the composition.

The picture was cut down along three sides at one time in its history, although it seems impossible to say by how much. The same simple conjunction of still-life elements appears as a detail in two large-scale religious paintings by Zurbarán and this fragment may be all that remains of another such painting. The motif also re-appears as one element in the larger, more complex *Still Life with a Basket of Oranges* of 1633 (Pasadena, California, Norton Simon Museum) and the National Gallery picture may perhaps be a study for a detail in that or another such painting. Finally, the canvas may only have been cut down slightly and remain more or less complete. Whatever the case, it has been pointed out that both limpid water and the mystic rose are long-honoured attributes of the Virgin Mary, manifestations of her purity and holiness. Even without direct representation, the Virgin is called to the viewer's mind here, and Zurbarán makes this small painting an expression of his piety and an object of contemplation for the devout.

Christopher Riopelle

PATRICK **CAULFIELD**

© Janet Nathan

born London, 29 January 1936

CAULFIELD ESTABLISHED some of the principal characteristics of his painting while still a student at the Royal College of Art, London (1960–63). His art reflects his fascination with the design of objects and interiors and with different conventions of visual representation. Always preoccupied by still life, Caulfield has long visualised it in interior settings. Each painting juxtaposes large, crisply defined, near-abstract areas of strong, flat colour with smaller but equally crucial passages of photo-realism.

Keenly observant of decorative styles and also, by implication, of social codes, Caulfield creates images that are humorous, but not satirical. For more than twenty years their principal motif has been places where people meet to eat or drink. Choice of colour, severe simplification and the manipulation of the fall of light and shadow are key means by which ambiguities of space and mood are explored. Caulfield lives and works in London.

Hemingway never ate here 1998–9

Acrylic on canvas, 190.5 x 182.9 cm, Tate, London, purchased 1999

FROM THE FIRST glimpse of this large, strikingly coloured canvas, the viewer is arrested by the strangeness of its imagery. In an enigmatic space Caulfield presents a visual dance between forms that range from seeming abstraction to the minutely realised representation of particular objects.

The notional setting is a *tapas* bar in an unspecified location. Whether this is in Spain or elsewhere, the painting continues Caulfield's exploration in paint of the visual triggers by which regional or national identity is evoked in public places, above all those where people meet to eat or drink (**1**). However, in Caulfield's numerous interiors (his principal genre) people are very rarely depicted, and when they are they usually seem subsidiary to the main theme. It is

thus all the more astonishing to be confronted, in this new painting, by a direct and dominating gaze. Though not that of a human being it seems at first glance to belong to a living creature – a lifesize bull. Appreciation that the bull is in fact dead, simply a stuffed head mounted on the wall, does little to undermine a sense of its living reality. This is enhanced by Caulfield's representation of the shadow cast by horn and ear, which

Francisco de Zurburán *A Cup Of Water and a Rose on a Silver Plate,* 1627–30

curiously resembles a frisky tail.

From the subtly lit room occupied by the bull we see through to a brilliantly illuminated space. The vista is contained by an irregular abstract shape in blazing yellow that is almost punched out of the presiding green ground. The cameo of forms it encloses is one of the painting's three principal subjects. Within it, the disc-like form of a light provides a foil to the complexity of detail in the bull's head. But the heart of the painting is the tiny still life on a small table that projects into our space. At its centre stands the cup on a silver plate familiar from Zurbarán's painting in the National Gallery. The contrast between the small scale of this image (in keeping with the original) and the scale of the setting in which it is now seen serves only to concentrate attention on the motif.

1 Patrick Caulfield *Trou Normand,* 1997, acrylic on canvas, 190.5 x 190.5 cm, London, The Saatchi Gallery

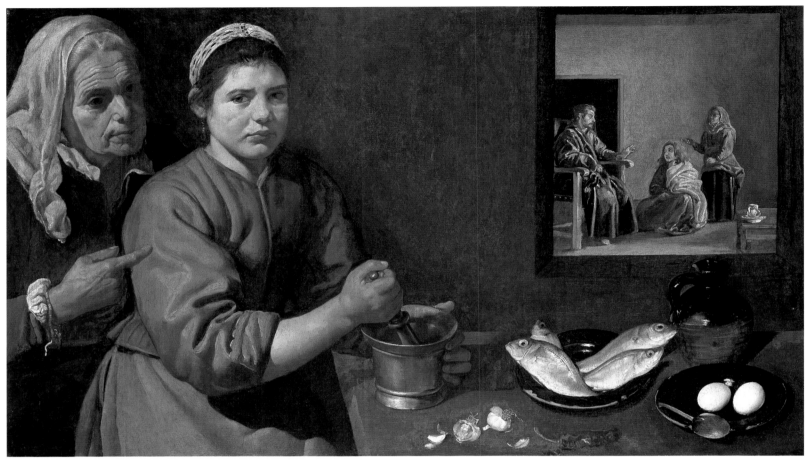

2 Diego Velázquez *Kitchen Scene with Christ in the House of Martha and Mary*, probably 1618, oil on canvas, 60 × 103.5 cm, London, National Gallery

Still life has played an increasingly important role in Caulfield's interiors. Its attraction for him lies partly in the attention it permits him to give to items so everyday that they are taken for granted. By natural extension his painting induces reconsideration of 'devalued' styles of design and decoration. The mood of his scrutiny is one of affectionate curiosity rather than satire. Caulfield's choice of works for his *Artist's Eye* exhibition at the National Gallery in 1986 demonstrated his interest in areas of art that had been not so much devalued as relatively less acclaimed. Significantly, half the works he selected did not normally hang in the principal galleries. His recollections are illuminating in relation to his present selection of the Zurbarán still

life (which the Gallery had not then acquired): 'By eliminating what I chose to rule out, I was able to go on to Dutch painting, for its humanism and its materialism, its ordinary subject matter I was after human qualities and some sort of continuity across the centuries.' He added: 'I wasn't against religious art *per se*, so much as flamboyant, expensive-looking, gold-decked religious art.'[1]

One of the few religious paintings he chose, *Kitchen Scene with Christ in the House of Martha and Mary* by Velázquez, is Spanish, and gives prominence to fish, eggs, garlic and cooking vessels (**2**). As in *Hemingway never ate here*, the view is over a still life to the picture-within-a-picture of the scene in the room beyond.

Spanish still life appealed to Caulfield for its beauty. The Zurbarán still life, in particular,

appealed to him for its absolute simplicity. At its centre is a vessel which offers immediate connection with his longstanding theme of the act of drinking and its social context. Through the constancy of form dictated by its function, such a vessel also serves Caulfield's predilection for 'continuity across the centuries'. Furthermore, as an object in ceramic, Zurbarán's drinking cup related to Caulfield's delight in pottery from other cultures, sometimes derived from examples in museums. Already in 1964 he was painting the central subject of the present work, a pot and a dish on a circular table (**3**).

The work's Spanish theme was further confirmed by a series of events, which also helped clarify its particulars. The decision of one of his sons to marry in Spain seemed to Caulfield to call for commemoration. The wedding took place in September 1998, but

3 Patrick Caulfield *Red and White Still Life*, 1964, oil on board, 160 x 213.4 cm, Birmingham Museums and Art Galleries

years. These even include a picture in which, as in the Zurbarán, a single pink rose is juxtaposed with two other items on a table (**6**). In his National Gallery painting, however, he omitted the rose as being too implausible for a scene in a *tapas* bar.

In earlier years Caulfield usually visualised a whole composition before beginning to paint. Nowadays, he works by improvisation, but cannot begin until he has established the painting's idea. Though knowing that it must somehow incorporate the Zurbarán, Caulfield began this picture with the bull's head. For a fee of £400 he hired it for six weeks from a firm in White City and was photographed beside it in his studio, wearing a 'Spanish' beret (see artist's photograph). He first drew the head on paper, life-size, and then traced the main elements on to the canvas. To make sense in the imagined scene, the bull's head had to be high in the painting. But in starting the picture in the top right corner Caulfield was also consciously continuing the procedure common to all the works in his major suite of interiors of 1996–7, each of which started with a 'given' (in this case the image of a lamp) at top right (**1**).

on a trip to Madrid some months earlier he had visited a comfortable, old-fashioned bar where on the dark walls hung the stuffed head of a bull. This led to the inclusion in his National Gallery painting of a motif he would never have painted without a Spanish rationale. On the same visit Caulfield chanced upon a restaurant, just off the Plaza Mayor, with a blind that bore the legend *Hemingway never ate here* (**4**). This determined the painting's title. Caulfield liked the bizarre negative emphasis of a phrase intended humorously to distinguish this establishment from the many claiming the patronage of the American novelist famous for his evocations of Spanish life (including the bullfight).

Caulfield's first interpretation of the Zurbarán was a virtually same-size drawing in pencil, in which the most conspicuous element is the rose (**5**). The only coloured part of the drawing, it is built forward in acrylic, in low relief. Roses in various styles have appeared in Caulfield's paintings across the

4 Exterior of the El Cuchi restaurant in Madrid, photograph, 2000

5 Patrick Caulfield *Drawing after Francisco de Zurbarán's 'Cup of Water and Rose on a Silver Plate'*, 1998, pencil and acrylic on paper, 25 x 30 cm, private collection

Caulfield got to know the bull well and sees it as imparting a certain sadness to a scene in which that is not the predominant mood. He accentuated its presence by including its 'waving' shadow. While painting the bull's head he delighted in working like an eighteenth-century sporting artist, though making a decidedly modern picture. The relative complexity of the initial image compelled severe simplicity throughout the rest of the picture.

Caulfield wanted the work to connect with the past but not to be enslaved by it, and a key factor in its drama is the juxtaposition of the older elements with ones that are distinctively modern. The first of these to appear was the form of the archway, which 'dictated itself' once the bull's head was achieved. This was quickly followed by the abstract shape of the table-top, linked to that of *its* shadow, which accentuates its occupation of real space. Though purposefully approached, the image from Zurbarán was introduced only at a late stage.

The artist wanted his version of the Zurbarán to feature a contemporary 'designer beer'. In Zurburán's *Still Life with Basket of Oranges*, the motif in the National Gallery's picture is balanced by a dish of lemons (**7**). This connection was the trigger for Caulfield's choice of a drink accessorised by slices of the closely related lime. He visualised the bottle here being drunk from directly, in the now fashionable way. The bottle he painted, however, had contained not beer but sarsaparilla. He chose it because he needed a bottle which was short enough to avoid splitting the line of the dado rail yet tall enough for the protruding slice of lime just to touch it. At the core of the whole work stands Zurbarán's drinking cup; it continues to contain water.

Caulfield's response to the Zurbarán was to its image rather than to its meaning for the artist and his contemporaries. He was unaware that the rose denoted love and the water purity, and that both these readings were inferred in a religious context. The use of transposition to alter meaning has many

6 Patrick Caulfield *Still Life: Mother's Day*, 1975, acrylic on canvas, 76.2 x 91.4 cm, private collection

precedents in Caulfield's art. The process operates not only, as here, through changes in detail and of context but also through the very way in which an image is formed. The classic example is his version of Delacroix's celebrated painting *Greece on the Ruins of Missolonghi* of 1826 (**8**,**9**). There, as in so much of Caulfield's work, the effect of the translation is ambiguous. In simplifying the original image he seems simultaneously to have blunted and sharpened its effect. A result that Delacroix would doubtless have considered offensive (as would Zurbarán the new version of his still life) can nevertheless be read as much in terms of admiration and respect as it can in those of irony.

Caulfield wanted to transpose Zurbarán's painting into a present-day reading without distorting the original image. Though he was selective in what he showed of it, the ceramic cup and silver plate do indeed maintain their integrity; their slight improbability in this contemporary interior underscores their key role in the picture. In its treatment of an Old Master image, this painting stands midway between the radical reformulation employed in the Delacroix and the direct copying of a seventeenth-century German painting, *Meal by Candlelight* by Gottfried von Wedig, in Caulfield's *Interior with a Picture* of 1985–6 (**10**).

At the centre of Caulfield's improvisatory method is a continuous process of judging what to include and exclude. He always aims to cut out extraneous description while retaining a sense of function and use. An example here is the table-top. We register not only the existence of its supporting leg (which is not represented) but also that of the absent chairs. We virtually sense, too, the ambient sound in this convivial interior.

Foremost among what we do not see in Caulfield's paintings, yet feel to be present, are the people who inhabit his bars and restaurants. Yet, although Caulfield examines nuances of style and taste through objects and settings, his pictures are no less about human interaction. Much has been made of the melancholy implicit in many of his 'empty' interiors, and since he activates a wide spectrum of emotion this reading is not wrong. Equally evident, however, is Caulfield's sense of the warmth of these places where people meet. Moreover, he finds bars and pubs not only engaging in human terms but also valuable for the exchange of information. Indeed, it was through an encounter in a pub that he discovered where to go to hire the bull's head used in this work.

7 Francisco de Zurbarán *Still Life with Basket of Oranges*, 1633, oil on canvas, 62.2 x 109.5 cm, Pasadena, California, The Norton Simon Foundation

8 Ferdinand-Victor-Eugène Delacroix *Greece on the Ruins of Missolonghi*,1826, oil on canvas, 209 x 147 cm, Bordeaux, Musée des Beaux-Arts

9 Patrick Caulfield *Greece expiring on the Ruins of Missolonghi, after Delacroix,* 1963,oil on board, 152.4 x 121.9 cm, Tate, London

The colour key of the present work is a reaction against the pervasive reds of Caulfield's suite of interior paintings of 1996–7. Yet the same sense of warmth is maintained in this picture despite its contrasting palette. Caulfield associates the dominant colour, green, with the atmosphere of interiors, which is why he chose it as the sole colour of his *Inside a Swiss Chalet* of 1969. That painting is not especially warm, yet in this new green painting the yellow (which pervades the picture, being part of the colour-mix of the greens and reds, as well as standing on its own in one key area) augments the welcoming feeling.

One of Caulfield's key preoccupations is the play between different conventions of representation. Here, the meticulous realisation of bull's head and table still life are set beside the nearly abstract portrayal of distance. The marks which represent depth in different ways are, of course, all flat. But in the top left corner what at first appears as painted representation of a decorative scroll is a real sash-cord, painted and laid on the picture surface in relief. This device signals both its own artifice and that of the picture as a whole. Indeed, not only is artifice central to Caulfield's procedures but it is also his paintings' subject. Fascinated by what is man-made, he paints pictures which make us ponder the factors that lead to objects and interiors being fashioned, displayed and used in the ways they are.

He is, however, not a sociologist but a visual poet. And if a painting abounds in visual

jokes their comedy is subsumed in a larger imaginative reality. In all this there is an analogy with Cubist paintings of the everyday world, not least depictions of café life. In each case, allusive forms often reduced to a point of near enigma communicate, between them, more about the situation than we are actually shown. At the same time each

painting, though revealing about the life of its period, has a satisfying self-sufficiency.

Caulfield's debt to Cubism is also evident in the configuration of shapes seen through the doorway, which might almost represent a Cubist painting or object. In relation to Zurbarán and the Spanish theme of the work, it is interesting to reflect that two of the three

10 Patrick Caulfield *Interior with a Picture*, 1985–6, acrylic on canvas, 205.7 x 243.9 cm, Tate, London

principal Cubist painters were Spanish. Picasso's life's work is a *tour de force* of continual re-contextualisation of imagery. Years after Cubism's heyday and under the pressure of appalling events in his native

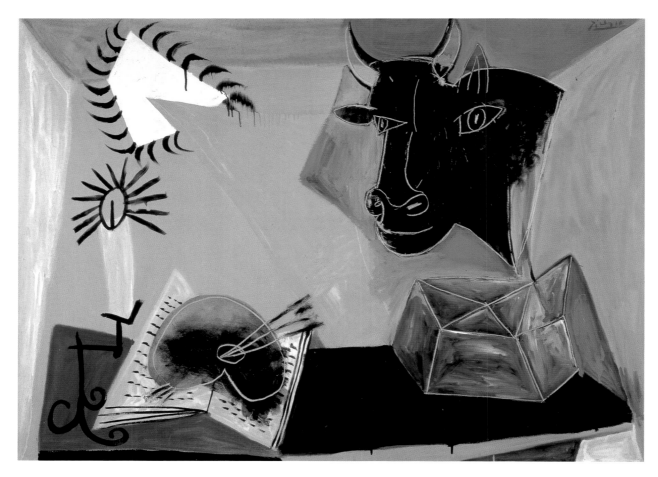

11 Pablo Picasso *Still Life with Candle, Palette and Black Bull's Head*, 19 November 1938, oil on canvas, 97 x 130 cm, Komaki, Japan, Menard Art Museum (Zervos IX, 240)

these artists present familiar objects with something of the same casualness as Gris.'[3] James Thrall Soby is even more specific when he writes that the qualities of a work by Gris 'give it a transcendental intensity, a kind of mystic purity which once more proves how persistent was the effect of Gris' atavistic sources …. However French his taste became, he remained the heir to Zurburán.'[4]

Though Caulfield's admiration for Gris began early in his career, the affinities between the two artists have, if anything, grown in recent years. Evidence of this is the enhanced focus Caulfield now accords a work's internal relations. This is the result of his decision in the late 1980s to contain the imagery in each work more explicitly, by preventing its 'bleeding' at the canvas edges (which drew attention to the continuity of a scene beyond those confines). Curiously, the abstract severity of Caulfield's paintings establishes a further link with Zurbarán. This is surprising, since in the latter's work, unlike Caulfield's, the human image is prominent. But Zurbarán delighted in what one writer has called the 'little trick of the puppet booth, the sacrarium, the shrine … on account of its abstract beauty as an enclosed area in which shadows and lights are caught, as the objects of a representation in which the strange modernity seems to lie in the fact that the *painter appears to bestow as much or more consideration, as much or more care, on things as on people'*.[5]

Greater formal autonomy permits the freer exercise of the implicitly architectural

country, Picasso deployed the motif of the bull's head in perhaps the most famous twentieth-century painting, *Guernica*. A group of his easel paintings from the same period provides a precedent for the new Caulfield. There the head of a bull becomes the key feature of still lifes in interiors, where it is juxtaposed with equally symbolic objects (**11**).

It is, however, to the other Spanish master of Cubism, Juan Gris, that Caulfield feels specially close. With memorable outward impassivity he has even painted his portrait (**12**). He observed recently how Gris ' interprets quite ordinary things to create an extraordinary world. He makes still life

almost architectural …. I feel more than anything an integrity to his work, in the sense of wholeness, completeness, and above all without any short cuts. There's a pervasive mood in Gris that's unlike anyone else's. His colour is formalised but creates an atmospheric feeling with a lot of depth.'[2]

Caulfield's admiration brings his neo-Cubist response to the Zurbarán full circle, for Gris himself responded strongly to the seventeenth-century master. As Douglas Cooper pointed out (naming the very three Spanish artists by whom the National Gallery owns still lifes), 'Juan Gris was deeply imbued … with the spirit of the Spanish tradition. Before one of his still lifes, one thinks not of Chardin or of Cézanne but rather of Zurbarán, Velázquez or Meléndez. For in their paintings one encounters a comparable austerity and clarity of composition, and

12 Patrick Caulfield *Portrait of Juan Gris*, 1963, oil on board, 121.9 x 121.9 cm, London, The Colin St John Wilson Trust

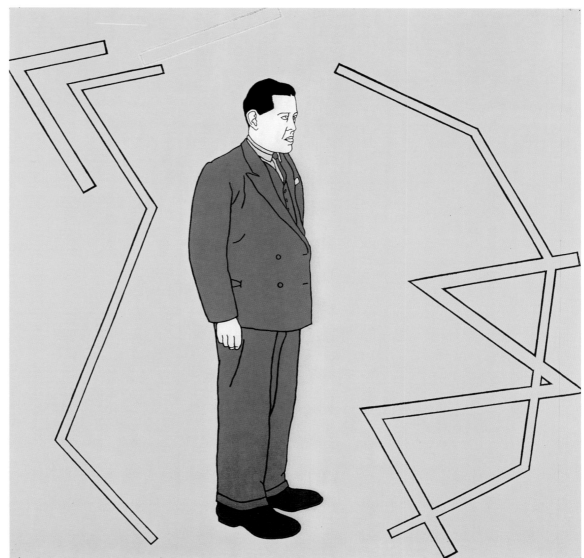

instinct that is one of the key directives of Caulfield's work today. The deployment of light plays a crucial role here. Like the inclusion or exclusion of figurative detail, Caulfield can use it at will to disclose areas of the depicted scene that serve his purposes in formal terms. Fundamental to Caulfield's aims in each picture, abstract vitality is easier to achieve because (except when copying an insertion from a printed reproduction) he is working only from a general concept and not from a specific motif. In improvising, he *constructs*. As examination of *Hemingway never ate here* shows, minute particulars of the design (for example shadows, the distant coat hook in silhouette and the nicks in the archway's green and yellow perimeters) help determine both the balance and the expressive effect of the whole.

Though not autobiographical, Caulfield's works are the product of an exceptionally observant and retentive mind. The fruits of this are subject, in the studio, to a process of meditation on the dynamics both of form and of human life. Such impulses were already evident in childhood. The only thing that put an end to Caulfield's attempts to run away from school was being given a set of building blocks, which he used to make imaginary structures. Today he does this in paint. As his response to Zurbarán shows, the results may be substantially abstract but they have a reality of their own which admits the viewer to a world at once credible and distinctive.

Richard Morphet

Notes

1 'Patrick Caulfield: a Dialogue with Bryan Robertson' in exh. cat. *Patrick Caulfield*, Hayward Gallery, London 1999, p. 29.

2 Ibid., p. 26.

3 Douglas Cooper, *Juan Gris, Catalogue raisonné*, Paris 1977 (present author's translation).

4 James Thrall Soby in exh. cat. *Juan Gris*, Museum of Modern Art, New York 1959, p. 61.

5 Julian Gallego, *Zurburán*, London 1977, p. 52 (present author's italics).

TITIAN
An Allegory of Prudence about 1565–70

NG 6376 Oil on canvas, 76.2 x 68.6 cm

THE ITALIAN RENAISSANCE saw the invention of a rich visual language of emblems and allegorical images intended to characterise forces of nature, eternal verities of life and high philosophical aspirations. The learned men who devised such *emblemata* often declared them to be rediscoveries from the lost visual language of the Ancients, only brought back to light in modern times, thus embuing them with the glow of a Golden Age. From elegant illustrated books, especially in Venice, such hieroglyphs gravitated to the painted or sculpted façades of public buildings, the ceilings of palaces, the eagerly sought-after canvases of master painters, and into the shared visual culture of sophisticated and aristocratic society across Europe. While today we need to be shown the key if we are to interpret such images, in the sixteenth century a well tutored duke or a connoisseur with access to a learned library would have recognised, or at least have known how to go about identifying, the meanings that informed such cryptic signs.

Here, the aged Titian (Tiziano Vecellio, active from c.1506; died 1576), greatest master of the Venetian school, takes motifs that he would have known from contemporary emblem literature, weaves them together, and makes of them a deeply personal allegory of prudence, full of intimations of his own mortality. The three animal heads at bottom – wolf, lion and dog – derive from an image in the most beautiful of Venetian early printed books, the *Hypnerotomachia Poliphili* of 1499. Allied with them are three male heads suggesting the three Ages of Man – old age, maturity and youth. The conjunction of human and animal heads in this way had been proposed as a representation of prudence by Pietro Valeriano in his *Hieroglyphica* of 1556. A Latin inscription at the top of the painting – the language would have presented no problem for a sixteenth-century man or woman of erudition – explains what the image signifies: 'From the past the present acts prudently so as not to spoil future action'.

Working in the broad, fluid and open style of his later years, where pigment is applied with an audacious freedom that arises, seemingly effortlessly, only from decades of painterly experience, Titian gives to the public image of prudence a private resonance. White-bearded, cheeks sunken by the years, the artist himself represents old age. His heir, Marco Vecellio, may represent youth, while his son Orazio may be maturity. Further, the conjunction of Orazio's bearded face, seen frontally, and the lion below evokes St Mark, patron saint of Venice, whose attribute is the lion, symbol of the Venetian Republic as well. An old man, having spent the whole of his life in the Serenissima, Titian here addresses both his family and his beloved city, counselling them in discipline, control and due care.

Christopher Riopelle

FRANCESCO **CLEMENTE**

born Naples, 23 March 1952

© National Gallery, London

CLEMENTE HAD no formal art training, but experienced the arts as a whole from an early age. Twombly's painting was an important early influence. Clemente's work conveys a sense of the ancient past and the immediate present, the carnal and the philosophical, life and thought in East and West. He has long studied eastern religions and Indian art. In 1973 he made the first of many visits to India, and he maintains a studio in Madras. He was a key figure in the tendency identified in 1979 as the Italian *Transavanguardia*. He established a studio in New York soon after his first visit in 1980, and has lived there since, though often in Italy and India.

Clemente frequently works in series, in techniques ranging from freely handled water–colour through richly sensuous pastel to fresco. His colour is substantial and often vivid. Some recent works have been anamorphic. Clemente's art centres on the human image, not least his own. His works evoke a gamut of sensation, from violence to tenderness. He ceaselessly examines physical and emotional drives, including all the appetites and bodily functions, especially sexual, and the inevitability of death. His art links human life to that of the natural order as a whole.

CLEMENTE

Smile Now, Cry Later 1998

Oil on canvas, 234 x 468 cm, Düsseldorf, Kunstsammlung Nordrhein-Westfalen

I N THIS ENORMOUS painting both the contrast and, by implication, the link between present pleasure and future sorrow are presented insistently by twenty-three male figures. Each holds a sheet of paper, on which is written a phrase that corresponds to the upward or downward curve of the simple crescent of his mouth. Smiles outnumber tears by a majority of one.

Given the picture's double-square format, this balance between pleasure and pain, along with their inescapable interconnection, might have been represented by confining each to one half of the rectangle. Clemente chose, however, to intermix the two states of mind in an all-over design, which he describes as a labyrinth. The labyrinth has the character of a living organism. The leaf-like forms that enclose the figures suggest the vigorous growth of a plant, penetrating its own interstices even as it also spreads outwards. Yet these leaves can also be read as window-like apertures in a kind of screen through which, at varying distances, we glimpse the numerous individual figures. Though each is confined in his own enclosure, their setting strongly implies a state of complex and continuous interaction, while the cropping of figures at the picture's edge suggests the group's indefinite proliferation. The picture therefore reads as an image of life as a whole, and its two-part message as reflecting the human condition.

When the painting is examined closely, the care, complexity and painterly sensuousness of its execution seem in continuous creative contest with its strongly improvisatory character. A further opposition is between the way the work insists on the physicality of its surface (and thus on its flatness) and the striking sense it gives of layering in depth, from the floating foreground form (which will be discussed below) to the soft

Titian *An Allegory of Prudence*, c.1565–70

pink 'wall' and then through its many gaps to figures seen both near and far.

Clemente was born and brought up in Naples, lived for a period in Rome and subsequently, during wide travels, established studios both in Madras and in New York (where he lives and this picture was painted). He discovered the picture's written message in a further city, Los Angeles (see below). It is therefore not surprising that one of the kinds of 'labyrinth' its image suggests is that of the city, an organism to which Clemente is strongly attracted, not least owing to its character as a cultural melting-pot. In a sentence that encapsulates the dual nature of this image of plants or windows, Clemente observes: 'The city is the forest; it is a beautiful thing'.[1]

Though he engages avidly with the multiple juxtapositions and endless surprises of life in the city, Clemente has no less strong a need to withdraw to places of quiet and isolation, in order to reflect. This duality, too,

is fundamental to the teeming *Smile Now, Cry Later*, and Clemente's response here to the National Gallery's Titian is, in essence, a response to the contemplative quality of that work.

Clemente first visited New York in 1980. Raymond Foye has recorded the fullness of his early involvement with the city's black culture.[2] That all the figures in *Smile Now, Cry Later* are black is the outcome, however, not of an initial intention but of the decision to be guided by one of the ground colours, in a painting which developed primarily by intuition. The result nevertheless reflects the importance of cross-cultural experience in Clemente's view of the world.

As so often in Clemente's work, the fact that the figures are unclothed supports their role as vehicles for the communication of basic truths about life. It is also very much in keeping with the source of the phrase that gives the picture its title, which Clemente discovered on human skin, in the form of a tattoo, a technique that links directly with the origins of art itself.[3]

The tattoo was on a friend in Los Angeles, who is a Chicano (a North American of Mexican origin). That Chicano culture constitutes a distinctive element within the kaleidoscope of US society automatically makes it interesting for Clemente. 'Smile now, cry later' has the status of a catchphrase among Chicano boys, and it is a popular choice of tattoo among them. In Clemente's friend's tattoo one half of the phrase appears on each arm, accompanied by the image of a pretty girl, smiling or crying as the wording dictates. Though Clemente changed the figures' gender, this juxtaposition of half the written phrase with an image of the human body was the basis of his painting for this exhibition.

1 Francesco Clemente *Broken Hearts,* 1990, tempera on linen, 132 x 106.7 cm, private collection, courtesy Sperone Westwater, New York

the end of the matter.

The title of Clemente's painting could be read as meaning that pleasure always leads to tears, but it could signify equally that one must proceed boldly in life, careless of the consequences. To Clemente, though he resists prescribing an approved reading, the words suggest a third notion, namely that 'later' will never come, for it is always now. As he sees it, this interpretation links directly with the declaration inscribed in the Titian. But no single meaning is mandatory. For Clemente, the written phrase in each painting is, in a sense, a story. Its association with images compounds this way of approaching it. It also reinforces his view that any good story contains a part that is not told, but which may be imagined. Crucial to Clemente is that in every case it is the viewer who must decide the significance of the painting's inscribed phrase, indeed must find in it his or her own truth. He sees each of his paintings as establishing an itinerary. It delimits a territory rich in relationships and analogies which are there to be developed.

Open though its possible interpretations may be, the imagery of Clemente's work as a whole shows clearly that a central purpose of his art is the representation of instinct and feeling. While conceptualising the emotional and physical drives inseparable from each person's existence, his images also evoke the sensation of experiencing them. A further subject of his art is the predicaments that can arise in consequence of following these impulses. Thus it is not only for decorative reasons that the leaf-like shapes that enclose the figures in *Smile Now, Cry Later* are in the form of hearts; or, moreover, that rather than being simply contained by them the figures seem to be trapped. In another painting of interlinked hearts and figures, image and title link love with suffering (**1**). Like the Titian, however, Clemente's work deals not with specific situations but with what he describes as 'the essential luggage of life'. Repudiating the

The phrase 'smile now, cry later' can be read equally as injunction or as commentary. The same might be said of the statement inscribed in Titian's *Allegory of Prudence* (see p. 92), with which, too, human images are juxtaposed. In both works, the written phrase combines directness of expression with the potential for a range of readings. For Clemente, an important part of the attraction of the tattooed phrase was the immediacy of its language, combined with the universal application of its content. But the attraction would not have been so strong if the message conveyed had been cut and dried for, as Clemente explains, though anyone can understand the words that is not

notion that the somewhat threatening labyrinth in *Smile Now, Cry Later* reflects his perception of the endemic violence of big city life, he observes that the only danger in life is emotional. He himself sees the picture as representing a movement from joy to sorrow, or from hope to fear.

The long, wall-like surface of *Smile Now, Cry Later* combines with the abundance of handwriting, the manikin-like simplicity of the figures and the quantity of lines of dripped paint to suggest a similarity to graffiti, a mode of urgent emotional expression in public form. The analogy with a wall is enhanced by the likeness of this (and many Clemente paintings) to time-worn fresco. The association with graffiti is reinforced by Clemente's close friendship with two of the principal New York artists who carried street graffiti into fine art, Keith Haring (1958-1990) and Jean-Michel Basquiat (1960-1988). Indeed, the huge transparent form which overlies the human network here was executed by spraying, the classic technique of modern urban graffiti.

Interested in all forms of expression generated outside the area of fine art, Clemente is always attentive to graffiti. Part of their interest lies in their cumulative character, which can bring together on a single surface different ideas from unconnected sources, each with its own flavour and traditions. Democratic in nature, graffiti are analogous to Clemente's paintings in their openness to many directions at once and in their non-hierarchical composition.

One of the attractions of the Titian for Clemente lies in the fact that the heads are looking in several directions (as does his own art). He connects their three-fold gaze with that of Indian gods, who look in four directions (**2**), and consequently fantasises that in the Titian there may be a fourth head we cannot see. Indian traditions of thought and

2 Four-headed Indian God, sculpture, London, British Museum

belief were formative for him from an early age. Indeed, 'The cultural multiformity of India led Clemente to accept fragmentation and and stylistic diversity in art, in contradiction to the prevailing cultural hegemony of the West ... [and led to his] abandoning the traditional hierarchical ordering of experience'.[4] This response corroborated Clemente's perception of late twentieth-century life in general as an experience of multiple disjunction. For this reason individual works by him tend not to have a single manner; their stylistic inconsistency is deliberately assertive.

Consistent with these affinities, *Smile Now, Cry Later* was painted intuitively and has no special point of focus. Clemente cannot recall with what element it began, and considers this unimportant. Its steady accretion is analogous to the spiral movement of successive figures that he identifies in several sectors of the picture, but for him its development is most like a circle, having no beginning and no end, as in the Titian (in which, moreover, he feels that, similarly, none of the figures has precedence).

Among other paintings by Clemente in which words are prominent is *Fortune and Virtue* of 1980 (**3**), which is boldly inscribed *LA RUOTA DELLA VIRTU LA RUOTA DELLA FORTUNA* (The wheel of virtue, the wheel of fortune). Not only does this balanced phrase anticipate *Smile Now, Cry Later* but its meaning in Clemente's mind links the two works still more closely; Virtue and Fortune are equivalent, for him, to order and disorder, and thus to what one can choose and what one has to accept. There is a similar existentialism in *Smile Now, Cry Later*.

The capital letters of this pronouncement recall Italy's long tradition of public inscriptions, not least those on Roman funerary monuments, for which Clemente has long had a passion. In particular, he is fascinated by such inscriptions when one character is missing (or is misplaced) because the stone-engraver ran out of space. His own works show a related interest in just how an image does or does not fit into the space intended to contain it. A case in point is the abbreviation of the images of many of the figures in *Smile Now, Cry Later* by the edges of the hearts that contain them.

Whenever he includes writing in a work, Clemente aspires to equal the casual confidence shown by the ancient letter-cutters. There is a link between their outlook and the relaxed directness and economy of both word and image in his own art. Such a quality is also

3 Francesco Clemente *Fortune and Virtue*, 1980, oil, pencil and pastel on paper, mounted on linen, 150 x 275 cm, private collection

one of the sources of attraction for him of the phrases which engage him, such as 'smile now, cry later'. Evidently springing from a sense of necessity (personal, universal or both), these phrases have no need of elaboration beyond the few words of which they consist.[5] Individual experience supplies the rest. Part of the appeal for Clemente of Titian's *Allegory of Prudence* is a comparable straightforwardness and absence of straining after effect.

Formative for Clemente well before he discovered Indian traditions was the medieval and Renaissance preoccupation with concise imagery, for example in emblems. He has a particular interest in the iconography of the *gryllus*, a curious type of image which appeared widely in medieval art between the late twelfth and late fourteenth centuries.[6] Michael Camille explains how 'for medieval people the *gryllus* came to represent the baser bodily instincts'[7] and quotes Foucault's description, in his account of the *gryllus*, of 'how the soul of desiring man had become a prisoner of the beast'.[8] Baltrusaïtis identifies two principal types of *gryllus*.[9] One takes the form of legs supporting a head without a body. The other consists of multiple heads merged to form a single entity. Tracing the incidence of the *gryllus* in art from Antiquity and through the Middle Ages, Baltrusaïtis concludes by registering its re-appearance in the sixteenth century, for example in the work of Hieronymus Bosch. He characterises Titian's *Allegory of Prudence* as a multi-head fusion of an animal image of past, present and future with a human one of the three Ages of Man. Of the several multiple-head *grylli* he reproduces, the earliest, from Antiquity, specifically represents the latter concept.

In combining things that could never be a unity in real life, the *gryllus* is always a hybrid. Clemente's interest in this form connects with his profound admiration for the poetic (as opposed to the political) world-view of Ezra Pound, whose 'method of compressing space and fusing disparate elements in the poem is the concept of the ideogram, a kind of word-picture A prime appeal of the ideogram is its ability to short-circuit the rational mind.'[10] Clemente himself has spoken of his interest in literary conventions in which 'seemingly meaningless imagistic elements rub up against one another to spark a flame of indeterminate meaningIn [such] writing, the distinctions between private and public, important and unimportant, trivial and overwhelming, the big scheme and the little detail all fall away.

They create a secular world of meaning, a constellation of familiar qualities that have an unfamiliar meaning, which makes us happy, and which it is the task of art to do.'[11] These interests help explain the appeal for Clemente of the succinct pictorial and intellectual conception of such a work as the Titian.

A further thematic link with this work by Titian in which human heads are paired with those of animals is Clemente's interest in medieval bestiaries. Indeed, as Titian does here, Clemente has juxtaposed his own image with those of other creatures. In some works (**4,5**), birds or animals cluster around the artist's head. Clemente has always seen other creatures as extensions of mankind, a means (along with implements and works of art) whereby humans can live beyond their bodies. He finds entirely natural the long–standing convention by which animals are invested with human feelings and fantasies. In

4 Francesco Clemente *Self Portrait: the First,* 1978, Chinese ink, pastel and gouache on paper, mounted on linen, 111.8 x 147.3 cm, Zürich, collection of Bruno Bischofsberger

the Titian, the dog denotes for him fidelity, the lion power and the wolf hunger. He also reads these animals as a progression, from being part of the pack (the dog) through lone triumph (the lion) to solitude (the wolf).

An *Allegory of Prudence* appeals, too, to

99

5 Francesco Clemente *The Celtic Bestiary VIII*, 1984, pastel, 66 x 48 cm, from a group of eight, private collection

Clemente's predisposition towards contemplation. The permanent truth of the statement it makes about life, in its simultaneous presentation of past, present and future, gives it, for him, a quality of timelessness. Paradoxically, what Clemente sees as insistence, in the Titian, on the permanent primacy of the present moment also collapses time.

Clemente's interest in this and in all the other works in the National Gallery is overwhelmingly more in what they tell us about life than in their character as objects. In any work he seeks to discover what might have been the reasons – the experiences and needs – that made its artist a painter. As he puts it, 'the miracle of these quiet images is that all you have to do is knock and they will speak'. It is therefore not surprising that the work to which he chose to respond includes a self portrait. As he stated recently, '... for me, the self-portrait is the beginning of an essential knowledge, to find out who is speaking. ... If you bare the self to its essential nature, it is simply a voice saying "I am, I am, I am". This is what all contemplative traditions teach.'[12]

In keeping with this quest for insight, Clemente values the quality of intimacy that he finds in *An Allegory of Prudence*. It is an intimacy based at once on the sense of personal necessity for Titian that he infers in this work and on the ease and directness of access to the work for the viewer. These qualities are always central to his own aims as a painter. This is one reason why, despite its enormously greater dimensions, *Smile Now, Cry Later* is distinctly approachable in feeling. Clemente is wholly uninterested in grand scale as such. The viewer can not only enter the work by way of its human content but is also drawn into examining its facture. The way in which paint sits on top of the very wide-weave canvas reminds Clemente of pastel, one of the media he uses most often.

A further way in which Clemente feels close to *An Allegory of Prudence* is in the hint of irony which he feels is common to Titian's picture ('Who wants to be a wolf, as an old man?') and his own. He also sees the two works as testifying to their artists' shared belief in the resurrection of the flesh. In this they believe both as Catholics and as Mediterraneans, for Clemente points out that the ancient Egyptians, too, believed in bodily resurrection. He sees this belief as one aspect of the Mediterranean passion for the body in

6 *Tintinnabulum* with five hanging bells, from Pompeii, first century AD, bronze, 35 cm high, London, British Museum

viewers for an arm, strangely culminating in eight outstretched fingers that resemble two hands. But, while such a reading cannot wholly be rejected, Clemente conceived it as a giant phallus.

In choosing to realise this motif in the contemporary street-mode of sprayed paint, and in superimposing it on a wall-like surface already crowded with simply formed images and written messages, Clemente extended the likeness of his painting to graffiti, in both method and subject. This particular phallus is unexpected, however, in such a present-day context, since the appendages at its right end represent not hands but wings.

The winged phallus has a long icono-graphic tradition. As Philip Rawson writes, 'The winged phallus, so widespread an image in Western sexual art from the large icons in the sanctuary of Delos (c.500 BC) onward, is a symbol for a sexual-cosmic vitality at once human and superhuman'.[13] He describes dildos shaped as phallic-headed birds and sold

openly in European markets through the Middle Ages and on into the eighteenth century as being descendants of such ancient Greek winged phalli.[14] A bronze *tintinna-bulum* from Pompeii is reproduced as **6**. A symbol of plenty and also a deterrent to evil spirits, it culminates in a winged phallus. A visually related creature forms part of an *Allegory of Copulation* engraved on copper some fifteen centuries later (**7**).[15] These crea-tures are at once phallus, bird and (in their hindquarters) lion-like animal. Unlike many of Clemente's works, *Smile Now, Cry Later* contains no imagery representing living creatures other than humans, at least overtly. Yet in view of the fact that it responds to Titian's picture, which does involve other creatures, the fusion of human and avian form that dominates Clemente's painting affords an unexpected further link between the two works.

7 *Allegory of Copulation*, anonymous North Italian engraving on copper, last quarter of fifteenth century, 150 x 224 cm, National Gallery of Art, Washington, Rosenwald Collection

which both he and Titian participate.

Clemente sees *An Allegory of Prudence* as representing the three ages not only of man but also of desire. On one level, this is the desire the three attendant animals differently embody, for companionship, for power and for food. On another the desire is sexual desire (in youth, middle life and old age), and this dimension not only links with the essentially emotional import of the phrase 'smile now, cry later' but also helps explain the enormous, long form which overlies most of the composition, diago-nally. This has been mistaken by some

8 Francesco Clemente *Untitled Painting*, 1998,
oil on canvas, 234 x 468 cm, collection Francesco
and Alba Clemente

The phallus was sometimes used in Antiquity as a symbol of the renewal of life after death. In Hinduism it can have a spiritual significance. On the other hand, in its strong assertion of carnality, the phallus links with the permissive atmosphere of *grylli*. The parallel with *grylli* is reinforced by the synthesis with wings. For, like *grylli*, the winged phallus not only links different periods of history and geographically distant cultures but also fuses two things that in the material world cannot form a unity.

Finally, a curious characteristic of the winged phallus in this painting is that, for all its dominance in terms of dimension, it seems not only (appropriately, for a winged creature) to hover in front of the labyrinth that underlies it but also continually to move between visibility and invisibility. While this quality is owing to the technique in which it

was painted, it also serves as a metaphor for the openness and, therefore, the instability of meaning that is a feature of Clemente's art. This point can be appreciated when one considers two other paintings (both untitled; **8**, **9**) which Clemente made at the same time as *Smile Now, Cry Later*. All three canvases are the same size and, in each, written words abound. The shared features give the three works the character of an informal triptych.

The two untitled pictures are emphatically cross-cultural, for in each the written words are in at least three languages, including non-European. Placed centrally in each is the image of a zip, partially opened to reveal a small V-shaped aperture at the top. The zip motif divides a left panel containing images of living or recently killed beings from a right panel in which, further darkening the reading of the connected *Smile Now, Cry Later*, all the words in the picture are inscribed on the blades of swords.

The image of a living being is an uneasy-looking giant head, which appears to be a

self-portrait (**8**). In the other untitled painting (**9**) its place is taken by the image of nine standing four-legged animals, each of which has just been decapitated, presumably by the one uninscribed sword. This appears on their side of the zip, which itself also streams with blood. In both pictures, each inscribed sword bears a single word, but the arrangement of the swords precludes any given sequential reading. Thus, as in *Smile Now, Cry Later*, these associated pictures invite each viewer to formulate their own story on the basis of word and image combined. Among the words that appear in both untitled pictures (only some of them in English) are bee, amethyst, microbe, house, fern, ring, vow and story.

These companion paintings seem to associate the operation of a zip with events ranging from the intimate and the domestic to the dire. What lies behind the zips is not specified, but both zip and sword have obvious connections with the phallus. Enigmatic though these companion pictures are, they therefore permit us to interpret

9 Francesco Clemente *Untitled Painting*, 1998, oil on canvas, 234 x 468 cm, collection of Francesco and Alba Clemente

Smile Now, Cry Later as implying, among other things, that both physical love and the emotions from which it is inseparable are risky things. Whether we read Clemente's painting in this exhibition as carefree, defiant or rueful, it accords with Titian's *Allegory of Prudence* in recalling the viewer to a sense of the complexity of life.

Richard Morphet

Notes

1 Interview with the author, 1 June 1999, from which all other unsourced quotations derive.

2 'New York' in exh. cat. *Francesco Clemente: Three Worlds*, Philadelphia Museum of Art, October–December 1990.

3 'Body painting, from which tattooing developed, is probably the oldest of the arts of mankind and the one which most obviously distinguished human beings from other creatures. Lasting no more than a single lifetime, it is also the least permanent and yet, paradoxically, so strongly regulated by traditions passed from one generation to another that it may well have kept alive motifs which appear in other, more enduring media widely separated in time and space' (Hugh Honour and John Fleming, *A World History of Art*, London and Basingstoke 1982, p. 551).

4 Raymond Foye, 'Madras', in exh. cat. *Francesco Clemente: Three Worlds* (cited note 2), p. 51.

5 A classic example which he cites is the phrase *festina lente* (hasten slowly), in which the attraction of the combination of economy with truth is compounded by the element of paradox. He is similarly interested in the form of the palindrome.

6 On *grylli*, see J. Baltrusaïtis, *Le Moyen Age fantastique – Antiquités et exotismes dans l'art gothique*, Paris 1955, Chapter 1, 'Grylles gothiques'; and Michael Camille, *Image on the Edge: The Margins of Medieval Art*, London 1992, pp. 11–55.

7 Camille, cited note 6, p. 37.

8 Michel Foucault, *Madness and Civilization: A History of Insanity in the Age of Reason*, trans. R. Howard, New York 1965.

9 Baltrusaïtis, cited note 6, pp. 32–33.

10 Raymond Foye, 'New York', in exh. cat. *Francesco Clemente: Three Worlds* (cited note 2), p. 124. Foye there describes Pound as 'the foremost example of an artist exploring a multicultural, non-hierarchical view of civilization' and, in the *Cantos*, as replacing a nineteenth-century view of history as a time-line with 'an open form, a space-time continuum extending simultaneously forward and backward'.

11 In Donald Kuspit, 'Clemente Explores Clemente', *Contemporanea* (New York), vol. 2, no. 7, October 1989, pp. 36–43.

12 In interview with Michael Auping in exh. cat. *Francesco Clemente – The Painter's Wardrobe*, Anthony d'Offay Gallery, London, April-June 1999.

13 Philip Rawson, *Primitive Erotic Art*, London 1973, p. 48.

14 Ibid., p. 71.

15 Both sides of the copper plate are reproduced and discussed in Jay A. Levenson, Konrad Oberhuber and Jacquelyn L. Sheehan, *Early Italian Engravings from the National Gallery of Art*, Washington, 1973, pp. 526-7. Oberhuber there explains that *uccello* (bird) remains a colloquial term in modern Italian for the male organ.

PIERO DELLA FRANCESCA
The Nativity 1470–5

NG 908 Oil on poplar, 124.4 x 122.6 cm

ONE OF THREE WORKS in the National Gallery by the Tuscan Renaissance painter Piero della Francesca (1415/20–1492), this majestic painting is probably unfinished, and it was probably damaged by over-zealous cleaning before its acquisition in 1874. These factors account for the blurred faces of the standing figures at the right and the empty areas of the foreground. The panel also shows the artist, at a relatively late moment in his career and having come under the influence of artists from Northern Europe, experimenting with the novel technique of oil painting, only recently imported to Italy. Nonetheless, the limpid clarity of the composition, and the crisp architectonic structure characteristic of Piero's works in tempera, are unimpaired. Each figure, every gesture is full of weight and a slow and solemn dignity worthy of the visionary event the artist depicts.

The Virgin Mary adores the new-born Christ Child, who lies upon the ground, his arms upraised. Five music-making angels, two of whom play stringless lutes, have gathered to serenade the divine infant. Though they stand stark still, the elegant placement of their feet suggests that they might well begin a celebratory dance. Joseph sits cross-legged on a saddle at right, as if awaiting the shepherds who, summoned by angels, have just arrived. One rustic points upwards as if to indicate the source of the divine intervention that has carried them to this place. To the right are the towers of Bethlehem and to the left a panoramic, rocky landscape that rolls away to the far distance and then blends with the over-arching sky.

Christ was born in a manger, set here in a shelter for an ox and a braying ass. This is the most austere element in the composition – three stone walls, two of which are crumbling into ruin, and a simple roof propped up by branches, upon which a songbird perches. Set at an angle to the picture plane, the lean-to does not physically protect the figures but stands behind them. Nonetheless, it enframes them; note how the head of the left-most angel, and of Joseph at right, are inscribed within the austere geometric form that the shelter implies on the picture surface. Moreover, the four planks of the makeshift roof recall the lines of a musical score, thus reinforcing the role of joyous music-making in the painting, and the musical syncopation, full of carefully calibrated intervals, with which the sacred figures are disposed across the compositional field.

Christopher Riopelle

STEPHEN **COX**

born Bristol, 16 September 1946

© Hugo Glendinning

STEPHEN COX first established a reputation in the late 1970s with austere plaster sculptures influenced by American Minimalism. In 1979, in a break with modernism, he left England to work in Italy, exploring the rich European tradition of cutting stone, marble and granite. His radical move from modelled to carved forms, from concept to drawing, took inspiration from the Renaissance *schiacciato* technique of linear, low-relief carving. In his ambition to relate the arts of architecture, sculpture and painting, he began creating coloured and fragmented bas-reliefs using the stones mentioned by Vasari in his *Treatise on Techniques*. In India he made free-standing sculpture in response to local rocks and traditions, and in Egypt he exploited a rare opportunity to extract and fashion the beautiful, but intractable stone from the imperial porphyry quarries. As his formal ideas become sparer, Cox enriches them with historic references to human and religious imagery shared by different cultures.

Cox has made a major contribution to the revival in the late twentieth century of the art of working directly and laboriously with stone, while taking advantage of modern technology. His involvement with his materials is spiritual, drawing on his sense of their history. Although Cox lives in England, he works for much of the year abroad, particularly in India and Egypt, in close relationship with the natural sources of his stone. Most recently he has returned to Italy, working in factories in Carrara, Tuscany.

Shrine 2000

Bardiglio marble and porphyry, 235 x 400 x 200 cm, collection of the artist

'WERE WE LED all that way for Birth or Death?' T.S. Eliot asked through the voice of one of the Wise Men in his poem *Journey of the Magi*.[1] The travellers were perplexed, not so much by what they saw when they reached Bethlehem – it was a birth right enough – but by its meaning. They had thought that birth and death were two distinct events, and Christ's Nativity confused them: 'This Birth was/ Hard and bitter agony for us, like Death, our death'. We may share something of Eliot's uncertainty as we move from Piero della Francesca's image of *The Nativity* towards Stephen Cox's monumental, tomb-like *Shrine*.

In Piero's painting a magpie perched on the roof and goldfinches pecking at thistles are present at the birth. They, like the vulnerability of the meagre shelter and of the baby lying naked on the ground, all foreshadow a bitter end.[2] Cox, too, aspires 'to represent a beginning and an end in one. The simplicity of the stable was one of the reasons I was drawn to rendering it,' he says. '*The Nativity* is a late, instinctive, painting by Piero in which perspective analysis is no use. His figures look as though they're floating on a cloud because there is no reference point. They simply hover, weightless. They're not standing firmly on solid ground. The shield-shaped space in which the figures stand is divided, as I see it, between Christ and the angels in a garden, perhaps a little Garden of Eden, and Mary, Joseph, the shepherds and the beasts inhabiting barren ground.'[3] Mary's cloak relates the two groups, linking the bare ground and the fertile soil, a distinction which is repeated at the end of Christ's life between the rock of

Piero della Francesca *The Nativity*, 1470–5

Golgotha, on which he died a human death, and the garden round Joseph of Arimathea's tomb, the place of Christ's Resurrection and his appearance to Mary Magdalene. If we recognise the close connection between Christ's Incarnation and Passion in Piero's representation of the Nativity, in what way does Cox's sculpture relate to Christ's birth?

The sheer scale and presence of Shrine arouses an aesthetic response to the work, which for Cox sustains the meaning of his sculpture irrespective of any religious interpetation. Nevertheless, to those familiar with the Christian story, its iconography may recall the tomb and its sacred content. Constructed with slabs of grey *bardiglio* marble, its box-like form evokes that moment at dawn when we, following imaginatively in the footsteps of the three Maries, arrive at the door of the

sepulchre in which Christ's body was laid after his Crucifixion. The two slabs across the front have been slid open, allowing us to look through a narrow gap as though into a sacred space. Lined throughout with polished Egyptian porphyry, the sensual concentration of purple-red, 'powdered with bright stars',[4] is only broken by three beams of light falling from holes pierced in the ceiling. The reflection intensifies the extraordinary nature of this glimpsed interior. Slanting panels on the ceiling, joined by strips of redder porphyry, are laid out like the tiles on Piero's roof, as though we were looking up at the inside of the shelter. For Cox this arrangement hints that the beginning of the story, an implication of birth, is embedded in the precious lining of the sculpture. As we move round the 'shrine', the reverses of the open doors, faced with porphyry, confirm the astonishing richness and mystery of its interior space.

Neither Piero nor Cox describes an actual occurrence. After two thousand years the facts of Christ's birth are a matter of faith or conjecture. 'All this was a long time ago,' as Eliot reminded himself.[5] *The Nativity* and *Shrine* are, in their different ways, visionary re-tellings of familiar stories in an attempt to put their viewers in touch with the real experience of a miraculous happening. Piero's painting combines the story of Christ's birth, as told in the Gospels, with the vision revealed to St Bridget of Sweden when she visited Rome in 1370. Bridget recounted that, when the Virgin realised that her child was due, she dropped to her knees and prayed. Suddenly something in her womb stirred and the baby

was born painlessly, enveloped in a light so bright that it eclipsed both Joseph's candle and the sun itself. At that moment the Virgin heard angels singing and she worshipped God and her son.[6]

1 Porphyry sarcophagus of St Helena, Rome, Vatican Museums

Cox responds to the simplicity of Piero's devotional picture with a modern, minimalist aesthetic. With this he aims to make a statement, which is as uncompromising in its geometry and the hardness of its materials as in the truth he seeks to convey. His preoccupation in this new work is with 'a truth beyond the surface and in its interior space, and associated with the stories embedded in stones. I'm interested in the power of narrative to give another dimension to the formal conception of sculpture,' he says. His choice of the stark, archetypal form of the sarcophagus, vacillating in its intention between a cave-like tomb and a shrine, imparts the continuing mystery surrounding the events of Christ's life, and the unfathomable meaning of human existence and human destiny. But Cox's poetic symbolism need not, as mentioned, be read as an exclusively Christian message. The experience he creates is of universal relevance, offering the visitor, through the unparalleled, atmospheric beauty of the porphyry interior, an apprehension of something beyond themselves, ultimately ineffable.

Stephen Cox believes that 'art is a metaphor for what religion gives man – a moving experience and a satisfaction of deep spiritual needs'. Of his work for this exhibition, he says: 'My main intention is to celebrate the Millennium, in recognition of two thousand years of Western civilisation since the birth of Christ. I chose Piero della Francesca's *Nativity* not only because it is a sublime painting, but also because I'd made a sculpture recently which related to his *Madonna del Parto* showing a pregnant Virgin in what was for me a symbolically loaded setting.[7] As an Adoration of the Child, it was an appropriate homage to the Millennium. The mysteries of the picture, which I've tried to unlock, suggested something of the layers of allusion that I wanted to convey in my own work. I also wanted to realise a

long-held ambition to make a porphyry room which makes reference to the birthing chamber of the emperors of the Roman Empire. Porphyry could symbolise both imperial blood and the sacrificial colour of Christ's blood. By using it I could also convey something of the mystique attached to the hardest of stones, which suggested that the emperor gods and their monuments could exist for ever.'

The imperial birthing chamber to which Cox refers was a square room set aside for the empresses' confinements in a pavilion within the grounds of the palace at Constantinople.[8] It was known as the Porphyra, or 'purple room', on account of its splendid decoration with porphyry. Children of the emperor were given the epithet *porphyrogenitus*, meaning, literally, 'born in the Porphyra'.[9] Its construction has been attributed to Constantine's reign, but it was certainly built later, probably not until the eighth or ninth century.[10] However, the beautiful purple porphyry (*porfido*, *porfido rosso*) was quarried under imperial authority from the first century BC.[11] Its sole source was the Egyptian quarry at Mons Porphyrites in the Eastern Desert, today Gebel Dokhan, and because of its rarity, but especially because of its colour, the stone became increasingly linked with the emperor and his household. By Diocletian's reign, AD 284–305, it was reserved almost exclusively for imperial use.[12]

The Porphyra survived only in popular memory as part of the legendary wonder of the Great Palace. Following the fall of Constantinople to the Latins in 1204 the porphyry was no doubt looted along with other imperial treasures. Whatever the case, no trace of the birthing chamber remains, but something of its extravagant character and of the prestige accorded the imperial family is evoked by the monumental porphyry sarcophagi in which Byzantine emperors were buried and honoured in death. Although porphyry is one of the most difficult stones to work, its fine texture allows it to be polished to a wonderful finish. Two spec-

2 Porphyry sarcophagus of Costantia, Rome, Vatican Museums

tacular examples survive in the Vatican Museums, that of Helena, mother of Constantine the Great (**1**), and of Costantia, his sister (**2**). Constantine was buried in similar style and, although he had adopted the Christian faith, was deified according to pagan custom.

The association of the emperor gods in birth and death with this sumptuous stone was a seminal inspiration to Cox, whose classically proportioned *Shrine* is a double cube, echoing the square shape of the Porphyra and the massive scale of the imperial sarcophagi.

Excavation in the famous imperial quarries had probably ceased before the Arab invasion in AD 641, possibly by the second half of the fourth century; their location was forgotten and was not rediscovered until the early nineteenth century.[13] When, in 1988, the British Government commissioned Cox to make a sculpture for the new opera house in Cairo as a gift to the Egyptian people, he was granted special permission to visit Mons Porphyrites,

this representation is sometimes alluded to in paintings of the Resurrection, where, once again, the artist often combines the imagery of the cave and the box, with its trinity of fused meanings. Cox himself drew on these references for his work in the parish church of St Paul, Harringay, where his porphyry altar stands in front of his reredos, *Christ the Saviour of the World*. There the celebration of the Eucharist takes place at the sacrificial table, which is at the same time the table of the Last Supper (**6**).

Cox parallels the complexity of Piero's icono-graphic meanings with an ambitious conjunction of Christian and non-Christian images expressing belief and non-belief, faith and doubt, birth and death, and the power of life over death. His symbolism slips between one image and another, often across cultures, relying on the power of visual communication. His

3 Guido da Siena *The Nativity*, thirteenth century, from the San Pietro Altar Frontal, tempera on panel, 100.5 × 141 cm, Siena, Pinacoteca Nazionale

and was possibly the first since Roman times to procure its precious stone. The porphyry he used for *Shrine* is among the last blocks acquired on that trip, and it is intriguing to think that it might, in different circumstances, have been quarried for a Byzantine emperor.

The Byzantine tradition, which Cox draws on in relating the use of porphyry to both birth and death, was continued in early Sienese painting. Cox was interested to come across an example in Guido da Siena's *Nativity* (**3**), in which the manger is repre-sented in red, a survival of the Byzantine status symbolism of red-purple tones. He made a sketch (**4**) of the arrangement of cave

and manger which supported other ideas he was exploring in the Pinacoteca Nazionale in Siena. The association of the rectangular, box-like shape to both manger and tomb became traditional in the Renaissance, but an *Adoration* by Domenico Ghirlandaio for the family chapel of the Sassetti in Florence is unusual in including an actual tomb, an ancient Roman sarcophagus (**5**).[14] The inscription commemorates the augur once buried there, who predicted: *NVMEN AIT QVAE ME CONTEG[IT] VRNA DABIT* (My coffin will give the world a deity).[15] In pictures showing the Christ Child laid on the top of the manger, rather than in it or beside it, its form was related simultaneously to an altar, understood theologically as a presage of Christ's sacrifice.[16] The Eucharistic nature of

search for correspondences and for some new form of universal symbolism is driven by his conviction that art has a spiritual potential and a capacity to reveal the inexplicable. This belief, inextricably bound up with his love of materials, was present even in his earliest Minimal pieces which concentrated on surface, among them *Surface: Charm* and *Surface: Shining Forth to George (Jackson)*, both made in 1977. It was in 1981–2, during the first of his visits to Italy, that he began to consider the powerful effect of narrative as a means of combining the strength of subject-matter with his own, primarily formal, concerns as a Minimalist. He began to develop more specifically biblical themes in stained and fragmented reliefs. Since, as he assumed, 'the only common narrative

4 Stephen Cox, *Nativity in a Cave after Guido da Siena*, 1999, pencil on paper, 14 x 10 cm, collection of the artist

Somaskanda group was used by the Pallava rulers as symbolic of their divine kingship. Such images are found in the Hindu rock-cut temples of South India in the holiest shrine, the *garbha-griha*, which means literally 'womb cell', and is traditionally undecorated except for the stone *lingam*, a sculptural image of the sacred phallus. When, during the Pallava dynasty a Somaskandamurti was placed behind the *lingam*, it assumed great iconic significance, and groups of this kind are, in fact, referred to in North India as the Holy Family. Cox's relief in black Indian granite, *Rock Cut: Holy Family*, 1986 (7), was one of his responses as a Westerner to Indian art.

The discovery of what Cox termed 'an iconic link' between Western and Eastern cultures strengthened his conviction that a shared religious and symbolic language of form and content would enrich his own image-making. It was while he was in India that he became sensitive to the religious nature of his material and its common roots.[17] The symbolism of the rock as Christ and the Christian Church was paralleled by the Indian belief in the sacred nature of the earth. Further, the experience of architecture and sculpture cut directly into the rock first suggested to him the idea of what he calls 'a godhead in the rock'. During his travels in Italy and India and, subsequently, in Egypt and the Holy Land, Cox remained passionately inspired by Adrian Stokes's poetic articulation of the idea that stones 'resonate' with history and with the human imagination enshrined in them. For Cox these associations, together with allied legends and mythology, enrich the meaning of his sculpture.

The stories surrounding Christ's life and, in particular, beliefs attached to the shrines in the Church of the Holy Sepulchre in Jerusalem were among Cox's chief preoccupations in evolving ideas for his National Gallery sculpture. He had already made a number of sculptures using the theme of Christ's Passion and Resurrection. In Egypt he took these concerns a significant stage further in his search for cross-cultural affinities. His carved porphyry sculpture *Chrysalis* (1989–91) denoted both rebirth, in its suggestion of a mummified form, and, metaphorically, resurrection. A visit to the Church of the Holy Sepulchre provided Cox

5 Domenico Ghirlandaio *The Adoration of the Shepherds* (detail), 1485, tempera on panel, 167 x 167 cm, Florence, Santa Trinità, Sassetti Chapel

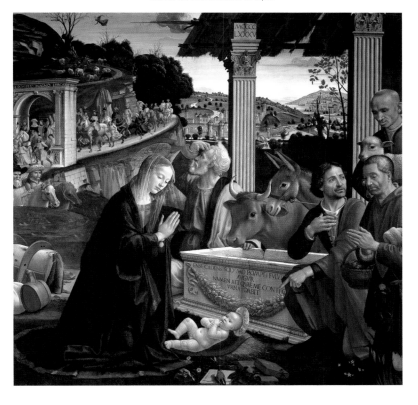

vocabulary was in the Christian stories', he treated symbolic moments in Christ's life and those of the saints in order to imbue the experience of his work with 'other dimensions of meaning, especially those brought to the work by the viewer'.

Cox's interest in specifically religious subject-matter took a fresh direction in the mid-1980s when he began working with South Indian temple carvers. His explorations of Indian art extended his interest in the classical sculptures of world culture and intensified his preoccupation with universal forms, which were to have such an important influence on the genesis of *Shrine*. In looking for themes that related to Western subject-matter, he discovered a correspondence between the portrayal of the Holy Family and the Somaskandamurti, which showed a group of three figures, the God Shiva and his wife Uma, or Parvati, and their divine son, Skanda. The religious iconography of the

6 Stephen Cox *Christ the Saviour of the World*, reredos, 1993, travertine with *ciment fondu*, oxides and gold leaf, 480 x 325 x 13 cm; altar, 1993, imperial porphyry and Hammamet *breccia*, 110 x 88 x 59 cm; London, Church of St Paul, Harringay

with more abstract notions of equivalence. There, it was important to him to have put his hand into the void above the rock in which Christ's Cross is held to have stood at Golgotha: 'To feel the space gave another dimension to the negative spaces which I used to indicate the three crosses in my Crucifixion for St Paul's, Harringay'. He also visited the Edicule, which houses the Tomb Chamber, and which has been the subject of a recent archaeological examination by Martin Biddle. Biddle's book, *The Tomb of Christ*, confirmed Cox's own intimation that, although the stones of the structure 'obscure what may, or may not, be Christ's proven burial place', this uncertainty 'makes no difference to the faith of the devout'.[18]

While Christian, Byzantine and Hindu narratives have fed Cox's subject-matter, his formal ideas shared the reductive language of Barnett Newman and of the American Minimalists Richard Serra, Sol LeWitt, Carl André and Donald Judd. *Interior Space* (**8**), which Cox made in Egypt in 1995 and originally subtitled *To Donald Judd*, revived his early inspiration in Minimal forms. His ambition to make a great box was influenced by the vast form of the granite sarcophagi in which the sacred Apis bulls, feted like Pharoah-gods, were buried and which were placed in arched stone cells in the necropolis underneath the temple known as the Serapeum at Sakhara, near Cairo.[19] Judd's boxes attracted him because they tempted the viewer with an interior as seductive as their exterior. But where Judd, with his industrial procedures, remained clear and ultimately austere, Cox's forms, though austere in their undecorated simplicity, are immensely complex in terms of the artist's craft and in their wide-ranging, emotive reference. Where American reductivism sought to make objects that were, in Ad Reinhardt's words, 'purer and emptier', Cox filled his with ever richer content.

Pursuing the idea of the box-like form, in 1999 Cox created a group of eight massive sculptures for exhibition in the Piazza del Duomo in Siena.[20] With the generic title *Interior Space*, they all took the shape of monumental sarcophagi with lids, and some had small openings. The series drew on the archaeology of ancient Etruria, roughly corresponding to present-day Tuscany, where Cox was working. For him, the boxes, all made of local stone, represented 'a section of the earth's crust, which made reference to the rock-cut tombs in Ajanta, Ellora and Mahabalipuram, as well as to the Necropoli, or places of the dead in Lazio, near Viterbo, in

7 Stephen Cox *Rock Cut: Holy Family*, 1986, Indian granite, 274 x 426 x 15 cm, Stockholm, private collection

Etruria'. One sculpture, called *Interior Space 'Insideout'*, employed Carrara marble, highly polished on the outside, while *Interior Space 'Terra degli Etruschi'* (**9**) exploited the texture of the stone and its crusty lid, as if it had been lifted straight out of the ground. Cox's intention was to highlight both sides of the stone, revealing the wonderful interiors with their fossils and archaeological finds preserved in the earth.

Since the summer of 1999 Stephen Cox has been working in Carrara in the shadow of

the mountains where marble has been extracted since Roman times and where Michelangelo, pre-eminently, spent long periods in the quarry selecting his stones. The face of the mountain and the daily, technical operation of cutting huge blocks of stone and bringing them down narrow, winding roads to be sliced in the stone yards are quite breathtaking in their scale. At the top of the quarry where the marble is at its most brilliant and pure, the drop to the sea is awesome. Here, too, the white cliffs are pierced by long slits

which open on to black cavernous spaces. There is no apparent access across the sheer face of the mountain, but these interior places, too, are made to yield their stone, and have exercised a particular fascination for Cox, reminding him of rock-cut caves and temples. For Cox, the collaboration of modern man and his machine at work in this sublime landscape in no way diminishes the

8 Stephen Cox *Interior Space*, 1995, Hammamat *breccia*, 243 x 187 cm, London, Michael Hue Williams Fine Art

mysterious process of opening up the rock.

The making of *Shrine* followed immediately after Cox's series *Interior Space*. An early preoccupation was how to retain a similar aura of the natural landscape, and how to crystallise the story of the Nativity as an abstract shape. 'Originally,' he says, 'my idea was to create two edifices, one which dealt with the stable in a perspective projection which paid homage to Piero, and the other a tomb-like box which represented a section of the rock of Golgotha.' These plans were eventually distilled into a single over-riding idea, to use porphyry to bring together the concepts of box and birthing room, and thus to encapsulate the Christian story in one reductive sculpture. Despite the complex references Cox derives from his materials he

never compromises the formal clarity of his monumental *Shrine*, which makes an immediate impact on account both of its spare beauty and of the extraordinary enticement of its interior. The cavernous space and reflective porphyry surfaces inside *Shrine* induce a meditative atmosphere not dissimilar to the sense of reverie induced by a series of deep maroon and black paintings by Mark Rothko. The interior recalls both the sense of occasion that existed in the imperial birthing chamber and the sacred aura of the Hindu *garbha-griha*, or 'womb room'. Piero della Francesca's *Nativity* foretells Christ's death. Cox's sepulchre looks both back and forward, conjuring up birth and resurrection. Drawing loosely on secular and religious analogies he has achieved a powerfully abstract expression of spiritual awe.

Judith Bumpus

Notes

The author would like to give special thanks to Dr Roger White for help and advice in researching this essay, and to thank, in addition, Dr Suzanne Butters, Elspeth Hector (Head of Libraries and Archive, National Gallery) and Robert Skelton.

1 T.S. Eliot, *Journey of the Magi*, 1927, written in the year in which Eliot was converted to Christianity.

2 The representation of the human soul as a bird goes back beyond Christian art to ancient Egyptian imagery, but the presence of a solitary magpie perched on the stable roof of Piero's *Nativity* almost certainly symbolised death. It may also suggest the humbleness of Christ's Nativity. For the bird with a reputation for thieving, there is nothing here of worldly worth to steal. The goldfinches seen on the ground are traditionally identified with Christ, and the thistles, which they peck at, signify earthly suffering. On account of their thorny nature, they allude to one of the symbols of Christ's Passion, his crown of thorns. The inclusion of such signs would, as Piero knew, indicate the close connection between Christ's Incarnation and Passion. For a discussion of Piero's bird symbolism, see Herbert Friedmann, *The Symbolic Goldfinch: Its History and Significance in European Devotional Art*, New York 1946, pp. 89 and 185, note 8. For another interpretation of the magpie, see Marilyn Aronberg Lavin, 'Piero's Meditation on the Nativity', in *Studies in the History of Art 48*, Washington, D.C., 1995, pp. 135–6.

3 Unless otherwise referenced, all quotations from the artist are from conversations with the author in 1999 and 2000.

4 This poetic description of porphyry by Paulus Silentiarius, writing 625–27 (cited by A.A. Vasiliev 'Imperial Porphyry Sarcophagi in Constantinople', in *Dumbarton Oaks Papers*, vol. 4, 1948, p. 24), is typical of the pictures conjured up in the minds of contemporary writers by the decorative allure of coloured stones. In *Shrine* it could be said to evoke a portentous blood-red sky at the time of Christ's Nativity and death.

5 *Journey of the Magi*, cited note 1.

6 See *The Liber Celestis of St Bridget of Sweden*, ed. Roger Ellis, Oxford 1987, I, p. 486; see also Lavin 1995, cited note 2, pp. 127–8 and note 11.

7 For his sculpture *Lingam of a Thousand Lingams* (1996) Cox used Piero's iconography as well as the symmetry of his painting *Madonna del Parto*, in which two angels hold apart the Virgin's gown like a tent to reveal her pregnancy. The image echoes the *lingam-yoni*, in which the combined organs of male and female creativity replace the stone phallus at the heart of Hindu temples.

8 Anna Comnena, *Alexiad*, 7.2.3.

9 See Richard Delbrück, *Antike Porphyrwerke*, Berlin and Leipzig 1932, p. 148. Liuprand, Bishop of Cremona, an ambassador to Constantinople, insisted that Porphyrogenitus meant 'not "born in the purple", but born in the Porphyra palace'. See 'Antapodosis' in *The Works of Liuprand of Cremona*, trans. F.A. Wright, London 1930, pp. 35 and 124.

10 Since extraction of stone from Mons Porphyrites ceased probably before the invasion of Egypt by the Arabs in AD 641, it is thought that the precious stone used to veneer the chamber was salvaged from Rome. See Walter E.H. Cockle, 'An inscribed architectural fragment from Middle Egypt concerning the Roman imperial quarries', in Donald M. Bailey, editor, *Archaeological Research in Roman Egypt. The Proceedings of the Seventeenth Classical Colloquium of the Department of Greek and Roman Antiquities, British Museum, 1993*, Ann Arbor 1996, p. 25. For a possible eighth-century date for the construction of the Porphyra, see *The Chronicle of Theophanes*, trans. Harry Turtledove, Philadelphia 1982, p. 155, which refers to the birth of Constantine VI in the Purple Chamber in 770.

11 Ibid. See also Delbrück 1932, cited note 9, pp. 15ff.; Meyer Reinhold, *The History of Purple as a Status Symbol in Antiquity*, Brussels 1970, p. 50; Maxwell L. Anderson and Leila Nista, *Radiance in Stone: Sculptures in Colored Marble from the Museo Nazionale Romano*, Rome 1989, p. 19. See Cockle 1996, cited note 10, p. 25.

12 Reinhold 1970, cited note 11, p. 59.

13 Suzanne Butters, *The Triumph of Vulcan: Sculptors' Tools, Porphyry, and the Prince in Ducal Florence*, Florence 1995, pp. 35, 39–40, contains a useful bibliography. For a speculative discussion of the possible over-exploitation of the imperial quarries, and of why and when excavation and the provision of porphyry to Byzantium ceased, see Vasiliev 1948, cited note 4, pp. 23–6.

14 Domenico Ghirlandaio's altarpiece, *The Adoration of the Shepherds*, was painted in 1485 for the family chapel of the Sassetti in Santa Trinita, Florence.

15 For further discussion of the meaning of this painting and the inscription on the sarcophagus, see Jan Lauts, *Domenico Ghirlandajo*, Vienna 1943, pp. 27 and 52; Eve Borsook and Johannes Offerhaus, *Francesco Sassetti and Ghirlandaio at Santa Trinita, Florence: History and Legend in a Renaissance Chapel*, Doornspijk 1981, in particular p. 34; Enrica Cassarino, *La Cappella Sassetti nella Chiesa di Santa Trinita*, Lucca 1996, p. 98.

16 See James Clifton, *The Body of Christ in the Art of Europe and New Spain, 1150–1800*, New York 1997, p. 42.

17 Cox later expressed the religious meaning of stone in relation to Stonehenge in *Hymn* (1991). For this and other

works by Cox referred to in this essay but not illustrated see Stephen Bann, *The Sculpture of Stephen Cox. Catalogue Raisonné*, London 1995.

18 Martin Biddle, *The Tomb of Christ*, Thrupp 1999, p. 1.

19 Apis, the sacred bull of Memphis, was worshipped like a god in ancient Egypt. When his incarnation died, there was public mourning until the priests discovered his next incarnation in another bull.

20 Exh. cat. *Stephen Cox: Interior Spaces*, Piazza del Duomo, Santa Maria della Scala, Siena, 1999

9 Stephen Cox *Interior Space 'Terra degli Etruschi'*, 1999, Rapolano travertine, 250 x 292 x 192 cm, collection of the artist

CLAUDE
Landscape with a Goatherd and Goats about 1636–7

NG 58 Oil on canvas, 51.4 x 41.3 cm

BORN IN LORRAINE, in eastern France, Claude Gellée, called Claude Lorrain (1604/5?–1682), spent almost his entire life in Rome, where he achieved rapid fame and a considerable fortune as a painter of landscapes full of luminous light effects. His works were coveted by Europe's grandest princes of Church and State, who admired images that often harkened back to a timeless Arcadian past of shepherds and wood nymphs. Other paintings evoked magnificent imaginary seaports full of many-masted ships and towering palaces and temples, all bathed in the dancing light of a rising or setting sun. In the painter's later years, such sweeping scenes were frequently animated by oddly elongated, gesticulating characters – the awkwardness of Claude's human figures was often noted in his lifetime – who, amid the sylvan splendour, extravagantly mimed tales from ancient myth and the Bible. Whatever the ostensible subject, such images were based on Claude's intense, life-long study of nature, recorded in chalk, pen and wash drawings made in and around Rome and later consulted as he worked in his studio on large-scale paintings. Indeed, truth to nature in its minute specifics was the necessary foundation of Claude's idealising art.

This small vertical landscape dates from the end of Claude's first decade of achievement. No specific literary source is known for the scene of goatherds tending their flocks, which, rather, evokes a range of pastoral motifs and poems. Primary attention is paid to the tall, vine-wreathed trees that tower at the left – the setting may derive from the park of the Villa Madama in Rome – and to vistas of distant blue hills that open up between their branches. The goatherds attend only to the sweet music of running water, and real-life intrusion into the bucolic setting is minimal. Claude recorded his compositions in a large book of drawings, now in the British Museum, which he called *Liber Veritatis* or the book of truth – he believed it would help prevent forgeries – and the present painting corresponds to the left-hand side of one such drawing.

For generations, British connoisseurs and collectors held Claude in particular esteem, and the twelve landscape paintings in the National Gallery today, many acquired during the institution's formative years, make up one of the finest suites of works by the artist to be seen anywhere. British painters, too, were fervent in their admiration for his work. Widely travelled and cosmopolitan in his artistic tastes, Turner bequeathed two of his paintings to the Collection on condition that they should hang side by side with two paintings by Claude, one of them a magnificent harbour scene. Though he never left Britain's shores, Constable was attracted to Claude as well, and made a copy of this small pastoral landscape in 1823 (Sydney, Art Gallery of New South Wales). Surely, he was drawn to its simplicity, truth to nature and unemphatic rural poetry, so like many of his own quiet English scenes.
Christopher Riopelle

IAN HAMILTON **FINLAY**

born Nassau, Bahamas, 28 October 1925

© Robin Gillanders

FINLAY, WHO HAS LIVED in Scotland since childhood, is a poet and visual artist, the two disciplines merging, since the early 1960s, in his work as Britain's pre-eminent concrete poet. He has published numerous prints, cards and books, many through his Wild Hawthorn Press (established 1961). In these, the arrangement of words on sheet or page is often complemented by pictorial imagery. Other works by Finlay are in the form of sculpture, frequently site-specific. They are to be found in many countries. Their materials include stone, marble, slate, wood, plaster, bronze, steel, ceramic, glass and neon. Many of Finlay's works in different media are realised in collaboration with specialists in particular arts or techniques.

Key themes addressed in Finlay's art include boats and the fishing industry, classical antiquity, the concept of Arcadia, the French Revolution, warfare (especially in the Second World War) and cultural and artistic conventions. By presenting motifs from these and other fields in altered contexts he opens up new associations and meanings. Since moving there in 1966 he has done this not least in works sited in the remarkable garden he created (and continuously evolves) at Stonypath, his home in the hills south of Edinburgh. Here, in a domain which Finlay has titled Little Sparta, nature and culture are mutually enriching. His garden has been described as a 'philosophical and poetic total work of art, a *gesamtkunstwerk*'.

5 x 1/5 1999–2000

Framed glass panel with illuminated sandblasted words, with frame overall dimensions 152.7 x 108.7 x 3 cm, collection of the artist

THIS WORK'S SIMPLICITY of form is in inverse proportion to the richness of its thought. Twelve simple words, all but one of them a single syllable, appear on a transparent plane, against a ground colour determined by that of the wall on which the work hangs. Each word names something familiar, and stands alone. As no sentences are involved, the words tell no given story. Attention is thus focused on the words themselves, and their relationships.

Their immediacy is the greater because they glow with what at first seems their own light. Engraved into the glass by sand-blasting,[1] they are in fact lit from a hidden source. Suspended in an indeterminate space, they call to mind husbandry, natural pheno-mena and man-made things in such a way as to invite the viewer to link these elements through the individual imagination. The words could hardly be more matter of fact, but when the viewer attempts to construct a meaning their mani-fold resonances become apparent. They connect the mind to a wealth of past imagery within the culture we have inherited. In Finlay's conception they lead, step by step, from a starting point in the present to five now-distant eras, the mid-twentieth, the late nineteenth and the early seventeenth centuries AD, thence to the first century before Christ and from there to still more distant times in ancient Greece.

In employing an unexpected form to affirm the continuing authority of past cultural conceptions *5 x 1/5* is an exemplary response to the idea of this exhibition, as well as to the purpose of the National Gallery. It also has unanticipated relevance to the exhi-bition's occasion, observance of the entry into the third millennium of the Christian era.

Responding to a painting, *5 x 1/5* is itself a picture and, appropriately, is framed as such.

For all its lack of pictorial imagery it exem-plifies Horace's famous dictum *'Ut pictura poesis'* (As it is in pictures, so it is in poetry).[2] But the relationship between these two disciplines is reciprocal, as Claude's work shows. As Humphrey Wine has written, *Landscape with a Goatherd and Goats* is 'a

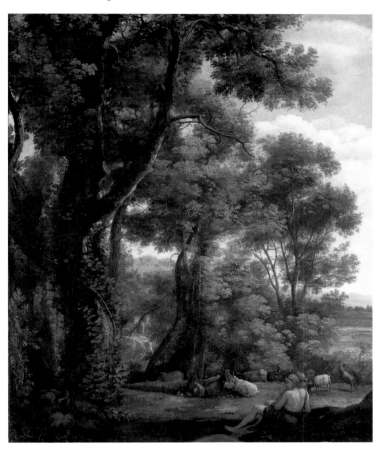

Claude Lorrain *Landscape with a Goatherd and Goats,* c.1636–7

visual equivalent to pastoral poetry, for example that in the *Eclogues*, a series of poems composed by Virgil between 42 and 37 BC. The poems describe a countryside of shady groves and murmuring streams peopled by contented rustics whose main concerns are those of love.'[3] He adds, 'Such paintings depended for their resonances on a literary tradition – that of the pastoral poem.'[4] Exactly the same is true of Finlay's new work itself, which adds to that tradition.

A central concern of Finlay's art has been to give new life, in contemporary terms, to the idea of the pastoral, and in his works he has from time to time evoked the vision or 'quoted' from the imagery of Claude, whose pictures gave definitive form to the conven-tion of the pastoral landscape. His choice on this occasion of *Landscape with a Goatherd and Goats* is due not only to its exemplifying this convention but, further, to its doing so in pure form, because, unlike many other of Claude's paintings, it tells no story.

A key location of Finlay's use of the pastoral is his remarkable garden at Stonypath, his home in the southern uplands of Scotland. This has been described as 'his own very personal gardening concept: a philosophical and poetic total work of art, a *gesamtkunstwerk*, comprised of the natural environ-ment, art and poetry, composed of references, metaphors, words and labyrinthine connotations … language and nature enter into a highly complex pattern of interac-tion. The one is no longer conceiv-able without the other. His garden "represents the yearning for an ideal Arcady".'[5]

As Yves Abrioux has pointed out, although the classical world is continually evoked in this garden, its inescapable absence leads to the fact that 'the elegiac is the note of feeling which pervades all of these fragmentary references to a lost order'.[6] The same is true not only of the paintings of Claude but also of the poetry of Virgil, to which Claude's work looks back. For, as Prudence Carlson has observed, Virgil 'spoke in his famed Eclogues of his own epoch's incurable remove from the brilliance – the Golden Age – of a Greek past'.[7]

The garden at Stonypath includes at least five overt evocations by Finlay of the vision of Claude. As is very often the case in Finlay's

1 Ian Hamilton Finlay with John Andrew *See Poussin Hear Lorrain*, 1975, stone, beside the Upper Pool, Stonypath

work, most were realised in collaboration with specialists in particular skills, in these cases letter-cutting. In *See Poussin, Hear Lorrain*, 1975 (**1**), 'the thought is that Poussin's landscapes are very defined plastically; Claude's are more lyrical and melodious. One can see the surrounding landscape in either way.'[8] 'Claude Lorrain'[9] is one of a number of works disposed around the garden that take the form of individual artists' signatures and together constitute *Nature over again after Poussin* of 1980. Quoted from Cézanne's well known aspiration for his own painting, this work's title links with Finlay's work for *Encounters*, which, in common with his source in a National Gallery Claude, does nature over again after an earlier artist. The Latin inscription *Il Riposo di Claudio* on an obelisk of 1982 (**2**) 'invokes "the peace of Claude", one of the effects desired by 18th-century landscapists'. *Claude's Bridge* of 1982 (**3**) 'is

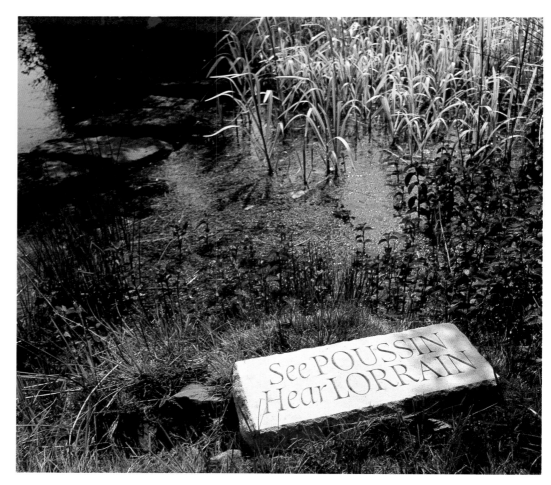

2 Ian Hamilton Finlay with Nicholas Sloan *The Peace of Claude*, 1982, stone, beside the Upper Pool, Stonypath

3 Ian Hamilton Finlay with Nicholas Sloan *Claude's Bridge*, 1982, concrete, in the garden at Stonypath

inscribed with one of Claude's signatures which, in effect, "signs" the Claudian landscape beyond'.

A fifth work has an even closer connection to the picture by Claude to which Finlay responds in *5 x 1/5*. Claude kept a record of his paintings by making drawings of them in his *Liber Veritatis*. The drawing that relates to the National Gallery's *Landscape with a Goatherd and Goats* is no. 15 in the *Liber* (**4**). It serves the function of recording two paintings by Claude of the same motif; the National Gallery's example is somewhat more freshly painted than its pair and corresponds to the drawing slightly less closely.[10] Claude's drawing after these paintings, which are in upright format, occupies the left side of his horizontal sheet. Unusually among these records, he extended it to the right, to reveal a panoramic landscape, absent from the paintings, through which flows a river which is crossed by a simple bridge. Finlay's *W AVE* 1998, in the garden at Stonypath (**5**), is inspired by this bridge. It has been described as follows: 'Its piers are lettered W and AVE. "W" echoes water in motion, disturbed by a bridge's piers; together the letters make a

4 Claude Lorrain *Landscape with a Goatherd*, 1637, from the *Liber Veritatis*, pen and grey-brown wash on paper, 19.5 x 26 cm, London, British Museum

"wave", such a disturbance's visible sign. Yet a *wave* can also be a movement of the hand in salute to a distant other, bridging a gap between them and ourselves; and the Latin for such a salutation is *ave*, here separated by water, joined by the bridge.'[11]

Two wider vistas in the garden at Stony-path reinforce the connection with the art of Claude. One (**6**) shows 'a somewhat Claudian aqueduct in Little Sparta',[12] while **7** shows 'a very Claudian landscape here, near (and behind) the bridge with Claude's signature (**3**). C[laude]'s landscapes are often "closed" with classical buildings, to right or left.'[13]

However, while reference to Claude is abundant in Finlay's work, the immediate allusion made by his work in *Encounters* is to a work by Finlay himself and, through that, to work by another living artist. *5 x 1/5* is an enlargement, in a different medium, of the last of the five sequences in Finlay's *5 x 1* of 1999. *5 x 1* is a poem printed on twenty-one pages of the book of the same title published by Finlay's Wild Hawthorn Press on the occasion of his exhibition in Barcelona in 1999.[14] Each of this poem's sequences uses the same twelve words as does *5 x 1/5*, but in each sequence the words are arranged differently. Two sequences extend across six pages and two across four. In three of the first four sequences at least one page is devoted to a single word. The sequence of which *5 x 1/5* is a version is

the only one to occupy a single page. Each sequence is separated from the one or two that adjoin it by a blank page of the book, which measures 16 x 10.9 x 1 cm. The same typeface is used throughout, but the font size varies within individual sequences. The title of Finlay's work in *Encounters* indicates that the sequence it displays is the fifth of those that form *5 x 1*.

Taken as an ensemble, the words used in *5 x 1* and thus in the new work evoke a landscape. The original publication of *5 x 1* associates these words explicitly with Claude's *Landscape with a Goatherd and Goats*, as the book of which it forms part concludes with

an essay by Thomas A. Clark, 'Landscape under the Stars', that is introduced by the following passage on Claude's picture in Christopher Baker and Tom Henry, *The National Gallery Complete Illustrated Catalogue* (1995): 'There is no literary source for this arcadian scene, but it can be associated with the mood of Virgil's pastoral poetry which inspired a number of Claude's works.' These words helped determine Finlay's choice of his source work for *Encounters*.

Nevertheless, the preceding work to which *5 x 1* makes most direct reference is much more recent in date. It is the poem *5 mal 1 konstellation* (5 x 1 constellation) by Eugen

Gomringer, which was published in 1960. Born in Bolivia in 1925, Gomringer was educated in Switzerland, where he lives. Between 1954 and 1958 he worked in Ulm as secretary to the abstract painter/sculptor Max Bill. During this period Gomringer articulated the concept of concrete poetry, of which he is one of the most important exponents. Moreover, as Thomas A. Clark's essay accompanying *5 x 1* explains, 'In his manifesto *from verse to constellation: aim and form of a new poetry* 1954 ... Gomringer invented the

5 Ian Hamilton Finlay with Peter Coates, *WAVE* 1998, stone, in the garden at Stonypath

form of the "constellation", in which groups of words were disposed "as if they were clusters of stars' ". In *5 mal 1 konstellation* and in Finlay's *5 x 1*, a given group of words is presented first in a particular arrangement and then 're-constellated' four times.

In *5 x 1* Finlay uses the same typeface as did Gomringer in *5 mal 1 konstellation*, lower case likewise being used throughout. In each

one word, 'wind', is common to the two poets' groups.

Finlay and Gomringer have corresponded since 1962. Finlay states: 'One of the reasons I like his work so much is, that it eschews trivial humour. I have expressed my admiration by example rather than by critical comment'.[15] An explicit earlier instance of this is Finlay's print *Prinz Eugen,* 1972 (**8**), in

this is signalled visually in the use of lower-case, sans-serif Helvetica. A bourgeois family unit, a man, a woman, a child and a dog, find themselves variously situated in an elemental landscape. It is an optimistic, slim and efficient poetry in which the capitals of history, the serifs of doubt, have been discarded.'

In *5 x 1* Finlay replaces the simple, universally accessible set of words chosen by

6 View in the garden at Stonypath, showing stone aqueduct, 1993, by Ian Hamilton Finlay

Gomringer by another set that can be described no less readily in the same terms. As in Finlay's work as a whole, however, an unpretentious act of substitution alters meaning fundamentally. Even before their source is disclosed, the combination of words Finlay substitutes generates an atmosphere distinct from that of Gomringer's poem. When that source is known, the latter's character can be seen as radically subverted. The words used in *5 x 1* come from the following passage in the writings of an earlier British poet, Christina Rossetti (1830–1894): '… to fill a bason and take a towel will preach a sermon on self-abasement; boat, fishing net, flock or fold of sheep, each will convey an allusion; wind, water, fire, the sun, a star, a vine, a door, a lamb, will shadow forth mysteries.' This passage occurs in Rossetti's 1882 essay *Letter*

of the five sequences he places his words exactly where Gomringer placed his, and varies the words' font-sizes correspondingly. The sole, yet crucial, change is that Finlay replaces Gomringer's chosen twelve words by a different twelve. Gomringer's words (in German) were tree, man, woman, child, dog, bird, hill, land, sea, cloud, wind, house. Only

which the printed inscriptions include the words 'homage to gomringer', in the same typeface and in lower-case as are used in the two artists' works now linked by *5 x 1/5*.[16]

As Thomas A. Clark further explains, 'As a former secretary to Max Bill, Gomringer sets his Concrete Poetry firmly within the context of Concrete Art, and this in turn is a late part of the wider project of Modernism. It is a "new poetry" we find in the konstellation, addressed to "the new reader". Already

and Spirit, a series of notes on the Commandments. Close to the passage selected by Finlay, Rossetti writes: 'Throughout and by means of creation God challenges each of us, "Hath not My hand made all these things?" Our prevalent tone of mind should resemble that of the Psalmist when he proclaimed: "The heavens declare the glory of God: and the firmament sheweth forth His handywork".… "When I consider Thy heavens, the work of Thy fingers, the moon and the stars, which Thou

hast ordained: what is man …?"'

The contrast with the view of life implied by Gomringer's poem is startling. To quote Thomas A. Clark again, 'Now each constellation is complicated by allusions, charged with potential self-abasement, always threatening to adumbrate mysteries. The flock may be caught in the fishing-nets; the fire is testing; a door opens on eternity; the sun is not of this world. Can a lamb in this context avoid being the Lamb of God? …The play of thought is disturbed by a question of meaning when nothing less than personal redemption may be at stake.'

Gomringer responded to Finlay's *5 x 1* in these terms: 'The words from a Swiss democrat replaced by an English pietist. You did it wonderfully! Both together are embracing the nature of world, better I think of the earth …. Isn't it a little big book? but a book that could only be made in Scotland and with your spirit. I thank you so much! I love your things all.'[17]

In the essay already quoted Thomas A. Clark explains succinctly how Finlay's *5 x 1* links him, Gomringer and Rossetti with Claude's *Landscape with a Goatherd and Goats*: 'It is as if a work by Claude reached back across the intervening Christian era to retrieve "the mood of Virgil's pastoral poetry", only here Gomringer has become the classical model and Victorian unease seems less remote from us than the recent past of a confident, utopian Modernism. If Pastoral has always been a critique of present assumptions of moral authority, one use of Pastoral might be to insist that no new poetry and no new reader is possible that is not predicated upon some accommodation with the past.'

There is no prescribed order in which the words in any of the sequences in *5 x 1* should be read, and it should be stressed that despite the work's vital link to the thought of Christina Rossetti there is far from being any

requirement that the poem be read in a Christian sense. As Clark writes, Finlay's 'declared Neo-Classicism … to a great extent … pacifies the content. The lamb is again allowed to be itself, the boat may be registered at a Scottish port.' Nevertheless, Rossetti's perspective remains insistent and each of Finlay's re-constellations of her words can be read as a commentary on human existence

7 View in the garden at Stonypath; on the right, the grotto of Aeneas and Dido

that culminates in an affirmation of the centrality of Christ.

This conception is also inseparable from the very form of *5 x 1/5*. On the printed page, the poems in *5 x 1* suggest the pronounced analogy with stars in the heavens that Gomringer's notion of constellations implies. Like stars, the words vary both in size and in degree of visual insistence. In *5 x 1/5*, however, this analogy is reinforced strongly by the words being illuminated as we view

them suspended in seemingly limitless space. As Humphrey Wine has observed, writing about Claude, 'The idea of a relationship between light and the divine was an established one.'[18] He quotes John 1:4: 'In him was life, and the life was the light of men'. This emphasis on light is relevant also to the work of Claude, whose 'distinctive contribution to the genre [of the pastoral] was to use light as the principal means both of unifying the composition and of lending beauty to the landscape'.[19]

The inclusion of 'sun' and 'star' in *5 x 1/5* is consistent with a preoccupation of pastoral painting and poetry with times of day. Such an interest is central in two of Finlay's works best known to Londoners, located in the

PRINZ EUGEN

homage to gomringer

IAN HAMILTON FINLAY / RON COSTLEY WILD HAWTHORN PRESS

8 Ian Hamilton Finlay with Ron Costley, *Prinz Eugen*, 1972, silkscreen, edition of 300, 38 x 50.6 cm

pleasures, but its in many ways stern message is that celebration cannot rightly be separated from principle in the conduct of human life. The perfection of Arcadia is a poetic construct. Its very unattainability has often imbued its representation with a quality of wistfulness and yearning. Moreover, as Poussin's paintings of Arcadia reiterate, even there, death lies in wait. For Finlay, the horrors of man's behaviour, not least in his own life-time, authorise an extension of such contem-plation by means of imagery that can be brutal in its dissonance (**10**). Such imagery often carries implicit criticism of the misap-propriation of the forms of high culture for the purposes of inhuman regimes.

Like Finlay's work as a whole, *5 x 1/5* insists on the seriousness of culture, the importance of our heritage from the past and

9 Ian Hamilton Finlay with Peter Coates *Home, goats, home, replete, the evening star is coming*, 1998, Caithness stone, London, Serpentine Gallery

grounds of the Serpentine Gallery in Hyde Park. His tree-plaque (**9**) is inscribed in Latin with words from Virgil's Eclogues X: 'Home, goats, home, replete, the evening star is coming', while one of the benches over-looking the lawn is inscribed with other lines from the same text, which then reappear on its seven companions in seven different trans-lations. These include that by C. Day Lewis of 1963:

'Look over there – smoke rises already
 from the rooftops
And longer fall the shadows cast by
 the mountain heights'.

Like that of *5 x 1/5*, the theme of this eight-part work is the transmission of a vision across time, reformulated in the manners of succes-sive periods yet continuously referring back to an originating model.[20]

In recasting Gomringer's modernist poem in words taken from Rossetti Finlay

questions, implicitly, a widespread modern impulse towards the jetti-soning of tradition. His association of his new work with Claude's Arca-dian image links it with an artist with whom he shares both a deep engagement with the past and a respect for artistic conventions. As often in his work, Finlay here joins previously unconnected things together to make something new. But, as Clark explains, 'Innova-tion is startling and beau-tiful not because it gives rise to a new poetry, which would be incomprehen-sible, but when it is an old poetry made new'.

Finlay's art abounds in wit and in delight in life's

10 Ian Hamilton Finlay with Michael Harvey *Of Famous Arcady Ye Are*, 1977, lithograph, 40.6 x 58.2 cm

its vulnerability in the contemporary world. In an arresting, poster-like image in white lettering on a red ground, Finlay declared in 1988:'Reverence is the Dada of the 1980's as irreverence was the Dada of 1918.'[21] That statement is no less valid when applied to present-day circumstances. It gives added resonance to Finlay's introduction of the words of Christina Rossetti as, across two millennia, *5 x 1/5* draws us, in imagination, through Gomringer and Claude to the vision of Virgil.

Richard Morphet

Notes

1 Finlay's first poem in sandblasted glass was made in 1964 and many have followed.

2 Horace, *Ars Poetica*, line 361.

3 *Claude, The Poetic Landscape*, exh. cat., National Gallery, London, January–April 1994, p. 68.

4 Ibid., p. 29.

5 Rosemarie E. Pahlke, 'Homesickness for Greek Temples', in Rosemarie E. Pahlke and Pia Simig (editors), *Ian Hamilton Finlay: Prints 1963–1997*, Ostfildern 1997, pp. 248–81.

6 Yves Abrioux, *Ian Hamilton Finlay: A Visual Primer*, Edinburgh 1985, p. 85.

7 In *Modern Antiquities*, n.p., publication on works by Finlay accompanying Finlay's exhibition *Garden Works*, Nolan/Eckman Gallery, New York, March–April 2000.

8 Ian Hamilton Finlay in letter to the author, 4 February 2000, from which all other quotations in this paragraph are taken.

9 Repr. in colour in Abrioux, cited note 6, p. 47.

10 See Michael Kitson, *Claude Lorrain: Liber Veritatis*, London 1978, pp. 61–2.

11 Harry Gilonis, *Finlay's Metamorphoses: variations on several themes in the work of Ian Hamilton Finlay*, publication accompanying Finlay exhibition at Fundació Joan Miró, Barcelona, February–April 1999, p. 8.

12 Letter to the author, 4 February 2000. Since 1978 Finlay has named the land in which Stonypath is situated Little Sparta. See Abrioux, cited note 6, pp. 17–18 and 21.

13 Ibid.

14 The exhibition was that detailed in note 11.

15 Letter to the author, 2 February 2000.

16 *Prinz Eugen* was a German Admiral Hipper-class heavy cruiser, famous for the battle in May 1941 when it and the Bismarck sank the British battle cruiser HMS *Hood*.

17 Letter to Ian Hamilton Finlay, 9 March 1999.

18 Page 34 in text cited at note 3.

19 Michael Kitson, 'Claude Lorrain', in *The Macmillan Dictionary of Art*, London 1996, VII, p. 389.

20 On Finlay's works at the Serpentine, see Ian Hamilton Finlay and Pia Maria Simig, *A Proposal for the Grounds of the Serpentine Gallery*, Wild Hawthorn Press, 1997. Finlay's third work at the Serpentine is an inscription on slate paving of words by Francis Hutcheson from *An Inquiry into the Original of Our Ideas of Beauty and Virtue* of 1725, which again relate closely to Claude's *Landscape with a Goatherd and Goats*: *The beauty of trees and their cool shades and their aptness to conceal from observation have made groves and woods the usual retreat to those who love solitude especially to the religious, the pensive the melancholy and the amorous*.

21 Centre-page spread, 29 x 62 cm, of Christopher McIntosh and Katherine Kurs (intro.), *The Little Critic*, 4, published to accompany a Finlay exhibition at Victoria Miro Gallery, London, September–November 1988.

CHARDIN
The Young Schoolmistress probably 1735–6

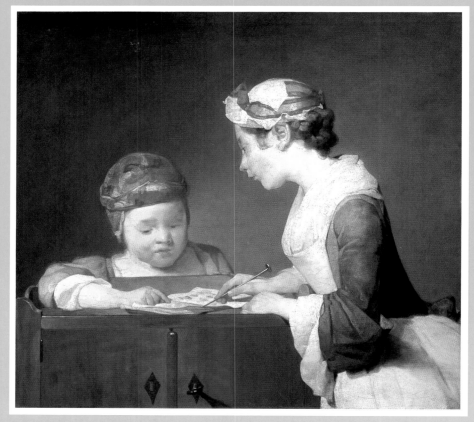

NG 4077 Oil on canvas, 61.6 x 66.7 cm

Long ADMIRED as one of the most subtle and technically adroit French artists of the eighteenth century, Jean-Siméon Chardin (1699–1779) was accepted into the Académie Royale in 1728 not at the highest level, as a history painter, but lower down the traditional hierarchy of genres, as a painter of still lifes and animals. His works are based on the quiet contemplation of natural phenomena and exhibit rare skill in evoking tactile sensations with the brush and in capturing the play of light across forms. His deceptively simple still lifes of game, fruits and household implements found a ready clientele among sophisticated contemporary collectors in France and abroad, for whom the old hierarchies of painting were less and less important, and won the penetrating praise of no less a critic than Diderot. Chardin expanded the thematic range of his art around 1730, when he began to paint genre scenes, often showing domestic servants going about their household duties, or genteel bourgeois figures at work or play in intimate interiors. To his skill in evoking form and texture he now added a psychological complexity, the hint that subtle emotions and desires animate his figures, even when they are given over to reverie.

Chardin was particularly adept in his exploration of the tentative emotional lives of children, from their earliest years to adolescence. Here, a young girl and her sibling pore over sheets of paper on a bureau top. The girl, needle in hand and pert profile turned toward her charge, points out the letters of the alphabet and begins to teach the rudiments of reading. She is perhaps mimicking the lessons she herself only recently had received from her mother or nursemaid. The baby tries to follow, chubby fingers tracing the forms, solemnly hoping to please but, it seems likely, apprehending only dimly, if at all, what the oddly shaped abstractions might mean. Chardin carves out the space the children inhabit by means of the slow modulation of dark into light across the rear wall; in a bravura touch, at the bottom of the picture the key in the bureau lock, light glinting off its edge, seems to project into the viewer's space. It has been suggested that the painting might be a pendant to the artist's *House of Cards* (NG 4078), which shows a youth carefully balancing playing cards one on top of another. In this reading, the two pictures would contrast meaningful and meaningless exertion. *Christopher Riopelle*

LUCIAN **FREUD**

born Berlin, 8 December 1922

© Bruce Bernard

ALTHOUGH OFTEN DESCRIBED as self-taught, Lucian Freud acknowledges Cedric Morris as his mentor. Freud studied with Morris and his partner Arthur Lett-Haines at the East Anglian School of Painting and Drawing (1939–42), and absorbed there an attitude to both life and art which was immensely stimulating for him. His early manner was linear and hard-edged and owed not a little to masters of the Northern Renaissance such as Dürer and Holbein. This minutely detailed style earned Freud the nick-name of 'the Ingres of Existentialism' from Herbert Read, but in the late 1950s came a radical revision. Freud abandoned the small sable brushes he had used to achieve his meticulous finish, and began to work with hog's hair. His delicate and hallucinatory brand of 'magic realism' was superseded by a style of representa-tion altogether more robust and vehement. The subject-matter, however, remained much the same, with Freud painting people, mainly women, from life, interspersed with the occa-sional still life of plants.

Lucian Freud settled in England in 1933 and was naturalised in 1939. For thirty years he lived in Paddington, before moving to Holland Park. He now divides his time between studios in Kensington and Holland Park.

CIAN FREUD

After Chardin 1999–2000

Oil on canvas, 15.4 x 20.3 cm, private collection

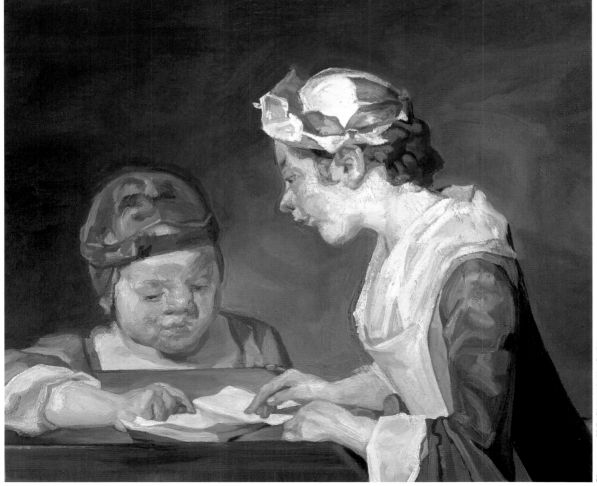

Oil on canvas, 52.7 x 61 cm, private collection

NAMED BY THE art critic Robert Hughes 'the greatest living realist painter',[1] Lucian Freud, in an immensely distinguished career spanning more than sixty years, has become especially famous for his nudes. Their meticulously observed anatomical truths are uncomfortable to some, but by others are considered the summit of contemporary figure painting. Freud's work, however, is far from confined to this category of subject.

'What do I ask of a painting?' Freud has written. 'I ask it to astonish, disturb, seduce, convince.'[2] Freud's long dialogue with the art of the past always returns him refreshed to his own work and contemporary interests. When asked by the National Gallery to select a painting in the permanent collection to which to respond, he had no hesitation in choosing Chardin's *Young Schoolmistress*. He has admired it for many years, and it was one of the masterpieces in *The Artist's Eye*, the exhibition he selected in 1987 of works from the National Gallery's Collection. He was also acquainted with another genre scene by Chardin in the National Gallery of much the same date, *The House of Cards* (**1**).

It seems clear that one of the features of Chardin's work that Freud was drawn to is the quality of his paint: the awkward, almost gritty texture which is yet capable of the utmost delicacy, as in the child's peachy, apricot flesh tones, and the girl's skin, all milk-white

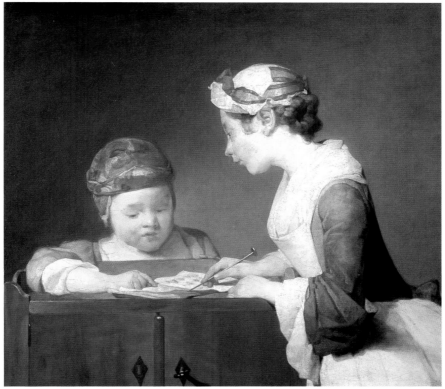

Jean-Siméon Chardin *The Young Schoolmistress,* probably 1735–6

and rose, in *The Young Schoolmistress*. The girl seems abstracted. There is a suggestion of melancholy, of the need to do one's duty rather than follow one's pleasure. Yet nothing is overtly stated: the image is one of delicacy and reserve. The painting's peacefulness is echoed in its restrained, finely balanced palette of soft opalescent colours enlivened by red and blue. Despite the contained calm of the picture, the figures are closely linked and their demeanour emotionally evocative in such a way as to introduce a subtext of ambiguity to the scene. Freud must surely have been drawn to the complexity of the relationship between these figures.

Chardin is the great painter of immobility and silence, but his simplicity is deceptive. Recent opinion presents him as a far more subversive painter than hitherto thought, but not in the sense of hidden narratives; rather the opposite – as being a pure painter. Chardin eschewed rhetoric and charm in favour of truth to what he saw, painted in the most direct manner. His is a classical realism, detached, sober, at times deliberately ineloquent. Even his genre scenes have a tranquillity and a timelessness attributable to their very lack of perceptible story, in contrast with those of many of his predecessors. These qualities suggest a link with the art of Freud, who denies his own

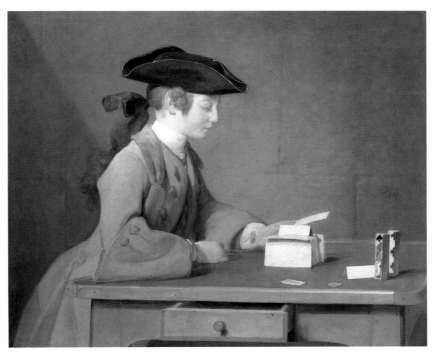

1 Jean-Siméon Chardin *The House of Cards*, oil on canvas, 60.3 x 71.8 cm, London, National Gallery

131

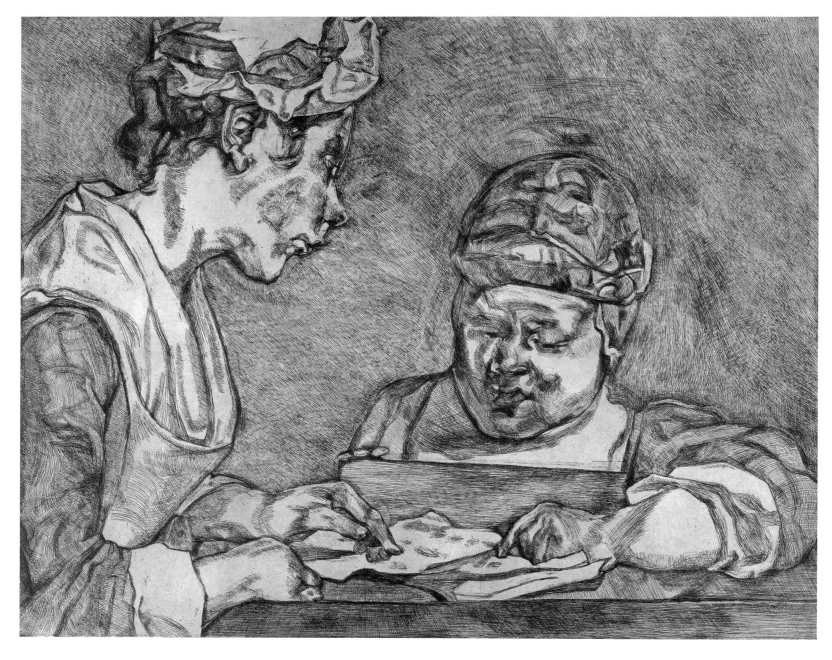

2 Lucian Freud *After Chardin's 'The Young Schoolmistress'*, 2000, etching, plate size 61 x 73.6 cm, private collection

paintings any obvious narrative content.

The Young Schoolmistress inspired Freud to make two painted versions of it and a further etched interpretation (**2**). Working over a period of many months at night in the National Gallery, Freud stood in front of Chardin's painting (specially lit with a halogen lamp) to make his own transcriptions in oil paint. He made no preliminary drawings, but began at once, on a small canvas, a detailed close-up of the faces of *The Young Schoolmistress* and her charge. Although Freud's early work is distinguished by its enamel-like finish, achieved through the use of small sable brushes, he abandoned this method of painting in the 1950s in favour of a style altogether broader and more expansive. Since then he has employed hog's-hair brushes, of which the effect can be seen in this small, tender painting. Large brushes have been used to achieve these delicate marks, marks which work both as description and simply as beautiful passages of paint – for

instance, on the right side of the girl's neck where the upper layer meets the underpainting. The mood of this painting is relaxed and trusting.

In the second, larger version, the atmosphere has perceptibly changed. The child looks as if he might easily become uncontrollable, an impression heightened by the boy's headgear, which Freud likens to 'a motorcycle helmet'.[3] Interestingly, in this version Freud makes both protagonists appear older: he puts the boy at five to seven years, and the girl at fifteen. Although her age is not certain, the girl in Chardin's picture is probably between ten and fourteen, and the boy much younger, perhaps only two or three. In this paraphrase, Freud has omitted the knitting needle-like pointer from the girl's hand, as not essential to his concerns. When it came to painting the book upon which both figures are supposedly intent (for the girl's attention seems to be straying), Freud was reluctant to copy another artist's shorthand. In the Chardin, what Freud describes as 'feathery' marks indicate printed characters or perhaps even a series of illustrations. Instead of imitating these Freud produced his own approximation of text, using a white ground with an overlay of off-white. One reason for making a transcription is to discover new structures and strategies that may be applicable to the artist's other work.

Working from the Chardin made Freud increasingly aware of how the original painting developed. He believes that

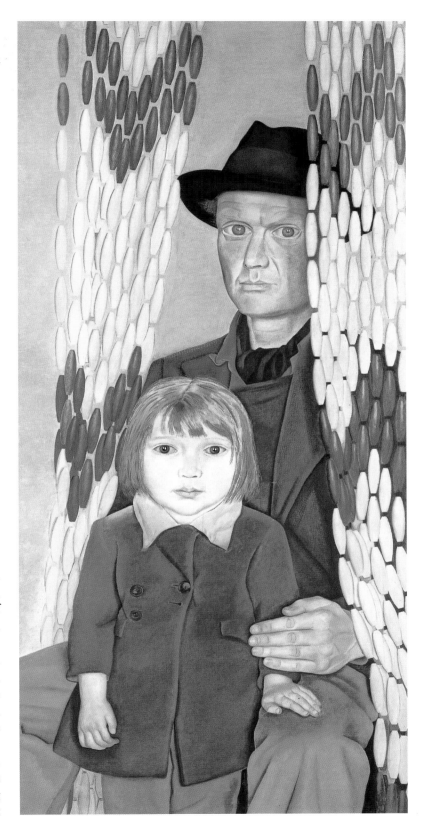

3 Lucian Freud *Father and Daughter*, 1949, oil on canvas, 91.5 x 45.7 cm, private collection

Chardin painted here 'the most beautiful ear in art', and in conversation he draws attention to the area of paint around and below the ear of *The Young Schoolmistress*. It is evident in Freud's second version that this is a focal point, constituting as it does a passage of changes to which the artist constantly returned. However, Freud is unwilling to highlight any particular feature, for the whole image should sit together harmoniously, as in the original. Neither the foreground nor the background should weigh too much, nor carry too much description. Accordingly, the background space remains mysterious, though the emphasis of the foreground has been subtly shifted by Freud's decision not to incorporate the entirety of Chardin's foreground furniture.

The straightforward, tender ease of the smaller painting confers a certain timelessness on the characters. Its arrangement is more intimate, the figures being brought closer together. The boy is painted with more sympathy and made to look more child-like and presentable. Freud was struck by the beauty of the girl in Chardin's picture and that is how he paints her, here in particular. In Freud's larger painting there is a perceptibly greater unease in the figures' relationship. The girl is preoccupied. Her chin appears more forceful, her lips more pursed. Although, as is usual in Freud's painting, no narrative is

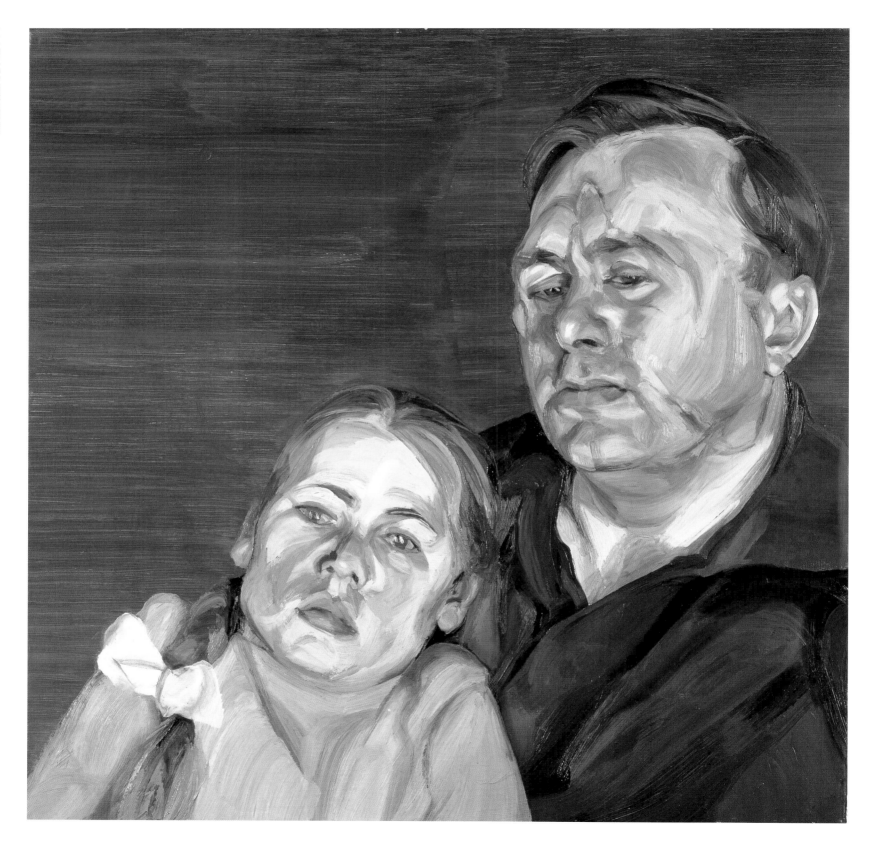

(Left) **4** Lucian Freud *A Man and his Daughter*, 1963–4, oil on canvas, 61 x 61 cm, private collection

readily discernible, the undertone of anxiety in this image combines with the bluntness and physicality of Freud's handling in such a way as to mark this larger work as distinctively late twentieth-century, when seen with its similarly sized eighteenth-century source.

Freud often paints figures together, whether clothed or naked. His images of a father and daughter from 1949 (**3**) and 1963–4 (**4**) have a brooding intensity which is either disturbing or compelling, depending on your sympathies. In *Painter and Model* of 1986–7 (**5**), a naked man confronts the viewer while the female painter stares composedly at the floor. It is a frankly odd painting which holds the attention partly through the unease of this juxtapositionof figures. The subtly nuanced monumentality of *Two Irishmen in W11* of 1984–5 (**6**) offers a more benign view of relationships, in this instance depicting a father with his son in respectful attendance. Quite different again is the relaxed friendliness which permeates *Polly, Barney and Christopher Bramham* of 1990–1 (**7**). This figure group of two children

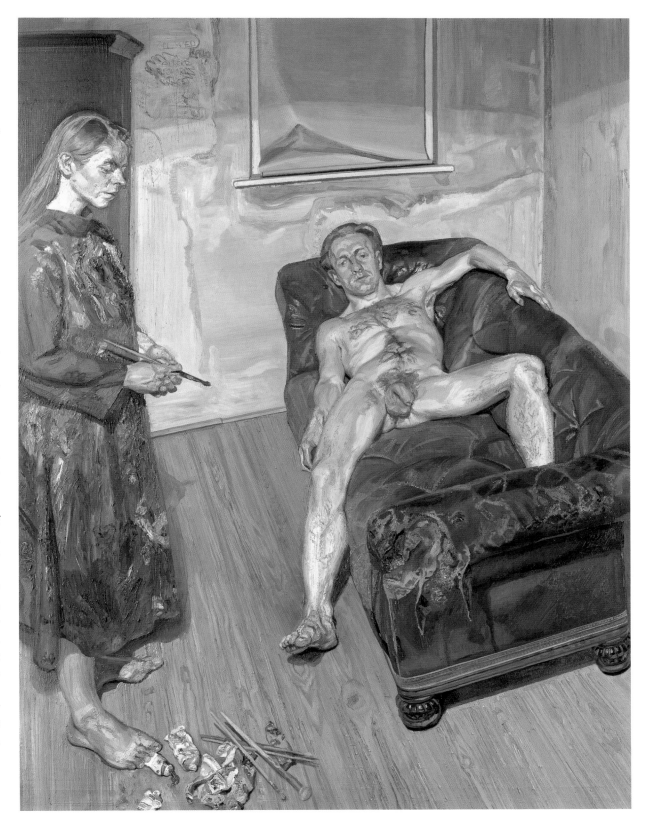

(Right) **5** Lucian Freud *Painter and Model*, 1986–7, oil on canvas, 159.6 x 120.7 cm, private collection

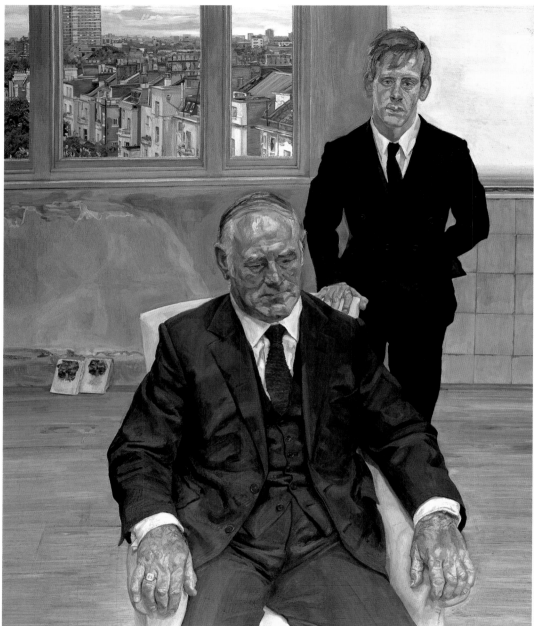

truth which can only be demonstrated on the canvas. In these transcriptions of Chardin, the hats are more essential to this truth than the furniture.

The vigorous conversation that Freud now maintains with the Old Masters was not always so inspirational. In conversation with Robert Hughes, Freud has commented on his early years thus: 'I always felt that my work hadn't much to do with art; my admirations for other art had very little room to show themselves in my work because I hoped that if I concentrated enough the intensity of scrutiny alone would force life into the pictures. I ignored the fact that art, after all, derives from art. Now I realize that this is the case.'[4] Hence the lack of early works made after the example of artists Freud admired.

The best known version of an Old Master that Freud has made is *Large Interior W11 (after Watteau)* (**8**) of 1981–3. He was much struck by a reproduction of Watteau's *Pierrot Content*, which depicts a scene from the Commedia dell'Arte in which the white-clad clown Gilles is enjoying being flanked on either side by admiring ladies, each in turn flanked by other male characters. Freud has said: 'I intended first to make a copy of it. Then I thought, why don't I do one of my own?'[5]

Freud's own version is quite different from the convivial original. For a start, at just over six feet each way it is over thirty times the size of Watteau's picture. (Freud has commented recently: 'Change in scale is good because to think of themes and ideas in different sizes is more refreshing than changing mediums, even.')[6] Secondly, the pervading mood is sombre, if not downright mournful. Freud's cast of characters (all real people) includes his daughter Bella playing the mandolin, his son Kai as Gilles in the centre, supported by Kai's mother and the painter Celia Paul. However closely juxta-

accompanied by their partly cropped-off father evinces a family unity refreshing in its ordinary naturalness.

As furniture has often assumed an important role in Freud's painting, his substantial omission of Chardin's table or desk may seem surprising, but his focus is on the figures, and in particular on their headgear. In the Chardin both figures wear bonnets or caps,

and their ribbons and decoration constitute some of the most exquisite passages of paint in the picture. In both of Freud's painted transcriptions the boy's hat forms a most delightful passage, almost a painting in its own right. (In the smaller version, the girl's bonnet is truncated, although, in the larger, full play is given to her ribbons.) Here are notable examples of Freud searching out a physical

posed they are – indeed squeezed together in the picture and actually overlapping – these figures remain intensely solitary, locked in their own worlds.

An unexpected work by Freud after another French painting of a relationship between two figures is his lively drawing from *Gabrielle d'Estrées and one of her Sisters* (**9**), a School of Fontainebleau picture in the Louvre painted over a century before the Chardin. Although in the 1950s he changed his painting style from a linear to a painterly one, Freud never ceased to draw. In fact, the activity of drawing has always been part of the essence of his work, though its products

8 Lucian Freud *Large Interior W11 (after Watteau)*, 1981–3, oil on canvas, 186 x 198 cm, private collection

have been less regularly exhibited than his paintings, and are less well known than his etchings. Freud's drawing after the Louvre picture, made in pastel, chalk, ink and crayon, is something of a rarity in his oeuvre. Another portrayal of a relationship between two people, it offers a witty 'take' on the strange beauty of the original.

Notes

1 Robert Hughes, *Lucian Freud paintings*, London 1989, p. 7.

2 Lucian Freud, 'Afterword', in exh. cat. *The Artist's Eye*, National Gallery, London, June–August 1987.

3 Conversation between Lucian Freud, Andrew Lambirth and Richard Morphet on 5 January 2000 at Freud's London home. Subsequent unattributed quotations are also taken from this conversation.

4 Hughes 1989, cited note 1, p.14.

5 Lucian Freud, quoted in Lawrence Gowing, *Lucian Freud*, London 1985, p. 202.

6 Quoted in *Lucian Freud in Conversation with William Feaver*, display guide for *Lucian Freud: Some New Paintings*, Tate Gallery, London, June–July 1998.

7 Lucian Freud, quoted in Gowing 1985, cited note 5, p.132.

9 Lucian Freud *Gabrielle d'Estrées and one of her Sisters*, 1991, pastel, chalk, ink and crayon, 25.4 x 28 cm, courtesy Matthew Marks Gallery, New York

Freud is on record as saying: 'I remember everything I've done because it was done with difficulty'.[7] Like Chardin, Freud has had to struggle towards perfection, along the way developing great skills in the realm of pure painting. Once he allowed paint to come into its own as a tactile substance, he developed its physicality further by introducing in the 1980s a heavily leaded pigment known as Kremnitz White, principally for painting flesh. This appears to coagulate on the canvas, producing the granular, encrusted look familiar from Freud's paintings of recent years. Sometimes the paint surface becomes so involved that it competes with the image for attention. Some critics have even complained that the paint then becomes altogether too reminiscent of the clay from which we were made and to which we will return.

Freud's Chardin transcriptions disprove this roundly.

Like Chardin, Lucian Freud is a painter driven above all by what he sees. The human relationship Chardin shows in *The Young Schoolmistress* plays a vital role in Freud's responding works, but what Freud literally saw was, of course, deposits of paint. He has transformed the landscape of abstract paint-marks which makes up Chardin's *Young Schoolmistress* into two paintings which have an independent life of their own. The discipline of his observation fuses with the striking freedom of his mark-making. It is a tribute to Freud's deep affection for Chardin that his poignant transcriptions of *The Young Schoolmistress* should have such clear-sighted elegance and freshness.

Andrew Lambirth

SAENREDAM
The Interior of the Grote Kerk at Haarlem 1636–7

NG 2531 Oil on oak panel, 59.5 x 81.7 cm

In seventeenth–century Holland the most accomplished painter of architecture, both interior and exterior, was Peter Saenredam (1597–1665). Trained in Haarlem, he took as his subjects the great Romanesque and Gothic churches that dominated Dutch townscapes, whitewashed within and austerely grand, spatially complex and imposing. The scale is established by diminutive figures who wander through the light-drenched spaces. The artist often chose odd vantage points and acute angles to render the scene more complicated, as in his *Grote Kerk at Haarlem*, where the foreground pillars dwarf those seen in deeper space, even those these are in reality their equal in scale.

Saenredam worked from a vantage point on the north side of the choir in the Grote Kerk. The painting was preceded by a preliminary drawing, signed and dated 29 May 1636 and described as being made '*naer het leven*' or from the life. The drawing was followed by a cartoon, in which certain liberties were taken with architectural reality for pictorial effect, and this cartoon was then transferred to the panel. The painting itself was finished after meticulous work and the application of enamel–like paint only in early May 1637, almost one year after Saenredam had first sketched the scene. Working at this speed, the artist did not achieve a large production.

Christopher Riopelle

THE REPRESENTATION OF architecture has long enjoyed a privileged status in European painting. Some of the finest ancient Roman frescoes are complicated fantasies on architectural themes. Brunelleschi's first experiment in perspectival painting, in the early fifteenth century, was a depiction of the Baptistery of Florence Cathedral. Raphael's great frescoes in the Vatican Stanze, such as *The School of Athens*, depend upon vast architectural volumes to order the composition and aggrandise the figures who move through them in stately procession.

RICHARD **HAMILTON**

born London, 24 February 1922

Between 1936 and 1951 Hamilton studied at London art schools and worked in design studios and as a technical draughtsman. From 1953 to 1966 he was an influential teacher of art and design at Newcastle-upon-Tyne, while maintaining a full life in London, creating important thematic exhibitions in both places. James Joyce and Marcel Duchamp are key influences on his art. He reconstructed the latter's damaged *Large Glass* in 1963–6 and has published typographic translations of his *Green* and *White* boxes.

Hamilton is driven by fascination for how things work, by admiration for great art of the past, by exploring technical innovation and by its application in fine art. Deciding in 1950 to rethink from scratch the process of representing the world through painting, he examined abstraction, perspective and systems of growth and motion before formulating in 1957 his land–mark definition of Pop art. To reflect the reality of the modern world, he applied to painting the sophisticated techniques and rich fantasy of advertising, film and photography. Within a continual re-examination of art's traditional genres, his concerns include topics of social and political concern, from mass images of modern war to issues of civil liberty. According primacy to the manipulation of paint and to printmaking skills, he has discovered a new beauty and poetry in modern life. Hamilton lives in Oxfordshire with his wife, the painter Rita Donagh.

© Timothy Greenfield Sanders

The Saensbury wing 1999–2000

THE VIEW SHOWN in this painting will strike visitors to the National Gallery as instantly recognisable, yet curiously changed. It is a re-creation by Hamilton of the most familiar vista in the Gallery's Sainsbury Wing, which, thanks to the generosity of members of the Sainsbury family, was built between 1988 and 1990 and opened to the public in 1991. The building is on several floors, but the view in question (**1**) is on the uppermost level, from the top of the grand staircase. It is of the perspective that leads towards the rooms in which the Early Renaissance collection is displayed. The Sainsbury Wing was designed by the American architect Robert Venturi and his wife, Denise Scott Brown. In Hamilton's painting their vista is re-designed in terms of the vision of Saenredam. The twist in the spelling of the second word of the work's title denotes the homage Hamilton pays to the earlier master. *The Saensbury wing* thus has two very different kinds of source in the National Gallery. In seeking to reconcile them Hamilton set himself a far from easy task.

Hamilton's painting is the same size as Saenredam's church interior and the two works have much else in common. Each is dominated by massive pillars, between which the eye is led into the distance and which dwarf the human figures shown. In each case the fall of light animates the scene and the picture is painted in a manner at once discreet yet visually rich. Importance is accorded to texture, to subtlety of tonal variation and to a range of hues established by the earlier work. While directed above

Pieter Saenredam *The Interior of the Grote Kerk at Haarlem*, 1636–7

all towards presenting the specifics of a particular interior, each picture also displays strong relationships of abstract form. However, the likeness between the works goes beyond their look to the processes by which, nearly four centuries apart, the painters arrived at what we are shown.

One impulse of Hamilton's work across some sixty years has been to explore exactly what we see and how and why it takes the form it does. Hamilton considered both the Saenredam and Venturi's vista in this light. The Saenredam was one of the works selected by Hamilton from the National Gallery's collection for his 1978 exhibition in the series *The Artist's Eye*. He wrote that all the works he chose were 'without bombast and all attain a high personal ambition. There is no rhetoric only a calm resolution in the undertaking of a remarkably daring endeavour.'[1] The exhibition poster (its main design reproduced on the catalogue cover) was a painted and collaged image by Hamilton after Van Eyck's Arnolfini portrait, in which he admired the 'incredible technical mastery (in a medium that van Eyck was himself inventing)'. Hamilton's own career demonstrates consistent preoccupation with technical investigation (and innovation) married with an attachment to the hand-made picture and to the sensuousness of paint. In all of this he has an affinity

1 Perspective on the main floor of the National Gallery Sainsbury Wing, architects Robert Venturi and Denise Scott Brown, photograph, 2000

143

2 Pieter Saenredam *Interior of the Church of St Odulphus in Assendelft*, 1649, oil on panel, 50 x 70 cm, Amsterdam, Rijksmuseum

with Saenredam, who 'is generally appreciated as the artist whose depictions of actual church interiors established a new genre in Dutch painting'.[2]

Hamilton's favourite Saenredam is *The Interior of the Church of St Odulphus in Assendelft* of 1649 (**2**), a picture notable for the beauty of its colour, its mastery of tone, its fidelity to the architectural facts, the vitality of abstract relationships within an exposed geometry and the serenity and completeness of the whole. The painting is also a classic example of the centrality, in Saenredam's practice, of the use of perspective, a subject of long-standing interest to Hamilton.

Hamilton admires Saenredam as being among the earliest artists to develop the potential of parallel perspective as a strictly controlled dimensional system for use in painting. In his method of constructing the

image before beginning to paint, he demonstrated the value of surveying and measuring his subject so that every aspect of the picture could be referred back to true scale. Hamilton finds extremely satisfying the verifiability of everything in Saenredam's painted interiors; through measurement, one can always work back to a datum point. Perhaps the most important of all influences on Hamilton has been the work and thought of Marcel Duchamp (1887–1968), who likewise attached great importance to precision in measurement and for whom perspective was a means of avoiding the more subjective picture-making conventions of his time. Duchamp relished conventions in art that were determined by rules and principles that the artist could faithfully apply, reject or, if necessary, re-invent. In 1966 Hamilton completed a reconstruction (**3**) of the damaged original of Duchamp's best known work, the *Large Glass* of 1915–23. This was made not by copying the appearance of the original but by following all Duchamp's

complex procedures from the beginning, step by step. On its completion it was signed by Duchamp.

Hamilton's interest in the architecture of museums was shown in his six reliefs representing the exterior of Frank Lloyd Wright's Guggenheim Museum, New York (**4**). In creating these, too, Hamilton was systematic. He first studied the architect's plan, elevation and section drawings and then made plan, elevation and section drawings for a representation of the museum in relief. He has described the resulting form as 'an attempt to mirror the whole activity of architecture in the confines of a 4 feet square panel'.[3]

Once Hamilton had identified Saenredam's painting as the work to which he would respond, he needed to find an accessible interior that could provide the motif from which to develop the structure of his own picture. Serendipitously, the National Gallery's own building provided the view. The chosen vista offers the closest built approximation in the Gallery to the sacred interiors painted by Saenredam. The suitability of the choice is underlined by Lord Rothschild's observation, written about the Sainsbury Wing: 'We live at a time when the museum building rather than the cathedral, church or railway station has become the architect's paramount vehicle of expression in the West'.[4]

Consistent with his practice when reconstructing Duchamp's *Large Glass*, Hamilton wished, in emulating Saenredam, to follow so far as possible the same sequence of procedures preparatory to painting. These were to measure the building; to make perspective drawings from the elevations; to make studies on paper, observing colour and texture and recording information on lighting; and finally

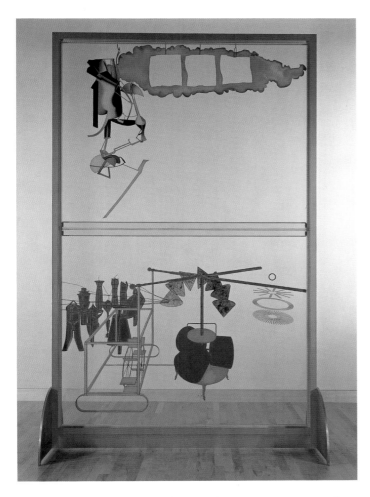

3 Marcel Duchamp and Richard Hamilton *The Bride Stripped Bare by her Bachelors, Even (The Large Glass)*, 1915–23, reconstructed, 1965–6, mixed media on glass, 277.5 x 175.9 cm, Tate, London

to paint the picture, using the data thus accumulated. He also wished to follow Saenredam in using the most advanced technical assistance available at the time; in his case this was computer technology. There were, however, two crucial differences. Hamilton adjusted the dimensions of Venturi's vista in sympathy with Saenredam's picture, and the latter work, rather than Venturi's, was his source for colour, texture and lighting.

Hamilton's starting-point was to photograph the space from Venturi's ideal viewpoint (**5a**) and then scan the result into his computer so that he could distort the photograph into a composition which would bring it more into keeping with the scale of Saenredam's Grote Kerk (**5b**). Further manipulation and the introduction of figures produced a composition which might be

regarded as the artist's sketch study for the project (**5c**).

Only after embarking on this process did Hamilton come fully to appreciate the extent of the problems resulting from Venturi's mannerist design (**1**). It is a diminishing perspective, in which the prominent pillars are shorter, and placed closer together, the further they are from the viewer at the top of the grand staircase. Hamilton began to realise that the falsity inherent in such a perspective had forced the architect into some unfortunate detailing decisions. For him this deficiency was underlined by the further reduction in architectural coherence once the visitor moves into these spaces after experiencing the initial prospect. As Caroline A. Jones has explained, 'Venturi's *Complexity and Contradiction in Architecture* (1966) attacked the institutionalized corporate modernism of the International Style, replacing Mies van der Rohe's classic dictum "less is more" with the sardonic "less is a bore" and rejecting a "puritanically moral language" in favour of "elements which are hybrid rather than 'pure'… messy vitality … richness … rather than clarity of meaning" '.[5]

To Hamilton, the idiosyncracy of Venturi's vista needed to be corrected. Given that his aim was to respond to the painting of Saenredam, an exemplary proponent of visual purity and of clarity of meaning, to do this became

essential. Hamilton sought to open up Venturi's space, to simplify and rationalise the detail and to give the view more of the inspiring character of Saenredam's lofty church interiors. In doing this he widened Venturi's openings, flattened his arches (which are almost semi-circular), removed a low ceiling and gave greater visibility to the clerestory in the second room. He resisted with difficulty the impulse to raise the height of Venturi's arches by placing his columns on more substantial, Saenredam-like bases.

An advantage of taking the Sainsbury Wing as his subject was that no measuring was necessary, since all dimensions were given in the architect's drawings of the space. Obtaining these from the National Gallery, he worked with Andrea Parigi at the Richard Rogers Partnership to enter information into a 3D programme to produce a computer model. This could be used to vary any dimensions Hamilton might choose, and to show on screen exactly how a vista with any given mix of dimensional specifications would look from any viewpoint within the space. A wide variety of choice was thus available. Hamilton

4 Richard Hamilton *The Solomon R. Guggenheim Museum (Spectrum)*, 1965–6, fibreglass and cellulose, 122 x 122 x 18 cm, New York, Solomon R. Guggenheim Museum

5 Richard Hamilton, Three stages in the development from the appearance of Venturi's vista towards the image of *The Saensbury wing*, collection of the artist:
5a The vista photographed by Hamilton from Venturi's ideal viewpoint
5b Figure 5a distorted in Photoshop to be more in keeping with Saenredam's painting of the Grote Kerk
5c Further Photoshop development, to create a sketch study for *The Saensbury wing*.

was, however, limited by the requirement he had set himself, namely to end up with an image that could be recognised as relating to this particular National Gallery view and at the same time to Saenredam's interior of the Grote Kerk.

The line drawings plotted on the computer, first using data from Venturi's plans and then registering Hamilton's alterations (**7**), equated with the first stage of any Saenredam painting, a perspective drawing based on acquired factual information (**6**). Having chosen his viewpoint within the three-dimensional computer model of the Sainsbury Wing, Hamilton had a two-dimensional linear skeleton of the design printed on to a canvas that had been primed and rubbed down to provide a surface similar to a wood panel of Saenredam's. Three-dimensional drawings of this kind are termed 'models' because they provide an armature that can be 'clothed' by 'rendering' simulated textures and effects of light. As Hamilton and another specialist collaborator, Mark Spencer at Colourspace, began to work on a computer visualisation, his motif went through a variety of lighting effects, some of them dramatic.

The physical specifications used in Hamilton's early adaptations of Venturi's vista were simply those of whatever architectural elements were

conceived as being visible from the viewing point. When lighting from a range of notional directions was added on computer, further modifications to the model were necessary. The problem was the absence from the computer model of reflected light from adjoining unseen walls and ceilings, for these, together with the structures that could be seen, would determine the overall character of the light. Hamilton and Spencer were therefore obliged to add light-reflective surfaces to the surrounding part of the building on computer. By this means Hamilton determined the particular characteristics of the painting he planned, before reverting to two dimensions and making a colour print. This print served the purpose of the watercolour Saenredam would have made of his line perspective prior to painting on the panel. Hamilton used it as the immediate source of the marks he

6 Pieter Saenredam *Crossing and Nave of the Church of St Odulphus, Assendelft, from the right side of the choir*, dated 9 December 1643, pen on paper, 50.7 x 74.5 cm, Zeist, The Netherlands, State Department for the Preservation of Monuments

painted on the canvas that already bore his computer 'underdrawing'. The whole process was infinitely more laborious than Hamilton had anticipated. He was pushing the available technology as far as it would go. As usual, he did this not for its own sake but in order to secure particular results.

7 Richard Hamilton, Perspective drawing from three-dimensional computer model of Venturi's drawings for the Sainsbury Wing, 1999, collection of the artist

8 Richard Hamilton *The citizen*, 1982–3, oil on two canvases, overall dimensions 206.7 x 210.2 cm including frame, Tate, London

image, published in 1985.

The citizen is not the only figure in *The Saensbury wing*. A young woman stands beside the nearest pillar, studying what we may take to be a Gallery guidebook. Her relative scale demonstrates the grandeur of the transformed space. She is nude and her juxtaposition with the cold stone calls to mind Sickert's observation, 'Perhaps the chief source of pleasure in the aspect of a nude is that it is in the nature of a gleam – a gleam of light and warmth and life. And that it should appear thus, it should be set in surroundings of drapery or other contrasting surfaces.'[7] For viewers of a later era the clothes worn by Saenredam's figures tie his interiors to a specific period. It was partly for this reason that Hamilton felt the figure moving through this scene should be nude. In his collage *Just what is it that makes today's homes so different, so appealing?* of 1956, a key work in the establishment of Pop art, the two principal figures are nude for the same reason, and also the more clearly to bring out their role as archetypes of 'man' and 'woman'. Almost the same principle might apply to *The Saensbury wing*, in which the nude is complemented by the lone figure of *The citizen*, clothed only in the timeless attire of blankets.

To Hamilton, as to the viewer, the manifestation of this nude figure, placed off centre yet crucial to the whole, has about it the same kind of grace as does the appearance of Hamilton's wife, Rita Donagh, in *Northend I*, a painting based on a photograph taken on an early visit to their present home (**9**). Hamilton

The real vista in the Sainsbury Wing culminates in a large picture by Cima. It was painted as an altarpiece and Hamilton, wishing to substitute a picture of his own, chose the nearest he has come to such an image, *The citizen* of 1982–3 (**8**). The first work in Hamilton's trilogy on the tragedy of the conflict in Northern Ireland, this is an oil painting after a computer-generated image by Hamilton, itself developed from documentary film images captured from the television screen. The subject is a Republican inmate in Long Kesh high-security prison near Belfast during the 'no wash' protest of the 1970s against the refusal by the British government to grant political status to IRA prisoners. All three paintings in the trilogy are diptychs; a figure occupies each right-hand panel, while the left might be taken at first glance for an abstract composition. In *The citizen* the left panel represents the prisoner's excrement, which he has smeared on his cell walls in protest.[6] Because *The citizen* is bisected by a central division, the version seen in *The Saensbury wing* is developed from Hamilton's dye-transfer print of the same

9 Richard Hamilton *Northend I*, 1990, oil on Cibachrome on canvas, 100 x 109.5 cm, Hamilton, Ontario, McMaster Museum

associates this quality of grace more with painted images than with real life, and, just as *Northend I* contains reminiscences of Velázquez's *Las Meninas*, so the nude in the new picture is also associated by him with earlier art.

The nude in *The Saensbury wing* is an artist friend and ex-student of Rita Donagh's. Her image here is taken from one of some seventy exposures Hamilton shot in a single session in 1998, for use as a repertoire of stock figures. In *The Saensbury wing* he visualises her as having just stepped out of a picture hanging in the National Gallery, perhaps Cranach's *The Close of the Silver Age* (**10**), which more than sixty years ago he had sketched when a student at the Royal Academy Schools. For Hamilton, the art of Cranach is always warm and engaging. Though this cannot, of course, be said of a

picture in which some figures are being beaten to the ground, the sweet-tempered women appear oblivious to the violence taking place behind them. Like the figures in Saenredam's pictures, but more so, Hamilton's nude humanises the formal space into which she is inserted. The reference to past art is enriched by the fact that, when taking the photograph on which this painted nude is based, Hamilton had in mind the famous image by Vermeer of a woman reading a letter by a window. Hamilton is strongly drawn to the formal clarity and sensuous paint handling of Vermeer's interiors.[8]

In Hamilton's art, this particular image of a nude first appeared in the Iris digital print *A mirrorical return* of 1998, and then in a closely related painting, *The passage of the bride* of 1998–9 (**11**), which was still being made when *The Saensbury wing* was begun. As in the painting after Saenredam, the computer played a crucial role in making possible the relationships shown in *The passage of the bride*. The nude we see was formed on the computer by 'flipping' her photographed image and ghosting it in as though it were a reflection in the glazing of a full-size drawing of the lower half of Duchamp's *Large Glass*, hanging in a passage in Hamilton's house. As the drawing was only faintly defined, a transparency of Hamilton's reconstruction of that section of the Glass, the 'Bachelor Apparatus', was scanned in to replace it. The title of Hamilton's painting relates his figure to the 'Bride', who occupies the upper section of the Glass. Thus in his picture she passes from one zone (and one personal state) to another within the *Large Glass*, even as she moves through the passage of Hamilton's house.

Such dropping in of pictorial elements,

often previously manipulated, is an important feature of the genesis of *The Saensbury wing*. This method brings to the finished work not only a heightened sense of the presence of what is shown but also an element of ambiguity as to whether these things are really there.[9] The fact that the nude in *The passage of the bride* is demonstrably only 'virtual' links with a now-you-see-it-now-you-don't quality in *The Saensbury wing*. Moreover, the pronounced firmness, regularity and solidity of the architecture in the latter picture embody an instability of their own. For while the nude has left her settled place in a nearby painting, the virtual space she now occupies transmutes the National Gallery itself into a different reality. Hamilton's painting thus exemplifies one of the consistent concerns of his work, the passage from one state to another.[10] This is itself the subject of another painting by Duchamp, *The Passage from the Virgin to the Bride* of 1912 (New York, Museum of Modern Art).

10 Lucas Cranach the Elder *The Close of the Silver Age* (?), 1527–35, oil on oak, 50.2 x 35.7 cm, London, National Gallery

11 Richard Hamilton *The passage of the bride*, 1998–9, oil on Cibachrome on canvas, 102 x 127 cm, collection of the artist

The passage of the bride is one of several recent paintings by Hamilton that return to the motifs of *Seven rooms*, a series of paintings of the mid-1990s representing interiors in his own home. In these more recent paintings the earlier pictures' unoccupied spaces are given figures, in the form of photographic images made by Hamilton and inserted by computer into images used in the earlier series.[11] Subsequently inserted into these new scenes by hand painting are brightly coloured geometrical abstract shapes, which combine being credible as parts of the interiors shown with strong autonomy as individual forms. Following Saenredam's motif of square boards hanging from the pillars in the church, Hamilton has also inserted abstract shapes into *The Saensbury wing*. All his works contain insistent references to an abstract

reality that complements their figurative subject. Here Hamilton makes reference to the exceptional clarity in the articulation of pure form that runs through aspects of Dutch art from Saenredam and Vermeer to Mondrian, De Stijl and beyond.[12]

Hamilton's interests both in discrete abstract shapes and in parallel perspective were evident in *an Exhibit*, a walk-through environment openly reminiscent of De Stijl architectonics which he, Victor Pasmore and Lawrence Alloway created in 1957 (**12**). The pronounced spatial recession of *an Exhibit* is a quality shared by many of Hamilton's works,[13] not least

12 Richard Hamilton, Victor Pasmore and Lawrence Alloway, *an Exhibit*, 1957, photograph of installation at Hatton Gallery, Newcastle-upon-Tyne

Lobby of 1985–7 (**13**), which in its motif of pillars is close to *The Saensbury wing* and especially its source in Saenredam. One of the most striking features of the latter is the way the spatial view is blocked by the massive pillar in the centre (on which hangs one rectangle as, in virtual form, three do on each pillar in *Lobby*). The rectangularity of the mirror-covered pillars in *Lobby* echoes, fortuitously, that of the lowest of the four faceted levels of the bases of those in Saenredam's Grote Kerk interior. In all three pictures, the effect of the pillars is to draw the eye deeper into the space we are shown. Saenredam's stage-like disposition of elements within his depicted scenes – here columns, but sometimes 'flats' – has been echoed by Hamilton when he has, on occasion, installed *Lobby* in a space that mimics the one shown in the picture and has placed a real, partly obstructive pillar at the entrance to the space.

Like Venturi's perspective in the Sainsbury Wing, such an installation, along with much else in Hamilton's work, is a kind of game. Moreover, as works from *Just what is it … onwards* show, Hamilton has contributed conspicuously to the disposition in modern art to bring together in a single work motifs from widely different and often seemingly incompatible sources. However, it does not follow from these parallels that Hamilton

13 Richard Hamilton *Lobby*, 1985–7, oil on canvas, 175 x 250 cm, collection of the artist

can be associated with Post-modernism in the ways that have led to Venturi being seen as exemplary of the tendency. Both artists are activated by a concern with the classical in artistic expression but Hamilton, for all his work's complexity, aims for a kind of purity. The central theme a work communicates is worked out by a consistent functional openness and self-exposure. Unsurprisingly, the kinds of modern architecture Hamilton likes best are those in which form and function are in harmony. Most of these enable ready comprehension of their structure.

It is the combination of purity and completeness in Saenredam's art that has driven Hamilton's revisualisation of Venturi's perspective. As he said in 1990, 'My love of art came from museums'.[14] And although his means lie at the cutting edge of current technology, as they have long done, a statement of Hamilton's in 1978 remains equally true today: 'The idea that you're competing with Oldenburg or Warhol ... these judgements are quite absurd. You are really competing with Rembrandt, Velásquez and Poussin ... That's the kind of time span that art is all about.'[15]

Richard Morphet

Notes

1 Introduction to exh. cat. *The Artist's Eye*, National Gallery, London, July–August 1978.

2 Walter Liedtke in *The Macmillan Dictionary of Art* London and New York 1996 , vol. 27, p. 507.

3 Unpublished pre-editing transcript of tape of conversation with Christopher Finch and James Scott made for the latter's film *Richard Hamilton*, Maya Film Productions, London 1969.

4 Foreword (pp. 14–17) to Colin Amery, *A Celebration of Art and Architecture*, National Gallery, London, 1991 (a history of the site of the Sainsbury Wing, the competition to design an extension and the genesis of Venturi's building).

5 In entry on 'Post-modernism' in *The Macmillan Dictionary of Art*, London and New York 1996 , vol. 25, p. 359.

6 The other two paintings in the trilogy are *The subject*, 1988–90, which depicts a bowler-hatted member of the Orange Order marching, holding a sword, and *The state*, 1993, depicting a British soldier in camouflage fatigues walking backwards in an Irish setting holding an automatic rifle. All three works belong to the Tate.

7 W.R. Sickert, 'The Naked and the Dead', *The New Age*, 21 July 1910, quoted in Osbert Sitwell, ed., *A Free House!... the Writings of Walter Richard Sickert*, London 1947, p. 327.

8 Hamilton contrasts Vermeer's *camera obscura*-based technique for establishing spatial relationships with the preoccupation with measurement that is central to Saenredam's work.

9 There is a link here with the contrast in Saenredam's interior between the permanence of the architecture and the transience of the contemporary figures we see within it. Also with academic debate as to whether Saenredam's figures are by his or another hand.

10 On this topic and its relation to transparency, time and abstraction see the chapter on 'Location and Identity' in the author's 'Richard Hamilton: The Longer View' in exh. cat. *Richard Hamilton*, Tate Gallery, London, June–September 1992, pp. 11–26.

11 In this way *The passage of the bride* develops Hamilton's earlier painting *Passage*.

12 Even in Mondrian's most severely abstract paintings Hamilton sees a combination of sensuousness and discretion in the handling of paint similar to Saenredam's. The Dutch artist Jan Dibbets (born 1941) has paid explicit tribute to Saenredam in many of his images of buildings in other countries.

13 *Chicago Project I* and *II*, 1969 (both reproduced. in colour on pp. 108–9 of exh. cat. 1992, cited note 10), which foreshadow the motif of receding verticals in *The Saensbury wing*.

14 Quoted as title of interview by Jonathan Watkins in *Art International*, no. 10, Spring 1990, pp. 51–2.

15 'The Distant Involvement of Richard Hamilton. An Interview', in *Vanguard, Journal of Vancouver Art Gallery*, September 1978, pp. 12–14.

INGRES

Jacques Marquet, baron de Montbreton de Norvins 1811; reworked after 1814

NG 3291 Oil on canvas, laid down on panel, 97.2 x 78.7 cm

JEAN-AUGUSTE-DOMINIQUE INGRES (1780–1867), perhaps the most original of Jacques-Louis David's students, displayed prodigious talent in capturing a likeness on his arrival in Paris in 1797. From the time he emerged as an independent artist early in the new century, however, he was always willing to sacrifice spatial logic and anatomical accuracy in his portraits in the interest of a wider compositional coherence. At the same time, his portraits were often compounded of countless meticulously observed details of dress and setting, rendered with bravura verisimilitude. Viewers were amazed by his ability to evoke the tactile sensations of fur and silk, polished bronze and glinting jewels, with nothing more than a paintbrush or lead pencil. In the early years of his career, however, this almost hallucinogenic skill led to harsh criticism of his art, and no artist was more sensitive to negative criticism than Ingres. He left Paris for Rome in 1806 under the onslaught of ferocious reviews. He did not return until 1824, when he finally dared to gamble again on Parisian success, and won.

In Rome he found a steady clientele for his portraits, first among the high officials of the Napoleonic occupation of the city and then, after the fall of the Empire in 1814, with Grand Tourists, many of them British, enabled by the cessation of war once again to travel on the Continent. Jacques Marquet, baron de Montbreton de Norvins, fell into the first category of sitter. He was one of those striving young men from the provinces, not unlike Ingres, who found their opportunity serving the Emperor abroad. Appointed Chief of Police for the Roman States in 1810, he turned to the artist the following year to paint a portrait worthy of his new station. Pinch-lipped, sharp-eyed, uncongenial – Stendhal described him as 'quite nasty' – Norvins turns to face us down, left hand shoved into his jacket in imitation of the man who had made him what he was. With Napoleon's defeat, however, it seems that Norvins asked Ingres to paint out a bust of the Emperor's son, the King of Rome, that had stood on a pedestal behind him at upper left, and to replace it with a politically innocuous bust of Roma, at right. Time has taken its revenge, however: as the oil paint becomes transparent with age the compromising bust emerges more and more clearly from behind the red silk curtain with which Ingres had covered it at his client's request.

Ever since his re-establishment in critical acclaim on his return to Paris, Ingres's renown as a portraitist has been based on an appreciation of the manner in which he wedded grand general effects with minute detail. Recently, for the first time, provoked by David Hockney's enquiries, the question whether Ingres used an optical instrument such as a *camera lucida* to anchor the exactness of his verisimilitude has emerged as a subject of debate.
Christopher Riopelle

DAVID **HOCKNEY**

born Bradford, Yorkshire, 9 July 1937

© National Gallery, London

EVEN BEFORE graduating from the Royal College of Art in 1962, David Hockney had established his reputation with touching, humorous, *faux-naif* paintings that employed the languages of child art and graffiti to express a very personal world view. Misleadingly identified with the nascent Pop art movement, he was recognised as a leading figurative painter by the mid-1960s, when he had relocated to Los Angeles and produced the first of the swimming-pool idylls that remain among his most loved works.

Hockney's prodigious talents not only as a painter, but also as a draughtsman, printmaker, stage designer, photographer and theoretician, have made for one of the most varied bodies of work in post-war art. His reputation will be guaranteed by the skills displayed in his drawings alone, most powerfully evident in the pen-and-ink portraits he began in the mid-1960s and in the series of Ingres-inspired portraits initiated in 1999. He lives in Los Angeles, but makes increasingly frequent visits to his studio and home in London.

D HOCKNEY

Twelve Portraits after Ingres in a Uniform Style 1999–2000

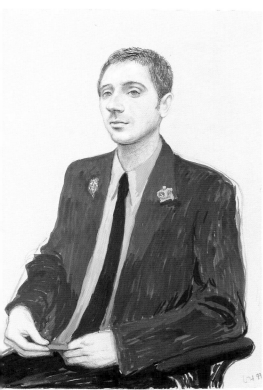
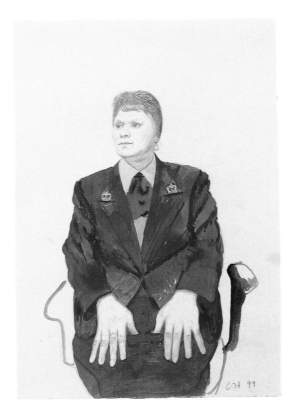
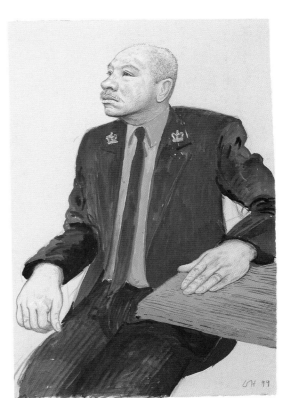

DAVID **HOCKNEY**

Each pencil, crayon and gouache on grey paper using a *camera lucida*, 56.5 x 38 cm, courtesy of the artist © David Hockney

155

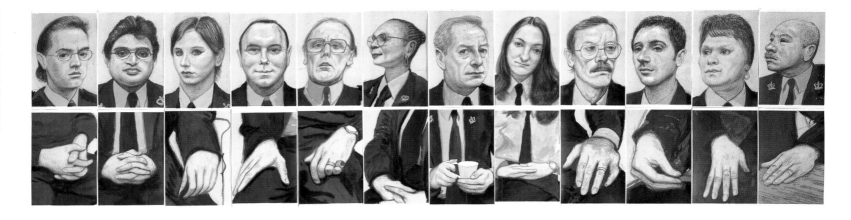

THE *Twelve Portraits after Ingres in a Uniform Style,* consists of twelve portraits of uniformed National Gallery warders, drawn from life in pencil, crayon and gouache on grey paper, executed at David Hockney's London studio between 16 December 1999 and 11 January 2000. Each was drawn in a single sitting lasting between three and five hours, with short breaks, so as to capture the intense and lively presence of each person. Although the lower register consists of drawings made in the closing days of 1999 and the top register of drawings produced in the first days of 2000, they are arranged not in chronological order but on visual grounds, so as to create the most arresting composition and to emphasise the individuality of each man or woman portrayed.[1] The drawings positioned at each of the four corners depict figures who are turning inwards, leading the eye towards the centre of the work and setting into motion the sense of people observing each other that

1 David Hockney *Twelve Portraits after Twelve Portraits after Ingres in a Uniform Style,* 2000, colour laser copies, 86.5 x 335 cm, courtesy of the artist © David Hockney

2a Jean-Auguste-Dominique Ingres *Mme Louis-François Bertin, née Geneviève-Aimée-Victoire Boutard,* 1834, graphite on paper, 31.2 x 24.1 cm, Paris, Musée du Louvre

2b Jean-Auguste-Dominique Ingres *Dr Thomas Church,* 1818, graphite on paper, 20.2 x 15.9 cm, Los Angeles County Museum of Art. Purchased with funds provided by the Loula D. Lasker Bequest and the Museum Associates Acquisitions Fund

2c Jean-Auguste-Dominique Ingres *Auguste-Jean-Marie Guenepin,* 1809, graphite on wove paper, 21 x 16.3 cm, Washington D.C., National Gallery of Art. Gift of Robert H. and Clarice Smith

is at the heart of the picture's meaning: for, if the warders' job is to keep a careful eye on visitors to the gallery, so the artist is engaged in an intense scrutiny of the features, body language, gestures and character of the people who have agreed to yield to his gaze.

In late January, on his return to Los Angeles, Hockney began 'playing' with these new drawings, as has become his habit, by creating photocopied enlargements of details such as the heads so that he could pin them up and study their network of marks more closely. Using a colour laser printer to capture as effectively as possible their tonal nuances and vivid hues, he found himself improvising a second, much larger, version of the work that consists of the twelve heads – laid out in a single row, but in the same sequence as the original drawings – surmounting the twelve pairs of hands (**1**). The resulting fractured images, which recall the post-Cubist experiments of his photocollages of the early 1980s, exaggerate the imposing physical presence of

2d Jean-Auguste-Dominique Ingres *Mrs John Mackie, née Dorothea Sophia Des Champs*, 1816, graphite on paper, 20.9 x 16.4 cm, London, Victoria and Albert Museum

the figures and call attention to the way that their personality and identity are conveyed as much through their manual gestures as through their physiognomy and facial expression. Created with the assistance of a photo-mechanical process, these 'copies' also bring full circle the dialogue with lenses and optical instruments that lay behind the creation of the original drawings themselves, for which he had availed himself of a *camera lucida*.[2]

Hockney's first idea for the *Encounters* exhibition was to take as his inspiration a work from the National Gallery collection that has been on loan to the Tate since 1997: Pablo Picasso's *Fruit Dish, Violin and Bottle (Compotier, violin, bouteille)* of 1914. That work appealed to him not only because it was the most modern in the collection, and by the twentieth-century artist whose work has influenced him most profoundly, but also because it seemed to him to be perhaps the only work in the National Gallery that was creating a new language, one for which there were no real precedents among its other holdings. By September 1999, however, he was so deeply engaged with drawing portraits inspired by the Ingres exhibition held at the National Gallery earlier in the year[3] that it made no sense to him to interrupt his by now fanatical dedication to a new way of drawing in order to produce a painting that he might otherwise have had no occasion to make. How much better it would be to express his gratitude to the National Gallery for mounting the Ingres show by making a work that would evoke with great directness the stimulation that artist had afforded him, and the lessons he had learned from his many visits to the exhibition. It was, in fact, the drawings (**2a–2d**) temporarily on display, rather than the two major oil portraits in the permanent collection (*Jacques Marquet, baron de Montbreton de*

Jean-Auguste-Dominique Ingres *Jacques Marquet, baron de Montbreton de Norvins,* 1811; reworked after 1814

Norvins and *Madame Moitessier*), to which he made particular reference.[4]

As a postgraduate student at the Royal College of Art Hockney had responded to the obligatory task of making a transcription in a light-hearted and highly personal way, rephrasing the Pre-Raphaelite masterpiece *The Last of England* by Ford Madox Brown in loose brushwork and reinventing the emigrant couple as a pair of embracing boys. At that time, he joked mischievously, 'All you [had] to do [was] make a fuzzy version of it and then put in big, significant lines.'[5] Unimpressed by the perfunctory compositional exercises that many students produced in response to works that did not engage them on any deeper level, he was determined to interpret an earlier picture in a style that was wholly his own and that also conveyed his identity as a man.

The National Gallery has been a familiar hunting ground for Hockney since he first

3 David Hockney *Joe McDonald*, 1976, lithograph in two blacks, 105.4 x 75.5 cm, courtesy of the artist © David Hockney

visited it in 1955 or 1956 as a teenage student from Bradford, in the company of his friend Norman Stevens, and the history of art stretching back as far as ancient Egypt has been a reference point for his work since the early 1960s. In one of his most memorable early paintings, *Play within a Play*, 1963, the humorous way in which his dealer John Kasmin is shown sandwiched between the canvas support and a pane of glass was derived directly from a pictorial device used in a detached fresco he had admired in the National Gallery, *Apollo killing the Cyclops,* by the seventeenth-century painter Domenichino. Years later, in *Looking at Pictures on a Screen* of 1977, Hockney painted

his friend the curator Henry Geldzahler admiring colour reproductions of four master-pieces from the National Gallery pinned to a free-standing folding screen.[6] It was this canvas that Hockney took as the centrepiece for his *Artist's Eye* exhibition *Looking at Pictures in a Room* at the National Gallery from 1 July to 31 August 1981, which he presented as an installation featuring the objects shown in the painting, and for the accompanying publication *Looking at Pictures in a Book*, in which he wrote about the pleasure one experiences in looking at art even in reproduction.

Hockney had long admired Ingres's drawings and had, in fact, consciously sought to emulate their precision of observation in the mid-1970s, in a group of crayon drawings made in Paris and in a series of lithographs made at Gemini G.E.L., Los Angeles, during two visits in 1976 (**3**).[7] After seeing the National Gallery exhibition he quickly realised, however, that his own earlier portraits – large in scale and intensely worked over three or four days, with a good day spent on the head alone – could not have been made in the same way as Ingres's drawings, which were generally very small and in which the vitality of the marks indicates that they must have been made in a single session in the space of just a few hours.[8] He read the Ingres catalogue from cover to cover,[9] hoping to find out how the Ingres drawings had been made. When he discovered that the essays and entries were rich in information about the sitters but made little reference to questions of technique, he took it upon himself to put to the test his own theory that Ingres might have used an optical

device known as a *camera lucida*, patented in 1807,[10] just when Ingres was embarking on his first portrait commissions in Rome, to help him quickly secure a likeness when drawing people he did not know. The *camera lucida*, an instrument still being manufactured today, is essentially nothing more than a small prism (mounted at the end of a metal arm) through which the subject is refracted and reconstituted as a virtual image on a sheet of paper.

With the characteristic single-mindedness that Hockney has displayed in the past, when embarking on a new venture such as the Polaroid photocollages of 1982, the 'home-made prints' made with colour photocopying machines in 1986, or the fax drawings of 1987,[11] he applied himself both intellectually and by reference to his practice as a draughtsman to working out for himself how Ingres might have proceeded. Well aware that his theories would require a radical reassessment of Ingres's work and might be met with some resistance by scholars demanding documentary evidence, he began corresponding on the subject of optical devices with friends and with art historians such as Martin Kemp,[12] so that he could begin to put his intuitions into words, and simultaneously began using a *camera lucida* himself in order to put those ideas into action. He became convinced that lenses and optical devices of various kinds had been widely used by artists for a good five hundred years to avoid awkwardness in drawing difficult forms. As he wrote in an article published in the heat of these investigations, 'I have always deeply admired the drawings of Ingres. I first came across them more than 40 years ago as an art student in Bradford. They were held up as an ideal in drawing: sensitive, full of character and uncannily accurate about physiognomy I looked closer and closer and began to think that some mechanical device must have been used here. I remembered many years ago buying a *camera lucida*: I tried it for a day and forgot about it. So I asked Richard [Schmidt, his assistant] to nip down

to our local art store and buy one – I knew they would have one. I made a drawing of Richard using it. It is a very simple device – quite small, really just a prism, but it enabled me to place the eyes, nose and mouth very accurately. I then drew from direct observation.'[13]

Hockney had always shied away from drawing people he did not know well and had long refused to take on commissions even from eminent sitters,[14] concerned that when drawing an unfamiliar face too much struggle would be involved simply in capturing a likeness. With the *camera lucida* to help him establish the position of the eyes, nose and mouth in the first few minutes, he was able to move on almost immediately to direct observation, secure in the knowledge that naturalistic accuracy would be assured. The first *camera lucida* drawing by Hockney, the portrait of Richard Schmidt, was made on 29 March 1999. Since learning how to exploit the instrument to best effect was not at all easy, he remarked that his assessment of Ingres's probable use of it 'in no way diminishes anything' for him but on the contrary increased his already great admiration for the French artist's skill.[15] Within weeks he had become much more confident in using the instrument, thanks to his daily practice, and had become 'utterly, utterly convinced' that he had been right in thinking that Ingres had used such a tool for similar purposes, and that it was nothing more than 'a measuring device' that enabled artists to produce a very sure and accurate line.[16] By late May he was producing extremely accomplished portraits, such as that of the publisher Stephen Stuart-Smith (**4**), that capture a person's appearance with such faithfulness and extreme concentration that one has the illusion not just of being physically confronted by that person but of being able to read his mind through the specificity of expression, the signals of every gesture and the state of tension within every facial muscle. With each passing week, the habit of such

relentless scrutiny and of such close attention to detail pushed him towards ever greater demands on his powers of observation and manual skill. He was particularly excited by the lively quality introduced by such fleeting expressions as a half-smile. In a portrait such as that of Jacqui Staerk (**5**), an image of such truthfulness and vitality emerges both from her facial expression and from the treatment of her wispy strands of hair and other defining features that viewers are easily persuaded they know her or would recognise her if they came across her in a crowded room: an experience the author can corroborate from meeting her

4 David Hockney *Stephen Stuart-Smith, London, 30th May 1999*, 1999, pencil and white crayon on grey paper, using a *camera lucida*, 38.1 x 35.6 cm, courtesy of the artist © David Hockney

at a party many months later.

An exhibition of Hockney's oil-pastel studies of the Grand Canyon planned for the Annely Juda Gallery in late June 1999 provided him with an opportunity to present a selection of fifty-six from the hundred or so *camera lucida* drawings he had produced since the end of May during his stay in London. Although it was too late to reproduce them

5 David Hockney *Jacqui Staerk, London, 26th June 1999*, 1999, pencil and white crayon on grey paper, using a *camera lucida*, 38.1 x 44.1 cm, courtesy of the artist © David Hockney

or even mention them in the catalogue, Hockney's text of 29 June for the gallery's press release asserted: 'The use of optics in drawings goes back at least to Holbein and Dürer'. He recounted making the drawings with an instrument that he described as 'essentially a prism on a stick through which you look with both eyes and can see an image and your pencil simultaneously. All you can use it for is measuring to capture subtle expressions – you cannot scrutinise a face through it.'[17]

By the time Hockney returned to London in December 1999 to begin work on the National Gallery portraits, he had produced some two hundred such drawings

with the *camera lucida*. Having returned with such conviction to portraiture as a direct result of his love for Ingres's drawings, after years of involvement with other subject-matter (including landscapes and near abstractions), stage design and experimental media (involving photography, digital imaging and reproductive methods), he was ready to meet the challenge of drawing a group of strangers who had been selected on his behalf. He wished to draw the warders – rather than the board of trustees, as an earlier artist might have done – in large part because he knew they would be on duty in the very rooms where his drawings would be shown, offering the visitor an unparalleled opportunity for comparing the portrait with the actual person.[18] He also liked the fact that they tended to be shy people whom others normally do not notice, since their job is to sit

in a corner and observe the visitors without drawing attention to themselves. By nature patient people, they were likely to make good models, able to sit still for long periods, even though most of them had never been drawn before. Compounding the challenge to his own ability was his knowledge that he would be visiting London for only a short period and that every sitting, day after day, would have to result in a successful drawing.

Hockney's original intention was to produce a group of six portraits, and to do so in the largest format he had yet chosen for his *camera lucida* drawings. (There is a built-in limit to the size of image that can be produced with this device; the closer the subject sits to the artist, the larger the image.) As soon as he began, he realised that the physical presence of the sitters would be heightened if there were more of them, at which point he settled on twelve as the optimum number: not so many that they became part of a crowd, but enough to call attention to the variety and individuality of each person. Virtually without exception, each figure is contained well within the borders of the sheet, emphasising that he or she exists within his or her own sphere rather than in a shared space. Great care has also been taken to avoid giving the impression that the warders are in conversation or glancing at each other.

The artist's only request to the National Gallery, whom he entrusted with the selection, was that they send him the greatest possible variety of male and female sitters of different ages, races and physical types. The National Gallery's head of security, Jon Campbell, invited one of the warders, Jack Kettleworth (himself a young artist), and his own assistant Caroline De Souza to help him make the selection; the ratio of one-third women to two-thirds men, like the mixture of nationalities and ages from early twenties to mid-sixties, accurately reflects the composition of the warding staff as a whole.[19] Once selected, they met Hockney briefly, usually a

day or so before being drawn, so that he could get to know them a little, study their faces, their expressions and their movements, just as Ingres had done by having lunch with his prospective sitters in advance of the portrait session.[20] All the drawings were made in Hockney's London studio, where the careful placement of the sitter under a strong overhead light – especially evident in the pronounced shadows under the nose and lips – helped him achieve a precise modelling of the features.

Although Hockney had tentatively introduced elements of colour into some of his previous *camera lucida* portraits, the National Gallery piece is the first to use colour so forcefully as an expressive element in itself. After applying this brushwork, he sometimes returned to the pencils to make adjustments, for example to soften edges. The use of gouache is limited to the uniforms, to

7 Pablo Picasso *Ambroise Vollard*, 1915, pencil on paper, 46.7 x 32 cm, New York, Metropolitan Museum of Art. The Elisha Whittelsey Collection, The Elisha Whittelsey Fund 1947

which it helps direct one's attention, and was applied in the final hour or so of the sitting with a vigour matched by the artist's freedom in departing from the official shade of blue. Given the comparative delicacy of the pencil marks that describe the heads and hands, this use of an opaque medium in such strong colours is particularly bold. The various blues, mauves and purples, and the shapes these make within the frame of each sheet of paper, establish a dynamic rhythm that has its own self-sufficient, abstract visual logic.[21] Hockney accepted whatever colour he mixed for each drawing, rather than worrying about maintaining consistency. As he laconically explained, 'I've certainly got my artistic license It was just renewed yesterday.'[22] Everything in these drawings, including the variety of ways in which the uniform is worn,[23] is geared to maximising one's sense of the particularity of each person, studied at close quarters over an extended period of time: the way they choose to sit, what they do with their hands, their facial expressions, how directly they address themselves to our gaze, the degree to which they are tense or relaxed. By turns self-possessed and secure, sad or withdrawn, content or lost in thought, they display a range of emotions that makes us believe in them as real people with definite personality traits.

Naturalistic portraits of people have featured prominently in Hockney's work since the mid-1960s, when he made his first concerted group of line drawings from life using a Rapidograph pen. At irregular intervals he has revisited the subject in a new way (for example in his post-Cubist experiments of the 1980s), using a variety of media including pen and ink, watercolour, coloured

6 Hans Holbein the Younger *Sir Thomas More*, 1528, black and white chalks, 39.7 x 29.9 cm, The Royal Collection

crayons and now a specific range of pencils chosen for the size and density of mark in relation to the dimensions of the paper.[24] The *camera lucida* drawings, and the portraits of National Gallery warders that provide such a specific group within them, are among the most haunting 'speaking' likenesses he has made in his distinguished production as a draughtsman for over forty years. Although inspired above all by Ingres, they also look back to the scrupulous objectivity of Holbein's portraits (**6**) and forward to the naturalistic drawings of Picasso even before his 'classical' phase of the 1920s (**7**), revealing the continuity of this tradition within the twentieth century and its role within Hockney's long and productive involvement with the work of Picasso. Somewhat

unexpectedly, these new drawings also have affinities with Van Gogh's reed-pen drawings (**8**) of the kind that had inspired Hockney in 1978, and which in their bold and intimate depiction of 'ordinary' people perhaps have acted subconsciously as an influence on the National Gallery portraits.

Hockney is well aware that everything an artist does, even when he is trying to emulate another artist, inevitably comes out as his own, marked by his temperament, his habits, the nature of his looking and his way of interpreting through his hands what he sees with his eyes. Confronted by these portraits, one soon forgets about Ingres, about the *camera lucida* and even about Hockney himself as their author, and thinks instead about the marvellous exchange of experience between one human being and another.

Marco Livingstone

Notes

1 From left to right, beginning with the top row, they are: Devlin Crow, 11 January 2000; Pravin Patel, 5 January 2000; Katherine Dooley, 6 January 2000; Graham Eve, 7 January 2000; Brian Wedlake, 10 January 2000; Lena James, 3 January 2000; Ron Lillywhite, 17 December 1999; María Vásquez, 21 December 1999; Ken Bradford, 20 December 1999; Jack Kettlewell, 13 December 1999; Fazila Jhungoor, 18 December 1999; and Vincent Simon, 16 December 1999.

2 In faxing the author a reproduction of this work on 27 January 2000, Hockney wrote: 'I have made this piece from the drawings and my machinery. I think it's the best printing piece I've done with this method It begins with 19th century ideas + technology and takes us in[to the] 21st century.' In a telephone conversation on 30 January he elaborated his thoughts about this work, which he sees as separate from the set of twelve drawings but as closely related to it: 'You look at the drawings another way, then you go back to the drawings Many years ago – fifteen years ago? – I tried doing portraits by putting the head on a small canvas, the hand on another and so on. They never worked for me very well Those hands in the drawings [of the warders] deeply relate to the faces and attitudes of those people. So when you separate one out and stick it next to the face, they work very well, because they were done at the same time and they're deeply about the way that face looked It's also using new technology in another way, but producing everything based on a pencil drawing, a 19th-century technology.'

3 *Portraits by Ingres: Image of an Epoch* was held at the National Gallery 27 January–25 April 1999, and then travelled in expanded form to the National Gallery of Art, Washington, D.C. (23 May–21 August 1999) and the Metropolitan Museum of Art, New York (5 October 1999–2 January 2000). Hockney saw it at all three venues and visited it with particular frequency in London.

8 Vincent van Gogh *The Postman Joseph Roulin* (*'Le Postier'*), August 1888, pencil, reed pen and brown and black ink on Whatman paper, 51.4 x 44.2 cm, Los Angeles County Museum of Art. Mr. and Mrs. George Gard De Sylva Collection

4 'It might not have been one specific picture in the National Gallery collection [that inspired me],' Hockney explained to the author by telephone on 30 January 2000, 'but it was something genuine I found which I took and used I learned a great deal in the National Gallery in 1999 that I hadn't known before. So when they asked me if I would do something from a work in the collection I then realised, "My God, I can!" It had taught me a lot ... and I demonstrated it.' The prolonged experience of drawing portraits during 1999 had a great impact on his own practice: in late January 2000 he began drawing portraits on a larger scale without the *camera lucida*, but with the lessons of measurement so fresh in his memory that he could now achieve similar effects with just his eyes. It also increased his insights into a great deal of the earlier art on display at the National Gallery. 'If you listen to my theories, you start looking at pictures in a lot more interesting way.'

5 In conversation with the author, 6 January 2000.

6 One of these paintings, Vermeer's *Young Woman standing at a Virginal*, c.1670, has coincidentally been chosen as a source for the *Encounters* exhibition by Claes Oldenburg and Coosje van Bruggen. The other works featured in Hockney's painting are all, like this Vermeer, favourites centred mostly on the human figure: Piero della Francesca's *Baptism of Christ*, Vincent van Gogh's *Sunflowers* and Degas's *After the Bath*.

7 For the small book announcing the publication of these prints, *18 Portraits by David Hockney* Los Angeles, undated [1977], the artist chose details of the lithographs, mainly of the heads, for the main section of colour reproductions, anticipating his practice during 1999 of pinning up rows of colour photocopy enlargements of the heads in his *camera lucida* portraits.

8 Conversation with the author, 11 January 2000.

9 Edited by Gary Tinterow and Philip Conisbee. The entries on the drawings were written by Hans Naef.

10 For a description and reproduction of this instrument, see the entry in *The Dictionary of Art*, London 1996, vol. 5, pp. 518–19.

11 For a discussion of these works, see Marco Livingstone, *David Hockney*, new enlarged edition, London 1996, pp. 235–8, 242–3 and 247–51.

12 Professor Kemp's book, *The Science of Art: Optical Themes in Western Art from Brunelleschi to Seurat*, London 1990, one of the most serious investigations yet undertaken on the use of optical instruments by artists, was read with great interest by Hockney, who made contact with Kemp and drew his portrait using the *camera lucida* on 22 June 1999. A frequent correspondence between them ensued by fax. Hockney is now working on a book that will consolidate his investigations into the use of lenses and other optical devices by artists from the Renaissance through to the nineteenth century.

13 David Hockney, 'The coming post-photographic age or Joshua Reynolds had a camera obscura that folded up to look like a bookcase', *RA: The Royal Academy Magazine*, no. 63, Summer 1999, pp. 44–7. Hockney considerably expanded his analysis to include the work of many earlier artists, among them Raphael and Caravaggio, for a paper called 'The Coming Post-Photography Age: Part II', which he presented on 12 October 1999 at the National Gallery of Australia in Canberra and on two occasions in New York: at the Ingres symposium held at the Metropolitan Museum of Art, New York, on 22 October 1999, and again on 27 October 1999 at the University of Columbia Graduate School of Journalism.

14 The 1971 *Portrait of Sir David Webster* commissioned by the Royal Opera House, Covent Garden, now in the collection of the National Portrait Gallery, is a notable exception. See the artist's account in *David Hockney by David Hockney*, London 1976, pp. 204 and 239.

15 Fax to Neil MacGregor, Director of the National Gallery, 10 October 1999.

16 Telephone conversation with the author, 2 May 1999, just after he had spent a weekend making eight or nine drawings with the *camera lucida*.

17 See also Hockney's remarks from an interview in June 1999, in *Hockney on 'Art': Conversations with Paul Joyce*, London 1999, pp. 255–8, and the copious transcriptions of his spoken and written observations published in an article by Lawrence Weschler, 'The Looking Glass,' *New Yorker*, 31 January 2000, pp. 65–75. It is evident from Weschler's article that Hockney not only faxed the same letters to numerous people, this author included, but rehearsed his arguments over and over in daily phone calls to them.

18 The National Gallery's Head of Security, Jon Campbell, in conversation with the author on 11 January 2000, referred to the warders as 'the "front-line troops", the people who deal directly with the public'.

19 At the time the drawings were made, the National Gallery was about ten short of its full complement of approximately 170 warders. Jack Kettlewell made just over half the suggestions for the initial selection, which were then examined in relation to those put forward by his two colleagues. He admitted to the author in conversation on 11 January 2000 that some of his choices were based on his own art historical interests: Graham Eve, for instance, reminded him of an early Lucian Freud portrait of Francis Bacon, while Ken Bradford brought to mind a Chuck Close self-portrait. He did not explain any of this to Hockney, however, not wishing to influence the way he saw the sitters, just as Hockney himself did not want to be tempted to choose the people himself on the basis of how interesting their faces might be to draw. Although a memo about the project was circulated to the warders in summer 1999, most of them told me they had known little or

nothing about the situation or the identity of the artist when they were invited to take part.

20 From the natural postures and psychological insights of Ingres's portrait drawings, Hockney deduced that Ingres 'must have had a way of charming sitters into being at ease'. The 'charm' factor was clearly also in Hockney's favour: 'down to earth' and 'easy to be with' were the descriptions of him that came up most often in the discussions the author had between 11 and 21 January 2000 with the twelve warders he had drawn.

21 In conversation with the author, 11 January 2000, Jack Kettleworth, the first to be drawn, recalls that Hockney had told him that he planned to perfect the blue so that he could have a 'lump' of it ready to use for the remaining portraits. His original intention was clearly abandoned soon afterwards.

22 Conversation with the author, 2 January 2000.

23 Warders may wear a jacket, a thin jumper and jacket, or a thick jumper with epaulettes over their shirts. In hot weather only they are allowed to work in their shirtsleeves. Hockney's portraits make particular play of the crown pins worn in the buttonholes of the lapels on the jackets, and of details that emphasise the character or physical attributes of each sitter: the way, for instance, that Brian Wedlake proudly wears his identity tag as a badge, or that Katherine Dooley's small stature is made obvious by the overlong sleeves of the jacket, designed for men.

24 In an e-mail to the author dated 28 January 2000, Richard Schmidt wrote: 'In making these drawings, DH uses a range of pencils form 2H to 9B, with most of the drawing being done I believe with the softer pencils, in the 4B–9B range.'

SEURAT
Bathers at Asnières 1884

NG 3908 Oil on canvas, 201 x 300 cm

BRIEF AS IT WAS, the artistic career of Georges–Pierre Seurat (1859–1891) was punctuated by the creation of three large-scale, enormously complex paintings, of which this is the earliest. Each of the three was technically audacious, provocative in subject-matter, and thematically interrelated with the others – provisional manifestos in Seurat's evolving conception of what monumental modern art ought to be. Here, the artist shows young working-class men bathing along the River Seine at Asnières, an industrial suburb north-west of Paris. In the distance, a steam train crosses a railway bridge and factory chimneys smoke. The artist made some half dozen drawings of individual figures in the painting, all of them seen in strict profile. He devoted more than a dozen small-scale preparatory oil sketches to an investigation of the landscape setting and to experiments with the placement of figures in it. Even after it was completed, Seurat returned to repaint various parts of the canvas in response to later developments in his art. If at the time the depiction of feckless youth wiling away their leisure hours at an

unlovely site might have seemed an unlikely subject for a painting of such size and ambition, nonetheless we now see the ways in which the work is deeply imbued with Seurat's knowledge of the grand Arcadian visions of such contemporaries as Puvis de Chavannes and of paintings by predecessors as august as Poussin, not to mention an enthusiastic acquaintance with the hieratic art of ancient Egypt, newly appreciated in the 1880s.

Many of the youths look or call across the water, to the Ile de la Grande Jatte at right, itself not seen here, a more elegant pleasure-ground directly opposite Asnières which was the setting for the artist's next great painting, completed two years later. Originally the same size as this work, *A Sunday on the Grande Jatte* (Art Institute of Chicago) was the first painting Seurat completed in his distinctive *pointilliste* style, consisting of countless dots of contrasting colour. He then returned to the *Bathers*, re-painting parts of it in the new *pointilliste* style – note the hat of the boy with hands to mouth, at right – and adding details such as the ferry boat with a flag that carries a well dressed bourgeois couple across to the Grande Jatte, alterations that subtly reinforce a connection between the two paintings. In 1888, Seurat completed his third major painting, the enigmatic *Models* (Merion, Pennsylvania, The Barnes Foundation). Here, three female models – or the same model depicted three times – pose in front of the Chicago painting, which leans against the studio wall; this picture, too, is then implicitly linked with the two that preceded it. The sequential interdependence of these three works, and their complicated mutual dependence on traditional art-forms and motifs, seen anew, announced central concerns of much innovative twentieth-century art.
Christopher Riopelle

HOWARD **HODGKIN**

born London, 6 August 1932

© Terence Donovan

Hodgkin STUDIED AT Camberwell School of Art and at Bath Academy of Art, Corsham (where he later taught). During the ascendancy of Pop and hard–edge abstraction, his paintings of the early 1960s seemed puzzling in their fusion of bold, declaratory colour and clear form with a sense of private experience and meaning. His central purpose is to create images that constitute living equivalents for remembered situations, at the same time achieving self-sufficiency as aesthetic objects. Crucial to Hodgkin's subject are human relationships and his own feelings; these are indivisible from his recollection of visual particulars, including many forms of artifice. Encompassing a rich *comédie humaine*, his oeuvre extends from scenes of powerful intimacy to landscapes animated by vivid effects of light. All aspects of his work convey a strong sense of place, not least in subjects resulting from his experience of India. He is an expert on Indian art, which has influenced his work.

Hodgkin has evolved a vocabulary of individually articulated marks that are at once elementary and intensely personal. Their execution ranges from blunt deliberation to gestures of arresting sweep and force. His choice of painting support is distinctive, from breadboards to the substantial picture frames he subsumes into the image. Creating vibrant colour relationships and compositions of marked, even luxurious decorative vitality, Hodgkin combines striking immediacy with imaginative resonance. Knighted in 1992, he lives in London.

RD HODGKIN

Seurat's Bathers 1998–2000

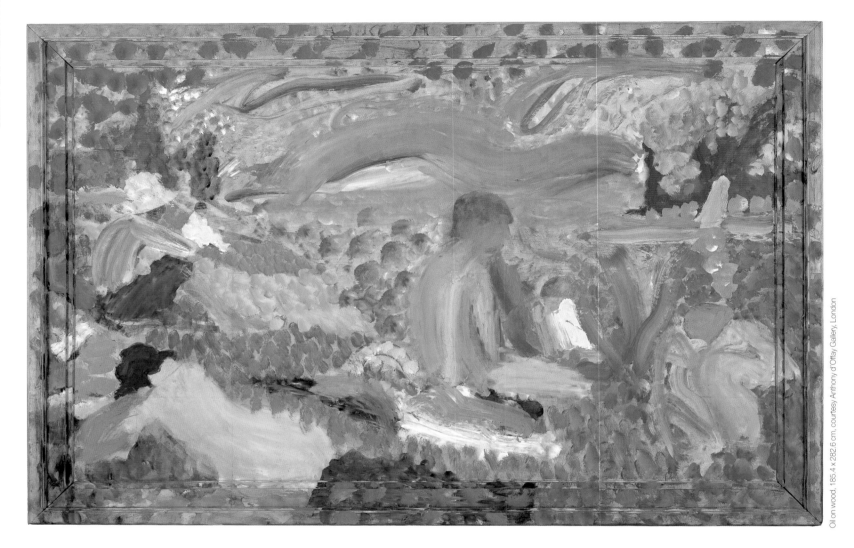

Oil on wood, 185.4 x 282.6 cm, courtesy Anthony d'Offay Gallery, London

Georges-Pierre Seurat *Bathers at Asnières,* 1884

HOWARD HODGKIN'S painting after Seurat is close to its source in size, making it the largest picture he has painted. It is also unusual for him in another way. The great majority of Hodgkin's works are about very particular situations that he has both observed and experienced on other levels. If the viewer knows the subject of a painting the work can often be seen to be remarkably accurate in terms of appearance. A Hodgkin painting would not, however, generally be perceived at first viewing as a likeness of its stated subject. *Seurat's Bathers,* on the other hand, declares its motif instantly and with dramatic force.

In the very act of affirming the Seurat, however, Hodgkin fuses appearances with feeling in such a way as to relocate the scene we see. Though it could not exist without its great precedent, the new picture places the viewer in a world distinct from Seurat's, replete with its own atmosphere, mood and range of sensations. Both works present a view that is radiantly light. But where the Seurat has been described as conveying 'a feeling of calm verging on lassitude',[1] the Hodgkin, despite the motionless postures of the figures, is strikingly animated. This quality derives from its heightened colour, from the colour relationships, from Hodgkin's handling of paint and from a conscious tension between flatness and space.

Along with immediate recognition of its subject, a first sight of *Seurat's Bathers* induces a feeling of shock. Its intensified colour shares with the gestures of Hodgkin's hand a quality of liberation. Renowned though Seurat rightly is for his broken touch, the substance of his paint reads as a smooth paste by contrast with the direct and at times even slammed

1 Audran after Nicolas Poussin *Echo and Narcissus*, (c. 1630), engraving, 35 x 49 cm, collection of the artist

Despite many differences, the two painters' outlook and practice have much in common. To both, the work of the great classical artists is an inspiration, not least that of Poussin: Hodgkin has lived for decades with engravings after Poussin's peopled landscapes (**1**). Like Seurat, Hodgkin works secretively. Individual paintings by Seurat might often take two years to complete; the same (and sometimes longer) is true of Hodgkin. To each, a picture's surface is of vital importance and no mark made is incidental. The hard-won unity achieved in each work afresh is in part fed, for both painters, by a willingness to draw simultaneously on the canonic past and on the urgent present, and by an inclination towards hybrid sources of stylistic influence.[2] Like the Seurat in its own day, the new work is surprising on several levels. In conforming to the 'given' of Seurat's design, Hodgkin appears to contradict his own customary radical invention of relationships of form. At the same time, his two principal abstract traits, the discrete spot and the

2 Howard Hodgkin *After Corot*, 1979–82, oil on board, 36.8 x 38.1 cm, private collection, courtesy L.A. Louver Gallery, Venice, California

marks that compose the new picture. When the works are seen together, the boldness of Hodgkin's gestures and the frankness with which he exposes each mark demonstrate strikingly the distance art has travelled since 1884. But forthrightness is not the only characteristic of Hodgkin's paint marks. They seem at once agitated and relaxed, impulsive and deliberated. Anxiety attended their formulation but it leaves no trace, for Hodgkin has invented a place in which hedonistic serenity is strangely combined with a sense of magical transformation. Distant aerial bubbles grow enormous as they advance, jostling in the middle ground beneath a vast, languorous emanation that descends from the sky. The panorama is bordered by dots. These enhance the sense that, through their containing garland, the picture discloses to us another state of being. Yet the dots themselves contribute to the effect of floating that pervades the prospect Hodgkin creates and surrounds the figures in their fixed positions.

Hodgkin had wanted to paint *Bathers at Asnières* for some three decades, so it was his immediate choice of source work when invited to take part in *Encounters*.

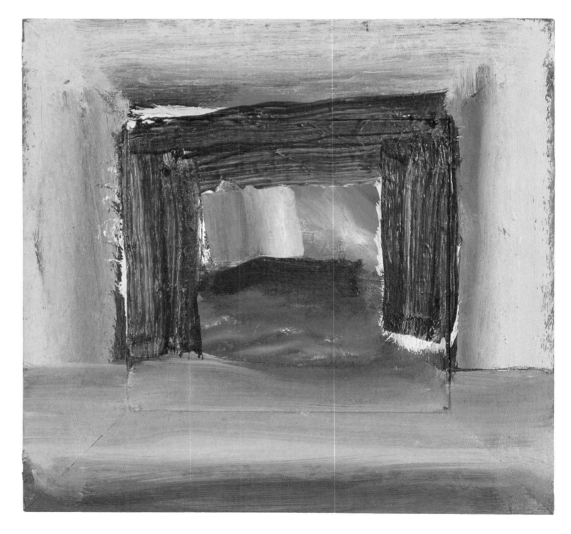

gestural sweep, are laid before us in a dialogue that is unusually equal and exposed.

A further affinity between the two painters is their pictures' synthesis of the elementary and the cultivated. In painting his central figure, Seurat looked back to the Antique, yet *Bathers at Asnières* also

anticipates the doll-like representation of social types that is so marked a feature of its sequel, *A Sunday on the Grande Jatte* (1884–6), and later works. His images of people combine an adult detachment and an acuteness of observation and placing with something of a child's delight in the visible

3 Georges Seurat *Le Crotoy, Upstream*, 1889, oil on canvas, 70.5 x 86.7 cm, in frame painted by the artist, The Detroit Institute of Arts. Bequest of Robert H. Tannahill

scene. A first impression of the Hodgkin is that the way it is painted physically has almost the innocence and assured directness of the

work of a child, with a concomitant sharpness of vision; yet both paint marks and composition are extraordinarily sophisticated.

As his own oeuvre shows, Hodgkin shares Seurat's interest in the *comédie humaine*, in social situations and in the styles and fashions of a period, but such directives are not at work in his picture here. Instead, what drives *Seurat's Bathers* is the impulse to retrieve the source work through memory. Inevitably, the retrieval – a kind of rediscovery – takes very personal form. Hodgkin found as he worked that reproductions of *Bathers at Asnières* were

an impediment to the directness of engagement he sought with the earlier painting. His relationship with Seurat's complex, carefully built up picture was mediated through his own impulse towards the individual, freshly made mark. Seurat is famous for his invention of pointillism, but in *Bathers at Asnières* this was only emergent. In Hodgkin's response, however, dots are asserted with a boldness that Seurat, with his 'points', could not have imagined.[3] Rather than coalescing into an unbroken hue, they assert themselves individually, both as things and as evidence of the painterly act.

Hodgkin's work abounds in paintings that contain representations of works of art by other artists, seen in particular settings. He is interested in the works thus depicted but also, not least, in their owners' relationship with them, in the contexts the owners have created and in human events occurring in those spaces. Museums have long been another preoccupation. Hodgkin has made paintings and prints of situations experienced in their gardens, their cafés and, of course, their galleries. In both types of work distinctive artefacts and individual people interact, at once pictorially and emotionally. Such images are distinct from a number of paintings Hodgkin has made which are titled after earlier masters, *After Corot*, of 1979–82 (**2**), *After Degas* of 1993 and *After Morandi* of 1989–94. None of these 'after' paintings is a memory of a particular moment; each is a construct created by Hodgkin from memories of many different pictures by the artist named.

In all three of these types of picture, as in his art as a whole, Hodgkin works towards the eventual image from an initial invention of his own. He has no idea what the composition of the final result will be, and its overall character can change many times as the painting develops. *Seurat's Bathers* is unique in Hodgkin's work in that he aimed from the outset to stay close to a pre-existing image by someone else.[4] This different starting-point removed many kinds of anxiety, while

5 Georges Seurat *Study for 'A Sunday on the Grande Jatte'*, 1884, oil on canvas, 70.5 x 104.1 cm, New York, Metropolitan Museum of Art. Bequest of Sam A. Lewisohn, 1951

introducing others. Before Hodgkin began to paint, his assistant drew the main elements of Seurat's composition on the flat plane of the support. Though this kept everything in the 'right' place, Hodgkin discovered that working from a given image in this way gave great freedom. Moreover, in revealing both the under-drawing and the bare wood ground at many points, the finished picture exposes each painterly gesture all the more openly, in an extraordinary fusion, in passage after passage, of tight control with turbulence and release.

As in the majority of Hodgkin's paintings of recent years, the paint support consists not only of the principal picture plane but also of a raised, stepped surround. Though formed here, as usual, by what was originally a conventional picture frame, in Hodgkin's hands this structure loses its previous function. Part of his translation of the source image is painted on it, and the resulting picture is frameless. Nevertheless, some of the large blue dots painted by Hodgkin are disposed on this outermost zone in such a way as to give the illusion that it remains a frame. We thus have the sense both that an image of bathers is seen through an enclosure and that the depicted scene is bled at the edges, thus potentially extending into our own space. The latter reading is reinforced by Hodgkin's forsaking his usual device of making the 'frame' element circumscribe the centre of the image tonally. Ultimately, however, any idea of implied extension beyond the confines of the image we see is sharply contradicted by the pronounced object-like character of the work as a whole (a Hodgkin characteristic). Even so, the effect of transparency that Hodgkin creates along the edges serves to augment the quality of

ambiguity that here, as in many of his works, goes hand in hand with an exhilarating assurance. In this work the role of the 'frame' has the added interest of reflecting Seurat's concern, in his later years, both with painting frame-like borders within his pictures (**5**, **7**) and with treating his real frames as extensions of the work (**3**). *Bathers at Asnières*, however, has a conventional frame. When it is seen together with *Seurat's Bathers* the slight

the picture surface and attempts to read the painting in terms of depiction are constantly deflected by awareness of the actions of Hodgkin's brush. In this process, the device of the dot plays a key role. On the scale employed here it is self-evidently discrete and it defines the location of the surface on which it rests. But the crucial contrivance by which the image is flattened is Hodgkin's replacement, with an enormous waving sweep of

equalises, and by sharing that figure's blend of hues, from creamy pink to terracotta.

Hodgkin has been continuously affected, still more than by Seurat, by the facture of pictures painted by the Nabis a century ago. Though often small, Nabi works by Denis, Sérusier, Bonnard and Vuillard enhance the viewer's recognition of the physical reality of a picture as an arrangement of deposits of paint on a flat surface. Hodgkin follows them in encouraging the viewer to comprehend an image as disclosing simultaneously both an observed scene and an interplay of form, colour and texture that constitutes a scene in itself. Thus in *Seurat's Bathers* the central figure is abutted on three sides by sheer slabs of paint, as well as being balanced, in terms of size, by the barely representational flower-like explosion of blue swipes that represents the water between him and the figure with raised arms. Hodgkin's rendering of the main figure itself is startlingly down to earth. While the head is misty (underlining this picture's independence of concern with the figures as individuals), the body is realised in parallel strokes of

6 Georges Seurat *Bathers in the Water: Study for 'Bathers at Asnières'*, 1883–4, oil on wood, 15.5 x 25 cm, Paris, Musée d'Orsay

difference in the two works' size appears larger than it is, simply because the earlier work is extended in this way on the wall.

Seurat's modelling of his figures, the diminishing scale of those disposed along the left side of the picture and the wealth of detail in the distance combine to create an effect of deep space. By contrast, Hodgkin sought to emphasise the flatness of the image he made. Thus eye and mind are drawn insistently to

paint, of the complex of images of large-scale industry that lies beyond the head of Seurat's central figure. One of Seurat's factory chimneys emits a huge plume of smoke, for which Hodgkin's flowing stroke could be read as an equivalent, but its essential character is abstract. In this scene of ease it is an assertive gesture, strange presence and vitalising phenomenon. For all its slowness of pace, it turns the lyrical into the delirious, an effect reinforced by the wildly painted sky above it. Its snaking aerial band flattens the whole composition by virtually touching the head of the picture's principal figure, which it

frankly material paint. The mind tells us instantly what they depict, but they have a concrete reality as simple brushstrokes that may be compared with the skirt of the figure in a strongly patterned picture by Vuillard (**4**).

Paradoxically, in flattening the image of his source in Seurat, Hodgkin simultaneously preserves a sense of deep space in his own picture. Conversely, evidence of an impulse towards flattening is given by Seurat himself, through his open separation of one brushmark from another. For Hodgkin, however, there is a special link with Seurat's oil sketches, and *Seurat's Bathers* responds

directly to these, as well as to the finished picture. Hodgkin's aim was to paint as freely as possible, while remaining faithful to Seurat's broad disposition of motifs. Long before *Encounters* was thought of, Hodgkin had been alerted to unexpected freedom in Seurat by examining the spirited mark-making in the large *Study for 'A Sunday on the Grande Jatte'* (**5**). Then, around the time of the invitation to take part in *Encounters*, he saw all thirteen of the oil sketches for *Bathers at Asnières* in the National Gallery's exhibition *Seurat and the Bathers* in 1997.[5] Small in scale, these present their subjects in a broad, painterly, semi-abstract yet distinctly immediate way (**6**). In combination with their physicality as objects, these qualities link them closely with Hodgkin's new painting, even though the Hodgkin's grandeur of scale, vigour of painterly engagement and expressive complexion make it a quite different kind of work.

In *Bathers at Asnières* Seurat is 'denying exchange between the figures'.[6] Hodgkin takes this further, eradicating any sense of personality. Indicatively, the most alert creature in the Seurat, the dog, is the least so in the Hodgkin; indeed, it hardly *is* a dog. The more distant figure in the water and the two farthest figures on the riverbank are recognisable as figures only from the context, while the three people in the punt and the rower in his skiff have disappeared altogether. Nor is the powerful gravity of Seurat's figures

retained. All these differences stem from the fact that Hodgkin's interest here is not in narrative or character but in the Seurat as an astonishing creation. Hodgkin describes it as 'a deep personal memory'. He was 'originally

7 Georges Seurat *Young Woman powdering Herself*, 1889–90, oil on canvas, 95.5 x 79.5 cm, London, Courtauld Institute Galleries

8 Howard Hodgkin *Evening Sea*, 1998, oil on wood, 175.8 x 260.3 cm, private collection, courtesy Anthony d'Offay Gallery, London

drawn to its totally powerful life as a picture', by which 'the subject is totally taken over'. It is 'not illustrational, because it is such a formal unity'. Its diverse components are held together perfectly, but 'there are so many anomalies that Seurat was on a knife-edge of success or failure. That is part of its appeal.'[7]

Hodgkin transmutes possible exchange between the figures into actual exchange between different kinds of mark. Oddly, in view of his vestigial attention to the figures as individuals, they seem in his picture less frozen than in the Seurat; one can more readily imagine them moving around. Again, this is to do with Hodgkin's dynamic marks. Movement, which in the Seurat is relegated to the middle and far distance, is immanent throughout the new painting. Nevertheless, it is no accident that Hodgkin chose to respond, in this exhibition, to a painting of a perfectly ordinary moment. His pictures use the language of art to bring back particular conjunctions experienced by him in what was often an instant of time, and in circumstances others might not have found exceptional. Many years ago he singled out Seurat's *Young Woman powdering Herself* (**7**) for the way in which an ephemeral moment is made timeless, while nominally incidental elements of the scene are very important in the painting and the picture's design becomes part of its content.[8] The same is true both of *Bathers at Asnières* and of Hodgkin's response.

Hodgkin is so well known for his paintings of people in interiors that it is perhaps insufficiently recognised how substantial is his contribution to landscape painting and how vivid his reflection of the effects of the natural world, including weather and conditions of light. In the directness of his response to sky, water and luminosity the new picture

may be compared with a work as differently structured as the recent *Evening Sea* (**8**). However, where that is an image of calm, in *Seurat's Bathers* the expressively neutral figures, in their pre-ordained positions, are counterpointed by the pictorial drama of a jostling dance of marks that evoke floating, buoyancy and a pervasive sense of celebration and new life. As if in recognition of their prominence in Seurat's later work, grass and leaves have an animation here that make them active participants in what is ultimately a mysterious communion.

In eluding complete analysis *Seurat's Bathers* echoes its great predecessor, for both works make emphatic statements, only to leave questions unanswered. Confronted with *Bathers at Asnières*, some viewers seek explanations for its protagonists' 'inactivity'.[9] Others speculate whether we are looking at contemporary Parisians or at archaic archetypes, whether social comment is implied in the foreground group or in the distant view of industry, and whether this self-sufficient masterpiece should be interpreted as a pair to Seurat's subsequent painting of an assembly of dissimilar figures on the opposite bank of the Seine. In the Hodgkin such questions hardly arise. Numerous particulars in the Seurat (dog, hats, boats, bridge, factory) are largely supplanted by shapes that are often no less particular, many of them invented. In the act of affirming the Seurat Hodgkin re-conceives it. Not only do we enter a world quite distinct from Seurat's in feeling and imagination but Hodgkin takes the language of painting in a direction that contrasts with the trajectory Seurat seemed to be following in his few remaining years. As he stated in 1995, 'Seurat's drawings are such an astonishing solution to the problem of describing three-dimensional forms on a flat surface, yet somehow his paintings (to me among the great paintings of all time) often seem to have started from almost a different premise, certainly growing more and more linear as time went by.'[10]

Hodgkin translates Seurat's conception into a tradition of sensuous painterly abundance that persisted throughout twentieth-century art. Such an approach has long enhanced the capacity of abstract painting for multiple suggestion. It has enriched depictive imagery with a sense of the vitality of colour, form and matter in themselves, but also with the power of these properties to determine mood and meaning. As *Seurat's Bathers* shows, Hodgkin renews this tradition in ways that continually refresh and surprise.

Richard Morphet

Notes

1 John Leighton and Richard Thomson, *Seurat and the Bathers*, exh.cat., National Gallery, July–September 1997, p. 58.

2 For example, Hodgkin, though in the mainstream of sensuous Western art, has been affected by the clarity and formal energy of Indian painting.

3 'At one time I thought I'd become a completely pointillist painter: a dot or a stripe is something over which one has infinitely more control than something which depends on the movement of the arm, which takes you back into autograph. To be an artist now, you have to make your own language, and for me that has taken a very long time' (Hodgkin interviewed by David Sylvester in *Howard Hodgkin: Forty Paintings 1973–84*, exh. cat., British Pavilion, XLI Biennale, Venice, June–September 1984, pp. 97–106).

4 He has from time to time made close versions of paintings by himself, for example nos. 143 and 256 in Marla Price's catalogue raisonné, *Howard Hodgkin Paintings*, London 1995, pp. 137–200.

5 See note 1.

6 Leighton and Thomson in *Seurat and the Bathers*, cited note 1, p. 130.

7 This and the four immediately preceding quotations are from an interview with the artist on 20 December 1999.

8 Richard Morphet, 'Introduction', in *Howard Hodgkin: Forty-five Paintings 1949–1975*, exh. cat., Museum of Modern Art, Oxford, March–April 1976, pp. 5–22, especially p. 16.

9 Cf. Richard Dorment, 'What is really going on here?', *The Daily Telegraph*, 2 July 1997, p. 23; and James Fenton, 'Seurat and the Sewers', *The New York Review of Books*, 25 September 1997, pp. 8–12.

10 Hodgkin in letter of 23 February 1995 to John Elderfield, quoted in Elderfield and Hodgkin, 'An Exchange', in *Howard Hodgkin Paintings* (cited note 4).

MANET
The Execution of Maximilian 1867–8

NG 3294 Oil on canvas (four fragments laid down on a single canvas support),
193 x 284 cm

THE ARTIST Edgar Degas was also an assiduous collector of art. His acquisitions were often motivated by personal admiration for his contemporaries, whether they were world-famous masters like Ingres or all but unknown rebels like Gauguin. Degas honoured Edouard Manet (1832–1883) as the leader of the modern school around whom he and fellow renegades had clustered in the 1860s and 70s, and he was appalled that, after the artist's death in 1883, Manet's family apparently allowed one of his most ambitious historical compositions, damaged by water as it may have been, to be cut into pieces and dispersed. Degas scoured the shops of Paris for the fragments, finally recuperating four of them, which he assembled on one canvas. They were acquired by the National Gallery as long ago as 1918, at the posthumous auction of Degas's collection in Paris. Subsequently cut up, the fragments were reunited on a single canvas support, re-establishing the original dimensions of the painting and also sadly signalling those parts of it

that are lost. What the viewer sees today is a scarred and partial ruin, though one full of enigmatic power.

The protagonist in the drama has all but disappeared. All we see of Maximilian, the hapless Austrian archduke whom the French emperor Napoléon III had installed on the throne of Mexico in 1864, is his left hand; at far left it grasps the hand of the faithful General Mejía as the two men, and a second general, Miramón, not visible here, face the firing squad of the Republican insurgent Benito Juarez on 19 June 1867. Defeated but valiant, the three men – and we know their configuration from other versions of the composition today in Copenhagen, Boston and Mannheim – calmly face their faceless executioners. The riflemen seem to stand only inches away from the victims as their guns explode, while behind them a sergeant prepares to administer the *coup de grâce*.

Manet was the painter *par excellence* of modern life, though only rarely did he address explicitly political themes in his art. However, he was an enemy of Napoléon III, who, having propped up Maximilian on the Mexican throne, scandalously abandoned him when it became expedient to do so. Manet saw an opportunity in this distant political tragedy to criticise the Emperor for his callous indifference. He based his painting on press reports and, when they became available, photographs of the execution. At first he showed the firing squad in Mexican dress, but when he learned that in fact Juarez's troops wore uniforms not dissimilar to those worn by French soldiers, he used as his models a French army company commanded by a friend. Few in Paris would have missed the sharp political implication of that choice, and certainly not the officials who rejected the definitive version of the painting from the Salon of 1869.

Christopher Riopelle

JASPER **JOHNS**

born Augusta, Georgia, 15 May 1930

© Dorothy Alexander

Essentially self-taught, the American Jasper Johns established his enduring reputation in 1958 with his first solo show, featuring paintings of the American flag and archery targets that overturned many of the assumptions of the prevailing Abstract Expressionist aesthetic. In place of the sublime, Johns proposed the banality of familiar everyday objects and signs, 'things the mind already knows', so that he could direct attention to more purely aesthetic and philosophical issues: the way the paint is applied, the relationship between the thing represented and the painting as an object in its own right.

Johns's influence has been immense on successive generations, from Pop art through to Minimalism, body art and conceptual art, but he has maintained his distance from all movements. He reinvented his art in the mid-1970s with an extended series of apparently abstract 'cross-hatch' paintings and again, a decade later, with the introduction of a new range of figurative imagery encompassing autobiographical and symbolic elements and perceptual games.

Having kept two studios for most of his career, Johns now divides his time between upstate Connecticut and the Caribbean island of St Martin.

Catenary (Manet–Degas) 1999

Encaustic and collage on canvas with objects. 96.5 x 145.5 cm, private collection

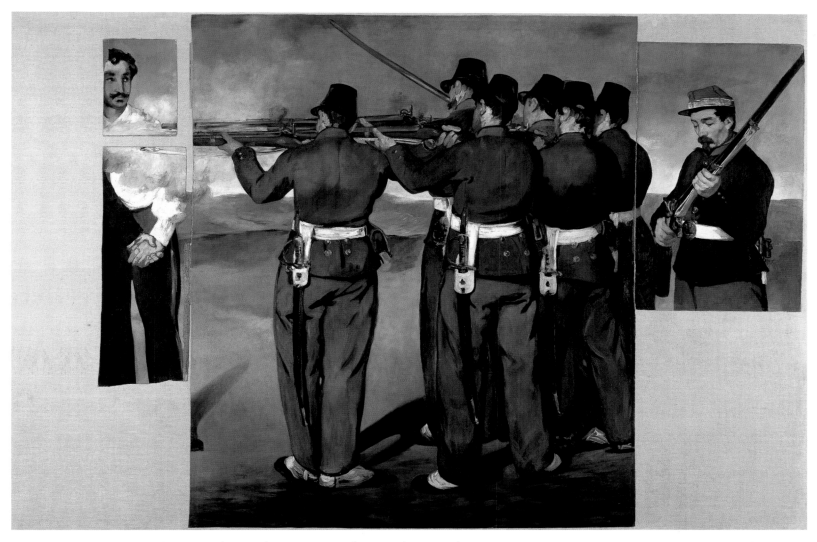

Edouard Manet *The Execution of Maximilian,* 1867–8

ON FIRST SIGHT, *Catenary (Manet–Degas)* consists of a quietly reticent, almost mute, grey surface, in front of which is suspended a humble piece of white string like a bridge traversing empty space. The contrast between the 'poverty' of such materials as the string and wooden stick and the luxuriousness of the lovingly worked paint surface is one of a number of oppositions simultaneously embodied in this work.

As in much of Jasper Johns's art, there is a sense both of concealment and of exposure. The presentation of elements as existing within our own space, and the implication that we might feel impelled to use them, provide an insistent sense of the here and now; yet in this case the artist also suggests to an unusual degree that we are witnessing a process of delving through layers into the past. The three-dimensional elements of the string and the wooden bar to which it is attached introduce an element of time, change and impermanence by subjecting the painting to the vagaries of the light in which it is seen, cautioning the viewer against seeing the work as fixed in form or as subject to a single interpretation.

However elaborate, layered and erudite it might appear, the process involved in Johns's production of this encaustic painting with objects might be considered an extension of his practice, since the mid-1950s, of taking as starting-points existing things and images such as flags and targets. But works of art also combine the communication of meaning with their existence as material entities. 'Works of art … can be treated like any object, since they are just given. And sometimes the image is so striking you simply want to use [it] again in some other context.'[1] Thus *Catenary (Manet–Degas)*, though conceived in response to the National Gallery's invitation to participate in *Encounters*, is not the first work by Johns to make direct reference to art by others. Moreover, Johns has often cited motifs from his own earlier works, inserting

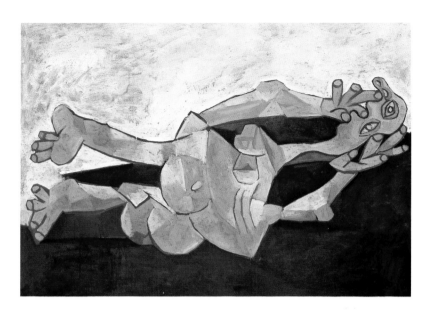

1 Pablo Picasso *Nu couché,* 1938, oil on canvas,
90 x 118.5 cm, private collection

them as immediately recognisable signs for his own artistic identity but also reinventing them with each new recontextualisation.[2]

Essentially self-taught,[3] Johns was never asked as a student to make a transcription from an existing work of art as a formal exercise. In fact, it was as recently as 1998 that he painted his first and only straight replica after seeing a tiny reproduction of Pablo Picasso's *Nu couché* of 1938 (**1** and **2**).[4] 'I had actually hoped to learn something from doing it! But that wasn't true in other cases, [where] I simply wanted to use them for my own purposes. So much of Picasso's work is so flabbergasting, I thought that by doing this I would have a deeper understanding of his thought processes, but,' he adds with disarming frankness and modesty, 'it had no such effect on me.'[5] Only after completing the picture did he chance upon the original at a commercial gallery in New York, at which time he discovered that the illustration from which he had worked was slightly cropped, upside down and in the wrong colours.[6] Yet Johns's copy, in spite of his own uncertainty about its status – he has yet to exhibit it, doubtful about whether he can call it his own

work – is beautiful and mysterious in its own right, with the aura of the original picture enigmatically enhanced by the degrees of misunderstanding and his own much more severe cropping) that separate one from the other. It serves as a powerful testament to the dialogue between two distinct minds and artistic temperaments that is involved in the making of a work of art prompted by another.

Johns was initially reluctant to participate in the *Encounters* exhibition, concerned as he was not to produce a work artificially simply for this purpose. After leaving for his studio on the island of St Martin on 18 November 1998, however, he looked closely at the *National Gallery: Complete Illustrated Catalogue* (1995) and decided to take as his starting point the four surviving fragments of Edouard Manet's *Execution of Maximilian*. He did not have the chance to visit the National Gallery during this period, but he had seen the painting reproduced in the catalogue of an exhibition at the Metropolitan Museum of Art in New York, *The Private Collection of Edgar Degas*, to which he had lent Paul Cézanne's *Bather with Outstretched Arms* (c.1883) from his own collection.[7] This personal link through

Degas with two nineteenth-century French painters whose work he especially admired must have been a major factor in confirming his choice, especially as it was Degas who had purchased the fragments after Manet's death and first had them glued down on to a large canvas in positions corresponding to their original placement.[8] By the time Johns took his own painting, unstretched, to his Connecticut studio in February 1999, it was almost complete; in the spring he expressed doubts about the appropriateness of this essentially grey picture for a 'celebratory show'.[9]

The format chosen by Johns, less a transcription of the Manet than a reformulation of it in his own language, relates to a series he had inaugurated in early 1997 with *Bridge* (**3**), the first of a group of works featuring a 'catenary', a curve formed by a piece of string or cord of uniform width suspended freely

2 Jasper Johns *After Picasso*, 1998, oil on canvas,
87.6 x 72.4 cm, collection of the artist

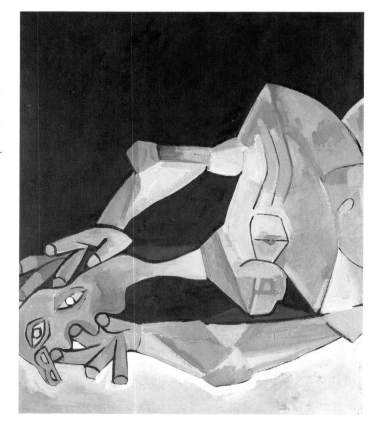

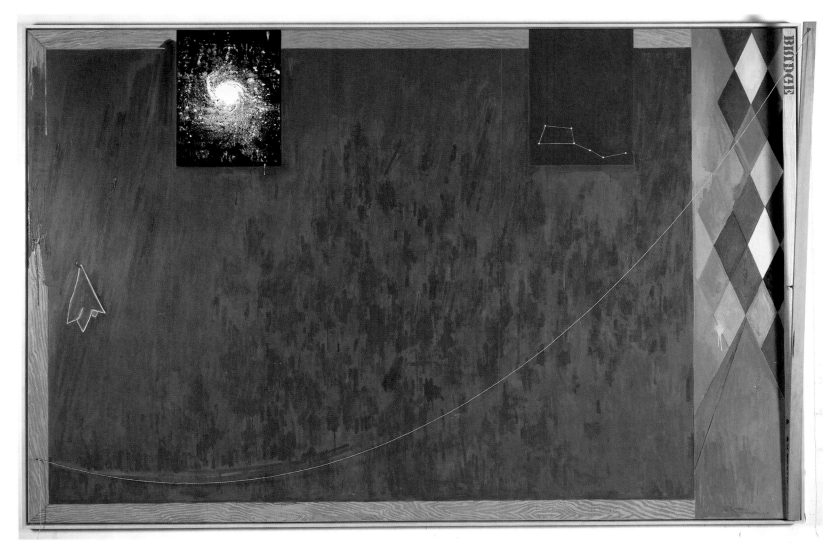

3 Jasper Johns *Bridge*, 1997, oil on canvas with objects, 198 x 299.7 x 19.4 cm, anonymous promised gift to the San Francisco Museum of Modern Art

between two points. The motif may have been prompted in part, though not consciously, by a poignant photograph published in *The New York Times* on 18 November 1996 (**4**), which he has had pinned to his studio wall in Connecticut since that day, showing a Rwandan Hutu refugee holding a transparent plastic pouch from which her daughter is being fed intravenously: the tube which joins them to each other like an umbilical cord in a life-saving action forms a curve much like those employed in Johns's paintings.[10] In each case the curve remains within the rectangle of the canvas, although its exact form changes with the position of the two points. Johns had been surprised and delighted to learn that there was a name for a form he had discovered for himself by chance, and that it was a shape commonly used in engineering for the design of such structures as suspension bridges.[11]

4 Rwandan Hutu refugees at Goma, 17 November 1996, photograph by John Parkin, Reuters

Curves and circles have been recurring motifs in Johns's pictures. As long ago as *Fool's House* of 1962 (**5**), and later in such works as *Voice 2* of 1968–71 and *Scent* of 1973–4, the viewer had been encouraged to conceive of the possibility of the extremes being joined up so that the flat surface of the painting would be transformed into the interior of a continuous cylindrical space.[12] Johns's intuitive discovery of the catenary may thus have come about as a twist on this long-standing concern with curved paths through three dimensions, now made literal with the suspended string. Certainly the play of one kind of curved space against another is suggested in *Catenary (Manet–Degas)* by the positioning of two truncated circles, created as imprints from heated cans, at the left and right borders of the canvas near the lower edge, so that one can think of them as joined or locked together. But the artist cannot recall at what stage in the production of these paintings he turned consciously to such matters: 'I think I've been so affected by the knowledge that this curve has a name that it's hard for me to remember the original impulse'.

Conjunctions are central to the meaning of this work. In piecing together the fragments of a dismembered canvas by Manet, Degas had linked them like the segments of a chain, a process re-enacted by Johns in the making of his own picture. The prominent stencilling of the title across the lower edge of the painting brings Johns's name, in the form of a signature, into direct association with that of his two illustrious forebears.[13] The painting that has led to all the others in the series, *Bridge*, was made for a wall in his St Martin studio previously occupied by other large canvases[14] and was thus consciously in dialogue with them, as also happened with the painting that took its place, *Catenary (I Call to the Grave)* of 1998. As Johns had commented in 1982, 'Working itself may initiate memories of other works. Naming or painting these ghosts sometimes seems a way to stop their nagging.'[15] So it is that in

Catenary (Manet–Degas) he is naming or painting other ghosts apart from those to which the parenthetical part of the title refers: 'I'm not sure it's something that one wants. Sometimes it's just the inability to discard thoughts and habits. I think it's interesting to have something appear again in an altered form. Maybe I feel that more strongly than other people would feel that, so maybe that affects what I do. But to the degree that one would like not to do that, I'm not sure I have that kind of control. One can't just make something new because one wants to.'

The word 'catenary', derived from the Latin *catena* (chain), emerges as extremely appropriate to the forms that appear in all the works of what Johns only gradually realised was a series; seen in relation to each other, the strings appear to link one work to the next. The notion of representing different kinds of space (planar, shallow, and infinite)[16] is constantly reinterpreted; so, too, is the sense that each picture simultaneously reveals its front (as a painted surface) and its back (through the suggestion of the wooden stretcher bars around which the canvas is stretched). Throughout the series, small rectangular subdivisions of the surface interrupt the plane defined by the overall rectangle of the canvas; while most of these contain overtly representational images such as the Harlequin and Mandarin characters, those in *Catenary (Manet–Degas)*, although corresponding to fragments of human figures, paradoxically look wholly abstract. Given this

5 Jasper Johns *Fool's House*, 1962, oil on canvas with objects, 182.9 x 91.4 cm, collection of Jean Christophe Castelli

dialogue from one work to the next, it seems natural that a drawing made after *Catenary (Manet–Degas)* while it was still in the studio (**6**) treats it as an object existing within its own

demarcated space, questioning the sense of boundlessness projected in the painting by demonstrating the definite borders that contain and define the hovering marks as paint on canvas. Every mark is shown as subject to conscious replication, to the extent that even the most apparently uncontrolled painterly gesture is demonstrably identified as a willed brushmark.[17]

Within the series there is also a complex chain of associations with the artist's childhood,[18] poetry[19] and the work of other

artists.[20] Both *Bridge* and *Untitled* 1997, the first two paintings, include references to the natural world (the spiral nebula), to the order imposed by man in diagramming the cosmos (the Big Dipper constellation), and to pictorial abstractions transformed into signs of reality and identity. As befits an artist adept at lateral thinking, the references establish a personal network of allegiances and debts rather than any linear progression. The imitation wood-graining, illusionistically rendered nails and real hooks call to

6 Jasper Johns *Catenary (Manet–Degas)*, 1999, graphite, watercolour, acrylic and ink on paper, 61.9 x 85.4 cm, private foundation, promised gift to the Whitney Museum of American Art

mind not just the Cubist painters but also the earlier *trompe-l'oeil* tradition exemplified by such American painters as John Frederick Peto;[21] the interlocking diamond patterns are suggestive of Harlequin costumes, particularly as shown in paintings by Picasso (**7**);[22] and the suggestion of an atmospheric space through the layering of brushstrokes calls to

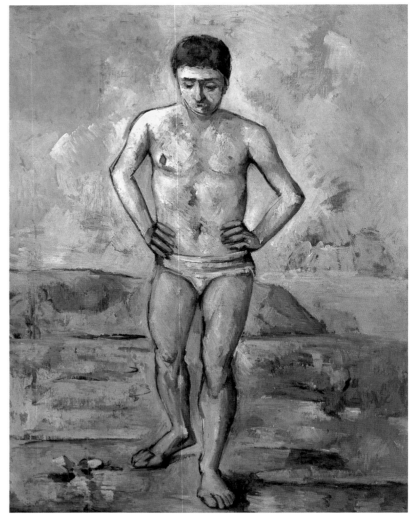

7 Pablo Picasso *Two Acrobats with a Dog*, 1905, 105.5 x 75 cm, gouache on cardboard, New York, The Museum of Modern Art. Gift of Mr. and Mrs. William A. Burden

8 Paul Cézanne *The Bather*, c. 1885, oil on canvas, 127 x 96.8 cm, New York, The Museum of Modern Art. Lillie P. Bliss Collection

mind the surfaces painted by Cézanne, the contemporary of Manet whom Johns admires perhaps over all other artists (**8**).[23]

Given Johns's profound interest in the work of Marcel Duchamp and his references to it over four decades, it is difficult not to relate his use of string here – as a kind of measuring device subject to natural influences not under his control – to the forms Duchamp created, in *Tu m'* of 1918[24] and earlier works, from his 'standard stoppages', strings of equal length allowed to fall into chance configurations through the force of gravity (**9**).[25] Johns was surprised when one reviewer of his San Francisco show likened his catenaries to the strings held aloft by Duchamp before being dropped. He claims not to have had these devices in mind, but accepts that someone else could see it that way and agrees that it could now just form part of his memory bank. 'People still ask me about Duchamp, but I no longer think much about his work. Like with anything, you draw on it, not consciously, but it shapes how you behave to some degree.'

In most of the *Catenary* paintings there are long fragments of curvilinear lines visible on the surface of the painting, just below the actual string. In at least two cases (though not in this one), *Catenary* of 1998 and *Catenary (Jacob's Ladder)* of 1999 (**10**) – the first painting completed since *Catenary (Manet–Degas)* – Johns attached a string to the canvas, painted over it and then pulled it off, leaving a thin ridge in the paint surface that retraces the configuration of the new piece of string put in its place. He laughs at the suggestion that it is a little like committing a crime and then removing, or tampering with, the evidence. 'You could say that. But I think

it's echoing the curve in a different material and a different kind of space.'

Since the late 1950s, beginning with such works as *Device Circle* of 1959, Johns has incorporated simple utilitarian objects that had served him in making the painting as found objects appended to the canvas surface. By presenting to view the evidence of the materials and the tools with which the paint was applied, he reveals in a very matter-of-fact way the process by which the painting came into being. The stick at the far right of *Catenary (Manet–Degas)* relates back to the presence of similar sticks as nakedly exposed implements or formal devices in earlier works, suggesting that the painting was conceived in part as a reformulation of such concerns. In the case of *In the Studio* of 1982 (**11**), where the stick is attached to the lower edge of the painting just left of centre, it projects towards the spectator as it rises, creating a palpable shallow space. In *Perilous Night* of 1982, where it appears to lie flat on the surface, it is placed along the right edge, as in *Catenary (Manet–Degas)*. A painted mauve stripe occupies the same position in *Ventriloquist* of 1983, so that the actual stick has metamorphosed into a painted substitute while still fulfilling a similar formal and spatial role. The sticks in the *Catenary* series, while always hinged to the bottom edge of the canvas, appear sometimes on the right, sometimes on the left, occasionally on both sides, and they are as likely to lean in or out from the vertical axis as to be perfectly erect, as they are in *Catenary (Manet–Degas)*.[26] Just as Johns accepted the shifting of their positions that occurred as they dried and became warped, so he is content to allow the shadows they cast to fall where they may.[27] 'I assume that will take care of itself and they will encounter different situations, just like the rest of us.'

The National Gallery's *Execution of Maximilian* of 1867–8 is one of several versions that Manet produced of the same subject (three large paintings, one small painting, a drawing and a lithograph) and the

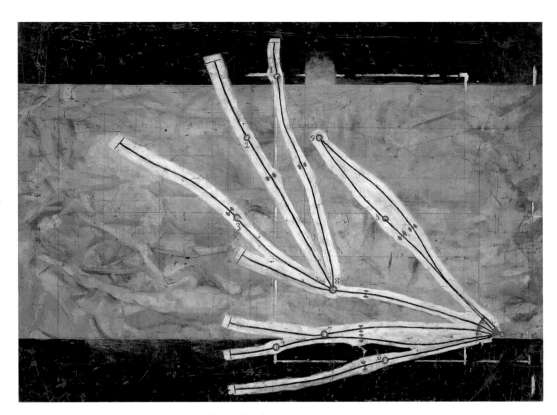

9 Marcel Duchamp *Network of Stoppages*, 1914, oil and pencil on canvas, 148.9 x 197.7 cm, New York, Museum of Modern Art. Abby Alrich Rockefeller fund and gift of Mrs. William Sisler

10 Jasper Johns *Catenary (Jacob's Ladder)*, 1999, encaustic on canvas with objects, 96.5 x 145.4 x 13.3 cm, collection of the artist

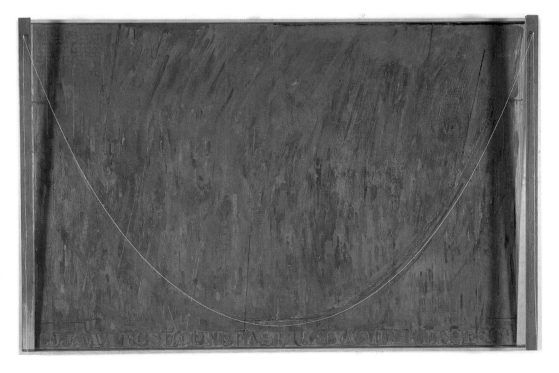

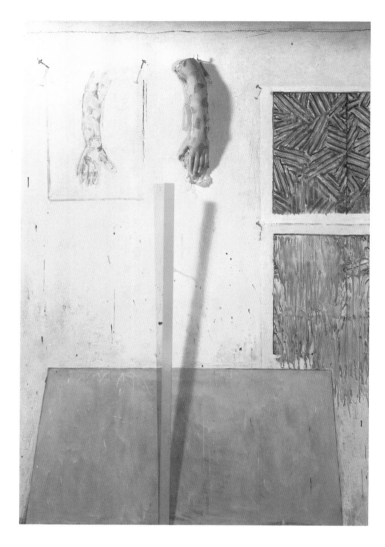

Johns had made tracings from found images as early as 1965,[32] and later produced numerous drawings and paintings derived from traced reproductions of works by other artists.[33] The very first of these art historical quotations, *Tracing* of 1977 (**12**), was from a work in the National Gallery collection, Cézanne's *Large Bathers*.[34] But there is no tracing embedded underneath the painted surface of *Catenary (Manet–Degas)*. Instead, he reformulated the Manet in its present reconstructed state in purely material terms, collaging patches of canvas (of similar shape to those in the National Gallery picture) on to the support in corresponding positions.[35]

the back of a stretched canvas, a drawer, a series of inset panels, an unrolled blind or an expanse of canvas folded in upon itself – beneath the surface in such a way that it seems to be sealed in or embalmed by the top layer of paint. By covering over the found surfaces while still leaving enough of the original object exposed for its identity to be apparent, he simultaneously reveals and conceals the depths lurking beneath, in both a literal and a metaphorical sense. In the early works there is a sense of secrets, or areas of intimacy and private identity, being deliberately but not completely withheld from view. A similar game of hide-and-seek in *Catenary (Manet–Degas)* is hinted at, but denied, both in the title's explicit avowal of its source and in the simple fact that there is no imagery hidden beneath the painted surface, only the structure of the work as it is revealed to the naked eye.

In 1964 Johns asserted:'Transformation is in the head. If you have one thing and make another thing, there is no transformation, but there are two things. I don't think you would mistake one for another.'[37] In another interview published that same year, he remarked: 'To be plain, the best critic of a picture is another picture.'[38] It is a question that he pondered seriously long before he started using motifs from art history, including even such a pervasive one as the *Mona Lisa*,[39] as elements of his own art.[40] The conclusion to

only one not to have survived intact.[28] Given that Johns, too, has long been in the habit of revisiting particular motifs, the existence of variations might have been an additional factor in his choice, although he maintains that this was unlikely to have been in his mind.[29] A more overt point of contact would have been the fragmentation of the image, a recurring preoccupation in Johns's art, often specifically in representations of the human body.[30] The relationship of the surviving parts to the original whole, a composition which can now be reconstructed with the aid of photographs and by reference to the other variants, is now perhaps the key point of access.[31]

Catenary (Manet–Degas) and related works are part of a lineage of essentially grey mono-chromatic paintings stretching as far back as *Canvas* of 1956, *Drawer* of 1957, *Gray Rectangles* of 1957, *Tennyson* of 1958 and *Disappearance II* of 1961 (**13**).[36] All of these, and the monochromatic blue *Tango* of 1955, involve the embedding or concealment of a real object – a music box,

which he comes today, in relation to *Catenary (Manet–Degas)*, is that it is not simply a question of works illuminating each other through their evident links, combined with the contrasting intentions and emphases. 'If there is criticism, it isn't because of the interconnectedness of the images or the fact that one is triggered by the other. It's on some other level, I think. Isn't it the statement of what painting is, or the demonstration of what painting is or can be? They don't necessarily reinforce one another. You could say that one is a distraction from the other!' With

characteristic humility, he adds: 'Also what we see as the accomplishment of the earlier work is a severe criticism of the present work, because we already see it as having a high value, a value of meaning'.

The overwhelming impression of grey in Johns's painting, even when modified by touches of bright colour that pay homage to the brilliant blues and greens of the Manet, establishes an emotional tone, one in keeping with the tragic subject-matter and concern with imminent death in the source. Fragmentation and mortality[41] seemed to him to

intermingle in this Manet, but he can no longer recall whether that relationship entered into his choice: 'It was not a reasoned thing, but an insight that I could work with this, or a feeling that I could work with this'. The sombre quality of Johns's painting cannot be said to arise from a conscious desire to look at the past 'through a glass darkly', since there is no imagery to be deciphered through the haze of brushwork. Given close enough scrutiny, everything is visible on, or immediately under, the surface of his abstracted version of the Manet. Yet the very nature of that surface, dark and impenetrable by comparison with his earlier investigations of art based on other art,[42] leads one to suspect that the human drama and sense of loss that animate the source work remain embedded in Johns's thoughtful and introspective response.

Marco Livingstone

13 Jasper Johns *Disappearance II*, 1961, encaustic and collage on canvas, 101.6 x 101.6 cm, Toyama, Museum of Modern Art

Notes

1 Interview with the author at the artist's studio in Sharon, Connecticut, 28 October 1999. Unless otherwise specified, all quotations and paraphrases of the artist's remarks are from this conversation.

2 'I suspect there are times when you would characterise my work as quoting from myself. I wouldn't think of it that way. There *are* times, however, when I *would* think of it that way. I'm not certain. I can't think of specific instances at the moment. I suspect that when I *would* think of it in that way, that there's very little difference.'

3 His formal art training was curtailed after only two semesters in a commercial art school and later a single day at Hunter College in New York.

4 Picasso's *Reclining Nude* of 1938 was reproduced on p. 82 of Laurie Attias, 'Jan Krugier: Expressions of the Soul', *ARTnews*, April 1998, vol. 97, no. 4, pp. 82–6.

5 He adds of his Picasso copy: 'I love to look at it, and I'm very happy that I have it to look at. In a sense I have the feeling that much of what's interesting about it is not willed, but is innate to the structure of the man who made it, and there's no way to replicate it in oneself. One can only admire it in the other person, or hate it if you happen to hate it!'

6 Johns finally saw *Nu couché* of 1938 in the exhibition *Picasso's Dora Maar: De Kooning's Women*, held at C&M Arts, New York, between 2 April and 28 May 1998; it is Zervos, IX, 218.

7 See exh. cat. *The Private Collection of Edgar Degas*, Metropolitan Museum of Art, New York, October 1997–January 1998, pp. 46–7, for the double-page colour reproduction of Manet's *The Execution of Maximilian* from which Johns worked. Johns's Cézanne is reproduced on p. 204, fig. 283. For a discussion by Joseph J. Rishel of *Bather with Outstretched Arms* and related works, see exh. cat. *Cézanne*, Tate Gallery, London, 1996, pp. 279–80.

8 This background must have added to Johns's sense of the layering of history in the work as it now stands. When the National Gallery acquired the work in 1918, the fragments were again separated and framed individually. Johns was not aware, however, that it was another painter of his own generation, Howard Hodgkin, who was responsible for showing the fragments in their original relationship, though on separate stretchers, when he chose them for inclusion as a single work in *The Artist's Eye: An Exhibition by Howard Hodgkin* at the National Gallery (National Gallery, London, 20 June–19 August 1979). It was only in 1992, for the National Gallery exhibition Manet: *The Execution of Maximilian. Painting, Politics and Censorship* (1 July–27 September), that the fragments were again reassembled on to a single canvas measuring 193 x 284 cm. A photograph taken of the

painting by Fernand Lochard in December 1883, after Manet's death, reproduced in the 1992 catalogue, p. 64, fig. 71, shows it before its dismemberment (though two figures on the left are missing). Ann Dumas, 'Degas and His Collection', in *The Private Collection of Edgar Degas*, cited note 7, p. 20, notes that 'Degas's concern for the physical integrity of paintings is evident from the trouble he took to reassemble the fragments ... which had been cut up, probably by Léon Leenhoff, Mme Manet's "brother", in the hope of selling the separate pieces'.

9 Letter to Richard Morphet, 16 April 1999. He noted that he would continue to work on the painting for the following few weeks and then decide whether or not he was willing for it to be shown.

10 See Richard S. Field, 'Chains of Meaning: Jasper Johns's Bridge Paintings', in exh. cat. *Jasper Johns: New Paintings and Works on Paper*, San Francisco Museum of Modern Art, 16 September 1999–4 January 2000, p. 26.

11 In a letter faxed to the author on 13 December 1999, Johns recalls that he first heard the word 'catenary' applied to the curve he was using from a friend, Henry B. Cortesi, who visited his St Martin studio in February 1997, just after he had completed the Bridge drawing. This accords with the information in Amei Wallach, 'Jasper Johns: A Master of Silence Who Speaks in Grays', The New York Times, 5 September 1999, but contradicts the account in Field, cited note 10, pp. 20–21, that he came across the term much later in the series, in 1998, when he began incorporating it into the titles and inscriptions of the pictures using this device.

12 See the discussion in Michael Crichton, *Jasper Johns*, London, revised and expanded edition, 1994, p. 59.

13 The inscription reads CATENARYMANETDEGASJJOHNS1999.

14 Work on *Bridge* began shortly after *Untitled* of 1992–4 (encaustic on canvas) was sent for inclusion in his retrospective at The Museum of Modern Art in New York in October 1996; the latter had replaced a very similar painting, *Untitled* of 1992–5 (oil on canvas), which had been acquired by that museum. All these paintings, including the two that replaced them, have the same dimensions, 198.1 x 299.7 cm.

15 Interview with Richard Francis held during November 1982, quoted in his monograph, *Jasper Johns*, New York 1984, p. 98.

16 See Joachim Pissarro, 'Jasper Johns's Bridge Paintings under Construction', in the 1999 San Francisco catalogue, cited note 10, pp. 46–51.

17 Field, cited note 10, p. 33, identifies marks that occur in a number of these paintings as representations of 'ejaculate fluid'. Johns counters drily, 'It could be that, but it could also be something else Just paint.' This 'semen stain' appears as a milky green area in the upper left of *Catenary (Manet–Degas)*, just to the right of the small canvas patch in the upper-left corner of the painting. In the version on paper, it reappears as a carefully drawn outline.

18 Johns introduced a new, highly personal, motif later in 1997: that of a Chinese costume that he recalls having worn one Halloween as a boy. In the absence of the actual costume or any photographs of it, he recreated the design as a combination of schematised elements: a golden dragon, frog buttons and a hat with pigtail.

19 See Pissarro, cited note 16, pp. 37–55, for a detailed discussion of the poetry of Hart Crane in relation to the *Catenary* series.

20 This and associated paintings by Manet have themselves been related by art historians to another celebrated picture, Goya's *Executions of the 3rd of May* (1814), and other twentieth-century artists before Johns have made reference to them both, including Picasso in his *Massacre in Korea* (1951) and much more recently R.B. Kitaj in *The Killer-Critic Assassinated by his Widower, Even* (1997).

21 The appearance of real or painted replicas of such objects as hooks and nails in Johns's recent paintings, including *Catenary (Manet–Degas)*, has tended to be viewed by writers as a comment on devices employed by European Cubist painters: illusionistic devices which through their self-evident artifice simultaneously undermine the illusion. The pre-modernist *trompe-l'oeil* realist tradition exemplified so powerfully by John Frederick Peto, an artist long admired by Johns and by fellow painters such as Jim Dine, is just as relevant. Johns made overt reference to Peto as early as 1962, in the inscription along the lower edge of *4 the News* – THENEWSPETOJOHNS62. In 1962 the dealer Ileana Sonnabend, then married to Johns's dealer Leo Castelli, had been struck by a resemblance between Johns's painting *Good Time Charley* of 1961 and Peto's *The Cup We All Race For*, of which she sent him a reproduction. Johns describes *4 the News* as 'a kind of response to learning about that painting'.

22 Two such paintings by Picasso executed in 1915 and in the collection of The Museum of Modern Art in New York, *Harlequin* and *Two Acrobats with a Dog*, would have been particularly familiar to Johns.

23 Cézanne's *Bather* of c.1885 is closely related to the *Bather with Outstretched Arms* in his own collection (see note 7).

24 *Tu m'* entered the collection of Yale University Art Gallery in 1953. Johns says, 'I think it has become a part of my unconscious, but it didn't enter consciously into my thought [in relation to the *Catenary* paintings]. It's a work that has been of enormous importance to me, that I've looked at and thought about, so there might be a residue in what I do.'

25 Duchamp's *Network of Stoppages* of 1914 was acquired in 1970 by The Museum of Modern Art, New York. For a more complex network of associations with the work of other artists, see *String and Rope* (exh. cat., Sidney Janis Gallery, New York, January 1970), which included Duchamp's *Trois Stoppages-Etalon* of 1913–14 along with works by Hans Arp, Man Ray and contemporary artists such as Eva Hesse, Robert Morris, Robert Whitman and Barry Flanagan. In a review by Bitite Vinklers published in *Art International*, XIV, no. 3, March 1970, p. 92, the works by Whitman (c. 1957) and Morris (1969) are described as using string 'in free suspension from another object or from the ceiling'.

26 The leaning effect was not intentional. The first of the series, *Bridge*, is particularly warped; he thought about changing it but decided he liked it as it was and would leave it.

27 *Catenary (Manet–Degas)* is best lit from the right so as to create an emphatic shadow cast by the strip of wood. In reproduction it is impossible to tell if it has a real shadow cast diagonally across the surface, a painted illusion of a shadow (as in Duchamp's *Tu m'* of 1918), or a combination of the two.

28 The three other paintings are in the Boston Museum of Fine Arts, the Ny Carlsberg Glyptotek in Copenhagen and the Kunsthalle Mannheim. Johns worked exclusively from reproductions of the National Gallery version.

29 The dimensions chosen by Johns, on a 1:4 scale with the National Gallery picture as it now stands – excluding the additional surface represented by the wooden slat in Johns's work – do not correspond closely to the other versions by Manet.

30 Johns has been so involved in exploring the relationship between the part to the whole, and in the part standing in for the whole, that he himself commented in 1978 that this question seemed 'so stressed in my work that I imagine it has a psychological basis'. See the remarks quoted in Fred Orton's *Figuring Jasper Johns*, Cambridge, Mass., 1994, p. 17. In his note about Manet's *Fragments of the Execution of Maximilian* in his *Artist's Eye* catalogue, cited note 8, p. 17, Hodgkin wrote: 'Fragments are a 20th century taste – Degas (perhaps the first modern artist) was ahead of his time when he stuck these together on one canvas Fragments are disturbing because they demand to be made whole but perhaps that's also why

people like them.' See also Linda Nochlin, *The Body in Pieces: The Fragment as a Metaphor of Modernity*, London 1994, especially her discussion on p. 37 of Manet's work in this context.

31 In one of his earliest published statements, for The Museum of Modern Art's *Sixteen Americans* catalogue (1959), Johns quoted Marcel Duchamp's remarks, in his notes for *The Green Box*, concerning the desire 'to reach the Impossibility of sufficient visual memory to transfer from one like object to another the memory imprint'. This kind of challenge to the mind is one he continued to explore consciously later on, for example in the cross-hatch paintings of the mid-1970s.

32 See the small graphite wash and metallic powder *Map* of 1965, still in his collection, reproduced in David Shapiro, *Jasper Johns Drawings 1954–1984*, New York 1984, pl. 77.

33 In 1982 Johns began making extensive (but often disguised) use of tracings from Matthias Grünewald's Isenheim Altarpiece, for example in *Perilous Night* of 1982; in 1986 he produced a series of nine tracings from Jacques Villon's etching after Marcel Duchamp's *Bride*; between 1990 and 1993 he made several paintings from a tracing of a poster reproduction of Hans Holbein's *Portrait of a Young Nobleman holding a Lemur* of c.1541; and in 1994 he made six ink-on-plastic *Tracings after Cézanne* from an exhibition poster of works from the Barnes Foundation. For illustrations of these works see exh. cat. *Jasper Johns: A Retrospective*, Museum of Modern Art, New York, 20 October 1996–21 January 1997, p. 325, pl. 189; pp. 350–51, pls. 209–16; and pp. 382–3, pls. 245–50. The idea of using tracings of found images followed on logically from his reliance on stencilling for the letters and numbers, given that in these, too, he was faithfully following an existing contour.

34 See exh. cat. *The Drawings of Jasper Johns*, National Gallery of Art, Washington, 20 May–29 July 1990, pp. 272–3, cat. 76.

35 Johns recalls that it was very difficult to replicate the irregularities of the edges, and even to keep the patches of canvas in the desired positions. The wax medium with which this work was painted has to be heated in order to become fluid, and he found that the positions of the fragments shifted a little in the process.

36 In an article by Joseph E. Young published in 1969, quoted in Richard Francis, cited note 15, p. 37, Johns spoke about his use of grey in the paintings he made in 1958 as a way 'to avoid the color situation ... [which in his view] suggested a kind of literal quality that was unmoved or immovable by coloration and thus avoided all the emotional and dramatic quality of color. The gray encaustic paintings seemed to me to allow the literal qualities of the painting to predominate over any of the others.'

37 'What is Pop Art? Part II', interview with Gene R. Swenson, *ARTnews*, vol. 62, no. 10, February 1964, reprinted in Kirk Varnedoe, editor, *Jasper Johns: Writings, Sketchbook Notes, Interviews*, New York 1996, p. 94. 'I certainly don't think you could mistake one for the other,' Johns remarks of his use of Manet, 'so in that sense it remains true.' But he adds: 'I don't know that I would make that statement with such certainty these days as I did then.'

38 Interview with Yoshiaki Tono conducted in Spring 1964, published in Japanese in *Geijutsu Shincho*, vol. 15, no. 8, August 1964, translated in *Writings*, cited note 37, p. 99.

39 The *Mona Lisa* first appeared as an iron-on transfer in *Racing Thoughts* of 1983.

40 As he told Vivien Raynor in an interview published in *ARTnews*, March 1973, reprinted in *Writings*, cited note 37, p. 145: 'I think art criticizes art. I don't know if it's in terms of new and old. It seems to me old art offers just as good a criticism of new art as new art offers of old.'

41 Although a concern with mortality has been present in Johns's work almost from the beginning, Mark Rosenthal remarks, in *Jasper Johns: Work Since 1974* (exh. cat., 43rd Venice Biennale, Pavilion of the United States of America, 26 June–25 September 1988), p. 60, that it first became more evident in 1982, when the artist was in his early fifties.

42 Other paintings that he made during the 1990s as transcriptions from art historical sources – such as some of those after Holbein – have used much brighter colours for immediate ease of identification. Even the India ink on plastic tracings made in 1994 after Cézanne's *Bathers* use a wide tonal range in order to make them more legible.

TINTORETTO
The Origin of the Milky Way probably 1575–80

NG 1313 Oil on canvas, 148 x 165.1 cm

THE FATHER OF Hercules was the god Jupiter but his mother was a mortal, Alcmene. In order to bestow immortality on his infant son, Jupiter held him to the breast of the sleeping Juno, his wife, where Hercules suckled. Rudely awakened, the goddess twisted away from the importunate child and the unfaithful, hovering husband who thrust him at her, scattering her milk in two directions. One stream fell to earth and was transformed into lilies; another rose to the sky to form the Milky Way, shown in this painting as a circle of golden stars floating away above her upraised arm. The story was told in the *Geoponica*, a Byzantine botanical text book translated in mid-sixteenth-century Venice. The artist depicts the moment of Juno's awakening and the struggle that ensues, while putti bearing attributes suggestive of love and its snares, and peacocks and an eagle, attributes of the divine couple, animate the scene. Large as it is, the painting seems to have been cut down at the bottom, as a reclining figure surrounded by lilies, known from a drawing and an early painted copy, is no longer to be seen.

Jacopo Tintoretto (1518–1594) worked in Venice at a time when the city's leading artists, including Titian and Veronese, enjoyed an international reputation and received the patronage of princes and kings across Europe. This painting is probably one of four mythological scenes commissioned from Tintoretto in the early 1570s by the Holy Roman Emperor, Rudolf II, for his splendid court at Prague. There, among Rudolf's sophisticated courtiers, such a sensual painting, based on a learned ancient source and treating the mythological origins of the universe, would have found an appreciative audience. There seems to have been a particular taste in Prague for such images of nature transformed by the acts of the gods, and artists and their advisers scoured obscure texts for appropriate themes.

Like his Venetian contemporaries, Tintoretto joined broadness of vision, bravura painting technique and a command of complex posture and spatial interaction to produce large-scale works of exquisite refinement. Indeed, one early commentator stated that the artist hoped to combine the draughtsmanship of Michelangelo with the colour of Titian. The influence of the former is seen here in the monumental, foreshortened nudes, while the composition as a whole is informed by the subtle play of light and shadow, especially across the bodies of Juno and Hercules, and by rich colour.
Christopher Riopelle

ANSELM **KIEFER**
born Donaueschingen, Germany, 8 March 1945

© Renata Graf

Anselm Kiefer studied art in Freiburg and Karlsruhe in the late 1960s, at a time when figurative painting was beginning to reassert itself in Germany. But the artistic scene was still dominated by conceptual art and by Joseph Beuys, with whom Kiefer studied from 1971 to 1972. These two strains in German art are mirrored in Kiefer's work. From the very beginning one of his main concerns was to try to come to terms with Germany's Nazi past and the Nordic myths that helped sustain it. Another concern was the possibility of painting at a time when its viability was in doubt. Kiefer's paintings took these subjects head–on and were often very large and dramatic; they were figurative and yet used words, collage and other devices to pose questions and evoke an expanding set of associations. From the mid-1980s Kiefer's imagery has broadened to include the Bible and the history and myths of other parts of the world such as the Middle East and Latin America. The materials that he uses have also expanded to include lead, copper and glass – often to form sculptures.

Since 1995 Kiefer has lived in the South of France, where he has continued to add to the richness of esoteric references in his work.

SELM KIEFER

Light Trap (*Lichtfalle*)1999

Shellac, emulsion, glass and steel trap on linen, 380 x 560 cm, collection of Susan and Lewis Manilow

ANSELM KIEFER'S *Light Trap* presents us with a view of part of the night sky which is more diagrammatic than observed. The individual stars are indicated by narrow labels made of thick, emulsified paint attached to the canvas – not the Arabic names that have come down to us over the centuries but those given to them by modern astronomers to describe their spectral type, luminosity and any other peculiarities. The stars are linked by white lines in the traditional manner to form constellations, not because there is any scientific connection between them but rather as an aid to identification. The heavens contain millions of more or less visible stars and so, since the earliest of times, humans all over the globe have read recognisable patterns and schematic images into their complex clusterings. The names they have given these constellations have varied according to different cultures, but most of those that we use today derive from the Egyptian astronomer Ptolemy, who in turn drew upon Mesopotamian and Greek sources.

According to Kiefer the constellation that he has depicted is Draco or the Dragon, an extended and not easily distinguishable pattern of stars that runs around the Pole Star, embracing in its coils Ursa Minor. One can make out a large reverse S-shape from top left to bottom right that corresponds to this constellation, but overlaying it are a number of other lines that do not seem to denote any constellations.

Underneath the star names and constellation lines is a thickly encrusted surface of

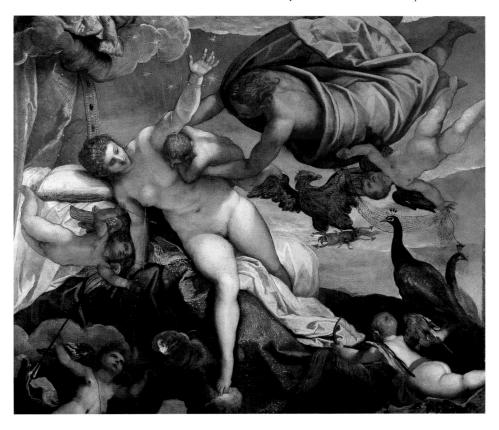

Jacopo Tintoretto *The Origin of the Milky Way*, probably 1575–80

paint, mainly black but peppered with white stars towards the edges of the canvas and covered with a white fog in the centre. At first sight this looks like a galaxy, a star cluster or nebula, but after a while one begins to make out a ghostly pyramidal structure with doors to a chamber on the top. If one knows Kiefer's work, one realises that it is a Meso-American pyramidal temple, probably Mayan. In the past few years Kiefer has painted a number of works on this theme. In fact *Light Trap* was painted over an earlier picture of a Mayan pyramid, but instead of obliterating the image Kiefer chose to retain a palimpsest of it. Running down the facing side of the pyramid is a line of golden paint, which, just below the centre of the canvas, meets a rusty-looking rat-trap. Thrust into its funnel-shaped heart are several shards of

glass bearing the numbers of stars.

What are we to make of this extraordinary conjunction of stellar map, geometrical lines, Mayan temple and metal rat-trap? And what relationship is there with the National Gallery's Tintoretto, *The Origin of the Milky Way*? The first thing to say is that, beyond its initial and considerable impact upon the senses, Kiefer's painting works by association. Images, signs, objects and colours suggest a range of meanings. It helps if one knows other works by the artist, since they feed off, and refer to, each other. The full significance of the starry sky and of a trap catching stars rather than rats is only revealed if one is aware of Kiefer's interest in the cosmologies of different ages and cultures and in the related esoteric areas of astrology, alchemy, Rosicrucianism and the Cabala.

Kiefer is attracted to the stars and to the firmament in general because of their awe-inspiring vastness; quintessentially, they possess the chief characteristic that Immanuel Kant ascribed to the Sublime, namely the power to overwhelm our understanding. Initially this fills us with fear. As our minds struggle to make sense of it, creating new intellectual structures to try and explain what may be unfathomable, we experience pleasure at our apparent omniscience. It is precisely this mixture of awed fear and the pleasure of the initiate that we find in Kiefer's work.

This is not the first time that Kiefer has made reference to stars in his work. As early as 1979–81 he painted a starry night in his

Midsummer Night (**1**). He has even referred to the Milky Way in several works, including a huge painting of 1985–7, *The Milky Way* (**2**). What is new about *Light Trap*, though, and a series of paintings done since 1998, is that they seem to depict the stars in a scientific way, noting down their exact classification and showing the constellations in the traditional manner by linking them together

between the earthbound plants, their sun-like flowers and myriad star-like seeds, and the network of heavenly bodies in the sky. In previous works it had been clear that Kiefer had drawn on a wide range of religious and mystical ideas about the nature of the universe and our place in it to create richly associative images. For example, in *Stars* of 1995 (**5**) he had pictured himself lying flat on

within us is reflected in the heavens and vice versa. The paintings are also about our search for enlightenment and spiritual refinement. The yogic position of *shavasana*, if successfully performed, is supposed to place the body in a deathlike state and release the spirit to roam free.

Turning back to *Light Trap*, we seem to have entered a more scientific world. This makes the presence of the rat-trap and the ghostly Mayan temple all the more incongruous and inexplicable. So we begin to ask questions. What is the significance of Kiefer's choice of the Dragon for his constellation? Is the rat-trap the *Light Trap* of the title and, if so, what could it represent? Were not Mayan pyramids built to line up with heavenly bodies and were not human sacrifices performed on them to guarantee the continuing rise and fall of the sun and movement of the stars?

Draco or the Dragon has been the name of a constellation at least since the time of the ancient Greeks. Its mythical origins are various. The most commonly cited myth is that of the dragon, Lodon, who guarded the golden apples of the Hesperides, the Eden-like garden set at the end of the world where earth and heaven met. The gods Zeus and Hera had chosen the Hesperides as a fitting place to celebrate the union of their marriage, and the golden apples that subsequently grew there became symbols of love and fruitfulness and very dear to Hera. This was the same Hera (or Juno to the Romans) that Zeus (Jupiter) tricked into suckling his bastard son Herakles (Hercules), in order to give him immortality. Herakles sucked so vigorously at her breasts that milk spurted upwards into the sky to form the Milky Way. Angered by this trickery Hera set Herakles twelve labours in the hope of his being killed. One of these was to slay the dragon, Lodon, and steal the golden apples. When Herakles accomplished this labour Hera rewarded the dead, faithful dragon by setting him in the stars. These mythical associations suggest links with Tintoretto's *Origin of the Milky Way*, but

1 Anselm Kiefer *Midsummer Night (Johannisnacht)*, 1979–81, oil, acrylic and emulsion on canvas, 170 x 190 cm, London, Anthony d'Offay collection

by lines. This is the case, for example, with the two recent paintings entitled *Constellation* included in the National Gallery exhibition (**3**, **4**). Here, however, Kiefer shows the heavens as seen through a number of large sunflowers, thus making a connection

the earth in the yogic position of *shavasana* with lines linking him to the stars above, while in *Dat Rosa Mel Apibus* (The rose gives honey for the bees; **6**) of 1996 he showed himself in a similar posture floating in the night sky at the centre of a series of concentric circles. Both these and other works are clearly about the relationship between human beings and the universe, between the microcosm and the macrocosm. What occurs

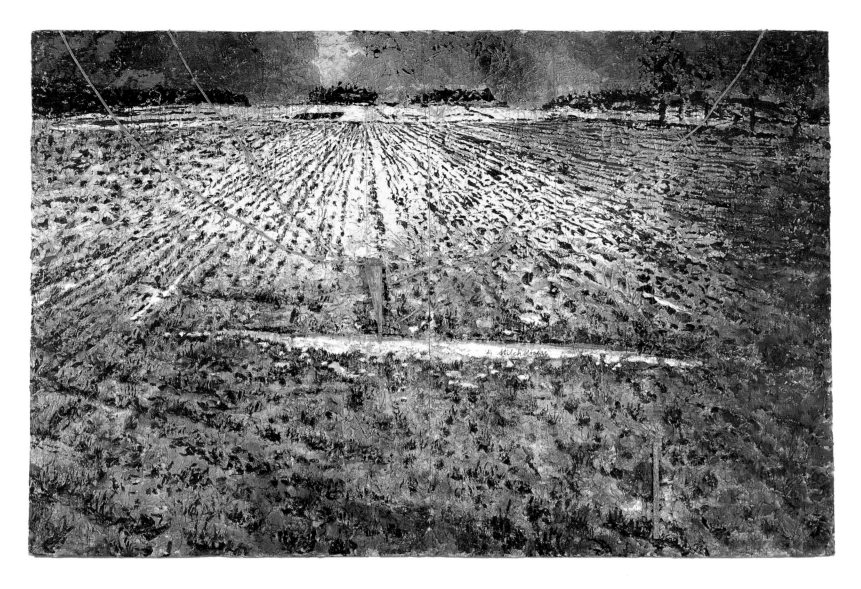

they also help to inform Kiefer's picture and will feed into the interpretation of other elements, notably the rat-trap.

The dragon, however, has another significance in the lore of alchemy, of which the complex symbolism has fascinated Kiefer since the early part of his career and continues to resonate in his work. According to Carl Jung, in his monumental book *Psychology and Alchemy* (1944), the dragon lies at the very heart of the alchemist's vision. It symbolises the chthonic, earthbound principle of the serpent and the airy principle of the bird. It was used as a symbol for mercury, which alchemists believed was able to turn base

metal to gold or spirit. As Jung put it, 'Mercury stands at the beginning and end of the *opus* …. As a dragon it consumes itself and as a dragon it dies and is resurrected as the [Philosopher's] Stone.'[1] Thus, in alchemy, the dragon stands for a system of thought that seeks to refine and purify, to bring human consciousness to a higher plane, leaving behind base and materialist thoughts. The alchemists even interpreted the myth of the Hesperides in this light. 'Metaphysically, the dragon is the lower, earthly self which the soul must learn to subdue and train, so that the higher self (the golden apples) may at last reign.'[2]

2 Anselm Kiefer *The Milky Way* (*Die Milchstraße*), 1985–7, oil, acrylic, emulsion and shellac on canvas with copper and lead, 380 x 560 cm, Buffalo, Albright Knox Art Gallery, in celebration of the 125th Anniversary of the Buffalo Fine Arts Academy, General and Restricted Purchase Fund, 1988

Having identified an alchemical connection in the constellation, it is possible to attempt an interpretation of the rat-trap. The title of the painting, *Light Trap*, or *Lichtfalle* to give it its German title, gives us our first clue. The trap is drawing light into itself and preventing it from leaving. The shards of glass are marked by letters and numbers indicating that they represent stars. Thus, the rat-trap

3 Anselm Kiefer *Constellation*, 2000, oil, emulsion, acrylic and burnt oil seeds on canvas, 200 x 360 cm, collection of the artist, courtesy Anthony d'Offay Gallery, London

becomes a black hole, 'a region of space-time from which nothing, not even light, can escape, because its gravity is so strong'.[3] Any objects or light falling into a black hole disappear from sight, swallowed up in blackness. The existence of black holes had been predicted theoretically many years ago, but only recently have any actually been discovered. Stephen Hawking's *A Brief History of Time* has done more than any other book to explain black holes to a broad audience. In it he writes: 'The number of black holes may well be even greater than the number of visible stars …. We also have some evidence that there is a much larger black hole, with a mass of about a hundred thousand times that of the sun, at the centre of our galaxy. Stars in the galaxy that come too near this black hole will be torn apart by the difference in the gravitational forces on their near and far sides. Their remains and gas that is thrown off other stars will fall toward the black hole.'[4] In his painting Kiefer is not referring to any specific black hole but rather to their general nature and to their tremendous potential to destroy matter, even light. His interest in cosmology extends not only to the creation of the universe but also to its possible destruction. As Hawking explains, black holes may play a role in that end. 'According to the general theory of relativity, there must have been a state of infinite density in the past, the big bang, which would have been an effective beginning of time. Similarly, if the whole universe recollapsed, there must be another state of infinite density in the future, the big crunch, which would be an end of time.'[5]

Kiefer's painting thus takes on a distinctly apocalyptic symbolism. This is not surprising considering that the work was made in 1999. Kiefer has made other works recently with titles that make these millennial visions plain. In 1996 he painted an enormous canvas called *The Sixth Trump* (**7**). Kiefer does not depict the sixth angel of the biblical Apocalypse whose blowing of the trumpet issues in the killing of a third of humankind; rather he suggests the empty land after this slaughter. The German title of our painting, *Lichtfalle*, can also suggest a forthcoming Apocalypse, as a pun on '*Lichtfall*', or 'light fall'. In this way it could refer to the stars falling from the skies as foretold in Revelation 6:12–14. One should be careful, however, not to interpret apocalyptic imagery in Kiefer's work as meaning the end of all things. In fact Christian belief as expressed in Revelation sees the Apocalypse as the prelude to the coming of Heaven.[6]

This progression from matter to spirit is also central to the alchemist's belief. Kiefer has a profound interest in and knowledge of alchemy and has acknowledged[7] that it also

4 Anselm Kiefer *Constellation*, 2000, oil, emulsion, acrylic and burnt oil seeds on canvas, 190 x 330 cm, collection of the artist, courtesy Anthony d'Offay Gallery, London

5 Anselm Kiefer *Stars* (*Sterne*), 1995, oil, emulsion and acrylic on canvas, 330 x 280 cm, Cleves, Ackermann Foundation

plays an important role in *Light Trap*. An alchemical reading of the rat-trap would see it as the alembic, or vessel, used by the alchemists to turn base matter into gold. In the first part of this process base matter was supposed to turn black and enter the stage known as *nigredo*, 'in which the body of the impure metal, the matter of the Stone, or the old outmoded state of being is killed, putrefied and dissolved into the original substance of creation, the *prima materia*, in order that it may be renovated and reborn in a new form'.[8] In a similar way the stars disappear into the black hole and are condensed into the very stuff of creation. It is perhaps not accidental (Kiefer is very widely read) that another word for the alembic is glass house, glass prison or glass.[9] Likewise the alchemists used the image of the black sun or *sol niger* to symbolise the death of base matter.[10]

As well as the alchemical readings of the trap, there are two mythical associations that should be emphasised, one of which has already been mentioned in connection with the constellation of the Dragon. This concerns the myth explaining the origin of the Milky Way. Hera was entrapped by Zeus into suckling Herakles. This trap is given visual form in Tintoretto's painting in the form of a net held by one of the flying putti. Another famous entrapment was perpetrated on the companions of Odysseus (Ulysses) by the sorceress Circe, who gave them a potion that turned them into swine. During the time that Kiefer was working on *Light Trap* he was also engaged in making a series of sculptural works on the theme of the Women of Antiquity.[11] One of these female figures was Circe. As for the other figures in this group, for the body he used a contemporary wedding dress (stiffened with plaster and fitted with an internal support so that it could stand on its own); for the head he used a rat-trap similar to that fixed

to *Light Trap*, into which he placed small plastic models of pigs.

Around the same time that he painted *Light Trap* Kiefer made a closely related work called *Light Compulsion* (*Lichtzwang*). The word 'Lichtzwang' comes from the title of a book of poems by Paul Celan (1920–1970) published in 1970.[12] Celan was one of the most powerful poets of the post-war period to write in German. His experiences as a Jew brought up in Bukovina (in what is now Romania), whose parents died in a Nazi

internment camp and who himself spent several years in Nazi labour service, had a profound effect on all his poetry. As well as providing the title for the book the word Lichtzwang occurs in one of the poems:

> WE WERE LYING
> deep in the *macchia* [bushes], by the time you crept up at last.
> But we could not
> darken over to you:
> light compulsion
> reigned.[13]

The poem looks back to the time when Celan was in labour service and the word 'light compulsion' refers to the enforced lighting around the camps to ensure no-one could escape under cover of darkness. The poem evokes an image of strong contrasts between light and dark, which is due in no small part to the composite word '*Lichtzwang*'. The English translation fails to convey the range of overtones the German word has. As well as the official jargon which means, 'All lights have to be kept switched on', the word can also be read as 'forcing light in, together, preventing it from escaping'. There is also a word cognate to '*Zwang*' (force), '*Zwinger*', which means a place to keep animals, a fort or donjon. Kiefer has long been a great admirer of Celan's poetry and has frequently used some of his most moving images in his paintings.[14] He was particularly struck by the power and richness of the word '*Lichtzwang*'. It may have been one of the factors in his decision to use a rat-trap into which light is forced. A rat-trap is, after all, a

6 Anselm Kiefer *Dat Rosa Mel Apibus* (The rose gives honey for the bees), 1996, emulsion, acrylic, shellac, chalk and sunflower seeds (partly burnt) on canvas, 280 x 380 cm, private collection

sort of cage for animals or '*Zwinger*'.

This connection with Celan's poetry, steeped as it is in the horrors of the war and of the Holocaust, inevitably introduces a further association into our painting. According to this reading the rat-trap assumes the terrible connotations of the extermination camp, the gas chamber, and the ovens into which the

7 Anselm Kiefer *The Sixth Trump (Die Sechste Posaune)*, 1996, emulsion, acrylic, shellac and sunflower seeds on canvas, 520 x 560 cm, private collection

bodies of the Jews were forced. Even the numbering on the shards of glass can be read as the numbers tattooed on to the victims' bodies. The shards themselves are also reminiscent of *Kristallnacht* (night of crystal) when the windows of Jewish shops, homes and synagogues were broken throughout Germany in 1938, and shattered glass became

the symbol of the emerging Holocaust.[15]

This further layer of meaning, both horrific and tragic, sits uneasily with the essentially spiritual reading of the alchemist's *opus*. However, it is precisely the ability to hold two or more contradictory ideas in one image, without their cancelling each other out, that makes art so precious. The world is complex and contradictory and art mirrors this in some way. One of the salient features of Kiefer's art, right from its beginnings in the late 1960s, has been his determination to face up to the reality of recent German history, *his* history, and central to that was the catastrophe of the Holocaust. For much of the post-war period many Germans preferred to ignore it, to block it out and not to come to terms with the feelings of guilt. For Kiefer, who was born in 1945, it was not so much a sense of guilt, as incomprehension. How could a highly cultured, modern nation, his fellow countrymen, commit such an atrocity? Was it something in the German character, in his character? Kiefer felt the need to explore the myths, the historical events and the culture that fed into Nazism so as to try to understand it. He also set it within a wider, transnational, trans-temporal context, layering other myths and ideas over and beneath it, not in any way to sanction it but so as the better to understand the psychological and cultural mechanisms that might lead to such madness. If the references to Nazism and the Holocaust have become less insistent in Kiefer's work in the 1980s and 1990s, as he has grown increasingly interested in general

8 Anselm Kiefer *Julia*, 1971, watercolour and pencil on paper, 47.5 x 36 cm, private collection

cosmological and religious ideas, they have not disappeared altogether and remain as a base note.

The last image to be discussed is that of the Mayan temple. These huge pyramidal structures, surmounted by a temple, astounded Western travellers and archaeologists when they first saw them rising out of the dense jungles of central America.[16] Since the Maya conceived of a close interrelationship between heaven and earth they needed to be able to calculate the movement of the

planets and stars with great accuracy. At certain crucial junctures blood-letting and human sacrifices were carried out to propitiate the gods so as to ensure future fruitfulness and prosperity. They were carried out mainly in the temples which were situated on top of the pyramids. The pyramids themselves were in part observatories, aligned to catch the rising and setting sun, moon and Venus at certain times of the year. In Kiefer's painting carefully drawn lines emanating from stars situated in the lower portion of the heavenly map converge at the two rectangular openings at the top of the pyramid. These portals led into the temple where the sacrifices took place. Descending from the top centre of the pyramid can be seen a gold-coloured trail where the main stairway would be. It was down this stairway that the bodies of the sacrificial victims would have been thrown. But the trail of red blood left behind has since metamorphosed into gold, symbolising the spiritual elevation of those sacrificed.

Kiefer's choice of gold for this bloody stairway is significant. Not only is gold the colour of the sun, the chief god of Mayan cosmology, but it was also the goal of the alchemical *opus* and symbolised the highest degree of spiritual awareness to which humans could aspire. The death of the sacrificial body in the Mayan religion and the putrefaction of matter in the *nigredo* of the alchemists are closely analogous, because they both lead on to this golden plane of existence.

Kiefer's work has often been linked to the wave of neo-expressionist painting that

marked the international art scene in the 1980s, but this is due to a fundamental misunderstanding of it. Kiefer has never been interested in the emotionalism of spontaneous gesture and exaggerated colour. Although much of his artistic output has been in the form of painting, his work is actually closer in its aims and strategies to conceptual art and to the expanded notion of art espoused by such artists as Joseph Beuys from the late 1960s onwards. This art was more concerned with ideas than form, with getting people to think about issues beyond the purely aesthetic, about life in its broadest sense. This is the background against which Kiefer's *Light Trap* should be seen. It is associative rather than formalist, intellectually suggestive rather than emotionally direct (although it does not lack a sensuous impact). It presents us with what at first seems to be a scientific world view of the universe, only to undermine it with a whole range of premodern, pre-scientific cosmologies: ancient myths, alchemy, Mayan religion. Kiefer is sceptical of science, because, according to him, it provides no answers. It may uncover the mechanical workings of the universe but it fails to answer the ultimate questions about meaning, about how we as conscious beings can relate to things. This is where myths, beliefs and religions come into their own. They focus on the human personality, on our perception and relationship with things. Their cosmologies may not tell scientific truth, but they do tell human truths, and over the centuries and in different cultures they have proved remarkably similar and consistent in their stories and exegesis.

Tintoretto's *Origin of the Milky Way* was probably painted in the late 1570s in the early years of the modern, scientific era. What attracted Kiefer to this painting was the linking of the creation of stars, of our universe, with human procreation, the mirroring of the macrocosm in the microcosm. Kiefer's painting *Light Trap* links the universe to human concerns. In fact, uncovering one further layer of meaning, it is possible to see the rat-trap as the embodiment of the female principle, sucking the male (the glass shards) down a funnel into its womb-like interior, where all the elements are fused together – perhaps to give birth to a new universe. Kiefer has been interested in the universality of the male–female relationship, the interlocking of the *yin* and *yang* principles, since at least 1970. In a watercolour entitled *Julia* of 1971 (**8**) Kiefer had depicted his first wife holding a marble heart with an inverted funnel-shape behind her. This funnel-shape is repeated in a number of landscapes linking together the female earth and the male skies.[17] In *The Milky Way* of 1985–7 (**2**) Kiefer fixed an inverted lead funnel to his canvas. Its tip is immersed in a white line stretching over a flat field, which Kiefer has labelled 'The Milky Way'. Thin strips of lead reach up from the funnel to the skies, denoting a link between the female earth and its milky fertility and the male stars of the Milky Way.

Kiefer takes a cyclical view of life and does not believe in a straight, linear development.[18] Could not a black hole, wreaking destruction in our universe, be but the precursor to a new big bang, a new creation? In the same way that life on earth is caught up in a seemingly endless cycle of birth and death, death and rebirth, so the universe itself might shrink to an infinitesimal singularity, the big crunch, only to explode again into new life, a new big bang.

Keith Hartley

Notes

1 C.G. Jung, *Psychologie und Alchemie*, Zurich 1944, p. 400 (author's translation).

2 Lyndy Abraham, *A Dictionary of Alchemical Imagery*, Cambridge 1988, p. 60.

3 Stephen Hawking, *A Brief History of Time. From the Big Bang to Black Holes*, London 1999 (first published 1988), p. 201.

4 Ibid. p. 106.

5 Ibid. p. 191.

6 Revelation 21:1–2.

7 To the author of this essay.

8 Abraham 1988 cited note 2, p.135.

9 Abraham 1988 cited note 2, p.85.

10 Abraham 1988 cited note 2, p.186.

11 Many of these sculptures (although not Circe) were shown in the exhibition *Anselm Kiefer. Die Frauen der Antike* at the Yvon Lambert Gallery, Paris, 6 November–23 December 1999.

12 A very good translation of a selection of Celan's poetry is available in *Poems of Paul Celan. Translated, with an Introduction, by Michael Hamburger*, New York 1995 (first published 1989).

13 Ibid., p. 297.

14 Celan's perhaps most famous poem, *Death Fugue (Todesfuge)*, about a golden-haired German woman, Margarete, and an ashen-haired Jewish woman, Shulamith, and their intertwined lives in a Nazi death camp, has informed several of Kiefer's paintings, particularly in the early 1980s.

15 9 November 1938.

16 For further discussion see Linda Schele and David Freidel, *A Forest of Kings. The Untold Story of the Ancient Maya*, New York 1990, p. 66.

17 See Mark Rosenthal, *Anselm Kiefer*, Chicago and Philadelphia 1987, p. 18.

18 Speaking to Joseph Beuys in 1985 Kiefer said: '… I can see more and more cyclical movements and, above all, happening at the same time… The belief in a linear, eschatological development leads to the danger of legitimising temporary catastrophes. Do you not think similar circumstances can re-occur, over and over again, albeit in a different form?' (author's translation). Quoted in *Ein Gespräch. Joseph Beuys, Jannis Kounellis, Anselm Kiefer, Enzo Cucchi*, Zurich 1986, p. 157.

VAN GOGH
Van Gogh's Chair 1888

NG 3862 Oil on canvas, 91.8 x 73 cm

I N LATE OCTOBER 1888 Paul Gauguin joined his friend
Vincent van Gogh (1853–1890) in the southern French city of
Arles. The two shared a house, painted and sketched side by side,
and compared the rapid advances each was making in his art. In
November Van Gogh painted two pictures, one showing a simple,
wooden chair in a corner of his bedroom, the other depicting a
more ornate chair that decorated Gauguin's room (Amsterdam, Van
Gogh Museum). The two works were surrogate 'portraits' of the
artists themselves, subtly suggesting their differing personalities and
celebrating their intense artistic collaboration. Indeed, both were
painted on loosely woven canvas that Gauguin had brought with
him from Paris and with which the artists were experimenting. Van
Gogh looks down on the rustic chair which he himself had painted
a bright yellow. His pipe and tobacco lie on its caned seat. The chair
is angled into a corner of the room, between the door at right and a
box at left containing bulbs which – as he felt his own creativity
had done since he arrived in the South – have begun to sprout with
new life. The painting's chromatic intensity is an innovation of the
stay in sun-drenched Arles, while the simplicity and directness of
the motif announces the artist's continued commitment to realism
and direct observation in his art. In the following weeks, the
harmony between Van Gogh and Gauguin faded as their aesthetic
differences became more pronounced. By Christmas they had
quarrelled bitterly and Van Gogh had mutilated his ear and been
hospitalised. From then on, until his suicide in July 1890, he had to
cope with the madness that intermittently descended upon him.
Christopher Riopelle

Bᴇᴛᴡᴇᴇɴ 1949 ᴀɴᴅ 1956 Kitaj was variously an art student in New York and Vienna, a traveller in Europe and a merchant seaman in the Americas. After two years in the US army he came to England on the G.I. bill and lived chiefly here for forty years. Settling in London in 1959, he studied at the Royal College of Art before becoming one of Britain's leading figurative artists. The group exhibition *The Human Clay*, which he curated in London in 1976, was a point of focus for the revival of awareness of the importance of the human subject in art. Since 1997 he has lived and worked in Los Angeles.

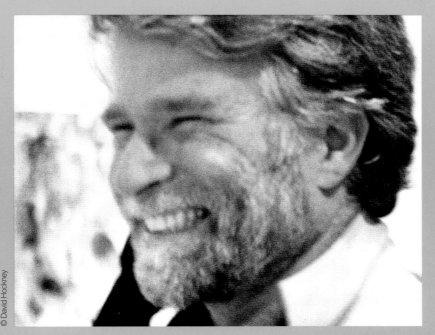

© David Hockney

Kitaj's work examines love, exile, sex, tragedy, comedy, death, art and his passion for books, cinema and great cities. In addressing these subjects he brings disparate motifs together in surprising juxtapositions. These create new, composite images that strangely interweave the political and intellectual history of the twentieth century with the story of his own life, both outer and inner. Many works examine the complexity of Jewish experience and identity and the enormity of the Holocaust. Kitaj continues to respond powerfully to the reinvigoration of the human image in the work of Degas, Cézanne, Matisse and Picasso. His visual art is closely linked to his writing, which is vivid, distinctive and frequently confessional.

R.B. KITAJ

The Billionaire in Vincent's Chair 1999

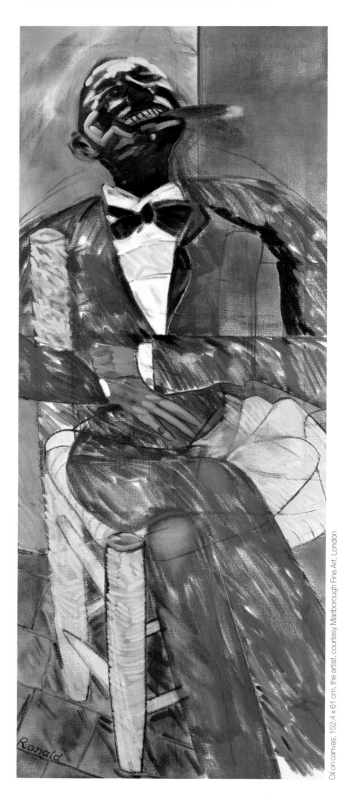

Oil on canvas, 152.4 x 61 cm, the artist, courtesy Marlborough Fine Art, London

VAN GOGH'S CHAIR is one of the best known paintings of the modern era. Its hold on the imagination derives, among other things, from the bold directness with which the form of the chair is exposed. This clarity of statement leads quickly to reflection both about Van Gogh's beliefs and about life itself. Against this background the first impression of Kitaj's image is of alarming incongruity. Not only is the chair partly blocked from view by an occupant but the manner of his occupation has a stridency that

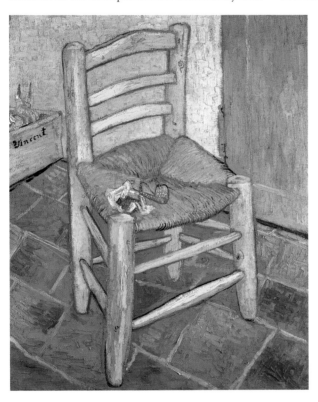

Vincent van Gogh *Van Gogh's Chair,* 1888

is in startling contrast with the quiet simplicity and thoughtfulness of its source.

Extending Van Gogh's image upwards to accommodate a whole figure, Kitaj's painting culminates in a disturbing head, a long cigar clenched between the teeth of its ambiguous smile. The geography of the face is marked out by harsh contrasts of light and dark, juxtaposed with curious lines of pink and blue so as to form a strange roundel that is arresting

as an abstract invention. Kitaj describes this as 'a painting within a painting', and recalls that 'Giacometti said the head is "sovereign". That's good, isn't it?'[1] In particularising the head Kitaj was also following a tradition of full-length portrait painting in which, by contrast with this point of concentration, the rest of the picture is painted more loosely. Below the head, a visual contest is enacted between the firmness of the near side of the chair and the restless treatment of the body, its red suit realised in long, seemingly mobile flecks of paint. Such instability is compounded by the absence, on the right side of the picture, of parts of the upper body, punched away beneath the shoulder. This partial removal forms what looks like a ruined arch, through which we see the ghost of the top right of the chair (which in the centre of the picture appears, paradoxically, as part of the shirt front). Glimpsed below, the chair seat resembles the blades of a shutter.

Van Gogh's painting of his chair is an unusual kind of self-portrait. Kitaj responds to it with another portrait, but this, too, is of an unusual kind. It represents not so much an identifiable individual as a human type. In 1980 the National Gallery showed an exhibition of over thirty works from its collection selected by Kitaj. In his introduction to the catalogue Kitaj wrote: 'Van Gogh ... believed that the future of modern art surely lay in portraiture! "It lets me cultivate what is best and deepest in me." It was in that temper that he painted 46 portraits during the year he spent in Arles I can't include one of those but I can show his famous empty chair to stand in for that renewal he anticipates. He sat in the chair in absorbing loneliness. He wrote that he wished to paint about that loneliness.'[2]

Kitaj's text continues: 'That portrait renewal has not ... come to pass as a real force in our time'. One could argue, however, that Kitaj's own major contribution to the genre

is among those that belie this judgement. It encompasses portraits of friends, from Auerbach and Hockney to John Ashbery and Philip Roth, and of figures from the past, including dead artists from Giotto to Bonnard and writers from Montaigne and Shakespeare to Benjamin and Pound. Some crucial images are of his own family, but in relation to Van Gogh an inescapable parallel is the importance that Kitaj, too, attaches to self-portraiture (**1**).

Kitaj's affinity with Van Gogh, however, has multiple strands. During crucial years of their maturity as artists, both were expatriates

1 R.B. Kitaj *Self-Portrait (Hockney Pillow)*, 1993–4, oil on canvas, 101.6 x 50.8 cm, private collection

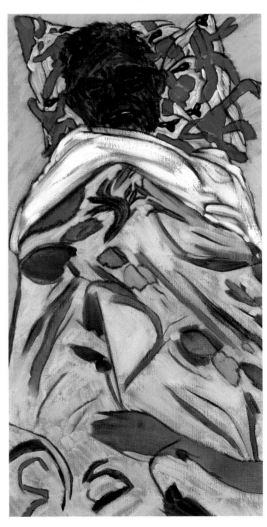

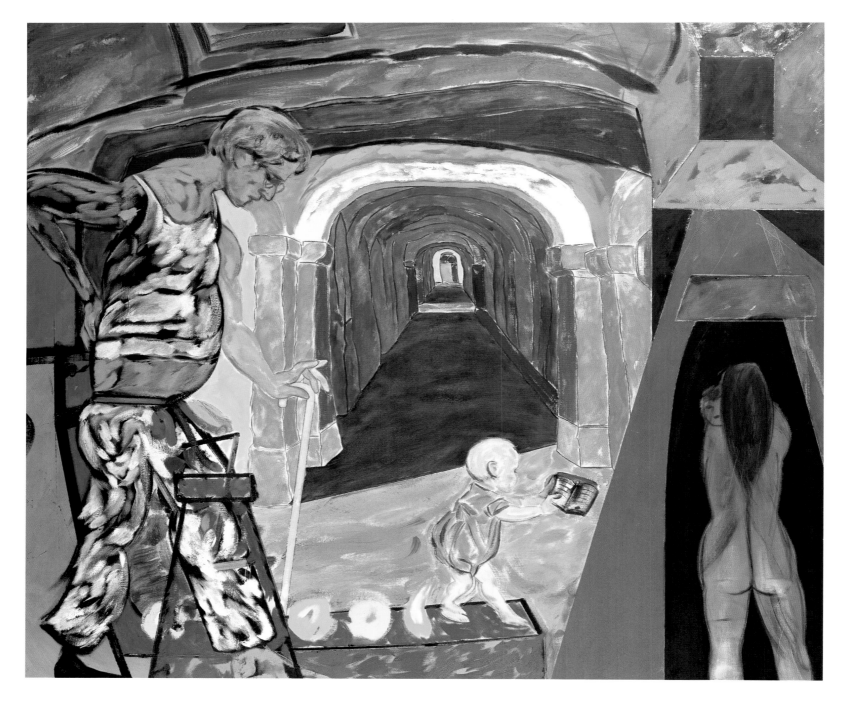

2 R.B. Kitaj *Germania (The Tunnel)*, 1985, oil on canvas, 183.2 x 214 cm, private collection

(in which condition Van Gogh painted the picture of his chair). Before painting the pictures that are paired in this exhibition, both artists lived in England. Indeed Kitaj, an American now resident in Los Angeles,

worked here for four decades. With memorable consequences, both painters responded to English art. Indeed, as explained below, it seems likely that Van Gogh's response included his choice of the very motif of Kitaj's source painting. But more than by expatriation the two artists are united by their role as outsiders. Kitaj's most memorable definition

of this condition is his *First Diasporist Manifesto*, published in 1989. This gives prominence to the intensity of the expression by Jewish writers and artists of what Kitaj has called 'un-at-homeness'.[3] But, as Marco Livingstone has written, 'The application of Kitaj's thesis not just to Jews but to all people classed as outside the mainstream of power in

their society, including women, foreigners, homosexuals and those of non-Caucasian racial origin, creates a potent image to anyone who feels both a part of that society and somehow also alienated from it. There are times when it seems that anyone who places a premium on culture and the artistic impulse … willingly adopts the situation of the diasporist as he describes it, finding him or herself "despised, disliked, mistrusted, sometimes tolerated" by much of the community at large.'[4]

Not surprisingly, Van Gogh is one of those named by Kitaj in his *Manifesto*, where he is described (p. 99) as 'surely a related alien type'. The two artists' work is linked by urgency of feeling, combined with directness of painterly means. Both engage frequently with issues of religious belief, and cafés and brothels are significant sites for the imagery they both create. Both are avid readers. Kitaj has made an entire suite of prints based on the covers of books and other publications, as well as paintings of his library, while Van Gogh's paintings of piles of books are well known. In sympathy with Van Gogh, whose picture here is signed *Vincent*, Kitaj has inscribed his responding work, no less prominently, with his own first name.

At the very time when he was painting the picture now displayed, Kitaj delivered a lecture, 'My Vincent',[5] which sets out in detail his identification with the older artist's vision. He explains there: 'My favourite place in the whole world is the cafeteria of the Van Gogh Museum in Amsterdam. During my last years in London I would retreat about four or five times a year to Holland whenever I needed to collect my thoughts, lick my wounds, ponder picture ideas, catch up on correspondence.'

Kitaj's contribution to the arts of our time would be significant even if he were not a major visual artist. A persistent writer, he early developed a trenchant style which yields extraordinary phrase-inventions and communicates vividly his own distinctive world view. His writing is also insistently self-revelatory. In the lecture he observed:

'The three fat volumes of Van Gogh's letters mean … he wrote in a fury almost every day. Those letters belong to the canon of great Confessional Literature …. The letters are often exegetical, like what the Jews call Midrash, and have emboldened my commentaries about my own pictures, getting me into deep trouble with those critics who can't bear hearing what the artist has to say.'

Among images by Kitaj that evoke the circumstances of Van Gogh's fraught life is the painting *Germania (The Tunnel)* of 1985 (**2**). Here, an image of Kitaj with his newborn son is juxtaposed with one of a young mother and child entering the tunnel leading to a Nazi gas chamber. Yet the eye is drawn down the centre of the composition where, inspired by Van Gogh's transcription of Doré's image of a prison courtyard, Kitaj has in turn transcribed Van Gogh's gouache of the interior of the asylum at St-Rémy. A later drawing (**3**) is a portrait of Van Gogh in which 'I have him measuring the sun with his fingers as a painter might do squinting'.[6] This image is developed from a photograph of Van Gogh seated beside the Seine virtually at the site which Seurat had depicted two years earlier in his National Gallery *Bathers at Asnières* (see p. 166).[7]

In the majority of his paintings Kitaj

3 R.B. Kitaj *Vincent Measuring the Sun*, 1994, charcoal and pastel on paper, 78.1 x 55.9 cm, private collection

brings together two or more motifs which have not previously been associated with one another. He thus creates a new place or story, to which he gives a strange life of its own. In the present instance, 'I had already sketched my BILLIONAIRE on the canvas when Neil McG[regor]'s letter arrived so I sat my BILLIONAIRE in Vincent's Chair because he's the only one who can afford it!'[8] As Kitaj added, 'Everyone can see how pleased with himself he is'.[9] Pressed for fuller information on the Billionaire, he replied: 'I don't yet

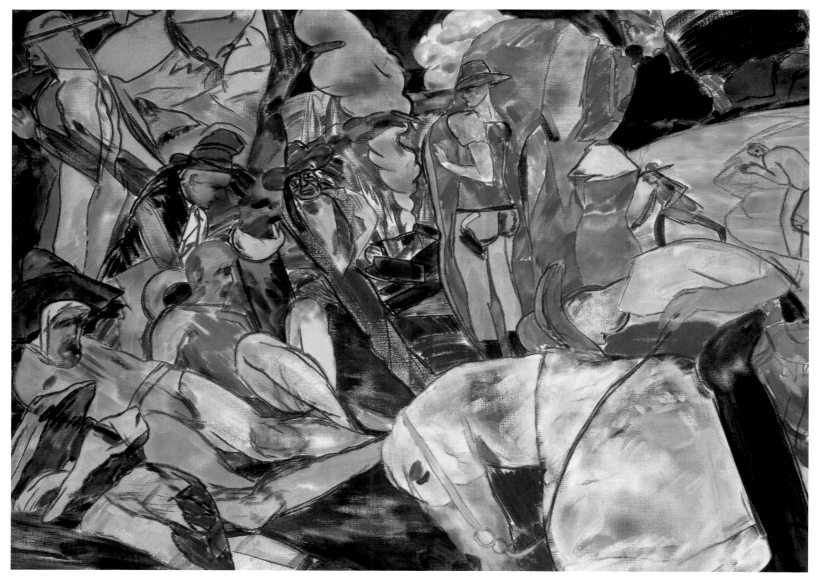

4 R.B. Kitaj *Western Bathers*, 1993, oil on canvas, 135 x 190.2 cm, private collection

know who he is. Let's pretend he's one of those unidentified bidders who has won Vincent's chair at auction at the other end of a Sotheby's phone. I don't think of him as black but deeply tanned (and shadowed). There were some frame-enlargements of sunBathers I used from a movie I suspect the sunBathers were from early modernist German or Russian movies'.[10] The spots of green on the billionaire's fingers denote

flashy rings. Inconsistently with Kitaj's customary framing styles but in keeping with the subject, the picture's frame is painted with gold leaf.

In accentuating the word 'Bathers' Kitaj refers to his preoccupation with this motif in the history of art. In his own work he has used it to conjure a range of conditions, from madness to lyrical beauty to the experience of tyranny. The Bathers motif speaks to him particularly strongly in the work of Cézanne. Significantly, he writes of *Van Gogh's Chair*: 'I feel closer to it than anything there [the

National Gallery] except the Cézannes of course'.[11] He has stated: 'My favourite painting in London is Cézanne's very late, very absurd "Bathers" in the National Gallery'.[12] In a major painting of 1993–4 (**4**), Kitaj responded to the Cézanne in a way that affords a precedent for his treatment of *Van Gogh's Chair*. As now, the original motif is brought together unexpectedly with a quite different theme. As in the later work, more-over, film stills played a vital role. Kitaj recalls how, 'Sitting in front of [Cézanne's *Bathers*] one day, the crazy figures looked like they

were grouped around a campfire and so I got the idea for my first Western'.[13] Inspired by frames from a specific Western of 1959, he proceeded to populate the canvas with a range of figures and characters from 'a dependable stock-company to act the character roles. My own regulars are drawn mostly from figures and images in past art which tend to stay with me always.'[14]

In Kitaj's art, the *Billionaire* is a successor to *The Millionaire*, 1992–3 (**5**), which, Kitaj has explained, is 'based, in its composition, on a frame-enlargement from René Clair's *Le Million*. Everyone is trying to light the Millionaire's cigarette, but now, with so many Millionaires around, I needed a Billionaire to buy Vincent's chair.'[15]

Despite their titles' different word-endings, for Kitaj both these images of rich men form part of a subdivision of his work devoted to the visualisation of human types, the great majority of which have titles ending in 'ist': 'The Millionaire and the Billionaire do rather belong to my tribe of ist(s). They are like a movie director's (Ford, Peckinpah etc) repertory company and also the ist(s) punctuate our century's isms. I myself feel like a modernist-diasporist pugilist (punch drunk).'[16] These works include *The Sensualist*, 1973–84 (a self-portrait)

and *The Novelist (My Neighbor, Anita Brookner)*, 1993. Those in progress at the turn of the Millennium include *The Christ*, *The Rayonist* and *Whist* (the latter inspired by Whistler). It is appropriate that Kitaj's response to *Van Gogh's Chair* should belong to such a group of paintings. For Van Gogh painted his own chair as a pair to a picture of one occupied by Gauguin and, though

neither work depicts a figure, each was conceived as a portrait of a distinctive type of personality.

In showing the figure seated, *The Billionaire in Vincent's Chair* is like Kitaj's early 'ist' pictures, such as *The Arabist*, 1975–6, and

5 R.B. Kitaj *The Millionaire,* 1992–3, oil on canvas, 91.4 x 91.4 cm, private collection

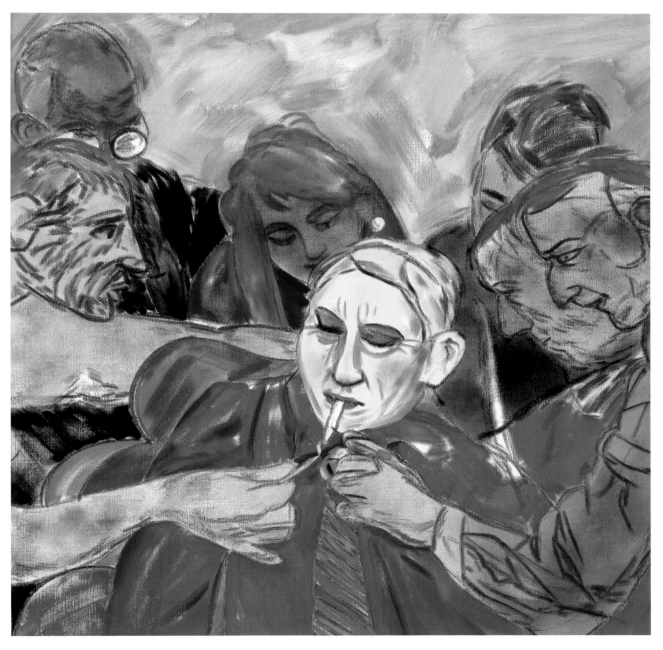

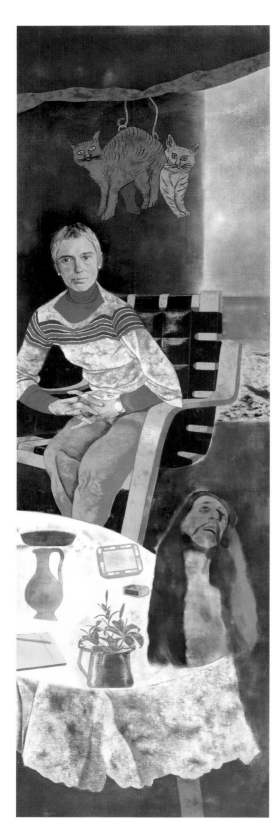

The Orientalist, 1976–7. Like *The Hispanist (Nissa Torrents)* of 1977–8 (**6**), seen in an Aalto armchair, and like Kitaj himself, reclining on a Le Corbusier *chaise-longue* in the non-'ist' picture *Cecil Court, London WC2 (The Refugees)* of 1983–4, he occupies a chair already made famous by a great artist. The slender upright format of *The Billionaire* is that of the majority of Kitaj's 'ist' pictures. This feature links it also to many of the later portraits by Sickert, a painter much admired by Kitaj. These Sickerts (**7**) similarly display a vigorous painterly roughness, draw on photographic sources and sometimes depict wealthy individuals.

Kitaj has observed: 'Whenever I see a Van Gogh picture I quickly think of them stacked around in the dust of his little rooms unsold and unwanted. It's quite hard for me to divorce what I know to be their visual "aesthetic" from their other lives as forlorn, largely disliked things in a very humble room, and now as priceless trophies of vast wealth.'[17]

An insistent theme of Van Gogh's letters is the difficulty of making ends meet. Two years before his death, he wrote to his brother: 'I must reach the point where my pictures will cover my expenses'.[18] This point was not reached in his lifetime, and, even when he continued: 'It will come', he cannot have imagined the prices his works would reach in future years. The most expensive picture ever sold at auction is by Van Gogh – one of the two versions of his *Portrait of Dr Gachet* of 1890. It was sold by Christie's in Spring 1990 for $82.5 million, since when its whereabouts have become unknown.[19] The passage in

7 W.R. Sickert *The Viscount Castlerosse*, 1935, oil on canvas, 211 x 70.2 cm, Fredericton, New Brunswick, The Beaverbrook Art Gallery

210

Kitaj's letter quoted in the previous paragraph continues: 'A recent book [20] traced this trajectory in the destiny of the *Portrait of Dr Gachet* from the young Jewish woman who bought it for $50 after Vincent died to the $80 million paid at auction by a Japanese Billionaire. In between, across the century it was owned mostly by Jews, which interested me, punctuated by the moment when Marshal Goering raped it.

'Isaiah Berlin wrote, "I have lived through most of the 20th century ... I remember it only as the most terrible century in Western history".'

Many commentators, and the institutions themselves, have regretted how the grave disparity between the funds available to them and the prices of works of top quality precludes the adequate representation of great art in their collections.

In his lecture 'My Vincent', Kitaj draws attention to Van Gogh's 'attachment to the Wretched of the Earth' in his early years as a painter, adding, in regard to his career as a whole, that 'Meyer Schapiro gave a hint as to what it was that so endears van Gogh to so many people. He ... was drawn to art as a communication of the good'. Even when the subject does not, in principle, call so clearly for such a response as does the painting of a figure occupying a chair that is reproduced here as **8**, Van Gogh's portraits are charac-terised by a quality of tenderness. By contrast, the power of possession radiated by Kitaj's image of the Billionaire is disturbing, in that the chair he sits in had so different a meaning for its creator. It is as though that meaning is being suffocated.

The shock of this perception is accentu-ated by the knowledge that for Van Gogh his and Gauguin's chairs 'were not just chairs but empty chairs'.[21] In or before 1882 Van Gogh had been greatly struck in a past issue of *The Graphic* by a woodcut after a drawing by Luke Fildes of Charles Dickens's chair left vacant at his desk on the day of his death. Referring to British artists he admired, Van Gogh wrote to his brother: 'Empty chairs – there are many of them, there will be even more, and sooner or later there will be nothing but empty chairs in place of Herkomer, Luke Fildes, Frank Holl, William Small, etc'.[22] He goes on to draw a distinction between material and moral grandeur.

Ironically, both *Van Gogh's Chair*, with its pipe and tobacco pouch, and Kitaj's picture in response, with its large lit cigar, draw attention to smoking. At first glance the two represen-tations of this pursuit carry sharply differing associations – of pride and of humility. Ultimately, however, they may make the same

8 Vincent Van Gogh *Worn Out: At Eternity's Gate*, 1890, oil on canvas, 62 x 44 cm, Otterlo, Kröller-Müller Museum

9 R.B. Kitaj *Erasmus Variations*, 1958, oil on canvas, 104.2 x 84.2 cm, private collection

point. For, 'in seventeenth-century Dutch art, as van Gogh would have known, pipe smoking was a symbol of transience'.[23] Surely the Billionaire symbolises the same quality. As represented by Kitaj, Billionaire and chair seem to be engaged in a contest for pictorial supremacy. Of the two, it is the chair that seems the more enduring.

The dominant colours of Kitaj's blazing image were suggested by Van Gogh's example. But for Kitaj another aspect of the earlier artist's methods was still more important. For him, Van Gogh is a pioneer of an important strand in art, cutting across 'isms', to which he has given the name 'Painting-Drawing'. In 'My Vincent' he writes, '... his mature style in oil painting is largely, but not exclusively, a great drawing style He is still drawing as if he had charcoal or a Japanese reed pen in his handThe emphatic outlining has at least two powerful sources in van Gogh's pantheon: Japanese prints ... and popular graphic illustration in cheap magazines ... he was a very early appropriationist[24].... He kept on drawing with his brush – strokes which compose the image – insisting on stabs of line in the modeling of each form as draftsmen do At some point in my own life and art ... three painter-draftsmen – Degas, Cézanne and van Gogh – worked on me so that I could feel myself drawing hard into the very "give" of the supple canvas with a brush loaded with color, mostly along insistent contours.'

The painting mode described here by Kitaj relates closely to that followed in his picture of the Billionaire. 'Painting-Drawing' has, indeed, been his principal painting mode for the past two decades. Its precedents are found not only in the work of masters of the past but also in his own painting manner of the late 1950s and early 1960s. The picture reproduced as **9** is an early example of this, as well as of Kitaj's 'appropriationism'. There, as now, these techniques were applied to work by a famous Dutchman of the past. The source was doodles drawn by Erasmus in the margins of a manuscript. Kitaj adapted these, using a

manner that reveals his admiration for the painting style of the Dutch-born Abstract Expressionist Willem De Kooning. In doing so he turned them into secret images of women he himself had known. Together with *The Billionaire in Van Gogh's Chair* this picture exemplifies Kitaj's strange and distinctive gift for transforming existing art into new images of people one could hardly have imagined, yet who, once we have been shown them, we feel we know.

Richard Morphet

Notes

1 Letter to the author, November 1999.

2 R.B. Kitaj, Introduction to exh. cat. *The Artist's Eye*, National Gallery, London, May–July 1980.

3 R.B. Kitaj, *First Diasporist Manifesto*, London 1989, p. 31

4 Marco Livingstone, *Kitaj* , London 1992, p. 41.

5 Published in *L.A. Weekly*, 30 April–6 May 1999, pp. 50–51.

6 Letter to the author, November 1999.

7 The photograph, which also shows Emile Bernard, is reproduced in exh. cat. *Georges Seurat*, Metropolitan Museum of Art, New York, September 1991–January 1992, p. 149.

8 Postcard to the author, April 1999.

9 Letter to the author, 13 May 1999.

10 Letter to the author, November 1999.

11 Letter to the author, September 1998.

12 Commentary by Kitaj on his *Western Bathers*, in exh. cat. *R.B. Kitaj: A Retrospective*, Tate Gallery, London, June–September 1994, p. 206.

13 Ibid.

14 Ibid.

15 Letter to the author, November 1999.

16 Ibid.

17 Ibid.

18 Letter 474, Spring 1888, in *The Complete Letters of Vincent Van Gogh*, London 1958.

19 On this aspect of the fate of many expensive masterpieces, see Gabrielle Morris, 'Hall of Infamy No. 22: The Art Market', in *The Guardian*, 15 May 1999.

20 Cynthia Salzman, Portrait of Dr Gachet: the Story of a Van Gogh Masterpiece, Boston, 1998.

21 Ronald Alley, *The Tate Gallery's Collection of Modern Art*, London 1981, p. 292 (the work was on loan from the National Gallery for some years).

22 Letter 252, December 1882 (see note 18).

23 Erika Langmuir, *The National Gallery Companion Guide*, London 1994, p. 288.

24 Kitaj's painting of the Billionaire commandeers unrelated images made by others at two separate points in the past eleven decades. In many paintings, however, Kitaj has taken Van Gogh's practice to voracious extremes when appropriating pre-existing images into his own art.

RUBENS
The Judgement Of Paris probably 1632–5

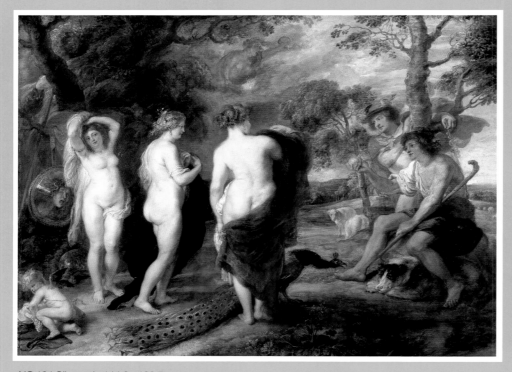

NG 194 Oil on oak, 144.8 x 193.7 cm

Pᴇᴛᴇʀ Pᴀᴜʟ Rᴜʙᴇɴs (1577–1640) was a sophisticated and erudite painter who moved with ease in the highest artistic, cultural and political circles of seventeenth-century Europe. From his studio in Antwerp he furnished powerful and wealthy patrons with portraits, landscapes, altarpieces and learned allegorical and mythological compositions, many of them monumental in scale and highly complex in composition. Rubens's painting was informed by the art of Antiquity, which he studied and collected with a passion, and by the great painters of the Roman and Venetian High Renaissance, not least Raphael and Titian. Once established as one of the most sought-after painters in Europe, he relied on numerous assistants to maintain his prolific production, including artists, such as Anthony Van Dyck, who themselves came to be recognised as leading masters. Rubens also travelled extensively, to Italy, Spain, France and England, where he was received at court and showered with commissions and honours. However, he always returned to Antwerp, to his family and circle of friends, and to the elegant, art-filled town and country houses he maintained there in grand, aristocratic style.

One of the most famous stories from Antiquity, told by Lucian, concerns the beauty contest between the three goddesses, Juno, Minerva and Venus, which the Trojan shepherd and prince, Paris, was called on to judge. Each contestant was as vain of her physical attributes as the next, and none of the three stooped from offering Paris a bribe for the golden apple that was his prize. Rubens shows the youth, accompanied by Mercury, presenting the apple to Venus, who had offered him the hand in marriage of the most beautiful woman in the world and who, in victory, steps forward now with a demure gesture of feigned surprise worthy of a Hollywood starlet at an awards ceremony. Rubens also implies the consequences of Paris's decision by means of the Fury of War, Alecto, who tears her wild way through the turbulent sky above. Paris would abduct the most beautiful woman in the world, Helen, from Greece and bring her to his homeland as his wife; the devastating Trojan War would be the direct result of Venus's bribe and of his own lust. *The Judgement of Paris*, an allegory of beauty and of the sometimes dangerous intersections of desire, was a favourite subject of Rubens's, to which he returned in some seven paintings throughout his career.

Minerva Protects Pax from Mars ('Peace and War') 1629–30

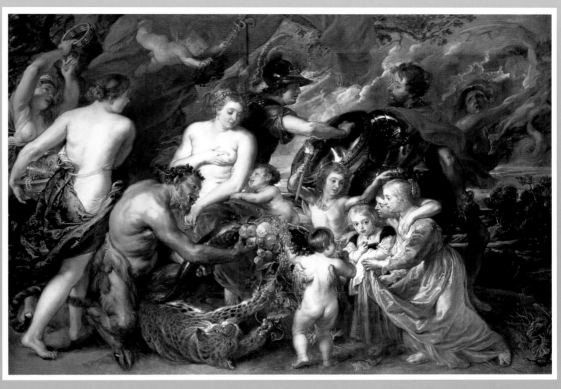

NG 46 Oil on canvas, 203.5 x 298 cm

Rubens was a courtier as well as a painter, and *Minerva protects Pax from Mars ('Peace and War')* is an inspired act of international diplomacy. Rubens was in England in 1629–30 at the behest of King Philip IV of Spain to negotiate an exchange of ambassadors which would lead to the end of hostilities between the two kingdoms reaching back to 1623. During the negotiations Rubens presented the English king, Charles I, with this allegory of his diplomatic aspirations. At the centre of the crowded composition, Pax (peace) prepares to feed the infant Plutus (wealth), while directly behind her Minerva (wisdom) drives away Mars (war) and his familiar, the bellicose Fury Alecto. At the left, nude women represent the

benefits of peace, prosperity and the arts, while a kneeling satyr presents a cornucopia laden with the abundant fruits of concord. For Rubens, the painting was a personal as well as a political statement; the allegory is his invention, and the sweet children wearing contemporary dress in the foreground, one of whom timidly turns to catch the viewer's eye, were the offspring of Rubens's British friend Balthasar Gerbier, with whom he lived in London as he negotiated. Rubens's mission was a success. So pleased was the king that, soon after the Spanish ambassador's arrival in London, as the artist prepared to take his leave for Antwerp, a grateful Charles I bestowed a knighthood on him.

RUBENS
The Brazen Serpent probably 1635–40

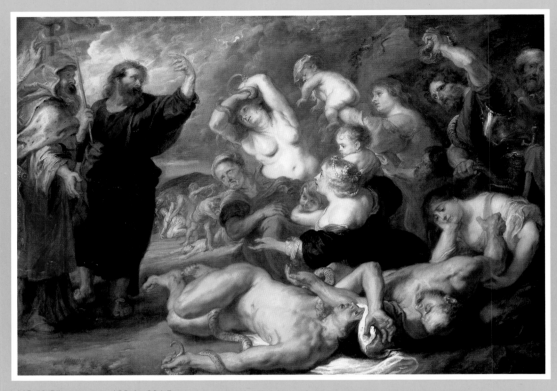

NG 59 Oil on canvas, 186.4 x 264.5 cm

The Brazen Serpent shows the artist, with considerable studio assistance, depicting a dramatic Old Testament scene full of dark forebodings. As a result of their sinfulness, the Israelites were visited with a plague of serpents. A mother holds up her baby for safety while nude figures writhe in terror on the ground. The latter poses derive from the great Hellenistic marble sculpture the Laocoön, which shows a father and his sons beset by a serpent. It was a paradigm for the depiction of intense pain and suffering in art, and Rubens had studied it intently in the papal collections at the Vatican. In contrast to the fallen figures at right, Moses at left, accompanied by Eleazar, stands and points upward, his hand silhouetted against a stormy sky, directing the Israelites' attention to a bronze serpent erected on a pole. He tells them that if they look on it they will be saved (Numbers 21:6–9). The story Rubens tells does not function on its own, however. A man of strong faith,

the artist knew, and knew that his audience would understand, that the brazen serpent was an Old Testament 'type', or anticipation, of the Crucifixion of Christ. Just as contemplation of the brazen serpent would save the Israelites, so too, under the new dispensation, would Christian contemplation of the crucified Christ lead to eternal salvation.

These three multi-figure paintings on political, artistic and religious themes show the range of Rubens's art and the erudition that lay behind it. While the symbolic and allegorical language they speak is not widely shared today, the basic issues with which Rubens dealt – the longing for peace, the lure of beauty, the search for salvation – are no less pertinent now than they were four hundred years ago.
Christopher Riopelle

LEON **KOSSOFF**

born London, 7 December 1926

© Roland Randall

KOSSOFF FIRST VISITED the National Gallery sixty-six years ago. He was deeply struck by Rembrandt's *A Woman bathing in a Stream*, from which he has often worked since. His years as an art student in London ended at the Royal College of Art, 1953–56. In 1950–52 he had attended David Bomberg's classes, which he found a liberating experience.

Kossoff draws continually – a practice fundamental to his work – both from great past art and from the world around him. His paintings manifest an unplanned symbiosis between the figures seen in these two contexts. His principal subjects are a few close family members, friends and nude models and the life of London, the city that has always been his home. Alive with human movement, his London subjects include building sites, street scenes, a crowded swimming pool, under- and over-ground railway stations, their outdoor tracks and trains, and the soaring façade of Hawksmoor's Christ Church, Spitalfields.

In each work Kossoff combines observation, memory, the presence of the subject, and the properties of light, colour and of his materials' physicality in a strongly stated image that also embodies his powerful emotional response. Usually replacing earlier attempts on the same support, the final picture is often achieved in a single session, the swiftness and intensity of the mark-making being openly displayed.

ON KOSSOFF

Drawings and prints after Rubens's *Judgement of Paris* 1996

Etching, plate size 28.2 x 40 cm

Etching, plate size 24.5 x 33 cm

All pictures courtesy L.A. Louver Gallery, Los Angeles and Annely Juda Fine Art, London

Charcoal and pastel on paper, 56.7 x 76 cm

Etching, plate size 45.3 x 60.6 cm

Etching , plate size 40.3 x 28 cm

Charcoal on paper, 56 x 75.8 cm

219

Drawings and prints after Rubens's *Minerva Protects Pax from Mars ('Peace and War')* 1996

Charcoal and pastel on paper 56 x 76 cm

Charcoal on paper 56 x 76 cm

All pictures courtesy L.A. Louver Gallery, Los Angeles and Annely Juda Fine Art, London

Etching, plate size 45.5 x 55 cm

Etching, plate size 45 x 60 cm

Etching, plate size 30.5 x 40.7 cm

Etching, plate size 45 x 55.5 cm

Etching, plate size 30.5 x 41 cm

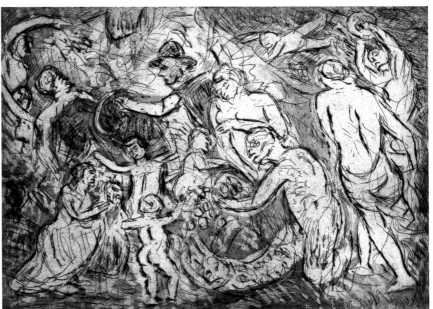

Etching, plate size 41 x 57 cm

Drawings and prints after Rubens's *Brazen Serpent* 1996

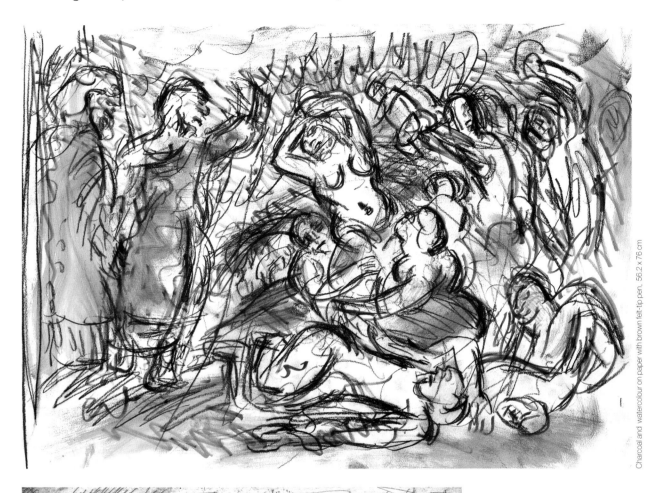

Charcoal and watercolour on paper with brown felt-tip pen, 56.2 x 76 cm

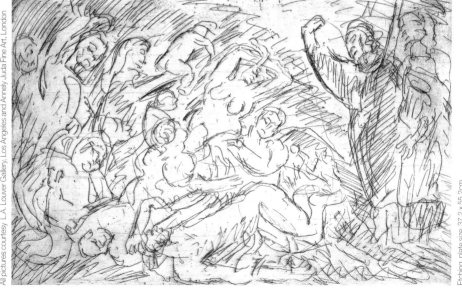

All pictures courtesy L.A. Louver Gallery, Los Angeles and Annely Juda Fine Art, London

Etching, plate size 37.2 x 55.2cm

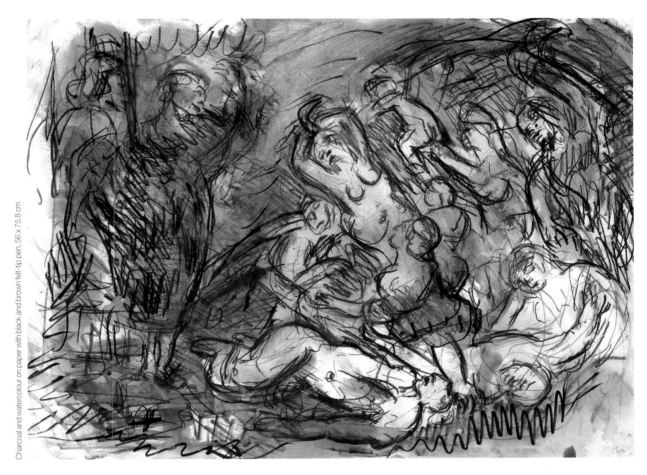

Charcoal and watercolour on paper with black and brown felt-tip pen, 56 x 75.8 cm

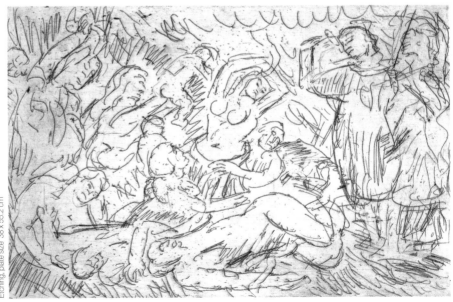

Etching, plate size 38 x 55.2 cm

223

LEON KOSSOFF has been drawing directly from paintings in the National Gallery for most of his life and Rubens was among the earliest artists from whose pictures he drew. In the group of works now shown, all the marks in the drawings and virtually all those on the plates from which the prints were etched were made in the Gallery, in 1996, from direct observation of Rubens's originals.[1]

Already by the age of ten Kossoff was convinced that the activity of drawing would have special importance for him. He looked to visits to the National Gallery as the means of learning how to draw well. Initially he simply studied the paintings with close attention. Though this led in due course to drawing from them in short snatched bursts, it was the example of his fellow student, Frank Auerbach, that gave him the courage to sketch in the Gallery in a more purposeful way, beginning in the early 1950s. Figure **2** shows a Kossoff drawing made in the

Peter Paul Rubens *The Judgement of Paris,* probably 1632–5

Gallery at that time after Rubens's *Minerva protects Pax from Mars.* While this is instantly recognisable as by the same hand as the drawings of the 1990s, its relative density and sense of volume are characteristic of the sensibility of the circle of David Bomberg, whose teaching (between 1950 and 1952) Kossoff found liberating.

Since at least the 1960s Kossoff has been widely admired for the strength and distinctiveness of his drawing. Nevertheless in 1987, nearly forty years after starting to draw there, he stated: 'In my work done in the National Gallery and

Peter Paul Rubens *Minerva protects Pax from Mars ('Peace and War'),* 1629–30

elsewhere from the work of others I have always been a student. From the earliest days when I scribbled from the Rembrandts in the Mond Room my attitude to these works has always been to teach myself to draw from them, and, by repeated visits, to try to understand why certain pictures have a transforming effect on the mind. In the copies, made in the studio, I have always tried to remain as faithful as I was able to the original, whilst trying to deepen my understanding of them. I have always regarded these activities as quite separate from my other work and only once, a long time ago, have I consciously used one of these works in the making of my own pictures.'[2]

Though Kossoff has drawn from Rubens's paintings in the National Gallery intermittently over the decades, only one of his paintings after such works has survived, the very substantial *Study from 'Minerva protects Pax from Mars' by Rubens* of 1981 (**1**), which is only a little smaller than the original. In a manner characteristic of Kossoff's revisualisations of crowded figure compositions from past art, his image gives the viewer a closer – even a more intimate – sense of participation in the scene being enacted than does the almost stage-like tableau from which it derives. This is despite Kossoff's markedly more abstract treatment of natural appearances, his elimination of the direct gaze of one of Rubens's figures and the complete absence from his intentions (unlike Rubens's) of the transmission of any moral about the conduct of public affairs.

Kossoff's drawings made from *Minerva protects Pax* at that time (**3**) show an increase in openness and fluidity compared with those made nearly thirty years previously (**2**). In

turn, those done from the same painting in 1996 suggest, when viewed beside the drawings of both earlier periods, an increased interest in the sculptural realisation of form. Such a concern is a clue to the circumstances in which all Kossoff's works in the present exhibition came to be made.

Kossoff had long felt a powerful response to Cézanne's paintings of bathers, especially the most monumental examples. He had often drawn from reproductions of the largest of these, *The Large Bathers* of 1906 in the collection of the Philadelphia Museum of Art (**4**), but had always wanted to draw it from the original. In 1996 the Philadelphia painting was shown for the first time in London, in the Cézanne retrospective at the Tate Gallery. This was a time of great pressure in Kossoff's professional life. He had just represented Britain at the Venice Biennale and final preparations were in progress for his own retrospective to follow Cézanne's at the Tate.

Peter Paul Rubens *The Brazen Serpent,* probably 1635–40

In these circumstances he felt unable to work from the Philadelphia painting. He has explained, however, how 'every time I looked at the painting and others in the exhibition I thought of Rubens and remembering how often Cézanne had drawn from him I approached the National Gallery and was kindly given permission to draw from the works in the evenings'.[3] The result was the body of work from which the sheets now exhibited have been selected.

Figure **5** reproduces a drawing by Cézanne after Rubens which is of unmistakable relevance both to Cézanne's own subject of bathers and to the imagery in the pictures by Rubens that Kossoff drew in 1996. In view of the strong link, for Kossoff, between Cézanne and Rubens it is also interesting to consider the drawings he made in the Royal

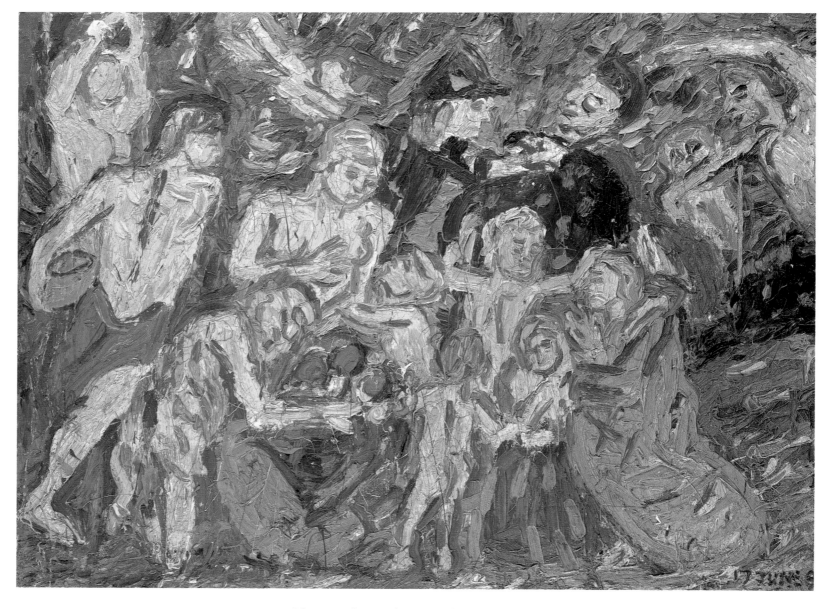

1 Leon Kossoff *Study from 'Minerva Protects Pax from Mars' by Rubens*, 1981, oil on board, 182.9 x 243.8 cm, private collection

Academy in 1988 (**6**), during the exhibition *Cézanne: The Early Years*, after a distinctly Rubensian image, *Pastoral (Idyll)*, of about 1870 (Paris, Musée d'Orsay). Here, as in Rubens's *Judgement of Paris*, three substantial nudes, seen from different angles, dominate the left side of a landscape scene that also includes male figures. These drawings by Cézanne after Rubens and by Kossoff after Cézanne evince the sense of sustenance inherent in a process of transmission which takes unpredictable forms, but which animates the development of art as a continuous web. The list of painters who have worked from pictures by Rubens in public collections includes Watteau, Boucher, Delacroix, Renoir and Maillol.[5] Like that of Cézanne, the work of each nourishes succeeding generations, albeit in ways that would often have amazed the artists who inspired them.

Each of the three paintings by Rubens that Kossoff drew in 1996 represents a scene of notable drama. In one a decision is being taken which will have the devastating consequences recounted in classical myth. In the other two we witness moments at which major disasters are arrested or averted. However, on the conscious level at least, none of these themes underlie Kossoff's choice of these works as the sources of his own drawings after Rubens. In all these works

2 Leon Kossoff *Drawing after 'Minerva protects Pax from Mars' by Rubens*, c.1954, charcoal on paper, 42 x 59.6 cm, private collection

(as also, conspicuously, in Cézanne's Philadelphia *Bathers*) it is the qualities of movement, of directional thrust and above all of the picture's 'architecture' – how the figures occupy the space – that compel Kossoff's attention. Also critical is his sense of the degree to which each work from which he draws in the National Gallery is a marvellous pictorial invention. Kossoff emphasises that the works' excitement for him is, therefore, overridingly visual. Divorced from speculations about iconography, it is the directness of such a response, the sense of wonder at the object seen and the urgency and intentness of Kossoff's traversing gaze, that give the images he creates in front of these pictures by Rubens their special quality of freshness, however many times he returns to the motif.

An additional explanation of the special character of such sheets is the fact that each is the outcome of the drive to learn, on which subject Kossoff has been quoted above. For this reason, however fully realised a viewer may consider these National Gallery drawings to be, Kossoff regards them as evidence of a process, rather than as works of art. He aims by that process not only to learn how to draw but also to get closer to understanding the greatness of the paintings from which he works. Although each new drawing or print reiterates a relationship already substantiated in earlier sheets it is also the product of an act of rediscovery. Through the concentration of a process of mark-making that depends on the complex of shapes he is looking at in the source painting, supported by his longer memory of the work, Kossoff seeks to see the original painting from inside and to be able thus to find a structure that is both true to his experience of it and has the quality of being

3 Leon Kossoff *Drawing after 'Minerva protects Pax from Mars' by Rubens*, 1981, charcoal on paper, 40.5 x 50.7 cm, private collection

227

something seen as if for the first time.

Drawing is central to all aspects of Kossoff's work. As in these prints and drawings after Rubens, it is the crucial means of his connecting with the source painting. But also in his work as a whole – most of which is not

day, either from the friend who sits for him or outside in the London streets he knows so well. He cannot work on a painting in his studio without having first drawn its motif afresh that day from direct observation. Though the pictures he draws in the National

and even subjects in his paintings of contemporary life rouse strong echoes of those in works from past centuries, their resonance being deeper through the absence of conscious intention in this respect. Yet, as we have seen, Kossoff's working engagement with works by the masters is actively enabled by drawing from real life.

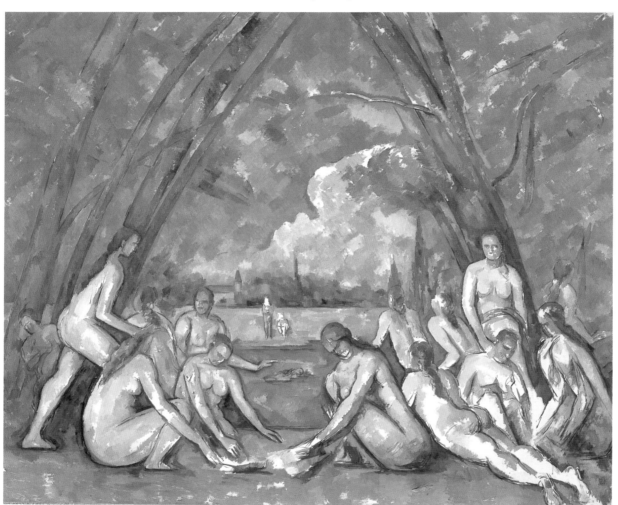

4 Paul Cézanne *The Large Bathers*, 1906, oil on canvas, 208.3 x 251.5 cm, Philadelphia Museum of Art. Purchased with the W.P. Wilstach Fund

The importance of drawing for Kossoff when working from paintings by Rubens or other masters, is attested by the constant renewal of his quest for a structure. He considers that great art throughout the ages was driven by the practice of drawing in particular, not least in the final statement of a work, regardless of its often not being itself 'a drawing'. He feels that whenever a great work has largely been lost to us through the depredations of time, of war or of purposeful intervention, the drawing that is fundamental to it often survives in whatever of the work remains, whether it be painting or sculpture.

In a letter to the author,[6] Kossoff expanded on the reasons for his reservations about participating in the present exhibition in the following terms. His first

from art by past masters – it is an activity without which he finds it impossible to paint. He has explained, indeed, that if he is unable to draw for two days, resuming work thereafter is like beginning his work as an artist all over again.

Kossoff draws or paints from life every

Gallery are replete with information from life, he finds his drawings from them less satisfactory the further removed they are in time from the activity of drawing from nature. Between working from contemporary life and drawing from Old Master paintings, a vital reciprocal process is in operation in Kossoff's art. While he rarely uses his drawings after past masters as aids to his paintings of contemporary subjects, plainly they enrich his entire work. Indeed, formal relationships

reference is to the display of Titian's *Flaying of Marsyas* in the exhibition *The Genius of Venice 1500–1600*, Royal Academy of Arts, London, November 1983–March 1984: 'When the Marsyas was shown at the R.A. we were all surprised and amazed. The extraordinary response the painting provoked was due mainly to its physical condition. It looked as though it had just emerged from Titian's studio. It was alive with immediacy enabling us to imagine, how other paintings of the

period might have looked when finished. Yet some works, though exposed to the hazards of passing from collection to collection (unlike the Marsyas), have a way of surviving. Though they are no longer the works that emerged from the artist's studio the passion involved in their making somehow keeps them alive. We can imagine the drive and drawing of a Veronese or a Rubens and there is a great deal we can still learn from them.'

He added in a later letter:[7] 'I am not sure that we can reconstruct in our minds the presence and identity of many Rembrandts. The recent exhibitions of Claude and Rembrandt show how necessary and helpful it is to approach these works through drawings and prints where these qualities are still intact.'

There is a connection between this perception and the importance of line in Kossoff's work after the masters, above all in his etchings. The paintings from which (in a double sense) he draws the image are rich in colour and in painterly touch. Kossoff, however, concentrates each work into an idiom of relatively summary line (in the process often coming closer to the preparatory drawings that preceded the master paintings from which he is working). This 'limited' line (as Kossoff describes it) embodies a three fold act of concentration – his selection from the mass of information before him; the compression of his response into the brief span of time of the work's execution; and, in the case of these three

works by Rubens, his experience of the source work accumulated over a period of decades. The last aspect is fundamental, because although each drawing on paper or etching plate is made quickly (always in a single session, lasting perhaps thirty minutes

5 Paul Cézanne *Three Naiads, after 'The Disembarkation of Marie de Médicis' by Rubens*, pencil on paper, 31 x 45 cm, Zurich, Mme. M. Feilchenfeldt

for a drawing and possibly less for the marks incised on a plate) it is the product of an encounter of a more extended kind.

Kossoff's drawings in this exhibition display gestures of great immediacy and are also somewhat larger than his concurrent etchings. One might therefore expect Kossoff to feel he had come closer to Rubens's paintings in the drawings than in the prints, but the reverse is the case. The reason has to do with the method of mark-making that is enforced by working on a plate, rather than direct on to paper.

Consistent with his need to draw before working in another medium, Kossoff customarily made one or two drawings from a Rubens painting immediately before incising the etching plate (also direct from the same source picture). This meant that he

moved almost without pause from making marks that were instantly visible to working on a surface on which the developing image was extremely difficult to see. Any considered judgement as mark-making progressed was further impeded by the speed of the operation. As a result, Kossoff was working in the unknown. The guidance given by his long experience of drawing from the same

6 Leon Kossoff *Drawn from Cézanne's 'Pastoral (Idyll)'*, 1988, watercolour and pastel, 56.5 x 67.5 cm, private collection

Rubens picture therefore took on still greater importance than when working from it on paper. Even more than when making a drawing after Rubens, Kossoff therefore felt able, in etching, both to interpret the source

painting as it were from inside and to re-make the image afresh.

The etchings present a symbiosis between the movement (both in its composition and in the action it depicts) in each Rubens and the swift gestures of Kossoff's hand (including marks reading almost as cancellations which were in fact made incidentally in the turbulence of creating the

image). Most of the plates Kossoff used for these etchings were of proportions that differed from those of the paintings re-visualised on them. This discrepancy reinforced for Kossoff the sense of the image being re-made as he worked, since he was obliged to find a way of expressing the idea of the painting within new confines.

In his etchings after Rubens Kossoff used

softground and aquatint less frequently than in his prints in the same period after some other masters (**7**). A few examples of the latter were hand-coloured and certain plates editioned. None of his etchings after Rubens was editioned.[8] Like many other prints by Kossoff, they were made with the artist–printer Ann Dowker, in a creative dialogue the results of which are the more effective thanks to Dowker's close understanding of the works from which Kossoff has drawn and of his own sensibility. The degree to which each plate is bitten is determined intuitively, and though these etchings after Rubens do not exist in different states each new impression is an experiment, both in inking and in choice of hue (the latter often suggested by the individual plate).

Kossoff's prints after earlier artists reveal a lively engagement with the medium. They highlight the capacity of printmaking to capture the artist's thought and feeling. A further attraction of etching is its ability unexpectedly to disclose images formulated by Kossoff that surprise even him by their validity. Nevertheless, he insists that his work in this medium should not be seen as 'printmaking', a concept he associates with a more prescriptive and regularised approach than is true to his own instincts. For him these works are above all about drawing, which in the process of being transferred

to paper simply becomes print. Among earlier artists, he admires Rembrandt, Manet, Degas and Sickert for the directness of their concern, in their prints, with giving primacy to drawing, their images' key constituent.

Though inspired by the work of an outstanding colourist, Kossoff's works in this exhibition are predominantly black and white. This restriction springs from the preoccupation with structure which drove their creation, but restriction is not the right word for images that, even when confined literally to black, white and their nuances, reveal so wide a range of light, texture and, one is almost compelled to say, hue. The choice of coloured inks for others among the etchings adds its own expressive quality, and where coloured chalks are employed in the

drawings they evoke sensations varying from torment to tenderness (the latter an increasingly prominent accent in Kossoff's art as a whole).

A paradox of Kossoff's works after Rubens (as after many other masters) is the degree to which the subject of an image continues insistently to engage the viewer's interest despite the primacy, for the artist, of the abstract properties of the original. Kossoff is in no way opposed to narrative or human interest in a work, but the question arises whether its richness in the works he makes after earlier artists is owing simply to the force

7 Leon Kossoff *'Salisbury Cathedral from the Meadows' after Constable*, 1988, etching, plate size 42.6 x 55.4 cm, private collection

8 Leon Kossoff *Family Party, January,* 1983, oil on board, 167.6 x 249.6 cm, private collection

of its expression in the original or whether his own input, too, operates to sustain the strength of depictive content. In this writer's view the latter position obtains. In Kossoff's works after Rubens we encounter an imaginative world in which scene, action and composition depend critically on Rubens's inventions but which in terms of human observation and psychic atmosphere is integral with Kossoff's representations of the world he knows at first hand. This is hardly surprising and is an index of the

works' authenticity.

All the paintings by Rubens from which Kossoff chose to work in 1996 are crowded scenes alive with action from edge to edge. This quality is carried through in Kossoff's 'transcriptions', not only by transmission of the currents of energy that pervade the originals but also by the vitality of the individual marks Kossoff makes, and by their abstract interaction. While re-presenting the original composition, in the same act he gives a commentary on it, not in words but in a language that, because purely visual, is better able to articulate what he feels about the work that generated his response.

One would not look to these drawings and etchings for a detailed record of the specifics of the original images, but the force, conviction, engagement and feeling with which they are realised render accuracy in that sense irrelevant. Kossoff makes the process itself part of these sheets' subject. The physical and the emotional constituents of that process are experienced by the viewer as a single quantity.

In each of the selected paintings by Rubens, there is an even pulse of human activity, whether calm in *The Judgement of Paris*, frenzied in *The Brazen Serpent* or, paradoxically, both in *Minerva protects Pax*.

This 'beat' is a characteristic of Kossoff's own paintings of the London scene or of groups in interiors. In two of Rubens's paintings significant incident is also seen in the sky, and it is not irrelevant that in Kossoff's cityscapes (as in Cézanne's Philadelphia *Bathers*) the sky is an active area, even though without supernatural presence. Complementing the overall vitality of each Rubens is a stability; and this, in Kossoff's work, is no less emphatic. It is instructive to compare *Minerva protects Pax*, with its firm triangular composition enclosing a circle of closer foreground activity, with a painting by Kossoff from contemporary life, *Family Party, January*, of 1983 (**8**).

Underlying stability in a scene of activity is a cardinal feature also of the Philadelphia Cézanne. A striking detail in that painting, the figure striding boldly in from the left,[9] links it both with the corresponding figure in *Minerva protects Pax* and with the frequency with which, in Kossoff's street scenes, equally convincing figures are shown moving into the picture from left or right. Very often these form part of a frieze-like arrangement of figures across the picture plane, which in turn is a marked characteristic of Rubens's *Judgement of Paris*.

Kossoff's images after Rubens are among other things a celebration of the nude. This connects them with the drawings and paintings from the nude model – or, recently, from such models as a couple (**9**) – which are at the heart of his work. As in the art of both Cézanne and Kossoff, all three pictures by Rubens include strong, solidly realised, individual nudes. It is not over-speculative to see all three artists' interest in this subject as affirmative of life. The stability of the nude figure of Pax at the still heart of the movement-filled

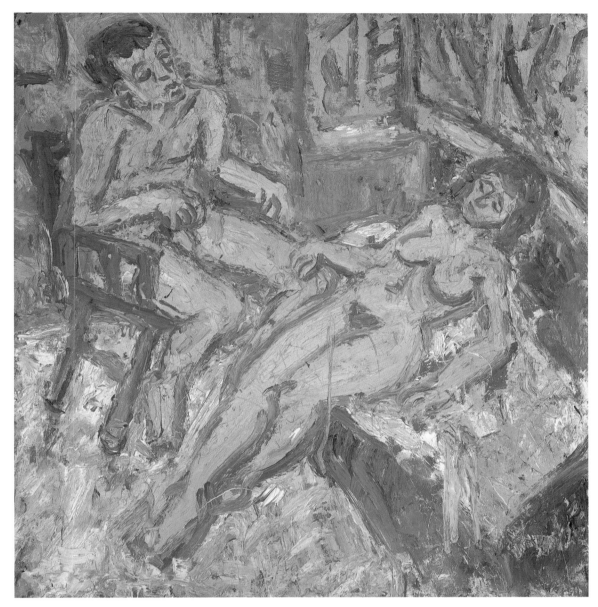

Minerva protects Pax is emblematic of this.

A key link between these Rubens works, Cézanne's *Bathers* compositions and one of the principal genres of Kossoff's art is the motif of figures gathered together, whether purposely or by chance. In each case, the interest of their conjunction is more than compositional. Always, something is going on. For, although neither the mysterious activity witnessed in the Cézanne nor the determinedly quotidian convergences in Kossoff's London paintings denote an

9 Leon Kossoff *Summer in the Studio, Pilar and Jacinto I*, 1997, oil on board, 142.5 x 135 cm, courtesy Annely Juda Fine Art, London

exceptional moment (unlike all three works by Rubens), all three artists' figure compositions communicate an emotional charge.

In the case of Kossoff this arises not only from his special relationship with the outside world but also from a tendency of the 'passersby' in his paintings to take on characteristics of people well known to him personally.

10 Leon Kossoff *Drawing after 'Landscape with a Calm' by Poussin*, 1999, watercolour and pastel, 56 x 78 cm, private collection

This helps explain why his ostensibly impersonal street scenes have a quality of such intimacy. As Kossoff states, 'Though I have painted many landscapes, most of my time is spent working from the individual figure in the studio. It is the people I draw and paint in this way that appear in the landscapes'.[10] This pervasive closeness suggests a further possible explanation of the appeal for him of these paintings by Rubens. All are based on repeatedly retold stories through which the protagonists, though sometimes divine, can come to seem familiars of anyone who engages, for whatever reason, with such striking representations of their deeds and relationships. All three works also emphasise human interaction, a theme which seems central to Kossoff's art, even when figures in today's city are shown as if glimpsed at a chance moment of intersection. Among the pictures from which Kossoff has worked recently in the National Gallery are Poussin's *Landscape with a Calm* (when on loan from the J. Paul Getty Museum, Los Angeles) and Constable's *Salisbury Cathedral from the Meadows*. Both are extensive landscape paintings which accord

great prominence to buildings, yet in his drawings (**10**) and prints (**7**) after these works it is notable how strongly he focuses on the human interest that forms a small though significant part of each. [11]

Considering how vestigial, in many cases, are the marks by which Kossoff renders the features of the actors in Rubens's dramas and also, from an academic point of view, how distorted, it is astonishing how convincingly we read each individual figure, feel the force and thrust of its gestures and the weight of its form, perceive a real grace in its demeanour and enter into the intensity of the situation represented. And all this despite (or because of?) the fact that from one sheet to the next, dependent on the same source painting, the very personality of a given figure may seem to alter completely. The reason is that each of these derivations from Rubens admits us to a sphere in which a passionate engagement with the greatness of the older artist liberates a vision that is peculiarly Kossoff's. In that vision form, space, gesture, past, present and an inherent human respect combine in a single expression that each reiteration makes compellingly new.

Richard Morphet

Notes

1 The National Gallery owns two paintings by Rubens of *The Judgement of Paris*. In 1996 Kossoff worked only from the later of these. The other is NG 6379, painted around 1600.

2 Letter quoted in exh. cat. *Past & Present: contemporary artists drawing from the masters*, South Bank Centre 1987–88, p.38. Kossoff has drawn from works in a range of exhibitions at the Royal Academy, including those of Venetian art, Neapolitan art, Hals, Goya and Courbet.

3 Letter to the author, 17 January 1999. During the late 1990s Kossoff worked in the National Gallery from paintings by a number of other artists, including Veronese, Rembrandt, Velázquez, Constable and Degas. Richard Kendall, *Drawn to Painting: Leon Kossoff Drawings and Prints after Nicolas Poussin,* is the substantial catalogue of exhibitions held simultaneously at the Los Angeles County Museum and the J. Paul Getty Museum, Los Angeles, January–April 2000.

4 Letter to the author, 1 July 1999.

5 The catalogue of the exhibition *Past & Present*, cited at note 2, reproduces drawings by Anthony Eyton, Francis Hoyland and Sargy Mann after the National Gallery's *Judgement of Paris* (NG 194), after which there are works by Kossoff in the present exhibition.

6 17 January 1999.

7 13 June 1999.

8 The incisions on the plates were made in 1996. The plates were printed in 1996 and 1997. Most were made on zinc plates, though one or two were on copper.

9 The same figure appears in the National Gallery's Cézanne *Bathers*.

10 Letter to the author, 13 June 1999.

11 'When I was working from the Getty picture I missed its pendant painting, "[Landscape with a] Storm", which is in Rouen and was shown together with "Calm" at the R.A. I turned to the [National Gallery's] "Landscape with a man strangled by a snake" – a painting that has haunted me forever – and fortunately a drawing and a print emerged. It was an alternative pendant. I have always been puzzled how a faintly indicated [detail] like the strangled man could affect and be involved in the feeling of the whole work. He is more clearly indicated in the print and drawing, yet it seems to work' (letter to the author, 13 June 1999).

RAPHAEL
The Procession to Calvary about 1502–5

NG 2919 Egg and oil on wood, 24.1 x 85.1 cm

THE PICTURE IS the central panel of the predella for a large altarpiece showing the Virgin and Child with saints that Raphael (Raffaello Sanzio, 1483–1520) painted for the church of Sant'Antonio, Perugia, early in the sixteenth century. The ensemble was removed from the church as early as 1663, and sold to Queen Christina of Sweden. The main part of the altarpiece is now in the Metropolitan Museum of Art, New York, as is a second predella panel. Other panels are in Boston and at Dulwich Picture Gallery.

As in the main panel originally above, the principal figures in this processional scene are the Virgin and her Son, shown here, weighed down with a cross, making his way towards his agonising death on Calvary. Two horsemen lead the slow-moving procession to the place of execution. Behind them, Christ is surrounded by armed soldiers who rudely drag him onwards, although one man immediately behind Christ seems to take on some of the weight of the cross for him. Of the many figures in the frieze-like composition, Christ alone turns to gaze upon the viewer, demanding our contemplation of his suffering. He is to the left of centre in the composition, and this placement, as well as the greater crowding of figures on the left side of the panel, intensifies the sense of a slow movement towards the right. At the far left, the rear of the procession comes to a halt as Mary, overcome with grief, swoons into the arms of her companions,

the three Maries, who, three days hence, will be the first to learn of Christ's Resurrection. Saint John the Apostle looks on in concern, his hands clasped in prayer. It is he who will join Mary at the foot of the cross at the moment of Christ's death. The vivid colours of the panel have been revealed by a recent cleaning, as have the brilliant streaks of light in the sky at right, towards which the procession moves, in a kind of promise of the Resurrection to come.

This may be the earliest of ten paintings by Raphael in the National Gallery's Collection. The diminutive scale and delicate gestures of the figures reveal a continued debt to his master, Pietro Perugino, at this time still one of the most highly regarded painters in Italy. At the same time, the torsion of the figures and their complex interaction in space evince Raphael's rapidly growing compositional sophistication and inventiveness. In a few years, his skill would lead to vast and ambitious commissions from the Pope for the Vatican and a definitive relocation to Rome. Before his premature death in 1520, he would already be recognised as even more influential among painters than Michelangelo. In centuries to come, wherever the classical tradition of painting was inculcated, Raphael would be the standard by which academic training was set and subsequent generations judged.

Christopher Riopelle

CHRISTOPHER **LE BRUN**

born Portsmouth, 20 December 1951

© John Erle Drax

L E BRUN'S PAINTING springs from seemingly conflicting impulses – towards powerfully charged imagery redolent of the Symbolism of Böcklin or Redon and towards painterly abstraction with roots in Abstract Expressionism. Soon after Le Brun studied at London art schools in the early 1970s abstract blocks of colour in his paintings began to yield to landscapes evoking an imaginary natural world. Over two decades he has unfolded an imagery of trees, forests, wings and suns, in which the most frequent living presence is that of magnificent horses, emerging from the paint as from a dream and, latterly, ridden by armoured figures. Other participants include skeletons and muses, palette in hand.

Developed intuitively and often long in gestation, Le Brun's images are formed by rich, gestural brushwork. Clearly articulated as archetypes, they lodge in the mind. They are rarely closely detailed, however, and thus direct the viewer's attention to the fluidity and nervous vitality of Le Brun's touch, the play of which across the surface becomes a subject in its own right. These paintings are therefore not 'about' their ostensible motifs alone. Their tenor is as much speculative, exploratory and about the present moment as it is deliberately archaic. Le Brun's imagery reappears in his sculpture, which shares the concern of the pictures with space and light. He lives in London.

After Raphael 1998–9

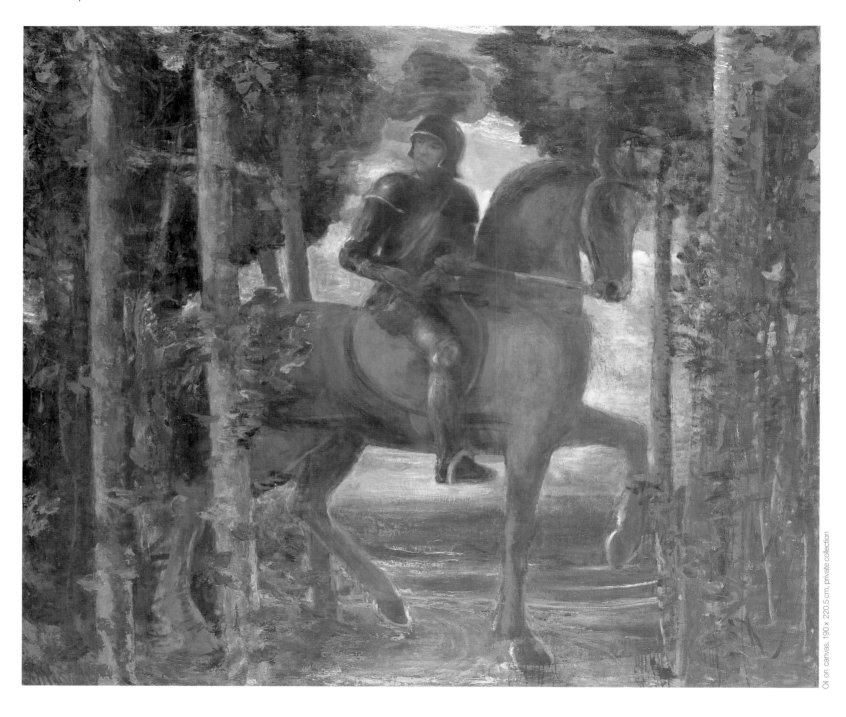

Oil on canvas, 190 x 220.5 cm, private collection

HIS ARMOURED figure framed between trees, a knight on horseback passes across our field of vision along the water's edge. A breeze ruffles the plumes on his helmet; the distance shines with a bright light. Under its rider's sure control his alert charger is ready to obey any command. Saddle, cloth, harness and feathers are united by a glowing red. This simplification combines with the distinctness of the silhouette of horse and rider and with the clear shapes of the tree trunks to convey a sense of instant comprehensibility. Moreover, the picture reads at first sight like one of total assurance – of the rider in his mission, and of the painter in realising a planned image and in translating the viewer from a contemporary context to one in the distant past. It therefore comes as a surprise to learn that *After Raphael* is above all about doubt and anxiety, and that the time on which it insists is our own day.

More than twenty times the size of the picture to which it responds, Christopher Le Brun's picture for *Encounters* refers to the image of the horse and rider at the right-hand end of Raphael's *Procession to Calvary*. The postures of both horse and rider correspond closely to those in the source, and the fluttering red pennant in the older

picture finds a parallel in Le Brun's plume. However, setting and tonality are altered dramatically. Furthermore, while Le Brun has represented horses and riders often, he has never previously shown a rider looking back. It was this feature in the Raphael that led Le Brun to choose it. In *The Procession to Calvary* the powerfully demonstrative emotions are

1 Christopher Le Brun *Travellers in a Landscape*, 1999, oil on canvas, 190 x 180.4 cm, London, Marlborough Fine Art

Raphael *The Procession to Calvary*, c. 1502–5

concentrated in the left half of the picture. On the right-hand side, the work's strong directional thrust is led by the confident, forward-looking horse that is the source for Le Brun's in the new work. One might, therefore, expect equal determination to be displayed by Raphael's rider. Instead, for Le Brun, he evinces uncertainty or, at the very least, second thoughts. The embodiment of this emotion in the image of a rider, one of the archetypes of Le Brun's art, provided for him an apt symbol of the dilemmas involved in the process of self-discovery through the vehicle of a representational image. That process and its resolution are the true subject of his painting in this exhibition.

Paradoxically, another part of the attraction of the source painting was a quality in contrast to doubt, namely Raphael's assurance as a painter. To Le Brun, 'Raphael is emblematic. At one level he represents the natural style of painting, but he is somehow so typical as to be almost invisible, and perhaps a bit inhuman. With Corot or Turner there would have been more character and idiosyncracy. Raphael represents a model of a particular kind of artist, rare and today thought

2 Christopher Le Brun *Dante and Virgil entering Hell*, 1999–2000, oil on canvas 190 x 180.3 cm, London, Marlborough Fine Art

impossible to try to follow. For this reason he is deeply interesting.'[1]

Raphael's clarity of purpose and his pursuit of perfection of style are the antithesis of Le Brun's approach. When painting, he feels the need to take his mind off whatever it is he is expected to do (even by himself), in the hope that the process of working will open up the territory in which he feels most at home. That is a place somewhere between the willed depictive image that was taken for granted from long before Raphael till the onset of modernism and those forms of abstraction that give primacy to the artist's intuition. To the viewer, it is not readily apparent that Le Brun's pictures occupy an intermediate ground, for his oeuvre alternates between paintings apparently intended above all to show recognisable motifs in particular contexts and ones that appear abstract. In both types of picture, however, such appearances deceive.

After Raphael is an example of the first type of work. As with many of Le Brun's pictures (**1**, **2**), its look, its aura and its intensity affiliate it with Symbolist painting, which flowered from the 1860s to the very early twentieth century. It is therefore relevant to consider the purpose served for Le Brun, working in so much later an era, by images that have strength and resonance of this nature. Such images are heavy with associations, yet in a word what they give Le Brun is freedom. His vision as an artist is strongly abstract in character, yet he finds it almost impossible to be true to himself through images that are abstract from the outset. At the same time he is powerfully drawn to art, such as that of Delacroix, Palmer, Puvis de Chavannes, von Marées, Burne-Jones and Böcklin, in which invented scenes (however markedly they may draw upon elements of observation) are the channel for rich and intense feeling. It is a common experience to be entranced in childhood by the kind of world represented by images of knights in armour. Yet in the modernist milieu in which Le Brun trained as an artist, and now again in a period when coolness and detachment are highly esteemed, neither early instinct nor the intensity of Symbolism are considered relevant indicators for new art, unless irony is involved. In so far as there is a kind of taboo on such models, Le Brun finds that employing them 'heightens the game'. He also considers that 'the implications of modern art have not yet been thoroughly taken up. If modern art is truly freedom, let us *have* true freedom.'[2]

For these reasons Le Brun's starting-point for a painting is often a mental picture of a particular kind of scene from what would commonly be regarded as a world of make-believe. His aim is to 'open the door of an idea, an atmosphere, and see what happens'.[3] As the image develops, Le Brun concentrates its design through acts of simplification which, paradoxically, increase its associative resonance by removing it, usually, from a specific narrative or location. But by thus distancing himself from the agenda of abstraction, he is simultaneously liberated to explore his own instinctual world of form, colour and touch.

Le Brun draws an analogy between this

way of securing an open situation in which to work and Chuck Close's decision to operate within particular conventions of the art of the portrait. By that means, Close 'put himself into a big empty room where no-one else would go'.[4] In his own corresponding space Le Brun is able to give form to a vision, in each work afresh, by fusing the dreamlike mood concentrated in the image with a language of mark-making that is unique to his own temperament. Both elements register a personal imaginative reality, for the painting can succeed only if the insistence of its image is balanced by the vitality of touch (something that is felt more than it is calculated). As Le Brun puts it, 'Too much certainty about the subject of the work does not allow my imagination to work'.[5] This applies to invented scene and painterly gesture alike.

Each picture begins as a search, of which the outcome is uncertain and which can move forward only when the momentum of painting is released. An image, a composition, the broad character of which is given at the outset, provides this impetus. In working with it and into it, Le Brun seeks to reach what he describes as 'an easy, fluid, unselfconscious state'.[6] But this cannot be willed and usually comes about only after persistent and at times frustrating engagement. One of the qualities the final image gives out is that of being built through time, but its power for the viewer depends also on its trapping the immediacy of instinct. In Le Brun's working process there is a link between perseverance and revelation. By immersing himself in the strange world of the picture he can break free from preconception and allow the vision itself to lead in directions that intellect alone might not wish to pursue. Significantly, it is often at the end of the working day, when Le Brun is really tired, that a painting takes a decisive turn. 'Perhaps I am then relaxing enough to allow what I really want to do to operate freely.'[7]

Thus in each of his paintings Le Brun is not so much disclosing an image as discovering himself. But while a work such as *After*

3 Christopher Le Brun *Wing with Disc II (Triple Motif)*, 1997, bronze, 22 x 15.5 x 7 cm, edition of six, London, Marlborough Fine Art

Raphael is not ultimately about history or fable, its moody setting and exotic trappings facilitate its inner purpose.

Le Brun has stated: 'A beautiful paradox of painting is that to reveal something you have to cover it over'.[8] In his own work he does this in three ways. First, his paintings accentuate the sense of one thing being laid on or placed in front of another. The very enclosedness of the forest in *After Raphael* carries this idea; it is instructive to compare it with the openness of the scene that Raphael shows. Horse and rider are slightly separated from us by the trunks of the nearer trees. Light (the antithesis of concealment) is a key subject

in Le Brun's art, yet it is notable how often he gives it added imaginative presence by occluding it in some way, as here, where horse and rider largely block our view.[9] Much of Le Brun's growing sculptural oeuvre gives tangible form to this sense of layering (**3**). In *After Raphael* Le Brun's concern with covering is reified, appropriately at the centre of the painting, by the image of armour. As he puts it, 'Armour enables you to abstract the figure behind a system of forms.' Finally,

image and facture combine to accentuate the parallel between hiding the distance by painting foliage and concealing the canvas by applying paint.

Covering up connects here, secondly, with conventions in the theatre, even though the theatre is also, no less aptly, the site of disclosure. Appropriately, Le Brun has painted a design for an enormous, stage-concealing safety curtain (**4**). At its centre, as

in *After Raphael*, there is a horse (Pegasus), which likewise is among trees beside water. Though riderless and winged, it, too, is accoutred in red, the giant swirl of paint that it seems to be breaking asunder. In *After Raphael* the scene is both 'staged' and somewhat stage-like; indeed, the way the tree trunks part, so as partially to reveal the knight's movement from left to right, has an affinity with curtains in the theatre.

4 Christopher Le Brun *Design for safety curtain for the Royal Opera House, Covent Garden*, London, 1982, oil on paper, 200 x 250 cm, collection of the artist

Moreover, Le Brun's comments on armour are a reminder that to don it in the modern world is to dress up. Such themes connect *After Raphael* with his memories of attending pantomimes as a child. To go up on to the stage, as children are asked to do, filled him at

5 Giorgio Morandi *Still Life*, 1951, oil on canvas, 22.5 x 50 cm, Düsseldorf, Kunstsammlung Nordrhein-Westfalen

once with horror and with fascination. He experienced simultaneous instincts of holding back and, in another part of himself, of being drawn irresistibly forward into public view. This ambivalence was prophetic of his eventual professional situation, for as an artist, too, he has a horror of revealing himself, yet powerful feelings insist that he do so.

When Le Brun's artistic identity was being formed, in the early 1970s, he was acutely aware of the achievements of the great Abstract Expressionists. Though it has become a cliché, there is truth in the notion that a canvas, for Pollock or De Kooning, was in a sense an arena in which to act. The 'stage' that, by a variety of means, Le Brun establishes in each work anew is also the place where a painter, when 'in' the picture in every sense, reveals himself with a directness and a personal emotional force that the nature of its imagery camouflages, at first sight.

Thus the third way in which Le Brun covers up in his art is by presenting a bold, charged and apparently easily read image, only in order to address rather different levels of experience. He explained this well when

he wrote about the art of Giorgio Morandi (**5**) in the following terms: 'Morandi counters subtly under the disguise of the recognisable; for him, seeing is metaphysical in nature, with another purpose, the imaginary. To the eye a painting is a surface. To the mind it is a surface suffused with absence. Morandi's unity of light and space permits the fluency of thought which enhances the atmosphere of the semantic and symbolic. He is the heir to Mallarmé, the poet of self-imposed distance.

'Thus a type of secretiveness, of the deliberately withheld occurs in his work. Where once the artist was a source of illumination, as the conveyor of appearances, now he is seen to be standing between the motif and ourselves, a source also of doubt and darkness

'The analytical and existential has come to possess all thought's prestige in our time, and with the closing of the picture-plane we achieve that self-awareness that comprises the prison of modernity

'The motif is not the subject but the object. Neither does the motif most directly indicate the world. The artist is the subject. It

is the touch by the subject that is the world.'[10]

The Procession to Calvary is, of course, not primarily about the emotions of the leading horseman but about a stage in the Passion of Christ, its principal figure. This central aspect of Raphael's narrative was not an active element in Le Brun's choice of the earlier work as a source and not till well into work on his responding picture did he consider it substantially. The significance of the scene that Raphael's rider observes does inform his own picture at some level, but it does so at two removes, since even the subject that Le Brun's painting ostensibly represents is equivocal in meaning. Moreover, it not only represents uncertainty but is also, for Le Brun, its site. As he has stated, 'I trust my touch more than I trust my judgement about what I am doing on an iconic level'.[11]

Thus in Le Brun's paintings the fusion of image and expressive touch has a strange and creative tension that would not be possible without there being at the same time a certain

6 Christopher Le Brun *Marcus Curtius*, 1983, oil on canvas, 251 x 350 cm, private collection

dichotomy between them. Yet that tension could not be so effective were the liveliness of Le Brun's handling of paint not balanced by the power of the figurative image he has formed. Thus we are brought back to the persistence of several motifs in Le Brun's art that are central to *After Raphael*. Crucial among these is the horse. The incidence of the human figure in Le Brun's work has been relatively infrequent till recently. This is perhaps a further instance of the holding back that is a continuous thread through his development (often, paradoxically, in tandem with imagery that is boldly assertive). The horse motif thus takes on added import, since, unlike other frequent elements in his paintings, such as towers and boats, it is animate. As fashioned by his brush, its image also carries associations of nobility, of temperament and of the role of the horse both in the historical past (including suggestions of the equestrian monument) and in exploits handed down in myth.

It is nearly twenty years since Le Brun began to paint variations (**6**) on the motif of another very small Italian picture in the National Gallery, roughly contemporary with Raphael and also representing a horse, namely *Marcus Curtius*, which is attributed to Bacchiacca (**7**). This work evokes the heroic self-sacrifice of an ancient Roman who, when a chasm opened in the Forum, plunged into it in order to save the city. Significantly, the horse he was riding unavoidably plunged with him. Horses are notable also in the work of Delacroix, a painter of importance to Le Brun, not least because of the way he 'carried forward the idea of the great master in respect of subject and composition'. A warrior on horseback is a key figure both in Delacroix's *Heliodorus driven from the Temple* (Church of St Sulpice, Paris) and in Raphael's *Expulsion of Heliodorus* in the Vatican Stanze, by which it was influenced.

In *After Raphael*, however, horse and

rider do not share the violence of movement or straining musculature seen in these earlier works. Encircled by trees, the motif is exactly placed within the rectangle formed by two particular trunks and the top and bottom of the canvas. Combined with its partial silhouetting against the light, this treatment not only focuses attention on the motif but also, in a sense, isolates it. Instead of being an image of action it takes on the character of an emblem, and almost of a cut-out. This quality is enhanced by the degree to which Le Brun formalises all the parts. Elementary shape is articulated wherever possible. The tree trunks, though credible, are also like rudimentary poles. In the centre, the eye is held by the circle within a circle formed by saddle-cloth and armoured knee, the former highlighted from an unexplained source. Thus, while the sense persists that this soldier is on a mission, he and his horse also act as a conceptualisation of all that has come down to us of the theme of mounted knights.

This interplay between reality, concept

7 Attributed to Bacchiacca *Marcus Curtius*, probably c. 1520–30, oil on wood, painted surface 25.4 x 19.4 cm, London, National Gallery

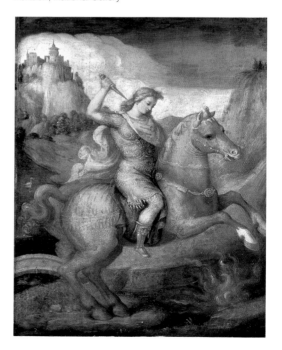

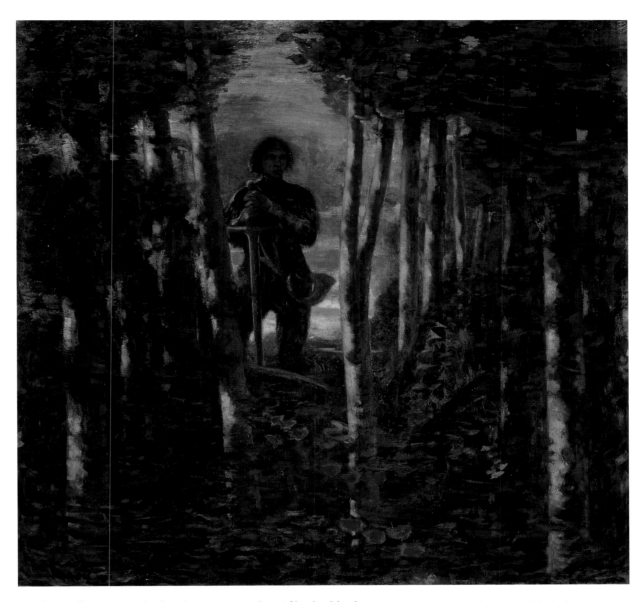

and abstraction is found, too, in the plume on the knight's helmet, which Le Brun describes as 'an extravagance of spirit, the necessary flourish'. He points out that today art is one of the few places where such spirited display can find a place. Here it works both as a reference to the world of chivalric spectacle and as an abstract exuberance within a strongly controlled design.

Le Brun's device, described earlier, of setting successive elements of a composition at different distances from the viewer (again, almost as if on a stage) increases the sense of being drawn in to the depicted scene, in imagination. The nearer tree trunks, which almost enter our space, have the effect of partially barring entry, yet the viewer is specially drawn on by the intensity and, psychologically, the promise of the radiant light beyond.

The part of a picture in which Le Brun is always most interested is wherever space is deepest. This is one reason why the motif of the forest exerts such a pull on his imagination. Forests invite exploration and signify the mysterious and the unknown. Consequently, perhaps, the figures seen in them in Le Brun's art are armoured, or in some way protected by implied supernatural forces. Not long before painting *After Raphael*, Le Brun created the large canvas *Siegfried* (**8**), which anticipates the later work in many ways. It was part of a commissioned sequence on themes from Wagner. In painting these, Le Brun found that the 'given' of having to represent required subjects made possible a

painterly freedom greater than if he had had to invent the subject himself. The same is true of his recent painting, *Dante and Virgil entering Hell* (**2**), a work close to *After Raphael* in its conjunction of trees (Dante's dark wood) with light beyond, and with figures whose governing emotion is doubt.

Notwithstanding this Italian link, Le Brun's frequent engagement with the topos of the forest is, like the Wagner project, an instance of his rapport with German culture over a long period. He has worked for the wider acceptance in Britain of German art,

8 Christopher Le Brun *Siegfried*, 1993–4, oil on canvas, 255.9 x 270.5 cm, private collection

particularly of the nineteenth and twentieth centuries, and was an early advocate here of the work of Kiefer, including especially 'his grand, loaded themes', a factor at the heart both of this German painter's art and of the difficulty some had in accepting it. Le Brun admired Kiefer's willingness to take on subjects that were considered taboo, as well as his art's ambitious imaginative range. Early in his career, Le Brun was much influenced by

9 Christopher Le Brun *Capriccio: Port Royal*, 1978, oil on canvas, 244 x 137 cm, collection of the artist

10 Francis Picabia *Without Limits* (*Sans borne*), undated, black chalk, 24.8 x 33 cm, collection of the artist

the writing of Adrian Stokes. As his own pictures of the period reflect (**9**), he responded to Stokes's evocation of 'the light of Italy, the candid object laid out in sunlight'. But the very authority of this vision prompted him to examine an opposite and, in general, more Northern European position, namely that 'what is not seen

must be imagined'.

This perspective gives the key to the role of the image in Le Brun's art. Compellingly devised in terms of depiction, it operates representationally on more than a literal level. As a depiction, it arouses states of mind and feeling. But it also represents such states as Le Brun experienced them in the studio. It does so through a complex of marks which, while coterminous with the image, are evidence of a play of instinct the meaning of which is not necessarily the same as that of the image. Such partial dissociation helps explain the quality of enigma that many may feel when contemplating a painting such as *After Raphael*, which at first glance can appear an improbable essay in historical revival. It also explains how an artist who paints angelic apparitions and legendary heroes feels affinity with such idiomatically dissimilar art as that of Baselitz (another

German), who inverts the image, and Picabia, whose transparent superimpositions of unrelated motifs yield a 'simultaneous draining of meaning and opening of new meanings' (**10**). Though Magritte is not among the artists whose work has special eloquence for Le Brun, the creation of new meanings through surprising recontextualisation is central to his art, too. Magritte's image of a different horse and rider among trees (**11**) relates interestingly to the puzzle provoked by *After Raphael* and other works by Le Brun: where meaning is to be located in a picture and, even, in a sense, where the image itself is to be found.

From Samuel Palmer, with *his* gleams of light beyond dense foliage, to the potent reductivism of Morandi, from the stillness of the classical presences in the landscapes of Puvis de Chavannes to Kiefer's seared and ravaged sites of conflict, Le Brun's imaginative relationships are diverse. Their common factor is a concern to lead the viewer through the crucial site of the contrived image into a

Notes

1 Christopher Le Brun in interview with the author, 16 December 1999, from which all subsequent unsourced quotations in this essay derive.

2 Interview with the author, 21 July 1999.

3 Ibid.

4 Ibid.

5 Le Brun in conversation with Colin Wiggins at the National Gallery, 24 March 1999.

6 Interview with the author, 21 July 1999.

7 Le Brun in conversation with Colin Wiggins (cited note 5).

8 Ibid.

9 'This desire of the eye for depth of space, for a world, is an energy of considerable power. When held back, or frustrated, its force may be spread laterally throughout the picture plane' (Christopher Le Brun, 'Giorgio Morandi', in exh. cat. *Giorgio Morandi: Etchings*, Tate Gallery, London, November 1991–February 1992, pp. 33–36).

10 Ibid.

11 Interview with the author, 21 July 1999.

12 Quoted in Bryan Robertson, Introduction in *Christopher Le Brun*, Marlborough Fine Art, London, October–November 1994

13 In his essay 'Giorgio Morandi', 1991 (cited note 9).

11 René Magritte *Carte blanche (Le Blanc-seing)*, 1965, oil on canvas, 81 x 65 cm, National Gallery of Art, Washington, D.C., Collection of Mr. and Mrs. Paul Mellon

world of the imagination. It is a world akin to dream, but, in Le Brun's case, as in those of many of his predecessors, its evocation bears the stamp of the period of its creation and of the unique temperament of its creator. As he stated in 1994, 'I have a tremendous anxiety about the image, which I suppose will never leave me';[12] and as he wrote of Morandi, 'A different type of thoughtfulness arises, changed from dreaming – the dreaming of connectedness and memory – to questioning'.[13]

Richard Morphet

VERMEER

A Young Woman standing at a Virginal about 1670 | *A Young Woman seated at a Virginal* about 1670

NG 1383 Oil on canvas, 51.7 x 45.2 cm

NG 2568 Oil on canvas, 51.5 x 45.5 cm

ALMOST FORGOTTEN for some two hundred years after his death, Jan Vermeer (1632–1675) was rediscovered only in the second half of the nineteenth century. His few paintings were recognised – about thirty survive but as he worked slowly not all that many may have been lost – and his innovative role in Dutch seventeenth-century genre and landscape painting was assessed. Unlike other such art-historical rediscoveries, of interest to academics and few others, it emerged that Vermeer's paintings also appealed powerfully to the general public, and today they are among the most popular works in the handful of museums and galleries where they can be found. Among Vermeer's Dutch contemporaries, only Rembrandt's name is now better known.

One reason for the quiet allure of paintings like these two depictions of young women in interiors is the sense they give that we have been granted privileged access to a serene and private world of art, music and intimate human interaction. Both women lift their heads from the virginals they play and slowly turn to

engage our eye as if, on a sunny afternoon, we have just been introduced into the chamber, and are made welcome. Indeed, the empty chair in one painting and the viola da gamba leaning against the wall in the other suggest that we may be invited to join in the playing, to help create a musical harmony that in the seventeenth century was often equated with the harmony of love.

In both pictures, light of an almost magical purity spills in from the left, glinting off rich fabrics, picking out the edges of objects, and casting shadows that reinforce the crisp geometry of the spaces. Paintings are so prominent within both pictures that, one suspects, they must be implicated in their meaning. Landscapes, on the wall behind the standing woman and on both virginals, suggest travel and distance, the absent lover, a longed-for Eden. The Cupid holding up a single playing card – in what looks like a work by Cesar van Everdingen – was an emblem of the fidelity that attends true love. Behind the seated woman, on the other hand, is what appears to be Dirck van Baburen's *Procuress* (Boston, Museum of Fine Arts), which might suggest a different sort of encounter. It has been proposed that the two paintings are pendants, perhaps contrasting different categories of love, but no concrete evidence supports this. Having cast his spell, Vermeer allows ambiguity to hold sway.
Christopher Riopelle

CLAES **OLDENBURG**
born Stockholm, 28 January 1929

COOSJE **VAN BRUGGEN**
born Groningen, 6 June 1942

© Robert Mapplethorpe

OLDENBURG LIVED IN THE United States from infancy. In Chicago he became a reporter and attended art school, before moving to New York in 1956. Living on the Lower East Side, he developed an art close to everyday life. Subject matter (and early materials) came from the vitality and detritus of the streets, and he created innovative Happenings. His early sculptures and reliefs of consumer objects and advertising images, in bright enamel paint over plaster, were followed by soft sculptures in sewn materials and later in vinyl. All these works played a major role in Pop art. Oldenburg transforms the meaning of objects familiar in daily life through their collapsed form, when soft, and their startling scale, when vastly enlarged. He suggests analogies to the human body, with its capacity for feeling.

Since 1977 Oldenburg and Coosje van Bruggen, art historian and writer, have created large-scale sculptures together for public sites. The artistic team has to date executed thirty-five sculptures in various urban surroundings in Europe, Asia and the United States. Van Bruggen takes the lead in creating the iconographic programme, relating the image both to its immediate surroundings and to the life or history of the community. Both artists are American citizens. They live and work in New York and Beaumont-sur-Dême, France.



Left margin vertical: CLAES OLDENBURG+COOSJE VAN BRUGGEN




Resonances, after J.V. 2000

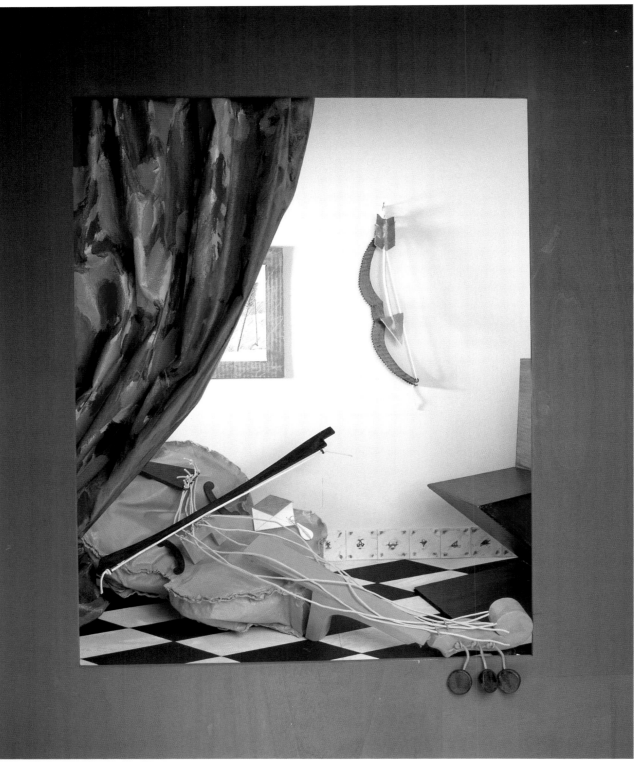

Work in progress on *Resonances after J.V.* photographed February 2000. Sculptural installation, wood, metal, urethane foam, canvas, cardboard, paper, string, resin, acrylic paint and varnish, pencil, crayon and watercolour, 148.5 x 140.2 x 4 cm, Claes Oldenburg and Coosje van Bruggen

LONDON IS THE home of four paintings by Vermeer, in each of which a stringed instrument[1] is being played by a young woman (**1**).[2] All represent interiors in which hang one or more paintings. Three show instruments that are played while held by hand. In the only painting that does not, the

Vermeer's intimate interiors as separate stills from an interconnected narrative. In their 'peepbox' they therefore present a moment in the imagined story that Vermeer's pictures tell. The way they do this heightens our awareness that the older master always suggests more than he shows.

sound-box by solids, which rest on its surface. Into the calm and the seeming certainty of the world of Vermeer has entered the creative disruption of which the world became aware when, forty years ago, Oldenburg first merged the conventions of fine art with the mutability, transience and decay of daily life in

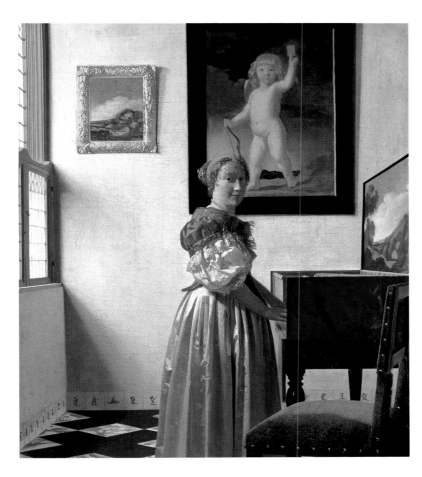

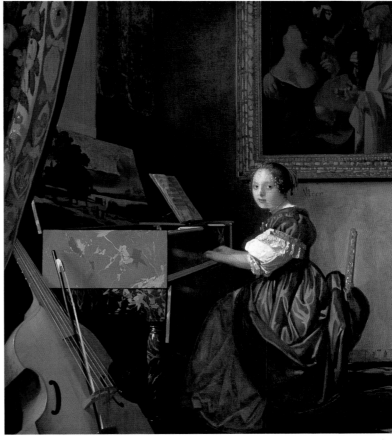

Jan Vermeer *A Young Woman standing at a Virginal,* c. 1670

Jan Vermeer *A Young Woman seated at a Virginal,* c. 1670

figure seen prominently in a picture behind the performer holds a weapon that is itself tautly strung.

Resonances, after J.V. responds in parti-cular to the National Gallery's two Vermeers, but it brings together motifs, notably the letter and the earring, drawn not only from them but from a number of his other works. Oldenburg and Van Bruggen conceive of all

As we look into this new version of a music room depicted by Vermeer it is as if, by magic, we are seeing not a flat image but the room itself. But this is not the supremely orderly scene we expect. Something has happened. The firm surface of the nearby *viola da gamba* has softened; not only is its shape changing but its very identity is meta-morphosing. Parts of its structure have become dislodged or are actually breaking up. This instability is compounded by the representation of the voids in the instrument's

unfashionable parts of the city. Simultane-ously he gave sculpture an enhanced sense of physical reality, from the tactility of its materials to a celebration of the play of appetite in all its forms.

In 1962 Oldenburg began making soft sculptures representing inflexible (as well as pliable) objects. Seven years later, in a prece-dent for the present work, he recreated the

rigid structure of a 'strung' image by an older master in soft materials, thus transforming both its feeling and its meaning (**2**, **3**). As in the new work after Vermeer, the effect of this technique is to undermine certainties and at the same time to multiply potential interpretations.

Coosje van Bruggen began her career as an art historian, in her native Netherlands. *Resonances, after J.V.* therefore connects with her background on many levels. She has a special love for seventeenth-century Dutch painting; moreover, detailed visualisation of the new work called for aesthetic and imaginative input to be combined with an art historical frame of reference. As usual, each of these disciplines was exercised by both artists, but with bias toward their origins respectively in design (Oldenburg) and iconography (Van Bruggen). Their contributions are complementary in further ways. 'If Claes is too symmetrical I will bring in a casual life force.

If I'm too chaotic he will bring order.'[3] But the roles can also be reversed, for work on each project is a dialogue. In recent years, as in this case, the subject has tended to be chosen by Van Bruggen, but once the essential image has been conceived both artists change and strengthen it, as the work advances through successive models.

Well before they met in 1970, the artists had links with the National Gallery. On visits to London in the 1960s Oldenburg chose Trafalgar Square as the site for some of his remarkable proposed colossal monuments for cities round the world. In recognition of the grinding traffic which, as today, was so striking a feature of the square, these visualised the replacement of Nelson's Column either by a giant wing mirror or by a towering gear-lever (see p. 25). As in a gear-shift, the gear-lever might change position at intervals, its sudden movement scattering the pigeons. Important, however, in the artists' willingness to accept the invitation to participate in the present exhibition was the impact of Van Bruggen's first visit to the National Gallery, at the age of twenty. She was in the building at the moment on 27 June 1962 when Leonardo da Vinci's drawing of *The Virgin and Child with St Anne and St John the Baptist* was damaged when a visitor threw a bottle of ink at it. Since then the National Gallery has always signified for her the importance of defending art.

For their work for *Encounters* the artists were drawn to Vermeer by the extraordinary way in which he integrates story-telling and still life. Vermeer is not known primarily as a still-life painter, but his works are remarkable in that respect, and for Oldenburg and Van Bruggen the objects he depicts are charged with feeling and association. At the same time, paradoxically, many of his objects, while retaining their depictive vividness, are given such concentrated form as to operate also as

1 Jan Vermeer *A Lady at the Virginal with a Gentleman (The Music Lesson)*, c.1662–4, oil on canvas, 74 x 64.5 cm, The Royal Collection

2 Pablo Picasso *Maquette for Richard A. Daley Center Monument, Chicago*, 1964, welded steel, 105 x 70 x 48 cm, The Art Institute of Chicago. Gift of Pablo Picasso

3 Claes Oldenburg *Soft Version of the Maquette for a Monument donated to Chicago by Pablo Picasso*,1969, canvas and rope, painted with acrylic, 96.5 x 73 x 53.3 cm, Paris, Musée national d'art moderne, Centre Georges Pompidou

virtual abstractions. This increases their appeal to the artists. But Vermeer's interiors also conjure for them a state of being so timeless that it is permanently relevant to the present and thus capable of being transformed, using their own visual language, without disrespect to the originals.

Crucial for them is that in each of the National Gallery's Vermeers we see a frozen moment of time. They, too, show such a moment. In their tableau the music-making has just ended. Confirmed by the paintings' strong suggestion of the presence of a second

person (who in the London *Music Lesson* is actually seen), they envisage the man and woman having just left the room. The *viola da gamba* is on the floor, an opened envelope lying on it (its contents having been read). In turn, an earring rests on the envelope, where it has dropped.

Oldenburg and Van Bruggen see the Gallery's Vermeers as representing two stages in a sequence of events. The young woman standing has her fingers on the keyboard but is not necessarily playing. This image represents for them a moment of anticipation, not just of sound but also of emotional and sexual fulfilment. The picture of the woman seated represents love being consummated. She is playing and, as the image of a procuress

behind her recalls, to 'play' has several meanings. The seated woman could therefore be 'playing with fire'.

The artists see Vermeer's representation of any interior as itself helping to communicate a particular human mood. By contrast with the relatively open or 'pure' interior with a woman standing, the room occupied by the seated woman is crowded with objects. Lovemaking is in full swing. But Oldenburg and Van Bruggen feel the absence of representation by Vermeer of the aftermath, and

4 Man Ray *Violon d'Ingres*, photograph, 1924

as Oldenburg has explained, 'Art is the disguise of eros so that art is always erotic but never obviously erotic'.[4] All this is true of the present sculpture, in which the implied action is focused specially on the viola da gamba.

A convention in modern art equates the form of the violin and its larger ilk with the female body (**4**). In these terms it is natural here to see the viola da gamba and the bow that has played on it as respectively female and male. However, in the art of Oldenburg and Van Bruggen a dominant masculine role cannot be assumed. As Van Bruggen puts it, 'Vermeer, a man, depicted the feelings of women, and in an equal relation with men. Yet he managed to do this with no narrative or anecdote, only a strength of feeling, reverberated by the composition, by the way the light falls and by the moment chosen.' She adds that, as *The Music Lesson* (**1**) shows, 'the woman can touch the man's heart and create a dialogue without words'. In this interpretation, Vermeer's work is about resonances over time; hence the title of the work we now see.

Reversing any conventional assumption about gender roles, in this work it was essentially a woman who stated the theme and the depicted situation, before its expression was realised chiefly by a man. As in all their work, the artists emphasise the equality of their partnership. This is exemplified by their most famous work in Britain, the sculpture *Bottle of Notes* in

Middlesbrough (**5**), in which greatly enlarged texts handwritten by each of them form a giant bottle, open in structure, which allows their individually distinctive scripts to interpenetrate visually. Oldenburg's and Van Bruggen's whole activity challenges the expectation that either the man or a single individual picked out by the system for commercial promotion will take precedence over an artistic partner. It also challenges the widespread belief that the most vital insights in art come invariably from the young.

In Vermeer's paintings it is above all women who are observed and then represented. The new sculpture assesses both Vermeer's mastery of appearances and the thinking it embodies. Thus Vermeer, a man, is observed here by a woman, before the hand

5 Claes Oldenburg and Coosje van Bruggen *Bottle of Notes*, 1993, steel painted with polyurethane enamel, 914 x 488 x 305 cm, Middlesbrough Borough Council

this is what they show. Again, the language used is that of objects. Owing, perhaps, to the passion of the lovemaking, the room is in disarray. At the same time, however, the mood is enigmatic, and here, too, the purpose is to follow Vermeer's lead. For, while insisting that each moment shown is specific, Vermeer leaves the outcome of any scene inscrutable. Like *Resonances, after J.V.*, his pictures place the final responsibility with the viewer.

A characteristic of the art of Oldenburg and Van Bruggen is the immediacy with which, often through semi-abstract forms and always only through sight, it communicates a wide range of physical sensations, for example compression, release, balance or floating. The motifs through which these sensations are mediated are usually quite ordinary objects of domestic or leisure use. Yet

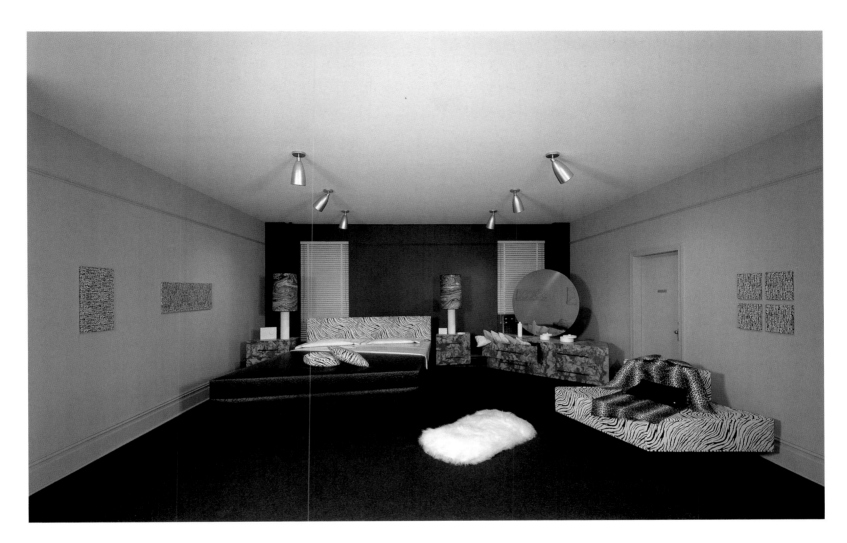

6 Claes Oldenburg *Bedroom Ensemble 2/3*, 1969, mixed media (wood, vinyl, metal, fake fur, muslin, dacron, polyurethane foam and lacquer), 303 x 512 x 648 cm, Frankfurt am Main, Museum für moderne Kunst

of a man gives her perceptions visible form. Taking as its theme the development of a relationship and its fulfilment, this tableau also refers to the artists' own history, on several levels.

Germano Celant has observed: 'The object feels. This is the great discovery that Claes Oldenburg has introduced to Modern art. Oldenburg intertwines the organic and the inorganic in his sculpture, conjoining human feeling and the physical properties of objects'.[5] It is feeling that accounts for the viola da gamba's altered state. The artists see the disruption of the supremely controlled forms to which we are accustomed in Vermeer's paintings as implied in the open-ended stories those pictures tell. And as Van

Bruggen has explained, 'What I am after is the unsettling beauty of the imperfect condition, a sign of humanity'.[6]

Not surprisingly in a relief made by sculptors after originals on a single plane, the view presented by this work introduces an element of ambiguity between two and three dimensions (an idea also implicit in Vermeer). Van Bruggen sought that the new work should build on the long history of such interplay in Oldenburg's art. His early environmental work *The Street* of 1960 used flats, hung one behind another. In 1961 *The Store*, itself an interior, sold reliefs and three-dimensional objects fashioned after two-dimensional advertisements. In *Bedroom Ensemble* of 1969 (**6**) Oldenburg exaggerated perspec-

tive conventions (a notable aspect of Vermeer's art) to create a room dominated by furniture seen from angles that suggest the whole thing could either pop up or fold away flat. In the new work ambiguity is enhanced by the protrusion of the principal form through the aperture into the viewer's space; the keys of the viola da gamba loll over the edge. This serves further to integrate the viewer with the interior and with the 'action', another idea that Vermeer's pictures often imply.

7 Johannes Vermeer *The Love Letter*, c.1669–70, oil on canvas, 44 x 38 cm, Amsterdam, Rijksmuseum

In Vermeer's interiors ambiguity is enhanced, for Oldenburg and Van Bruggen, by the strangeness of the perspective that results from the oblique view of the floor tiles, but also by the fact that many depicted objects signify more than they literally represent. A prime example of this is the chair (a motif which in some pictures Vermeer painted and

then removed). In *A Young Woman standing*, which for them is an expectant image, a chair occupies a position equal in importance to the viola da gamba in its National Gallery companion. For the artists this denotes an imminent arrival. In their work in response it suggests that someone has just left. Inserted into this 'seventeenth-century' scene is the image of an archetypically modern object, Rietveld's Zigzag Chair of 1934 (which, too, looks as if it could be folded up). Its incon-

gruity in terms of period augments the prevailing theme of disruption. It also acts as a sign of the thinking of a compatriot of its Dutch designer. Above all it echoes, in its sharp angles, the decorative motif of Vermeer's floor, thus reinforcing the work's theme of fluctuating perspectives, of which the looseness (and thus the changeability) of the viola da gamba is a key indicator. The perceptual instability of Vermeer's positive/ negative floor corresponds to the sense that shifting readings flicker through the new work, as through the old. These make it alive with nuances and with the 'resonances' of its title. This quality is enhanced by the theme of pointing, now this way, now that, that is enacted within the composition by the floor tiles, the aperture of the envelope, the chair, two arrows, the bow on the viola da gamba, and the instrument itself.

Oldenburg and Van Bruggen's first model for the chair in this work was of the type seen in many of Vermeer's paintings, including *A Young Woman standing*, but they found this impossible to integrate. The design of chair Vermeer painted is a period piece of his time. The artists therefore sought an equivalent from the modern era. Vermeer placed chairs in his foregrounds to enhance the sense of space beyond. He also created a dialogue between the bright spots of paint that represented their brass studs and other small highlights throughout the picture. As we have seen, Oldenburg and Van Bruggen use their chair, too, as a formal and a linking device. This chair also complicates the work's human narrative for, in addition to implying the imminent or recent presence of a person, it resembles one. Corroborating the hardness of its form, its bent 'knee' juts into the composition and assumes a male role in relation to the female persona of the soft and yielding viola da gamba towards which it points. The tableau can thus be read both as representing a just vacated room and as showing one in which the protagonists are present, albeit in surrogate form. This ambiguity increases the interest of the doubt, expressed recently by

8 Samuel van Hoogstraten *A Peepshow with Views of the Interior of a Dutch House*, c.1655–60, oil and egg on wood, exterior measurements 58 × 88 × 60.5 cm, London, National Gallery

another participant in *Encounters*, whether figures are present in Vermeer's paintings at all.[7]

In *Resonances, after J.V.* the motif of the envelope has an importance out of all proportion to its small size, for it is a means not only of establishing for the viewer the idea of communication between the parties but also of indicating the passion of their relationship without representing them directly. The red of the envelope's aperture is the colour of love. Appropriately it is its chromatic brilliance that holds together the whole of a composition in which most other elements are falling, in one way or another. Envelope, earring and stringed instrument link the sculpture with other well known Vermeers, such as his peep-box-like *Love Letter* (**7**), in which the lady receiving the envelope holds a cittern.

Items that are small in real life are frequently greatly enlarged in Oldenburg and Van Bruggen's art. Their purpose is not enlargement *per se* but to establish the right degree of presence for an object in relation to its surroundings. Thus they felt no need to respond to the Vermeers on a large scale. The dimensions of the present work were chosen so as to be in sympathy both with the modest scale of their source and with the intensity Vermeer was able to achieve within a small format, by the exercise of a degree of abstrac-

tion. The convention of the peep-box was adopted in rapport with those made roughly contemporaneously in the Netherlands, of which the National Gallery owns an example (**8**). The new sculpture also resembles a small stage. This analogy is reinforced by the prominent curtain, which alternately conveys a feeling of the sudden revelation of an intimate scene and of the partial concealment of what the room contains.[8] These implications relate also to the story we glimpse here; the open

257

9 Claes Oldenburg and Coosje van Bruggen
Soft Saxophone, Scale A, Muslin,1992, muslin, hardware, cloth, urethane foam, wood dacron and latex paint, 28.6 x 68.6 x 124.5 cm, collection of the artists

in any society they are in. Americans, they were born in two different European countries and made this work in a third (France). Moreover, Van Bruggen felt able to address so intensely Dutch a subject only outside the borders of her native land.

Texture has been important in Oldenburg's work from an early date. By contrast, Vermeer's paintings appear smooth, yet marked textural variety is crucial to their effect, too. This concern is central in the new work, as is the artists' response to Vermeer's concentration on how light falls on surfaces. However, where Vermeer, on close examination, can be seen to have manipulated form in order to convey the effect of the fall of light, Oldenburg and van Bruggen's alterations of form are in terms of the operation of gravity (a property of key importance throughout their work). Here, this interest centres on the

envelope is exposed, yet we remain ignorant of the contents of the letter it enclosed. An influence on the small-stage format was the memory of puppet theatres, and in particular of Punch and Judy shows, in their portable boxes. With apertures at roughly this height they, like Vermeer's paintings, create an immediate tension for the viewer and a strong sense that action seen in a space accorded such special focus will be charged with significance.

Part of the magic of the peep-box form is the sense it gives of being able unexpectedly to see into a past age. At the same time, the openness of the artifice underlines the unbridgeability of our distance

from that time. Such simultaneous participation and detachment mirrors the situation of Oldenburg and Van Bruggen in making the new work. Its theme connects both with their deep engagement with Vermeer's vision and with their own life experience, yet they feel not only the gulf of time that separates them from the seventeenth century but also that they are outsiders

10 Claes Oldenburg *Soft Drum Set Ghost Version*, 1972, canvas filled with polystyrene chips, painted with acrylic; metal and painted wood parts; wood base, 122 x 183 x 213 cm, Paris, Musée national d'art moderne, Centre Georges Pompidou. Gift of The Menil Foundation in memory of Jean de Menil, 1975

sagging, broken-limbed viola da gamba, which lies as though collapsed.

The art of Oldenburg and Van Bruggen shows an exceptional interest in function – in how things work and what it is we actually do with them. Vermeer's paintings, with their images of instruments being played and of pouring, lace making, weighing, measuring and writing, portray a world in which the responding artists feel very much at home. The affinity is enhanced because the objects that abound in Vermeer's art are articulated so distinctly. Nevertheless, Oldenburg and Van Bruggen find a compelling and complementary beauty in the ways in which a familiar form can change (thereby losing its function) when it 'gives in', simply accepting the dictates of gravity, and thus enters a new state.

This is, indeed, what each human being must do in the end. The artists' assertion of such a truth is also a statement about contemporary taboos. In their art, as Germano Celant explains, 'The shattering of the object is accompanied by a freeing from the constriction of outlines and limits. This freedom helps to expose and liberate a constant uprooting of the object, and ultimately its disclosure into death. Modern society, based on the endless distribution and consumption of things, prohibits the death of an object.'[9] In a consumer culture that is often aseptic and

impersonal, the art of Oldenburg and Van Bruggen asserts the permanent value, in art and life, of the sense of tactility and of our occupation of the body.

Musical instruments have featured often in their work. They are drawn both to their beauty as objects and to their power of transporting the listener into another world. Though the artists' sculpted instruments are expressively silent, they are analogous to music in their concern with colour, rhythm and cadence. One even resembles a convulsed musical score (**9**). Another (**10**) is not only an extensive landscape but resembles Delacroix's *Death of Sardanapalus*, a disordered interior that emphasises the body and its sexual role.

Like the paintings of Vermeer, *Resonances, after J.V.* is rich in pictures within the 'picture'. The shapes on the curtain are an abstraction from images of peaches and pears (a further sign of the equivalence of male and female throughout this work). Following a programme of Van Bruggen's, Oldenburg painted the row of 'Delft tiles' (**11**) with a sequence of images of private significance to the artists. These were first painted and then partially abstracted by blurring. Such ambiguity and secrecy parallel a quality central to Vermeer's art, as the artists read it. He is known as 'the Sphinx of Delft'; they, too, do not disclose the full import of what we are shown. Signalled by the arresting red lozenge, the emptiness of the envelope is a constant reminder that we do not know what has led

11a Claes Oldenburg, selected paintings representing Delft tiles in *Resonances after J.V.,* 1999–2000, each tile crayon and watercolour mounted on balsa wood, 6 x 6 cm, collection of the artists
11b Detail of above, showing tile representing *Flying Blueberry Pie*

to the conjunction of objects that form the tableau at the heart of which it lies.

Apart from this vivid accent there is one other item to which the eye is specially drawn. This is the bow and arrow that hang on the wall, in approximately the same position as the bow held by Cupid in the largest of the pictures shown by Vermeer in *A Young Woman standing*. Like the viola da gamba, the arrow has lost its rigidity. Its bent form suggests that for the moment its force is spent, it having been shot. The conjunction of arrow and viola da gamba implies that Cupid has done his work on the participants, who we both see and do not see in this tableau. It

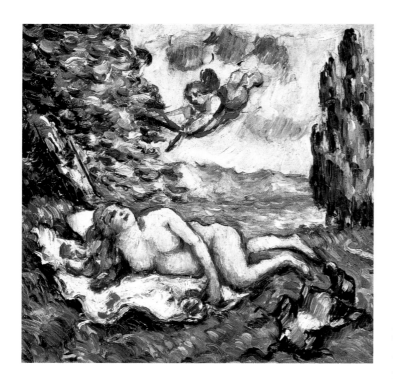

12 Paul Cézanne *Venus and Cupid*, 1873–5, oil on canvas, 21 x 21 cm, Takei Art Museum, Japan

is irresistible to connect it with *Venus and Cupid*, as memorably painted by Cézanne in a closely similar composition, formerly owned by Degas (**12**). On this interpretation the viola would represent a reclining female nude.

The tableau includes a second bow and arrow. Partially obscured by the curtain, a framed picture hangs on the wall (**13**). It represents Oldenburg's visualisation of Cupid's Span, the enormous outdoor sculpture he and Van Bruggen are creating to be sited in Rincon Park, San Francisco, beside the Oakland Bay Bridge. This work represents Cupid's instruments. The bow's stringing echoes that of the bridge behind, with its suspended cable, and the strings of the viola da gamba.[10] At the same time the interstices of the bridge's upright echo the sharp angularity of the pattern of floor tiles in the room. Typically of the artists' multiple vision, bow and arrow here also resemble a ship, thus turning the seashore on

which the sculpture is sited into notional waves.[11]

The sculpture will be placed as if embedded in the earth, thus paralleling many of the artists' outdoor sculptures.[12] But unlike them it has the curious property of bringing together in a single static image two different moments in time. The merging of two separate stages in an action into one is likened by Van Bruggen to a dissolve in a film. The tautness of the drawn bow denotes the moment of maximum tension, yet being embedded the sculpture also suggests the target has been hit, when the bowstring would be less taut (a state reiterated by the suspension bridge's looping curves). The image is a reminder that *Resonances, after J.V.* is an examination of tightening and loosening, in a range of senses.

The limp strings of the viola da gamba and its slackened state following whatever has happened imply not only sexual release but also the traditional conception of sexual fulfilment as a small death. As Ellen Johnson put it, 'Eros, ever present, is ever wedded with death'.[13] This work's dominant theme of disorder thus calls to mind Caravaggio's well known painting *Victorious Cupid* (**14**), in which the god of love, arrows in hand, straddles a scene of chaos that he has caused, prominent in which are a rumpled bed and two stringed instruments. As Helen Langdon

writes, 'Its composition reminds us of the traditional vanitas still life … dominated by a skull ….Here … Caravaggio has replaced the skull with … Cupid.'[14]

The new tableau signifies that what has taken place in Vermeer's room is a rite of passage. Passage implies time, one of this peep-box image's central subjects.The work's stories unfold within time, but it also reinforces our awareness that it is time that separates us from the action, as it also does from the world of Vermeer. Nevertheless, Vermeer's vision establishes a permanent present, through which we are able to participate in what he showed.The events the new room has witnessed remain similarly fresh in the imagination. Its tableau is no more mute than are Vermeer's paintings; indeed, the themes that weave through the new work call

13 Detail of *Resonances after J.V.*, Claes Oldenburg, *Cupid's Span* (Visualisation of proposed sculpture by Oldenburg and Van Bruggen in Rincon Park, San Francisco), 2000, pencil, crayon, pastel and watercolour, 27.8 x 24.3 cm, collection of the artists

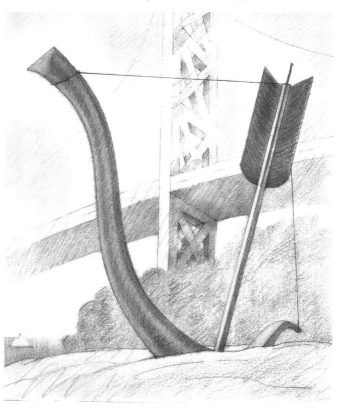

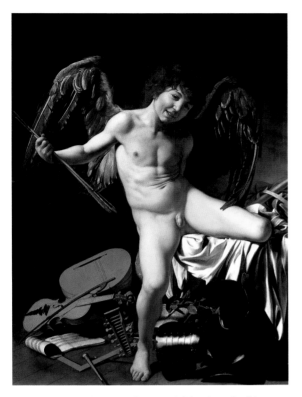

14 Michelangelo Merisi da Caravaggio *Victorious Cupid*, c.1602, oil on canvas, 154 x 110 cm, Staatliche Museen Berlin, Preussicher Kulturbesitz Gemäldegalerie

Notes

1 In three cases virginals and in the fourth a guitar.

2 The only one of the four paintings not reproduced in this essay is *The Guitar Player*, c.1672, oil on canvas, 53 x 46.3 cm, The Iveagh Bequest, Kenwood House.

3 Van Bruggen in the two artists' interview with the author, 27 November 1999, from which all unsourced quotations derive.

4 In 'Notes', New York, 1965–66, quoted in Germano Celant, 'Claes Oldenburg and Coosje van Bruggen: Urban Marvels' in exh. cat. *Claes Oldenburg Coosje van Bruggen*, Museo Correr, Venice, May–October 1999, p. 49.

5 'Claes Oldenburg and the Feeling of Things' in exh. cat. *Claes Oldenburg: An Anthology*, Hayward Gallery, London, June–August 1996, p. 13.

6 'Coosje van Bruggen, Germano Celant, Claes Oldenburg: A Conversation' in Venice 1999, catalogue cited note 4.

7 In 'A Master Copy', *The Daily Telegraph*, 22 January 2000, Martin Gayford reports of Lucian Freud, 'The people in Vermeer, he explains, aren't real people. "It isn't," he goes on, "a matter of incompetence. It is that, in a funny way, his people just aren't there."'

8 The employment here of the peep-box form, the necessity of looking down on the sexually charged *viola da gamba*, the sense of ambiguity as to what it is we are seeing and – as will be explained – the drawing of the eye through to a distant scene involving water all combine to give the new work an affinity with Marcel Duchamp's enigmatic mixed-media installation *Etant donnés*, 1946–66, Philadelphia Museum of Art.

9 Germano Celant in 'Claes Oldenburg and Coosje van Bruggen: Urban Marvels', in Venice 1999, cited note 4, at p. 33.

10 'Bruggen' means 'bridges'. The artists' *Clarinet Bridge* of 1992 (Washington, D.C., National Gallery of Art) visualises a musical instrument as a bridge. It is reproduced in colour as fig. 297 in the 1996 exh. cat. cited at note 5. So are the following further works which make analogies between a bridge and quotidian objects: *Bridge over the Rhine at Düsseldorf in the Shape of a Colossal Saw*, 1971 (fig. 203); *Screwarch Bridge (Model)*, 1980–81 (fig. 234); *Spoonbridge and Cherry*, 1988 (fig. 270).

11 The wrecks of ships from the Californian Gold Rush in fact lie beneath the reclaimed land of the site.

12 For example, among works reproduced in the 1996 exh. cat cited at note 5, *Giant Three-Way Plug*, *Scale A*, 1970–71 (fig. 195); *Trowel I*, 1976 (fig. 217); *Pickaxe*, 1982 (fig. 231); *Stake Hitch*, 1984 (fig. 239); and *Buried Bicycle*, 1990 (fig. 281).

13 Ellen H. Johnson, *Claes Oldenburg*, Penguin New Art, 4, Harmondsworth 1971, p. 24.

14 Helen Langdon, *Caravaggio: A Life*, London 1999, p. 216.

15 William Shakespeare, the opening lines of *Twelfth Night*.

to mind the famous line 'If music be the food of love, play on'.[15] In the moment we observe, the music, so important in Vermeer's pictures, has stopped, its purpose achieved, for a time at least. Yet the recent melody still vibrates in the inward ear. Moreover, the multiple role of strings remains lodged in the mind. At the heart of the complexity of meaning here, it confirms the aptness of the word 'resonances' in the title of this work.

Richard Morphet

HOGARTH
Marriage A-la-Mode: Scene I, The Marriage Settlement before 1743

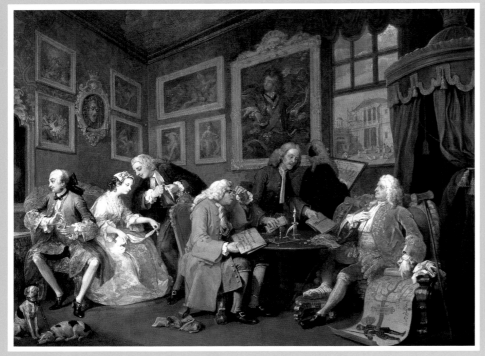

NG 113 Oil on canvas, 69.9 x 90.8 cm

T HE SIX PAINTINGS OF *Marriage A-la-Mode*, by William
Hogarth (1697–1764) tell a single cautionary tale of venality,
lust and corruption among the high-born, immensely rich and
bored in eighteenth-century London. It is the story of a spectacu-
larly unhappy arranged marriage between the depraved son of a
nobleman and a wealthy and ambitious alderman's daughter, inno-
cent to begin with but soon equally unfaithful. The couple live
extravagant and dissolute lives and it all ends, badly of course, with
the murder of the husband by his wife's lover, caught in the act, and
the subsequent suicide of the ruined wife. They leave behind a
syphilitic child. Hogarth's paintings are as full of vivid and telling
details as a novel. In many of them the richly decorated rooms of
splendid city houses are filled with works of art, particularly paint-
ings in the styles of various Old Masters, which provide their own
wry commentary on the events that transpire below them.

In the first painting of the series, the marriage
contract is agreed upon between the Earl of
Squander, seated in his bedroom, at right, a finger
pointing to his supposedly illustrious and ancient
family tree, and the alderman, seated across from him,
who brings to the proceedings the heap of guineas
lying on the table, which will help to finance the
extravagant house shown under construction out of
the window. At the left sit the intended bride and
groom, their backs turned to one another. He,
foppish and French in dress – Hogarth reserved some
of his sharpest barbs for the ghastly French and those
who aped them – takes snuff and admires himself in
the mirror. She, weeping and virginal, consults with a
lawyer named Silvertongue, who will play an impor-
tant role in the narrative as eventually he becomes
the bride's lover. Around them, paintings in gilt
frames hang two deep on the walls. Many show saints
undergoing martyrdom, including Lawrence and
Sebastian, just as the young people are sacrificed to
their fathers' greed and vanity. A *Medusa* head, after
Caravaggio, shrieks in horror at what is to come. Squander himself,
portrayed in the largest, most pompous and Frenchified picture on
the wall, seems to hear Medusa's warning and, startled, turns his
head to shoot the gorgon a sharp look.

Hogarth invented picture cycles of this kind, calling them his
'modern moral subjects.' He intended that, like his earlier narrative
series, *Marriage A-la-Mode* should be engraved – in this case, 'by the
best Masters in Paris'; the French did have virtues after all – and the
engravings sold by subscription and widely distributed. Only then
were the paintings themselves sold to a private collector.
Christopher Riopelle

PAULA **REGO**

born Lisbon, 26 January 1935

© National Gallery, London

A LTHOUGH PAULA REGO first attracted widespread recognition in Britain as a major figurative artist with a retrospective exhibition in 1988, she had already won a leading reputation in Portugal by the early 1960s. She has represented both countries internationally and continues to be highly regarded in each.

As a student of the Slade School of Art (1952–6) and consistently since, Rego has worked in a narrative style through a period when figurative art was unfashionable, attracting an audience for her imaginative subjects drawn from childhood recollections, nursery rhymes and folk-tales. Her haunting, psychological dramas of the 1980s and 1990s used traditional methods of figure drawing and composition, and, since 1994, the medium of pastel, with the scale and fullness of painting. These drew admiration, but touched a raw nerve. Their powerful emotive charge, with a sexual, often violent, undertow, makes her one of the most forceful creators of character in the twentieth century. Rego has also put her considerable story-telling skills into printmaking, public mural painting, and socially critical pictures.

A British citizen since 1959, Rego divided her time between Portugal and Britain, but in 1976 established a permanent home and studio in London with her husband, the British artist Victor Willing (1928–1988).

PAULA REGO

After Hogarth: Betrothal; Lessons; Wreck 1999

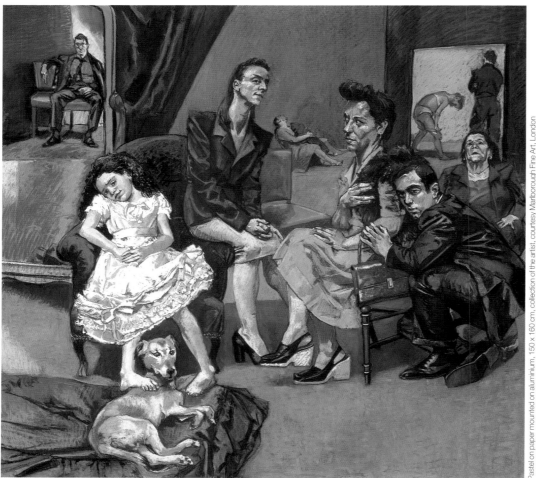

Pastel on paper mounted on aluminium, 150 x 160 cm, collection of the artist, courtesy Marlborough Fine Art, London

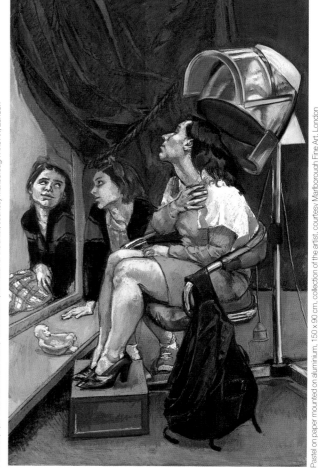

Pastel on paper mounted on aluminium, 150 x 90 cm, collection of the artist, courtesy Marlborough Fine Art, London

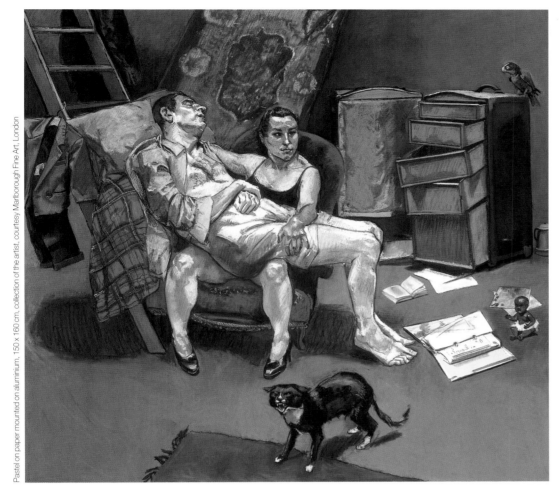

Pastel on paper mounted on aluminium, 150 x 160 cm, collection of the artist, courtesy Marlborough Fine Art, London

of the family, by cultural attitudes to women's position in society, and their relationship to men. Rego deals with social, political and emotional power. If romance has any place in her narrative, it is confined to the dreams of a young girl in white satin and lace, and to her fanciful gaze in the mirror of a hair salon. By the end of her marriage the woman, for this is really her story, has both her feet firmly planted on the ground.

After Hogarth is an updated version in two main acts of Hogarth's perennially popular six-part series, *Marriage A-la-Mode*. Drawing on memories of growing up in Portugal in the 1940s, when arranged marriages, with unhappy results, were still enforced, Rego tells of 'a marriage contract between a boy and a girl made by their parents and its disastrous outcome'. She transposes Hogarth's plot with considerable licence to two moments of time, purportedly around the 1950s and 1980s, which are, on inspection, impossible to pin down. In Rego's first scene a woman in a fur stole meets a power-dresser of the Thatcher era, while the girl wears an Indian party frock bought in Brick Lane in 1999. A woman in an old-fashioned hairdresser's wears a short skirt and sports a contemporary slouch bag. This is historical costume drama from the dressing-up box, enacting calamity with a touch of humour. The device enables Rego to stir fact and fiction, past and present, into a timeless

P AULA REGO DESCRIBES her three-part picture, *After Hogarth*, as 'a modern love story'.[1] The subject pays homage to Hogarth's sparkling satire on the human condition, and no-one is fooled by her ironic reference to 'love story'. This is a tough tale in which the success or failure of 'love' is determined by the manoeuvres and strategies

William Hogarth *Marriage A-la-Mode (The Marriage Settlement, The Toilette, The Bagnio)*,1742–3

1 Paula Rego *Triptych*, 1998, pastel on paper, mounted on aluminium, each panel 110 x 100 cm, London, Marlborough Fine Art

amalgam. From a core of personal experience she weaves a narrative in which the issues she raises about the meaning of marriage are as universal as William Hogarth's picture of marriage in eighteenth-century society.

Over two hundred years after Hogarth, society and its marriage conventions have changed beyond anything an eighteenth-century imagination could have envisaged. Human nature has not. Hogarth's theme of sleaze in high places is still the fascinating stuff that sells a million newspapers. The celebrity wedding, social impropriety, financial corruption, upper-class entertainment of a morally dubious nature, adultery, murder and suicide are all reported daily with the same cruelly searching eye for detail. Current subjects at issue in Paula Rego's picture – the

family and its controlling influence on marriage, male–female relationships, rape, domestic violence and bullying of one kind or another – are modern variants in kind, but not degree, of the appalling catalogue of ills documented by Hogarth.

The late twentieth-century canvas on which Paula Rego paints her story is of an entirely different social order, in which fashion and opinion are led not by the aristocracy but by a middle class of all ranks and degrees. The story she tells is personal, but its subject, marriage, is commonplace. Its material is not explosive, of a kind that would drag the private lives of Lord Squander and his heir across the front page. The unknown, middle-class couple of Rego's story would only make the letter pages of the Agony Aunts, but their problems are all the more accessible to a mass audience.

Unlike Hogarth, Rego uses only three scenes, *Betrothal*, *Lessons* and *Wreck*, to

develop her drama, but she spans the same essential story, told now from a woman's viewpoint: how a marriage made for the wrong reasons and without mature reflection is bound to end on the rocks. The plot is concentrated in the two lateral pictures, *Betrothal* and *Wreck*. What happens in between these 'before' and 'after' episodes is left to our imaginations, but there are clues. Rego chooses a tripartite composition to create a flow of narrative from left to right, but reverses the arrangement conventional in religious painting by placing the key elements to the sides. The central picture, *Lessons*, acts as a hinge, a rite of passage between childhood and adulthood. Although Rego calls *After Hogarth* 'a love story', she also describes it as a battle for power and control. The two are not contradictory in her tale. If the girl is to survive in life and love she must learn to deal with them as two sides of the same social currency.

In *Betrothal* all the essential members of the family are assembled for an important transaction: the father dominating the scene from the mirror, the two negotiating mothers, the old grandmother, the child bride and her pet dog, and the future groom in his best suit, lurking behind the protective skirts of his mother. Scenes behind the central tableau presage darker issues of power and dependency within marriage. *Lessons* expands the first scene as the mother teaches the girl both how to exercise power in a man's world by means of her feminine charms, and how to value herself within the relationship of marriage. When we next encounter the betrothed, in the last scene, *Wreck*, some thirty years have elapsed. The couple, presumably married, are alone, the extended family nowhere to be seen. The man, according to Rego, is 'a victim', unlucky in life's lottery. The woman, practical and as devoted to him as ever, is left 'to clean up the mess'.

The leap in the action is as tantalising as it is disconcerting. Apart from the crimson armchair, the certainties of the first picture have completely vanished. Obviously something of cataclysmic proportions has occurred. On one level the havoc is emblematic of the couple's personal misfortune. On another, we can read the confusion as a graphic metaphor for cultural change. In the thirty years following the Second World War, social upheaval and transformation swept Western European communities from a conservative code of behaviour to a system of values which favoured a cult of youth, individuality, personal authority and self-interest, and which often left the traditional family marooned. In Spain and Portugal, Rego's native country, controlled until the mid-1970s by right-wing dictators, the late

2 Rafael Bordalo Pinheiro *The Journalist*, late 19th century, polychrome terracotta, 13 x 19.5 cm, private collection

introduction of modern democracy literally catapulted these societies into the freedoms we associate with the late twentieth century. But even in the West, as Rego showed in her *Triptych* of 1998 (**1**), which indicts the law prohibiting abortion in Portugal, women's choices are still restricted.[2] In other parts of the world individual liberty, particularly for women, is virtually non-existent.

Rego's scenario for *After Hogarth* is as carefully devised as any of Hogarth's satires of English life. Her characters are moved by strong emotions, if not driven to the extremes of cruelty and violence we meet in *Gin Lane* or in other Hogarth engravings that have excited her imagination since she first pored over them as a girl. Behind her own humorous insights into human behaviour stand other early heroes such as Gustave Doré and Honoré Daumier (**3**), and the Portuguese cartoonist and ceramist Rafael Bordalo Pinheiro (**2**). Facial expressions, poses and,

3 Honoré Daumier *The Widow*, 1846, lithograph, Paris, Bibliothèque nationale

LES GENS DE JUSTICE.

— Vous êtes jolie nous prouverons facilement que votre mari a eu tous les torts !

the humans. It's also a good formal element. Pictures begin with an idea, and the story then evolves within the framework. My story-telling is a way of finding out what it is I wish to tell. I trust my own intuition, and put things in on impulse. One thing follows another, and becomes part of the story. The images in a picture engage with each other, lock together into a visual drama.' The relationships between the father, the girl with her controlling foot on the dog, the boy huddled against his mother, and the two women are built on a wide inverted triangle. Set uncomfortably off-centre, this angular structure suggests the psychological tension and uncertainty on which everything in this scene is precariously balanced.

'The contract is seemingly made by the two mothers who are linked by their over-

particularly, the almost ludicrous gestures with legs and feet we encounter in *After Hogarth* communicate as eloquently as the body language of Daumier's widow and lawyer. Rego composes her scenes, if not with the intricacy of Hogarth's *Marriage A-la-Mode*, with a purposeful selection of animals, objects and accessories, all of personal significance to her, which add in a meaningful way to her story. As in *Marriage A-la-Mode* her sets, or 'backgrounds', are an essential component of the drama. She goes to great lengths to arrange her studio, and to cast, costume and furnish it as for a play, often acquiring specific items for a picture. The characters, mostly members of her family and well tried models, contribute in their own unpredictable ways to the unfolding narrative. She draws with pastels, their brilliant, often harsh, colours reflecting the impassioned tone of her story-telling, but always refers to her work as painting. Indeed, the scale of her pictures and the substantial surfaces she creates acquire the character and presence of paintings.

A recollection of Rego's upbringing in Estoril was the starting point for *Betrothal*, which is set in a typical middle-class Portuguese drawing-room (**4**). 'The tone of the pen-and-wash study is quite different to the finished pastel. It's much sweeter, much nearer the atmosphere of life as I knew it. The space between the first drawing and the final picture is where you find out what it is you've got to say. This comes in your head. When you have the figures in front of you to get their individual expressions and the relationships between them, it all changes dramatically because you have real people there. You invent a picture as it goes along. Apart from the four central figures, the stuffed dog and the mirror, all the other elements, like the image of the man I suddenly saw reflected in the mirror, were added later. The dog represents a good presence, a helper, as in fairy stories, in which the animals and birds assist

6 Unknown master *Pietà*, Gothic period, painted wood, Vallodolid, Museo Nacional de Escultura

behind the grandmother points to the future direction of a relationship without affection or respect. 'The rape scene between the girl as she grows up and her lover was always part of my conception of this scene. It's based on a marvellous picture of a man and a girl which Vic [Paula Rego's husband, Victor Willing] painted in 1957.[3] My picture was done with it in mind. That's why I did so many studies for it. I even built a Plasticine model, bought dolls' furniture and made figures in Plasticine in order to do this scene, and then I made drawings of it from various sides.'

The act of seduction or acquiescent rape appears from the colour of the carpet to be taking place simultaneously in the adjoining room. But closer inspection reveals, from a shadow on the right-hand side, that the scene is depicted on a canvas which leans against the wall, and which echoes the presiding image of the father reflected in the glass on the other side of the room. The tall man standing with his back to us, his arms folded, as though he were policing the situation, demonstrates no physical violence towards the girl struggling rather comically out of her tights. His commanding stance, which meets with cringing submission, represents a psychological domination, which, Rego suggests, the girl later misses. Who is this man? Is he lover

7 Paula Rego *Study for Pietà*, 1999, pencil, collection of the artist

lapping knees, but the space cut-out between their heads and shoulders stands for a gap in their relationship. Their disharmony is reinforced by the colliding yellows of their skirts, and the awkward difference in their sizes. One of the mothers with her fur stole and exaggerated roll of hair is rather large and vulgarly over-dressed, and the other one is more refined, suggesting social differences between the young couple. But in the background there's a father who is looking on and who is, in fact, controlling the whole show. I wanted the mood to be rather tense and brittle.'

Apart from the boy, reluctant to let go of his mother, all the figures are isolated, linked only by wary glances among the individuals. Actual eye and physical contact are anxiously avoided. As in Hogarth's first scene, *The Marriage Settlement*, the boy and girl show no interest in one another, and the scene going on

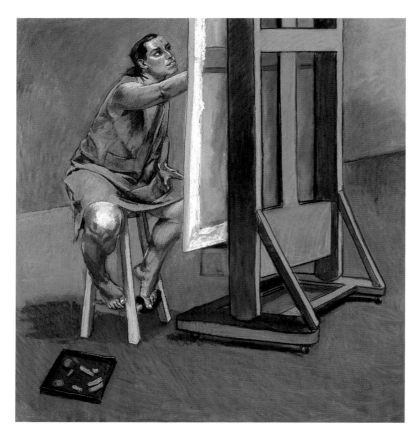 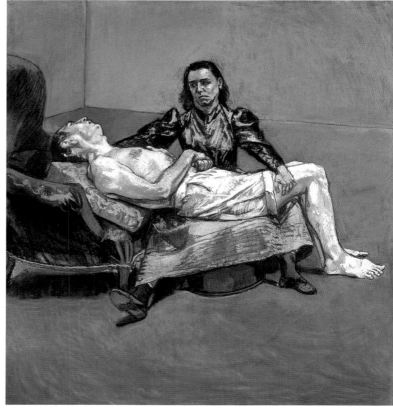

8 Paula Rego *Martha* (left panel of triptych), *Mary* (centre), *Mary Magdalene* (right), each 1999, pastel on paper, mounted on aluminium, 130 x 120 cm, courtesy Marlborough Fine Art, London

or husband, idol or tormentor? For Paula Rego, the ambiguity of the relationship between the man and the girl mirrors that of real life. Its psychological complexity is difficult to unravel. What, despite all the odds, binds one person to another? Fear? Loyalty? Or love, as is suggested in the vignette to the left of the scene of domestic rape? There, apparently at the back of the room, the older girl plays with her pet dog. The image recalls Rego's *Girl and Dog* series of 1986 and 1987 in which the animal represents the male as victim, variously sick, helpless and dependent. The roles of man and prey are reversed, as they appear to be in the third scene.

The scene in the central, pivotal picture of the triptych takes place in a hair salon about

two years later. The significant figure is the mother, who now assumes a controlling influence over her daughter's education. 'In this picture, *Lessons*, the mother is teaching the daughter, who is looking at her in the mirror. The little girl is in shadow, and you see her best in the mirror, looking up to, and at, her mother, as a saint might look up at her idea of Jesus. She has that sort of look in her eye. The mother is giving her lessons about looking after her appearance – the tricks of the trade, so to speak. The mother's bag hanging on the arm of the chair is large and modern-looking and it's already heavy with things in it, with shopping, and, metaphorically, with her personal conquests and trophies. On her head she's got a helmet, which is the hair dryer. My scene differs from Hogarth's *The Toilette*, in which the Countess is having her hair crimped, because the girl is not yet married. She's still learning.'

Rego's image of a powerful female in this

picture is much more ambiguous than her figure of *The Avenging Angel* of 1998, or Judith and Holofernes in *Crivelli's Garden*, the mural she painted for the National Gallery in 1990–91.[4] 'The bond between a mother and daughter has simultaneously to do with fascination, admiration and aversion or repugnance,' Rego believes. She took the idea for *Lessons* from the exemplary role of the father in Pedro Berruguete's portrait of Duke Federigo of Urbino with his son Guidobaldo (**5**). Berruguete celebrates the Duke's military prowess and intellectual pursuits, while Rego draws our attention to the mother's sensuality and self-esteem. In the battle of the sexes the hair dryer is an essential piece of equipment. The culture of the beauty parlour is more important to the girl's education than book learning.

The last scene of *After Hogarth*, titled *Wreck*, moves the story on by thirty years. The couple have been together for some time and,

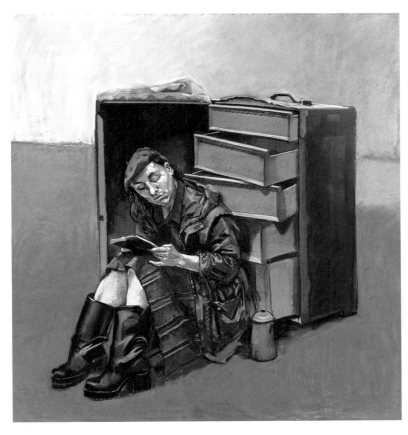

world. In Hogarth's last scene, *The Lady's Death*, the Countess kills herself, but my woman is left to do the clearing up and get things back to normal.'

The composition for this scene was inspired by the religious imagery in *The Bagnio*. As Rego was looking at Hogarth she became aware of how similar the dying Earl looked to the figure of Christ in scenes representing the Descent from the Cross.[5] Fortuitously, on an unrelated visit to the National Museum of Sculpture in Valladolid, in the north of Spain, she was struck by the weeping figure of a Gothic *Pietà* (**6, 7**).[6] 'Mary is looking so cross, upset and disgusted at Christ's death,' Rego said. 'Her reaction seems so natural, like a real person.' It was on this sculpture that she based an image of Mary that became the central figure in her triptych, *Martha, Mary and Mary Magdalene* (**8**). She wanted to demonstrate from her perception of the Gothic *Pietà* that the saints were first and foremost women with human feelings, later adapting this reading to her design of *Wreck*. 'If you look at Hogarth's scene V, *The Bagnio*, the pose of the Earl as he collapses wounded looks like a Deposition, in which Christ is taken down from the Cross. It's like a religious pose and is really rather sacrificial. The Countess is looking up at him, clasping her hands and crying, begging forgiveness, pleading, perhaps. But I've brought him down to lie on her lap like a *Pietà*. The ladder

is there behind the chair. She still cares for him, but she turns her head away.' At the end of the story we cannot be sure whether the husband is already dead, or dying. Or whether he will die at all. We remain uncertain about the couple's true relationship. There is something almost comic about the way the small woman grips the cumbersome body of the very much larger man to prevent him falling. To Rego it recalls the very human, if irreverent, use of religious imagery in Max Ernst's painting *The Virgin beating the Child Jesus before Witnesses* (**9**), itself derived from the Italian Mannerist artist, Francesco Parmigianino. But why does the woman turn away? Perhaps to free herself to get on with her own life? Once again Rego's explanation leaves the role of the man and the exact nature of the couple's relationship open to question: 'She has no husband and no money, so she hasn't got freedom and never will have it, because

9 Max Ernst *The Virgin beating the Child Jesus before Witnesses*, 1926, oil on canvas, 196 x 130 cm, Cologne, Museum Ludwig

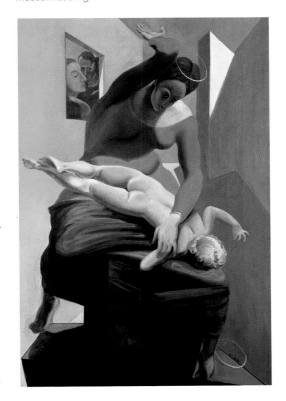

judging by the surrounding chaos, the battle is over. The collapsing state of the room, in which all is awry, is emblematic of their ruin. This final episode in Rego's story corresponds with Hogarth's penultimate scene, *The Bagnio*, where the husband is killed by his wife's lover. 'In my story what has happened is that he's spent all their money. There they are in the leftovers of what they own. They've had to sell the rest of the property. The accounts are strewn all over the floor. The creditors have gone through all the drawers of his travelling trunk, because he's been to Brazil, like many Portuguese men, to make his fortune. But he failed. He lost everything. You can tell he's been in Brazil because of the parrot he brought back. The little black doll suggests that he had a second family there, perhaps. Anyway, everything has been dissipated. But, despite the misfortune, she's holding him on her lap to comfort him. The blind cat's there to defend them against the

she's not conditioned for freedom.'

Rego's examination of feminine roles in her pictures has taken many forms, from images of subservience, such as *The Policeman's Daughter* of 1987, to paintings in the 1990s in which the woman offers a more positive model. *Crivelli's Garden* (1990–91) is filled with heroic monuments to female saints and other myth-ical women. In *The First Mass in Brazil* (1993) woman is depicted as child-bearer, what Rego calls a sacrificial role, compared to her imaginatively creative life as an artist, which she represented in *St Joseph's Dream* (1991) and *The Artist in Her Studio* (1993). Her first narrative series, *O Crime do padre Amaro* (Father Amaro's Crime, 1997–98), was based on a famous nineteenth-century novel of the same title by José Maria de Eça de Queirós (1845–1900), the celebrated Portuguese writer of critical realist novels. Father Amaro's crime is his affair with a young parishioner who expects his child, a plot which inspired Rego's moving explo-ration of a relationship based on their respec-tive need for power and domination. The penultimate scene of this series – in which the girl, having prayed *In the Wilderness*, sits in the bare waiting room of, we assume, an abor-tionist – may have suggested her next series, of 1998–9. Called *Untitled*, it does not tell a story; it 'denounces a condition', the unseen misery of many young girls in a country in which abortion is still illegal.[7]

Rego's triptych, *Martha, Mary and Mary Magdalene*, begun immediately after the abortion pictures, returns to more positive ways of representing women in everyday situ-ations. Martha portrays the practical woman,

10 Rogier van der Weyden *The Magdalen reading*, c. 1435, oil on mahogany, 62.2 x 54.4 cm, London, National Gallery

the artist and creator who works with her hands. 'Her canvas is turned from view, but we know she's making sense of everything by putting it in her pictures. It is the artist who's chronicled the marriage, including the painted seduction scene in *Betrothal*. Mary Magdalen is based on a panel in the National Gallery of *The Magdalen Reading* of about 1435 by the Netherlandish painter Rogier van der Weyden (**10**). She's sitting against a travelling trunk, reading and meditating because she's an independent woman, the one who finds freedom, through the intellect, books, travel and teaching.'

The travelling chest (**11**), originally

owned by Douglas Fairbanks Jr, Hollywood star and matinée idol of the 1930s, belonged to Rego's late husband, Victor Willing. Like many of the treasured objects in her pictures, the chest contributes significantly to her personal memoir and appears again in *Wreck*, the final marriage scene, in which the figure of the Magdalen, 'the one who finds freedom', is conspicuously absent.

'Mary symbolises maternal woman, the carer, but in *Wreck*, in her capable tender-ness, I see her also as wife. This is not a religious picture as such, and her role is subsumed in the woman here who repre-sents the qualities of both Mary and Martha, both spiri-tual and practical. *Wreck* combines the religious and the sensual, because religious imagery has a kind of intense sensuality, which you find in Roman Catholicism, but in life as well. The decision to use this imagery was aesthetic, a means, as it was for Hogarth, of creating a narrative.'

By contrast to Hogarth's scenes, there are no doors or windows in any of these pictures. Paula Rego's characters are trapped in a heavily draped, airless domestic circle. This is a private drama. Yet for all its sense of enclo-sure the marriage is strongly determined by outside events. Social structures and codes of behaviour based on power decide the fate of the couple. Yet for Rego, it is the woman who, when the crunch comes, despite her apparent powerlessness, saves the day.

Judith Bumpus

11 Travelling chest in the artist's studio, photograph, 2000

Notes

1 Paula Rego in conversation with the author, February 2000. Unless otherwise stated, all quotations are taken from conversations with the author between 29 November 1999 and March 2000.

2 *Triptych* was the centrepiece of a series of otherwise untitled works on the subject of abortion exhibited in Portugal in 1999; see note 7 below.

3 Victor Willing, British artist, 1928–1988.

4 *Crivelli's Garden* is illustrated in John McEwan, *Paula Rego*, 2nd edition, London 1997; see pp. 248–71

5 Ronald Paulson has also made this point, unbeknown to Rego, in *Hogarth: His Life, Art and Times*, New Haven and London 1971, p. 486, note 4.

6 Rego visited Valladolid in February 1999.

7 Exh. cat. *Paula Rego: Untitled*, Centro de Arte Moderna José de Azeredo Perdigão, Lisbon, 1999.

REMBRANDT
A Woman bathing in a Stream (Hendrickje Stoffels?) 1654

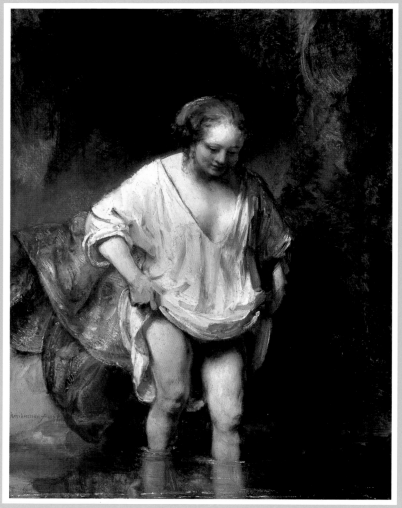

NG 54 Oil on oak, 61.8 x 47 cm

A YOUNG WOMAN delicately lifts the hem of her simple white chemise, exposing pale thighs as she wades into a stream. Her legs are exactly reflected in the still water while sunlight, filtering down through the dense foliage of a forest clearing, glints off her high forehead. Unconscious of our intrusion into the peaceful scene, she gazes into the water as she makes her

careful way. For our part, we cannot be sure who the woman is, only that, feeling the cool water on her flesh, she is absorbed in the sensuality of the moment. Casually tossed on to the bank behind her, however, is a cloak of dense gold brocade, its crimson lining dipping down to the water's edge. It is the raiment of a goddess or a queen.

Rembrandt van Rijn (1606–1669) was a brilliant editor of his pictures, particularly in his later years, paring down historical and allegorical compositions with an inspired economy of means. Indeed he often reduced them to single figures who evoke rather than explicitly enact biblical or mythological tales. This woman may be Diana the huntress, spied on by Actaeon; or Bathsheba the sight of whom fired King David's lust; or the bathing Susannah, thus casting ourselves the spectators in the role of lubricious elders. All these ancient stories of unselfconscious female nudity and the desire it provokes in the clandestine observer are hinted at here, while the splendid cloak that sets off the rich chain of associations was probably no more than a studio prop which the artist hauled from a dusty corner for that very purpose.

The model for the bather has been convincingly identified as Rembrandt's mistress and future wife, Hendrickje Stoffels, whose scandalous liaison with the artist was publicly exposed in the very year he painted the picture. This must account for the air of privacy that, whatever the grand theme the artist may have had in mind, animates the painting with a sense of intimate personal encounter. Rembrandt's sensual involvement with the woman is nowhere more strongly suggested than in the intensely physical way in which he has applied paint to the panel. Areas of thick impasto alternate with audacious touches of raw pigment applied rapidly and with perfect assurance. In few works is the act of painting so immediately revealed as a manual activity involving the manipulation of more or less pliant oils across a surface. It is not unlike the way the lover caresses his beloved.
Christopher Riopelle

ANTONI **TÀPIES**

born Barcelona, 13 December 1923

TÀPIES IS BOTH painter and sculptor, whose work is close to but distinct from abstraction. His art is deeply rooted in Catalan identity, its heritage of mysticism, the violence of the Spanish Civil War and the fight for freedom, both then and later. His works emphasise the thickness and tactility of their materials, the insistently physical, often gestural, means of their making and the importance of intuition in their creation. His paintings' surfaces often resemble walls and their abundant inscriptions (of signs, letters and words) associate them with graffiti. He has stated, 'My works are often paintings, objects and poetry in one'.

The feeling of Tàpies's work is of strong contemporary urgency and immediate vitality. In its restricted hues and time-worn appearance, however, it simultaneously evokes a distant past. His motifs, such as feet, armpits, coils of wire or the simplest household objects, are matter of fact. Distrustful of purity, he often violates the images he makes, yet a key aim of his work is to assert the dignity, almost the sacredness, of the ordinary. The cross with which he marks his work signifies the balance of opposites and recalls his long interest in many religions and philosophies, not least those of the East. Tàpies lives and works in Barcelona.

TONI TÀPIES

This is the Body 1998–9

Marble dust, varnish and paint on wood 270 x 220.5cm, Barcelona, private collection

ANTONI TÀPIES occupies a central position among the many continental European artists for whom, during the last fifty years, the physical presence of matter itself has been a key interest. His work has also enriched the development of abstraction. But while declaring afresh the vitality of his preoccupation with palpable substance, *This is the Body* reminds us, no less powerfully, that 'abstract' is a misleading term when used to describe the work of an artist so urgently engaged, throughout his career, with representing both the physical and the psychological reality of human existence.[1]

Like all Tàpies's works, this monumental painting abounds in signifiers of meanings and feelings that can be named. Of fundamental importance in Tàpies's art, however, is the role of intuition. None of his works is the outcome of a programme; in their genesis instinct and atmosphere are paramount. Even when a work is complete Tàpies himself does not claim to be able fully to explain it. Indeed, any attempt to pin down its meaning exactly or in full would falsify its nature. A quality of enigma is central not only to the work's materialisation but also to the viewer's experience of it. *This is the Body* is a kind of tablet of mysteries, not only confronting the viewer but also, owing to its scale and to the immediacy with which the materials are handled, drawing him or her in.

In Tàpies, as in Rembrandt, image and form are realised through the articulation of dark and light. In both artists' work a rich gloom is often crucial to the expressive effect, as here. One source of Tàpies's preoccupation with sombre hues is his regional heritage. He has written, 'If I paint as I paint it is first of all because I am Catalan'[2], and this deep identification affects more than his use of colour. Darkness in Tàpies's painting recalls the sense of enclosure of the streets in the oldest sector of his native Barcelona but also of his studios in both city and country. Shut in to an unusual degree, these laboratories of art purposely exclude the outside world – and even restrict the quantity of light – in order to facilitate an inward exploration.

This exploration is undertaken in a spirit of meditation, in which reflection on the affirmative and the painful aspects of existence is combined both with recollection of the objects and sensory experiences of daily life outside the studio and with a heightened sense of the properties of Tàpies's raw materials. In the enclosed setting this multiple concentration induces a feeling almost of trance, in which the sometimes abrupt manipulation of materials yields images rich in association and in combinations of meaning. Submitting to the capacities of material itself, Tàpies becomes the agent of unforeseen revelation. The openness of the configurations thus created embodies reality more effectively for him than would the literal representation of appearance.

Tàpies's predisposition to such a method of achieving an image connects not only with Surrealism, of which he was specially aware through the example of the Catalan Joan Miró, but also with a tradition of Catalan mysticism in which the greatest figure was the theologian, philosopher and poet Ramon Llull (1232–1315/16). Tàpies has said of his own art: 'My works are often paintings, objects and poetry in one'.[3] The often near-monochrome darkness of many of these relates, too, to a wider Spanish mystical

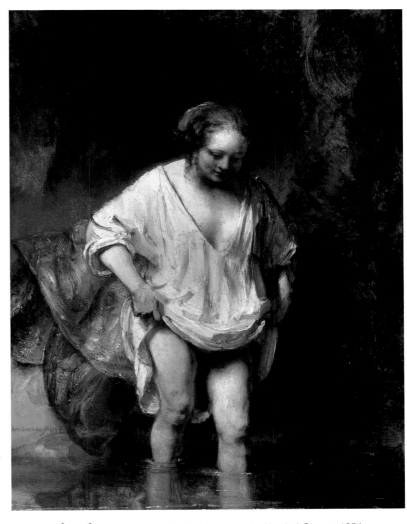

Rembrandt *A Woman bathing In A Stream,* 1654

tradition in which darkness is equated with spiritual illumination. In art, this interpretation is reinforced if, as in Tàpies's reading of Rembrandt's *Woman bathing in a Stream*, the painter's motif is unpretentious.

At the heart of Tàpies's response to Rembrandt's picture lies his fascination with the still astonishing formation of this image through the manipulation of materials, seemingly almost before our eyes. The Rembrandt engages his interest with particular insistence because its unusually frank exposure of the painter's physical gestures is inseparable from the completeness of his realisation of the subject. Moreover, as Frank Auerbach has

1 Rembrandt *Jupiter and Antiope* (the larger plate),1659, etching, plate size 13.8 x 20.5 cm, London, British Museum

observed, 'If you stand in front of a daring Rembrandt, you do not feel he has elaborated on some other painter's knitting pattern. It is a confrontation with the unknown'.[4] For Tàpies, Rembrandt's conjuring of the palpable presence of a woman through the handling of paint imbues both that act and the resulting image with a kind of mystery.

Despite the difference in medium, the same may also be said of the human image in Rembrandt's etchings. Tàpies has long been interested in the etching technique, and not least in the density of tone employed by Rembrandt and others and in the evidence an etching gives of the incisions made on the surface of the plate. He himself owns etchings by Rembrandt. Among these is an impression of *Jupiter and Antiope* (the larger plate) of 1659 (**1**). Of the same decade as *A Woman bathing in a Stream*, this work likewise gives prominence to the image of a woman's body. Among Rembrandt's etchings of the same period are several which not only show a single female figure but are close to the National Gallery's bather in relating the figure to water, sometimes that of a stream.

Tàpies's interest in *A Woman bathing in a Stream* involves neither her rich garments lying at the water's edge nor speculation that she may represent Diana, Bathsheba or even Hendrickje Stoffels. It centres instead on the universal character of Rembrandt's image of a woman's body. Tàpies at once associated this image with the idea of motherhood. This link was all the more compelling owing to his fascination with language, for he connects *mater*, the Latin word for 'mother', with *materia*, the Spanish for 'matter'.

The connection between matter and body was stronger still for him because of the very ordinariness of the woman represented here – what Tàpies calls her 'earthiness'.[5] Tàpies admires Rembrandt for being mysterious and earthy at the same time. In his response to the older artist's work he sought to combine these qualities, in his turn. The subject of his painting is the very taking shape of a body, in the material – its *emergence* into form.

Tàpies has described the body of Rembrandt's bather as being 'banal' in its ordinariness. For him such a characterisation denotes anything but disrespect. For Tàpies has long been concerned to provoke recognition through his art that even the lowliest of subjects, in the world's terms, are embodiments of the divine. For him 'the transcendence of things is comprehended in their immanence'.

2 Ercole de' Roberti *The Institution of the Eucharist*, probably 1490s, oil on canvas, transferred from panel, 17.8 x 13.5 cm, London, National Gallery

Though he broke when young with the Catholic faith in which he had been raised, Tàpies has stated, 'My roots lie in religious art as a whole'.[6] Nevertheless, when he contemplated Rembrandt's bather on a visit to the National Gallery some years before being invited to participate in the present exhibition, he immediately associated it with the Christian belief in God's embodiment in man, through his son, Jesus Christ. In turn this led him swiftly to link Rembrandt's picture with another image in the National Gallery collection, that of Christ's utterance of his commandment to the Church to acknowledge his own real presence in a distinctly humble form – bread, or the wafer – through its consecration in the Mass. This second picture which thus also underlies Tàpies's image is *The Institution of the Eucharist* by Ercole de' Roberti (**2**).

For Tàpies the compelling factor in this image of the Last Supper is that it represents the very moment of the coming into being of a most sacred manifestation of the fusion of matter and spirit. In that moment Christ declared: 'This is my body'. In Ercole's picture the power of this pronouncement is reinforced by Christ's posture and by his central position in the grouping of figures. In Tàpies's painting these forms of authority find a parallel in the prominence accorded above all to two features – the body itself, dominating and central, and the legend which is inscribed, with declaratory vigour, in capital letters, HEUS AQUI EL COS. The language is Catalan. The words, which translate as THIS IS THE BODY, give Tàpies's painting its title.

In substituting 'the' for 'my', Tàpies makes clear the independence of his image from a specifically Christian reading. Nevertheless, many aspects of the work (not least the cross, also prominently inscribed, which will be discussed below) help locate it in a spiritual and philosophical context.

There is a close connection between Tàpies's response to the earthy quality he perceives in Rembrandt's image and his own

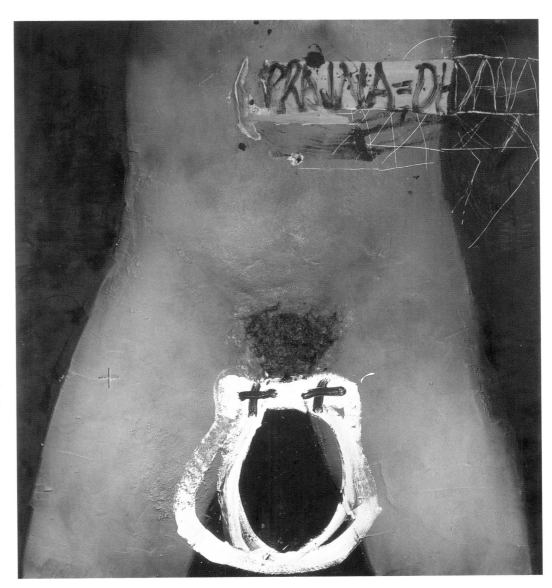

use of a kind of earth as the material of his painting. Here, as it has been in many works over the decades, marble dust is mixed with synthetic varnish. The two are integrated to form a fine tilth, though here and there minute fragments of the stone lie proud of the dry surface, accentuating its likeness to that of rock, crater, cave or dried sea bed. In other places, drops of pure varnish augment the main image. The material was variously applied, with hands, by spatula and with a very large brush. Like most of Tàpies's paintings this one was made with its support laid on the

3 Antoni Tàpies *PRAJNA=DHYANA*, 1993, marble dust, varnish, acrylic and human hair on wood, 220 x 200.5 cm, private collection

floor. One result is the sculptural distinctness of the pools of matter that have hardened, like mud, lava or even, in places, wax. In one of its many dualities, the final image conveys a feeling both of fixed stasis and of active fluidity.

As a work progresses, Tàpies's materials react in ways he could not fully have anticipated. He stresses that when the painting

develops a life of its own the artist must, to a degree, take *its* orders. In such a process there is an element of speculation, as in a game of chance. For the viewer of the finished object it is like witnessing the unfolding of its creation as it occurs.

There is a link between this perception and the opposite feeling conveyed by a painting such as *This is the Body*, that of the endurance of its forms through long ages. The work has an almost archaeological quality, suggesting a further kind of operation of chance in the evolution of its image, namely the ravages of time and of decay, including human interventions and the effects of weathering and erosion. The merging of a feeling of ancientness with the peculiarly late twentieth-century character of the sprayed imagery assists Tàpies's aspiration somehow to break with time. He is interested in the

ideas of the new physics, which show that time and space are inseparable. It is no accident, therefore, that we should have the sense, when viewing this painting, of a cosmic as much as of a studio setting for the process we observe, that of a mass of material in formation.

Tàpies has stated that he sees his art as 'a means of communicating with things. I see it as a kind of contact with universal matter which governs the entire being of the universe and which I think we all, in our own way, resemble'.[7] The treatment of the body in this new painting – at once embedded yet seemingly beginning to float free – reflects this understanding.

The body has always been a central subject of Tàpies's art. There is a link between its imagery and the means of its representation. Even before one considers what his works depict, they recall the body directly through the very nature of the marks made, their gestural immediacy and the sense they often convey of the artist's reach. Then

frequently Tàpies's motif is an object or receptacle, such as a chair, bath or bed, which, while shown unoccupied, at once evokes bodily use. In a strikingly large number of Tàpies's works the body, while not recognised by the viewer immediately, is nevertheless represented explicitly in some way.

Very often such representation is of a part, only, of the body. The instinct to fragment runs through Tàpies's work, fragmentation being a reminder that everything in life is part of a larger whole. Within a single work Tàpies tends to present disintegration in one or more forms, yet also to imbue the broken elements with a new sense of wholeness when the work is viewed overall.

In *This is the Body* the central motif is the back of a torso, observed in a posture which could be either crouched or kneeling, but cut off at the neck and shoulders. Tàpies does not see the forms that run vertically along left and right edges as arms. The image of a torso cut short in some respect is so recurrent in his art (and subject to such idiomatic variation) as plainly to speak to an inner impulse. Recent examples include *PRAJNA= DHYANA* of 1993 (**3**), in which a torso with thighs occupies the whole of an enormous surface to the exclusion of other body parts, and *Cos i filferros* (Body and Wire) of 1996 (**4**), in which one severed arm is bleeding, while the separated hand at the right in some ways parallels the feet in *This is the Body*.

A further reason for fragmentation in Tàpies's imagery is to bear witness to the reality that nothing in life is perfect. He abhors purity of form, and in marking a surface claims it, as it were, for the realm of life. Thus in *This is the Body* the work's central element, the 'new-born' body itself, is not only headless and armless but also mutilated by dark rents. Just as this painting's image of a cosmic coming-into-existence implies the displacement of a primordial void, so Tàpies sees the destruction of the 'given' of the body through violation (or, indeed, through natural forces) as implying an inevitable renewal. Both the fissures in the torso in this

4 Antoni Tàpies *Cos i filferros* (Body and Wire), 1996, mainly paint and wire, 162.5 x 260.5 cm, Barcelona, Fundacio Antoni Tàpies

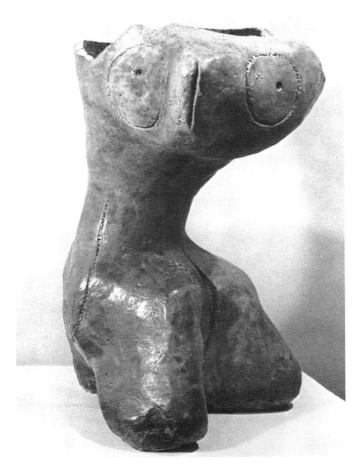

5 Joan Miró *Dona (verda)* (Woman (Green)), 1968, ceramic, 75 x 60 x 45 cm, private collection

painting and its likeness to a husk unearthed after long abandonment provide a parallel with sculptures of the female body by Tàpies's Catalan predecessor and contemporary, Miró, for example his *Dona (verda)* (Woman (Green)) of 1968 (**5**), with its hollow interior and gashed surface.

An element of violence is also essential to Tàpies in recognition that life involves pain (both emotional and physical) as well as pleasure. Running throughout his art, this theme is influenced by his study of Buddhism and is explicit in a number of works prominently inscribed with the Buddhist word *dukkha*, signifying suffering. Already half a century ago extreme pain and suffering were shown startlingly in Tàpies's *Tríptic* (Triptych) of 1948, with its image of an armless torso with bleeding stumps and weeping head (**6**).

The soles of the two feet at the base of the torso in *This is the Body* are outlined in black with arresting thickness, each on its own flat 'stone'. In Rembrandt's image of a bather the feet are beneath the water and cannot be seen but, consistent with his interest in the ordinary, Tàpies gives prominence here to a part of the body to which he returns repeatedly. His affection for the foot derives from the disdain with which it is often regarded. Commonly considered impolite because it smells, it has on occasion been accorded imposing status in his art (**7**), and indeed he has selected the armpit as the subject of another large work. Tàpies's elevation of the despised is the obverse of his instinct to undermine too automatic a respect for things that are more generally admired. As he has written, 'I have looked for parts of the human body that are generally considered undignified, in order to demonstrate that all the parts of the body have an equal value'.[8]

Such an impulse cannot be separated from the passion for democracy that made Tàpies's art so subversive in its articulation (both coded and uncoded) of often specifically Catalan demands for freedom, under the repression of the Franco era.

Similarly, Tàpies's, at first sight, negative gestures of acts of mutilation or irreverence cannot ultimately obscure the essentially affirmative nature of his representation of the world and especially of the body. For, however disturbing some of their details may be, the prevailing atmosphere of all of his works is one of warmth. In *This is the Body* it is even one of tenderness. Tàpies hopes, indeed, that contact with his art can effect a kind of healing. He has stated: 'I think of paintings as magical objects, like something you could use to cure an illness'.[9] The capacity of his art to achieve this is linked to

6 Antoni Tàpies *Tríptic* (Triptych), left panel, 1948, oil on canvas, 97 x 65 cm, Barcelona, Fundacio Antoni Tàpies

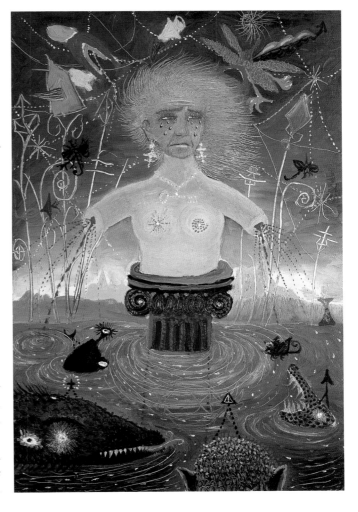

7 Antoni Tàpies *Matèria en forma de peu* (Matter in the Form of a Foot), 1965, paint and marble dust on canvas, 130 x 162 cm, Barcelona, Fundacio Antoni Tàpies

his conception of the artist as a mystic, bringing opposites into synthesis and, through his disposition of archetypes, giving access to deep levels of feeling that can be experienced by all.

Towards the painting's left edge, prominent in its clarity of form and in the flesh-coloured hue it shares with the purely intuitive scroll above it, is the shape of a cross. For Tàpies the inscribing of this sign on every work has become, over the years, irresistible. He describes the impulse to make this mark as a kind of mania or superstition. It signifies for him the continuous action, within human existence, of contradictory forces.

In a lecture of 1994, 'Crosses, Exes, and Other Contradictions',[10] Tàpies enlarged on the multiple significance of this motif. He prefaced his talk with words from the ancient Greek philosopher Heraclitus, including: 'The most beautiful harmony is born of opposites', 'Everything proceeds from discord' and 'The world is both multiple and one'. Tàpies's text traces the relation of the cross to the beliefs of Christianity and of many pre- and non-Christian cultures and philosophies.

Tàpies's conviction of the importance of this sign lies partly in its property, across so many systems of thought and faith, of recalling the viewer to essential considerations in the conduct of life. These include truth, justice, democracy, respect for other cultures and the primacy of such concerns over the imperatives of materialism.[11] In works such as *This is the Body* there is an accord between the insistent presence of the sign of the cross and Tàpies's choices of colour and texture. As he has written, 'I seek and imagine another colour, a dramatic, deep colour capable of expressing essential values The colour does not exist in itself. I need an interior colour'.[12]

Elsewhere he has written: 'I loathe the clean, polished appearance of machine-made objects Old things are imbued with traces of humanity. The products of industry, of design, have lost all the spiritual functions which are essential to human life'.[13] There is a close connection between such a view and Tàpies's attachment to the idea of the wall, which so many of his paintings suggest, both in their texture and in the sense they convey of having been marked by time and by the passage of humanity.[14] In *This is the Body*, the analogy is all the closer because the phrase which gives the work its title is applied to the work's mortar-like surface by spraying, the mode particularly associated with street graffiti in recent years.[15]

The roots of Tàpies's concern with both walls and graffiti lie in the impact of the horrors of the Spanish Civil War, when walls were not only marked by insistently inscribed political slogans but also pitted by the longer-lasting marks of bullets. Later he became familiar with Brassai's photo-documentation, beginning before the war, of often astonishing graffiti in Paris. Appraising today's graffiti, Tàpies laments a loss of pictorial immediacy by comparison with the richness of invention of that earlier period, with its graphic erotic images – often the result of collective improvisation by successive passers-by unknown one to another. He also esteems the greater degree to which such mark-making penetrated the wall plane, by scratching, scraping and even chiselling. Hence, in *This is the Body*, graffiti restricted to the surface (a feature, as he sees it, of much of today's culture) are complemented by gouging and furrowing of the *matière* and even by chipped indentations that recall the impact of small-arms fire in streetfighting in Barcelona during the Civil War.

8 Antoni Tàpies *Cub creu* (Large Cross), 1988, fireclay, 73.5 x 112 x 106 cm, private collection

been profound. Zen brings together a number of Tàpies's key concepts, all present in this painting, for example: a respect for what is earthy, an interest in what is unconsidered and the attachment of value both to the operation of chance and to the trace of the artist's gesture. Also crucial is the idea of the simple, accepting recognition of what exists. Hence the relevance of a Zen story in which, when an older monk was asked by a younger for a last word to those who would come after, he replied simply: 'Tell them, "This is!" '.[16]

Richard Morphet

Such interplay between surface and depth enhances our awareness of the element of relief in a painting which, like so many by Tàpies, is literally built upon its supporting plane. This quality accentuates the work's object-like character, despite its being displayed on a wall. It reminds us that Tàpies is a sculptor as well as a painter (**8**).

Tàpies's painting and sculpture are linked not only by his painting transcending limitation to the flat surface but also by the force with which they manifest a work's subject. As we have seen, *This is the Body* directs special focus on the very act of materialisation of the work's central image. Tàpies's choice of this event as his subject makes it specially appropriate, therefore, finally to recall that within his response to a wide range of strands in Eastern thought the influence of Zen has

Notes

1 Equally misleading would be to assume that Tàpies intends, in the often stark forms or violent gestures of his art, to effect a rupture with the art of the past. The idea that a complete break with past art is either desirable or possible is dismissed by him as a cliché. His own art asserts an umbilical connection with the art of the past and of other civilisations.

2 From 'I am a Catalan', in Antoni Tàpies, *La pràctica de l'art*, 1970, published in English translation in Kristine Stiles and Peter Selz (eds.), *Theories and Documents of Contemporary Art*, Berkeley, 1996, p. 55.

3 Barbara Catoir, *Conversations with Antoni Tàpies*, 1987, first English language edition Munich, 1991, p. 104.

4 Michael Peppiatt, 'Talking to Frank Auerbach', in exh. cat. *Frank Auerbach*, Marlborough Gallery, New York, September–October 1998, pp. 4–7.

5 Interview with the author, 16 April 1999, from which all subsequent unattributed quotations are also taken.

6 Catoir, cited note 3, p. 96.

7 Ibid., p. 73.

8 Ibid., p. 77.

9 Michael Peppiatt, 'The Soul Revealed by the Hand: An Interview with Antoni Tàpies', in *Art International*, no. 13, Winter 1990, pp. 34–43.

10 Published in English translation in exh. cat. *Tàpies*, Guggenheim Museum, New York, January–April 1995, pp. 66–78.

11 In his 1990 interview with Michael Peppiatt, cited note 9, Tàpies observed: 'We become attached to things of secondary importance these days and we lose sight of essentials. There's even a culture industry whose aim is not to spread knowledge but rather to make money ... Asiatic art, for example, was inseparable from religion and philosophy, so was the art of the European Middle Ages and African art. But now, using the excuse that we have lost our religious faith, we have tried to secularize transcendental values without finding any true equivalent for art's original function.

'I want to provoke [the spectator], to arouse his solidarity and altruism and to help him to develop the potential we all have within us but which is stifled by industrial society.'

12 In 'I am a Catalan' cited note 2.

13 Catoir, cited note 3, p. 80.

14 The word *tàpies* means 'walls' in Catalan.

15 The first 's' in the inscribed phrase is reversed. This often happens in Tàpies's art, both because he is ambidextrous and as a device to heighten the viewer's attention.

16 As recounted by Thomas McEvilley in an interesting passage on the importance of Zen for Tàpies in 'The Aria of the Dust: the Work of Antoni Tàpies', in exh. cat. *Antoni Tàpies*, Marugame Genichiro-Inokuma Museum of Contemporary Art, Marugame (Kagawa), May–June 1996, pp. 18–26.

TURNER
The Fighting 'Temeraire' tugged to her Last Berth to be broken up, 1838 before 1839

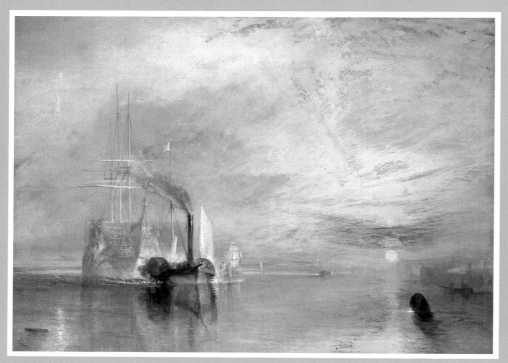

NG 524 Oil on canvas, 90.7 x 121.6 cm

FROM THE TIME Joseph Mallord William Turner (1775–1851) first exhibited this painting, at the Royal Academy in 1839, it has elicited strong emotions in British viewers, not least a patriotic pride that is sometimes tinged with regret at the indifference of the modern world to former glory. The huge, three-masted gunship, the *Temeraire*, launched in 1798, had fought valiantly along side Nelson's *Victory* at the Battle of Trafalgar in October 1805. By the 1830s, however, its usefulness to the Royal Navy, like that of many other warships which, now outmoded, had long guaranteed British naval superiority, was at an end. Steam was replacing sail, and in 1838 the *Temeraire* was decommissioned and sold to be broken up. Turner depicted the once proud vessel's fate. It is towed away from its naval moorings by a squat, smoke-belching tug, headed for demolition up the Thames at Rotherhithe. In the distance another ship under full sail evokes the lost splendour, the majestic force the *Temeraire* once incarnated, but no-one honours the ship itself as it is shunted to oblivion.

Early writers insisted that Turner's was a faithful and accurate depiction of the sad scene, and the myth that this is what the artist saw, that his painting is an act of vivid *reportage*, has proved remarkably long-lived. Only slowly, as research on the painting has progressed, has it become clear exactly how inaccurate a representation of events the painting is, and at the same time how brilliant a polemical construction. Turner did not see the *Temeraire* being towed away and almost surely worked from press reports. He hated Napoleon, however, and honoured the memory of Nelson and the heroic achievements of his navy, and almost every brushstroke here is, it seems, calculated to provoke a comparable patriotic sentiment in the viewer. The ship's three masts, which were re-usable, had been removed by the Royal Navy before the ship was sold, but Turner restored them to underscore the comparison between the proud old *Temeraire* and the squat, efficient tug. Similarly, the latter's smoke-stack has been moved far forward, its belching smoke an added affront. The setting sun is in the wrong position for a ship heading west but serves as a potent symbol of waning power. In nature, the sun and moon, the latter seen at left, are often found in the same sky but here the phenomenon accentuates the sense that a fiery past – and how the old ship gleams in the fading light – is being replaced by a cold, ugly and unromantic new world.

Turner never sold the painting, though offers were made. Early on he determined that it would be among the works he offered to the nation, a reminder of the neglect with which, from time to time, it treated its noble past.

Christopher Riopelle

CY **TWOMBLY**

born Lexington, Virginia, 25 April 1928

© Nicola del Roscia

Twombly GREW UP IN the American South. He studied art in Boston, New York and at Black Mountain before visiting Italy and North Africa with Robert Rauschenberg in 1952–3. He developed a painting style close to Abstract Expressionism but also to Dubuffet's wall-like densities. Since 1957 he has lived chiefly in and near Rome. Drawing on classic literature and art of earlier centuries, his work declares deep attachment to the history and myths of the Mediterranean world. Such preoccupations, and their embodiment in a painterly semi-abstraction, were unusual in the 1960s and 1970s, but Twombly followed his own distinctive trajectory. Creamy paintings of the early 1960s, clotted with bright markings evoking bodily sensation, were followed by cursive scrolls on blackboard-like grounds and later by lyrical, airier sequences evoking plants, skies, seas, boats and the seasons. These ranged from works on paper to a painting fifteen metres wide.

Twombly's sensuous facture is fused with a loose but urgent calligraphy, in which phrases, numbers and the names of great poets are inscribed, conveying an intense imaginative engagement. Forms drift expressively across the surface of works that are insistently contemporary yet evoke an archaic or dreamlike setting. Twombly has long made constructed sculptures. Often frail, and slightly removed by their chalky surfaces, these, too, suggest a long spectrum of time, from familiar toys and household implements of today to the rites of ancient Egypt.

Three Studies from the Temeraire 1998–9

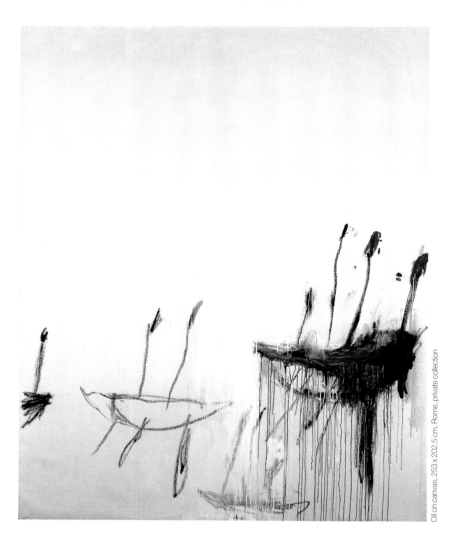

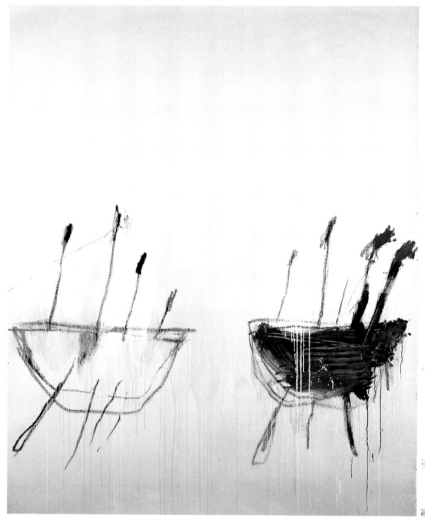

Oil on canvas, 253 x 202.5 cm, Rome, private collection

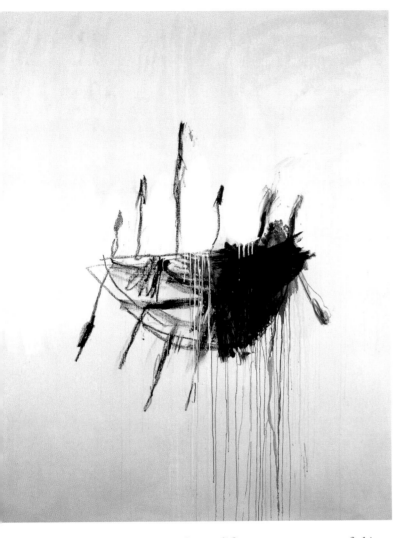

The canvases were painted in one room of Twombly's house at Gaeta, on the coast between Rome and Naples. They were conceived as individual works, each with Turner's *Fighting Temeraire* in mind, and this is what they remain. However, though each picture was painted on a separate wall, the three developed in concert and were continuously visible as an ensemble. When displayed together, they call for a single plane; thus combined, they form an image that is strong and strange.

Although *The Fighting Temeraire* was crucial in the genesis of these paintings, Twombly did not study a reproduction as he worked; his pictures were independent from the first. Nevertheless, his response intentionally retains Turner's motif of a dominant and a lesser vessel, as well as bold contrasts of light and dark in their depiction. In both artists' images water, air and atmosphere are of key importance and there is a pronounced sense of movement across the scene.[1] In each case, moreover, the painter's regular observation of shipping on waters close to his home

canvases are seen as a single panorama, the number of vessels per canvas increasing from right to left, the identity of each boat begins to fluctuate. We might be seeing many individual boats or several repeat appearances, or even, in places, a parti-coloured image of two boats in one. Compounding the uncertainty, one boat sails off the left edge, while another lies beneath a veil of white.

Inescapable, though, is the sense of a procession. It culminates in the 'flagship' that brings up the rear. Twombly's vessels can, indeed, be seen as a fleet – small or large, depending whether the image is read literally or (as its character encourages) imaginatively. The sense of a fleet is present, too, in Twombly's source, in which 'Turner conjures up a mysterious effect of numerous sailing-ships receding into the far distanceThackeray was to describe them as "a countless navy that fades away".'[2] The two artists' pictures also share an other-worldly quality. In the earlier, the *Temeraire* is presented as 'unreal and already ghostly In Turner's eyes, the entire ship has taken on the pale gold of a vision.'[3] As if reciprocally, the boats in Twombly's procession have a vividness akin to dream. Their strange immediacy is the more arresting for seeming like a magical glimpse of something separated from us by many epochs, or even moving within an

J.M.W. Turner *The Fighting 'Temeraire' tugged to her Last Berth to be broken up, 1838* before 1839

C Y TWOMBLY'S prolific output across half a century has not issued as a steady flow of new work, but is the result of periods of intense activity separated by intervals of relative calm. The pattern is explained by the importance of intuition in the genesis of his art. *Three Studies from the Temeraire* emerged unexpectedly after a significant intermission in Twombly's painting. They bring together in a new way ideas and motifs that have a long history in his work, but the catalyst of their creation was feelings roused quite suddenly by consideration of a particular image by Turner.

fed into the images we see.

While having in common a motif of two principal vessels, each artist's work also represents a range of craft. In a degree inconceivable for Turner, however, Twombly's ensemble is alive with shifting meanings. The canvas on the right is the only one to depict a lone boat, and is specially emphatic. Twombly conceived this as depicting the main boat and the rest as either versions of this prototype or descendants of Turner's tug. But when the three

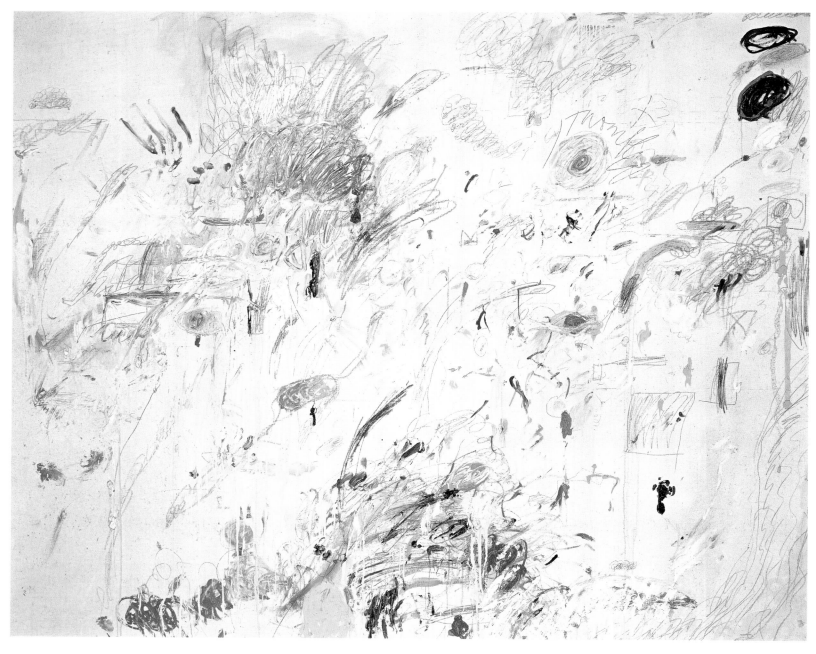

1 Cy Twombly *Empire of Flora*, 1961, oil, crayon and
pencil on canvas, 200 x 242 cm, Berlin, Marx Collection

element that is outside time or space.

Twombly approached artistic maturity at
a time when Abstract Expressionism was
supreme in the United States. Like its older
masters, he has long merged the urgency of
intimate self-revelation with a sense, for the
viewer, that each work registers something
relevant to all. Also like his predecessors,
Twombly draws openly on European prece-
dents while making marks of which the
blunt directness is as distinctively American
as the openness of their painted field. But he
has moved gestural painterly art into new
territory. In ways one might have thought
impossible, Twombly has made the features
described co-exist both with an extraordi-
nary lightness and ease and with a feeling of
active participation in the rich cultural life of
the Mediterranean world, stretching back
across millennia.

Fundamental in this remarkable fusion
was Twombly's move to Rome, forty-three
years ago. He first visited Europe and North
Africa in 1952–3, but since 1957 he has

divided his year between Italy and the USA. Over half a century, his work has encompassed remarkable contrasts of idiom, none more pronounced than that between the exciting, seemingly improvisational scatter of brightly coloured daubings, doodles and scrawled words against rich creamy grounds of 1960–2 (**1**) and the austere yet nervously vital grey and white 'blackboard' pictures of the mid-1960s (**2**). While the former idiom reached a climax of hot colour and erotic frenzy in the *Ferragosto* pictures of 1961, the latter tendency connects, in its absence of strong hues, with Twombly's extensive work as a sculptor, in which simply assembled forms rich in association are presented in matt, almost lunar whites and greys.

Twombly's move to Rome coincided with the appearance in his pictures of overt references to the world of Antiquity, which continue to the present. Among them are words – sometimes single and at other times whole phrases – which are inscribed loosely, but with graphic clarity. Acting simultaneously as exclamations and as evocations, these are combined with an abundance of signs and of allusive abstract or semi-abstract marks, dispersed across an expansive surface. For the viewer the effect is of seeming to be placed in an environment that, in an act of enchantment, merges the studio and its sensuous manipulation of materials with the actual scenes described in

2 Cy Twombly *Untitled*, 1967, house paint and crayon on canvas, 200.7 x 264.3 cm, private collection

3 Cy Twombly *Volubilis*, 1953, white lead, house paint and crayon on canvas, 139.7 x 193 cm, private collection

classical poetry and myth. This two-pronged directness is in no way undermined by the further importance in Twombly's frame of reference of the great writers and painters – themselves likewise invoked in scrawled words – by whose work our sense of the classical past has been shaped.

Twombly's oeuvre to date includes other types of painting that again form a sharp contrast to those so far discussed. Rich but muted, his pictures of the early 1950s had a wall-like character, their primitive, animate forms suggesting ancient cave art or contemporary graffiti, as well as the example of the French painter Jean Dubuffet (**3**). The 1990s have seen the creation of a quite different, almost ethereal world of space, light and

floating form, infused with a palpable sense of yearning for a distant past (**4**). *The Three Studies from the Temeraire* bring these widely separated approaches together in a new way.

Already before the National Gallery's invitation Twombly's work suggested a natural affinity with the work of Turner.[4] As Kirk Varnedoe has written of the *Summer* panel from the first (Museum of Modern Art, New York) of Twombly's two sequences of paintings titled *The Four Seasons* of 1993–4: 'Awash in the warm shimmer and dazzle of misty light on water, it returns, in its dominant play of melting yellows and whites, to the atmospherics of Turner's landscapes, which Twombly has so long admired'.[5] The light to which Turner was so responsive was, not least, that of Italy. He recorded the blue of sea and sky on the coast, south of Rome, where, at Gaeta, Twombly painted *Three Studies from the Temeraire*, their soft blue grounds summoning the same atmosphere (**5**).

Both water and sky are elements in which one can float and Twombly has spoken of the 'irresponsibility to gravity' of his own art.[6] The present work is a classic example. There is a fortuitous correspondence between the reflection of Turner's vessels on the calm surface of the water and the streams of paint that pour down from three of Twombly's

4 Cy Twombly *Untitled Painting*, 1994, oil paint, acrylic, wax crayon and pencil on canvas, overall dimensions 400 x 1585 cm, Houston, Texas, Cy Twombly Gallery

hulls. But the latter's boats are all shadowless, even weightless, and these paint streams anchor them within the composition as a whole. Fluidity *per se* is a vital aspect of the use of paint by both masters. Each also exhibits a long-standing preoccupation with water. Both of Twombly's Italian homes are near it and boats were a strong interest during his regular childhood visits to coastal New England. In 1959 he titled a suite of drawings *Poems to the Sea*.

By the terms of Turner's will, the National Gallery demonstrates permanently the strength of his admiration for the work of Claude Lorrain. Key concerns of Twombly's, including air and its hues, light, water and seaports, are prominent in the works of both earlier artists that are paired at Trafalgar Square.[7] The parallel is closer still when one recalls that both artists painted in Rome, where Claude spent almost all his long career and Twombly lives. *A Harbour Scene* (**6**) exemplifies these interests in Claude.

5 J.M.W. Turner *Vesuvius*, 1819, pencil and watercolour, 22.5 x 40.5 cm, Tate, London

6 Claude Lorrain *Harbour Scene*, 1636, from the *Liber Veritatis*, pen and wash on paper, 19.6 x 25.6 cm, London, British Museum

Curiously, while Turner was painting *The Fighting Temeraire* he was also at work on a same-size oil of the Tiber at Rome, including oar-propelled boats (Twombly's motif), one of them a boat of death (**7**). Twombly shares with Turner and Claude a preoccupation with scenes from Antiquity. The boats in his new painting are like descendants, not all that distant, of ones painted in nearby Stabiae nearly two millennia before (**8**). Each of these artists' images gives the viewer the strong sense of actually being in the scene depicted. This is striking in the case of both Claude and Turner, who look back to scenes they had not witnessed, but even more so in

Twombly since his work offers almost no circumstantial detail.

Twombly's initial response to *The Fighting Temeraire* was a work on ten panels using stronger colour than the *Three Studies* and more closely worked. It is still in progress. By contrast, the pictures for this exhibition make a virtue of directness and simplicity. The radiant pale blue ground, which Twombly sees as like air itself (though it also stands for water), is a simple wash over the creamy priming, which in turn overlies canvas deliberately chosen for its rough weave. Some of the marks made on to this ground seem only just to touch the surface. Others were worked in fierce congestions, kneaded by the fingers, as in the shells of the darker boats, revealing on close examination hues of purple and of Indian red. Paint was applied partly by brush and partly by oilstick, the forms of these tools curiously parallelling the linear elements in the pictures.

Twombly sought, and has achieved,

a quality of innocence, almost naivety, unhampered by a story or by specified associations. New marks were prompted by the emerging image itself. Though tempted to add writing, he was nervous of doing so lest it should necessitate overpainting in pictures that he felt must be unpretentious. Nevertheless, these works, which result from a kind of drawing in paint, have something of the urgency of the closely related convention of graffiti. Their fingerpainting is like gouging (cf. **10**) and the boats have a swift, schematic character allied with a sense of something first felt inwardly and then inscribed on a flat surface as an irresistible act of self-declaration. Their images also suggest an archaic stage of human development, both in navigation and in image-making.

Each boat image is formed of a rough half-circle, from which protrude stick forms. Pointing both upward and downward, these represent oars. Those rising above the boat are in a resting position, but might also be read as

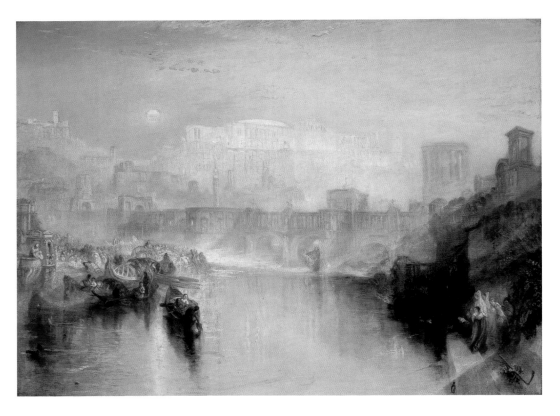

7 J.M.W. Turner *Ancient Rome: Agrippina landing with the Ashes of Germanicus*, first exhibited 1839, oil on canvas, 91.5 x 122 cm, Tate, London

rudimentary depictions of figures or even of masts. This near-abstract configuration abounds in Twombly's recent art, and it sometimes appears with the half-circle inverted and the protrusions only rising (**9**), thus representing 'flowers emerging on spindly stalks from a massive mound of earth'.[8]

Here, however, the consciously rather toy-like character of the boats links back to Twombly's childhood paintings from observation and also to his present collection of model boats. As it happens, Turner's *Dido building Carthage*, in the National Gallery, includes a scene of children playing with a toy boat, where 'the device … causes us to see

the dazzling water in the foreground as an ocean, the arena of Dido and Aeneas' trials exiled from their homelands'.[9] In the context of Twombly's art of the past decade or more, even a figuration of boats as simple as that in the *Three Studies* draws us immediately into the ancient world, and into its heritage of literature and myth. His largest painting (**4**), its throng of ghostly boats thick with active oars, is inscribed *Say Goodbye, Catullus, to the Shores of Asia Minor*, in allusion to the death of the poet's brother and to his burial at Troy, site of the wars that inspired Twombly's ten-painting sequence *Fifty Days at Ilium* of 1977–8. For all their 'innocence', it is impossible not to associate the *Three Studies* similarly with the long past of the Mediterranean, its shores and its history of naval warfare.[10]

The harbour at Gaeta, overlooking which they were painted, was 'a legendary

8 *Harbour City*, third quarter 1st century AD, detached mural from Stabiae, Naples, Museo Nazionale

port in antiquity'.[11] Long after, in 1571, it was from here that the fleet that would be victorious set sail towards Lepanto (near the Gulf of Corinth), where there took place what Twombly describes as 'the last naval battle fought in the antique way' (the silk standard of its flagship is still preserved in Gaeta). The *Three Studies* follow naturally from Twombly's recent monoprints titled after this battle (**10**), which similarly are a suite in three parts. Each depicts a single ship with masts, flags and oars. Themes of war not only recur through Twombly's art but also play an elusive yet real part in the genesis of the new paintings, for in selecting their 'source' Twombly was keenly aware of the illustrious role of the *Temeraire* in Nelson's victory at Trafalgar.

In terms of idiom, the exceptionally sophisticated images in the *Three Studies* might be called childlike. Varnedoe has written illuminatingly that for Twombly 'the quality of the infantile is central to understanding the sensual, instinctive dimensions, and the "irresponsibilities" which he feels are the grounds of a liberating affinity between aspects of his own temperament and Mediterranean culture. There is a necessary and close exchange in Twombly's work between his affection for the venerable and timeworn and for the fresh and simple; in the fantasy of the work they fuse to their mutual benefit. His experience of the ancient world as continuously, sensuously alive … needs constant refreshment by his parallel love for a crude, naïve, and uninitiated manner of expression …. It is the heavy role of instinct and feeling that he designates as the "infantile" element in Italian, and by extension Mediterranean, culture.'[12]

As this text helps us appreciate, the subject of the *Three Studies* is at once objective entities – boats, the Mediterranean – and Twombly's self-intuition, which is, of course, subjective. The two cannot be disentangled. They meet, crucially, in an idea that is central to the works' 'meaning', that of passage. This theme operates here on several levels.

A key aspect of the attraction of the Mediterranean for Twombly is as a place of connection, giving access to distinct regions – 'in two hours you can be in Asia, in Egypt or in Africa'. At one end of this aptly named sea, Istanbul excites him as the very location of the narrow step, across water, from Europe to Asia Minor. But Twombly's procession of boats also denotes passage from the present into the past. As Roberta Smith has written,

9 Cy Twombly *Thermopylae*, 1991, plaster on wicker and closely woven fabric, graphite, wooden sticks, plaster-coated cloth flowers on plastic stems, wire, 137 x 89 x 66 cm, private collection on loan to Houston, The Menil Museum

'His art presupposes an unbroken continuity of culture and of aesthetic experience (and pleasure) in which the past is perpetually available to the present, this being "a body of

10 Cy Twombly *Lepanto I*, 1996, cardboard plate engraving printed as monoprint by the artist, 100 x 62 cm, London, Anthony d'Offay Gallery

cultural knowledge that his own body – culminating in the gestures of his arms, hands and fingers – makes manifest in his art".[13]

Born in the American South, Twombly himself observes that a concern with layers of reference is a Southern characteristic. Needing time and lack of pressure for its articulation, recollection emerges slowly; deeply embedded, it is eloquent when it does so.

The passage we witness in these paintings may also be seen as being from this life into the next. Pictures of a journey to death are a

fitting response to Turner's image of the Temeraire being towed to her end. Painted chiefly in black and white – both colours of death – and at once luxuriant and sombre, Twombly's *Three Studies* are pervaded by a sense of mystery that seems to connect with travelling into the unknown. The same sense is present in dark boats in his earlier paintings, but it is notably prefigured in his pale sculptures, especially those on the recurrent motif of boats with oars, whether single (**11**) or numerous.[14] A key source for these were ancient Egyptian sculptures of boats which Twombly saw in the Cairo Museum. These are vessels for the passage of the soul to the underworld, a reference present in Twombly's mind as he painted the present works.[15] The theme also suggests a comparison with a painting almost contemporary with the Turner, in which, as in the *Three Studies*, boats are seen in echelon within a strangely rarified atmosphere of light, sea, sky and awareness of mortality, Caspar David Friedrich's *The Stages of Life* (**12**).

On one level, Twombly's sequence of images could not be more straightforward, yet it is the site of insistent oppositions. It is arrestingly direct, yet also elusive; austerely reductive, yet richly sensuous; starkly contemporary, yet exerting the pull of a distant past; insistent on the surface, yet opening up deep space; 'obvious' and universal, yet personal and hermetic; playful, yet grave; transparently innocent, yet strangely wise.

Turner would not have known what to make of it, yet *Three Studies from the Temeraire* would never have been painted without his haunting picture. It, in turn, would not have been painted without the *Temeraire*'s decisive participation in a historic naval engagement. Twombly's fascination with the Mediterranean and with its links to other continents has been described. It is curiously satisfying not only that the Battle of Trafalgar, site of the *Temeraire*'s fame, should have taken place within sight of the Mediterranean's western outlet, the narrow strait that separates Europe and Africa, but also that the first showing of this new maritime image should take place in a Gallery overlooking the very square in which Nelson and his victory are commemorated.

Richard Morphet

11 Cy Twombly *Winter's Passage LUXOR*, 1985, wood, nails and paint, 54 x 105.7 x 51.6 cm, private collection on loan to the Kunsthaus, Zurich

12 Caspar David Friedrich *The Stages of Life*, 1835, oil on canvas, 72.5 x 94 cm, Leipzig, Museum der bildenden Künste

Notes

1 In the Turner, the movement is from left to right. Twombly reverses this; though unplanned, the pronounced motion across the three canvases is consistent with the distinctive and animating quality of directional drift that develops in most of his pictures, as marks accumulate.

2 Judy Egerton, *Turner: The Fighting Temeraire*, London (The National Gallery) 1995, p. 84.

3 Ibid., p. 81.

4 This was commented on by both Nicholas Serota and Harald Szeeman in exh. cat. *Cy Twombly*, Whitechapel Art Gallery, London, September–November 1987, pp. 7 and 11.

5 Kirk Varnedoe, in exh. cat. *Cy Twombly: A Retrospective*, Museum of Modern Art, New York, 1994, p. 50.

6 'Twombly has spoken of an "irresponsibility to gravity" as central to his art, and has described his understanding of classical mythology as a realm of imagination which is not only shadowless but also without weight or constraining centre' (ibid., p. 34).

7 Cf. Michael Wilson, in exh. cat. *Second Sight: Claude, The Embarkation of the Queen of Sheba; Turner, Dido building Carthage*, National Gallery, London, February–April 1980.

8 Varnedoe, as cited note 5, p. 49.

9 Wilson, cited note 7, p. 21.

10 'It has often been remarked that Twombly's oeuvre is like a great and comprehensive memory of the Mediterranean, a firmament that reflects the recurring meridians of its myths and metamorphoses. The genesis of the antique culture of the Mediterranean pervades this universe of imagery, as the great conception of a living spirit' (Heiner Bastian, Preface to *Cy Twombly: A Catalogue Raisonné of the Printed Graphic Work*, Munich and New York 1984).

11 Varnedoe, as cited note 5, p. 49.

12 Ibid. and footnote 176, p. 64.

13 'The Great Mediator', in exh. cat. cited note 4, p. 15.

14 E.g. *Untitled (Boat)*, 1991, reproduced in exh. cat. cited note 5, plate 119, p. 160.

15 See note by Heiner Bastian on Twombly's *Four Seasons* paintings in *Cy Twombly: Catalogue Raisonné of the Paintings*, 1972–95, IV, pp. 35 and 37, for a summary of the ancient Egyptian religious symbolism.

MONET
The Water-Lily Pond 1899

NG 4240 Oil on canvas, 88.3 x 93.1 cm

IN 1883 CLAUDE-OSCAR MONET (1840–1926) moved permanently to a house in the small town of Giverny, to the west of Paris. Immediately adjacent to the house he cultivated a formal garden featuring symmetrically disposed beds of brilliantly coloured flowers. Like earlier gardens he had grown, Monet often depicted the Giverny garden in his paintings. Several years later, in the 1890s, he acquired a second parcel of land on the far side of a railway track that ran by his property. There he designed and installed another garden, freer in form, which centered on an artificial, irregularly shaped water-lily pond. Tall trees formed a canopy through which the dappled sunlight filtered down. Monet spanned the pond with a simple single-span wooden bridge of Japanese design. A manifestation of his long-held admiration for

things Japanese – his house itself was filled with Japanese prints – the bridge served as a decorative feature in the garden as well as a vantage point from which to view its increasingly abundant flowers and foliage. Late in the 1890s, Monet began to paint in this new garden, and by the final decades of his life it had become the principal, all-encompassing subject of his increasingly monumental art. The great suite of nineteen *Water-Lilies* canvases that he created for the Orangerie in Paris all depict aspects of it.

Beginning in 1899, at the start of his obsession with painting this new garden, Monet executed some seventeen views of the water-lily pond, including this work, all of them on more-or-less square canvases, and he exhibited many of them together the following year in Paris. This painting is one of the most straightforward of the works shown that year. The Japanese bridge is viewed frontally as it arches gracefully over the pond. White in reality, it is mottled here by dancing green and blue reflections from the flower-choked water below and the foliage above. The pond recedes into the distance in the bottom half of the picture but the viewer's eye is pulled back to the foreground by the curving form of the bridge, the dangling branches and the rich play of impasto across the painting's surface.

Monet was the longest-lived of the Impressionist painters, and his artistic reputation was in partial eclipse by the time of his death, his late paintings being generally little considered. Over the course of recent decades, however, his late paintings in particular have had a wide influence on artists and continue to exert an enormous appeal on the public imagination. Now among the most popular artists in the world, Monet is most appreciated for those images of water, flowers and sunlight that he created in the privacy of his Giverny garden.
Christopher Riopelle

EUAN **UGLOW**

born London, 10 March 1932

EUAN UGLOW first distinguished himself as a junior student, aged sixteen, at Camberwell School of Arts and Crafts, where he was taught by Claude Rogers, Victor Pasmore and the sculptor Karel Vogel. He also came under the influence of William Coldstream, who had been a co-founder with Rogers and Pasmore of the Euston Road School in the late 1930s. The Euston Road style promoted sober realism based on monocular measurement. When Coldstream became Principal of the Slade School, it seemed natural for Uglow to follow him there, first as student, later as teacher, but Uglow began at once to pursue a more extreme method. He campaigned success-fully for longer model poses, and used geometry to order his compo-

Photo courtesy of Browse and Darby, London

sitions. Drawing was an essential discipline. It is Uglow's aim to paint a structured picture full of controlled emotion in which every mark matters as both form and meaning. Uglow paints still lifes, landscapes, nudes and portraits. He has gradually refined the formal construction of his paintings whilst deploying increasingly strong colour to artic-ulate their spaces. Euan Uglow lives and works in the Clapham studio he moved to in 1959.

UAN UGLOW

Nuria 1997–2000

Oil on canvas laid on panel, 36.2 x 54.3 cm, London, Browse & Darby

EUAN UGLOW is extreme both in approach and temperament, a radical. Each painting is designed with the aid of geometry and proportion. A rectangle is devised or adopted which will make pictorial sense to him, and offer what he calls 'a proper order'.[1] All subsequent measurements are then taken in relation to this rectangle. Uglow proceeds by tiny increments to an overall plan that is pre-determined. Earlier on, at the drawing stage, the rectangle may change if the form of the intended image requires it, but by the time the board or canvas has been selected the image has usually settled. Layer by layer of paint is added to the fretted surface, sometimes recalled and scraped out, sometimes left and added to.

Uglow's obsession with geometry recalls the notion attributed to Archimedes that mathematics is the shadow of the real world projected on to the screen of the intellect. For Uglow, the successful depiction of form is of supreme importance. To this end, he defines each plane and facet of his subject clearly – in this following Cézanne – modulating colour across a body in cleanly laid, abutting touches. He requires a constant light to calculate the spatial relationships of his forms, and makes use of a plumb-line and monocular measurements.

The painted signs and crosses of the measuring marks, the coordinates by which Uglow navigates around a picture, appear as a general rule only on the day-time paintings which are done on canvas. The ones he paints at night are on canvas laid down on board, which is more resilient, so Uglow uses a pair of dividers to measure and mark the surface, as he does in the drawings. However, none of this should strike the viewer unduly. Too much critical attention is often given to his method, which, after all, is only the scaffolding which enables the builder to work.

Claude Monet *The Water-Lily Pond,* 1899

Nuria, painted in oil on canvas laid on board, measures 36.2 x 54.3 cm, a proportional relationship of two to three. It was begun immediately after Uglow's latest painting exhibition in May 1997. It responds to *The Water-Lily Pond* (1899) by Claude Monet. Both the model's body and the support she rests on, as well as the curve of her arm, are analogous to the Japanese bridge which dominates Monet's picture. The floor beneath the model corresponds to the lily-shrouded water.

The idea for the picture was fairly clear in Uglow's mind from the outset, evolving as it did from another quite different and unsuccessful painting with which he found he could not continue. (It involved an idea about a suspended form over a horizontal plane.) Nevertheless it took two or three sessions to establish the new pose. Altogether Uglow made seven preliminary drawings to discover what he wanted from the model. These range from the most schematic diagram, actually drawn at the top of a sheet devoted to another idea altogether, to a highly finished drawing exhibited in 1999. Between these two extremes are five studies of *Nuria* in variants of the final pose, with her arms and legs at slightly different angles. Beside the diagram, only one other (**1**) reverses the pose entirely, and tries out the idea of placing her head to the left and her feet to the right. This different dynamic was, however, soon abandoned. Six of the drawings are swiftly drawn and immediate in character, constructed from a flickering, sensitive, nervy line (**2**). The seventh is equally sensitive but more considered, more carefully analysed; evidently it was the last drawing made before the painting itself began (**3**).

Nuria is a night picture, but because the location, in a corner of Uglow's downstairs studio, is so dark, it could actually be worked on at any time. Whether it is summer or winter, the light can be kept constant. When the painting was in progress there might be up to three sessions a week, each of three hours. A session tended to consist of an hour's work followed by a quarter of an hour's break, followed by three-quarters of an hour's work,

1 Euan Uglow *Study for 'Nuria'*, pencil drawing, 10.7 x 19 cm, London, Browse and Darby

best Irish linen canvas. It stands eighteen inches from the ground, and is four feet in length.

The set-up for the painting included a constant vertical and a constant horizontal. The vertical was supplied by a bricklayer's plumb-line and bob, the horizontal by fishing twine suspended from hooks and kept taut with sections of lead pipe as weights. A cardboard German wine-box, its flaps carefully unfolded and angled, was fixed around the light bulb. On the wall behind the set-up is a large map of England ('so many models are foreign and don't know where anything is,' Uglow comments) and an architectural drawing of Brunelleschi's dome of Florence Cathedral ('one of the most beautiful things on earth'). Neither of

then another break before the final forty-five minutes. As the end of the sittings approached, Uglow worked on it for longer hours, knowing the model had to return to Spain.

Uglow's nature includes a strong impulse towards making things (**4**). He effectively built his studio-home and readily constructs the props required for his paintings. He built the not easily defined piece of furniture on which *Nuria* leans, and also made the model's support in another recent night painting, *Jana* (**5**). In the shop where he bought the materials to make both, he could have chosen straight legs, but in both instances chose curved ones. 'It was just convenience,' he says, 'there was a wider surface to attach the top to.' The top of *Nuria*'s support is padded with foam and covered with

2 Euan Uglow *Study for 'Nuria'*, pencil drawing, 20.3 x 25.4 cm, London, Browse and Darby

3 Euan Uglow *Study for 'Nuria'*, pencil drawing, 26 x 35.5 cm, London, Browse and Darby

these ever appears in a Uglow picture.

In *Nuria*, the model rests her right knee on a piece of foam padding. This knee took most of her weight as her body was inclined over the couch in the direction of the viewer. She was obliged to position her thumb around the leg of the bench, which was not always easy nor entirely comfortable. Her hair is tied back; what could be a continuation of her hair under the couch is in fact shadow. The white scar-like shapes on her back are the patterns of light falling on her flesh.

On the floor are marks from two other paintings – *Propeller* of 1994–6 (**6**) and *Jana* (**5**) – which constitute a little of the history of the studio, its archaeology as it were. The marks include a shark's fin-like shape in white paint which was the outline of the shadow of the model's left elbow in the similarly sized *Propeller*. Uglow tends to draw in the major shadows in the night pictures because of the evenness and predictability of the electric light under which he works. The floor itself is covered with hard-wearing Pirelli rubber tiles of industrial strength, of the kind used at airports. Although they have a closely-patterned raised circular motif this is not usually included in their depiction.

Uglow's basic night palette, which for years has consisted of yellow ochre, blue-black and white, has recently been augmented with a red, scarlet vermilion. This first occurred in *Jana*, when he decided to allow the true colour of the tiles to appear in his composition. Uglow explains: 'The red is used only as a local colour, and is not allowed to go anywhere else in the picture'. He is adamant in restricting its use. 'I just wanted to introduce this new thing in the one area of the tiles. Even if she had red ear-rings they wouldn't go in.' Previously, when Uglow painted a night picture in the same setting, as

he did *Propeller*, no red whatsoever was admitted to the canvas.

How closely does *Nuria* relate to Monet's famous painting? The first point to make is that Uglow refuses to limit his frame of reference: 'I don't feel I'm indebted to one picture. The whole of the National Gallery works by osmosis and one is influenced by every good painting in it.' Even though Uglow actually stayed at Giverny during the course of painting *Nuria* whilst visiting an ex-student working there, he was not particularly influenced by the place. Nor is Uglow attracted by Monet's sense of

colour or structure, though he does respond to 'the mood he makes'. In fact, although Monet is not one of Uglow's favourite painters, he admires him and certain links between the two artists do emerge.

4 Euan Uglow's studio set-up, photograph, 2000

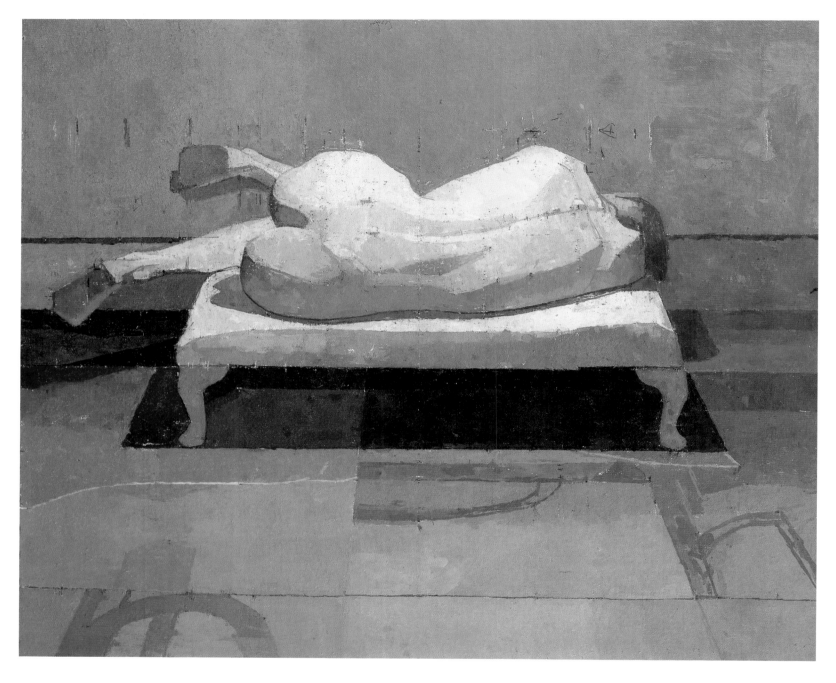

5 Euan Uglow *Jana*, 1996–7, oil on canvas laid on panel, 35.6 cm x 42.5 cm, private collection

Like Uglow, Monet was involved in re-designing appearances. His water-garden at Giverny was a self-contained universe, modelled to his own specifications. The pond, for instance, was not only enlarged but curved to give the impression of distance. Monet worked at this garden in the 1890s, building a Japanese bridge in 1893 to empha-size its eastern flavour. His pictures of the water-garden depict an enclosed scene, with no sky and no troubling foreground. The viewer is deposited in the middle of nature and deliberately immersed in nature's healing powers. The canvas is roughly square (it measures 88.3 x 93.1 cm), divided by the gently arching footbridge, which never-theless creates a strong sense of geometry within the composition. Monet's Japanese bridge paintings have a clarity of form not found in many of his more experimental pictures – one reason perhaps why Uglow

was drawn to this particular one.

The Water-Lily Pond has an all-over intensity that made a natural appeal to Uglow, while the abstract pattern-making of the image serves a purpose analogous to his own imaginative re-creations of the human body. Uglow's concerns with re-creating reality are not dissimilar to Monet's. What is particularly interesting is the way Uglow adapts the structure of a Monet landscape to his own picture of the figure. Uglow has himself painted a number of lucid and distinguished landscapes over the years, but there was no question of that here. The single figure is still his first preference.

Uglow has marked out the extreme limits of this painting – the rectangle is drawn in and visible, not occluded by the frame. (Uglow makes his own frames for his paintings, in the same ratio as their dimensions.) In recent years, he has made the edges of his rectangles more visible: 'I want people to know where the picture stops,' he says. Again, the stress is on the proper shape and its deliberately chosen proportions. There is the same powerful combination of visual order and sensuality that we find in ancient Greek or Egyptian statuary, or indeed in the paintings of Piero della Francesca. We are here reminded of the solidity and stillness of Piero's images, their monumentality and detachment, their serenity.

Uglow paints nearly always the single figure, except when the idea for a composition comes from the imagination. The most important painting to cite here is *Musicians* of 1953 (**7**), in the National Museum of Wales. Although it is completely invented, Uglow went to the extreme of making detailed working drawings for this Arcadian scene. ('It must be one of the few modern pictures painted purely in terms of perspective,' he comments.) He can tell you for instance how high the mountain (actually the Matterhorn) is in the background, or how wide the trees.

6 Euan Uglow *Propeller*, 1994–6, oil on canvas, 35.6 x 53.3 cm, private collection

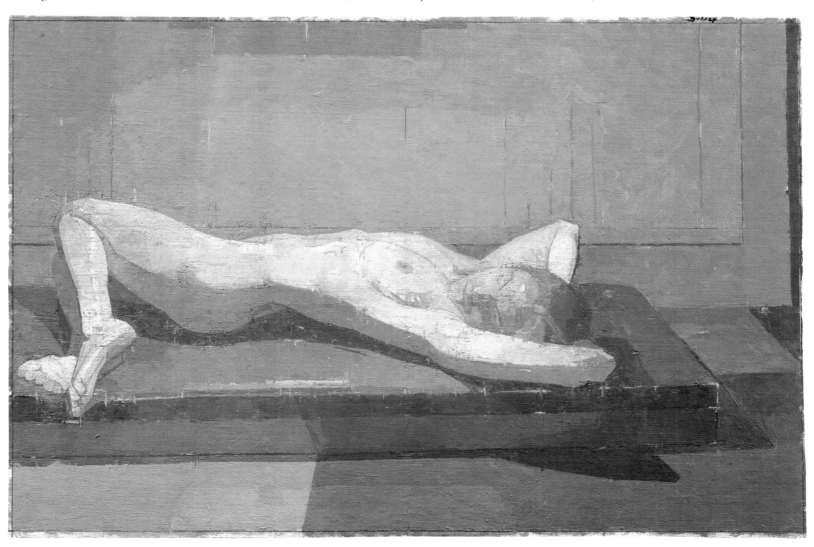

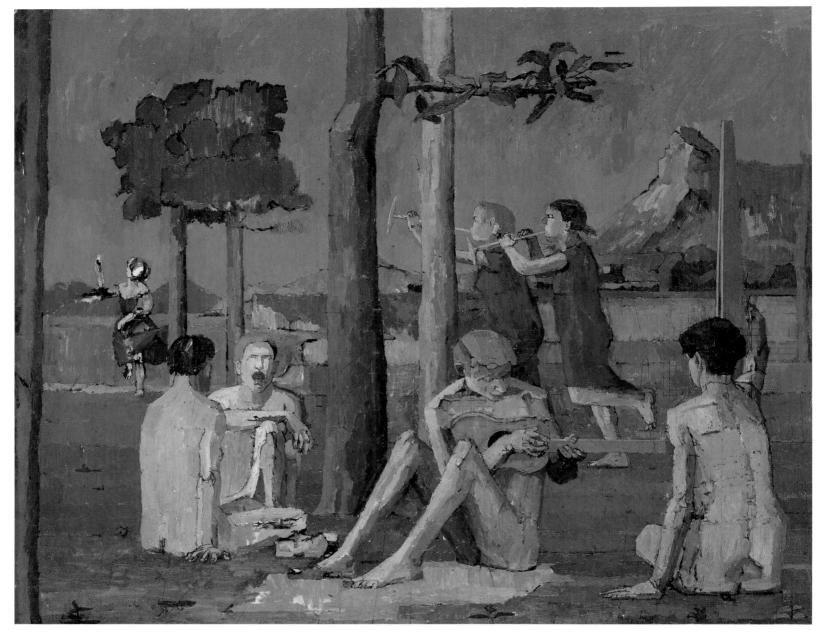

7 Euan Uglow *Musicians*, 1953, oil on canvas, 101.6 x 127 cm, Cardiff, National Museums and Galleries of Wales

There are also a number of paintings done from remembered or invented incidents, rather than from posed models. Amongst them is *Narcissus* (1986), which involves the depiction of a man – extremely rare in Uglow's work – leaning clothed on a mantelpiece and admiring his faceless self in a mirror, a naked girl meanwhile abandoned on the foreground bed. *Narcissus* is unusually autobiographical if the central figure is taken to represent the artist – looking at life but taking no part in it.

Although his practice involves total scrutiny of the subject, Uglow is an image-maker, not a recording instrument. Picture-making for him is founded upon ideas, and each painting is a problem to solve. Its solution involves the pursuit of pictorial harmony by way of a particularised order of paint across the canvas. Uglow is capable of arranging his nudes into the most apparently uncomfortable or even unlikely positions in order to distance the viewer, to remind them of the artificiality of what they are looking at. There is an element of ritual in this staging of the pose, as well as imagination. Reality is re-made. But the end result must be beautiful.

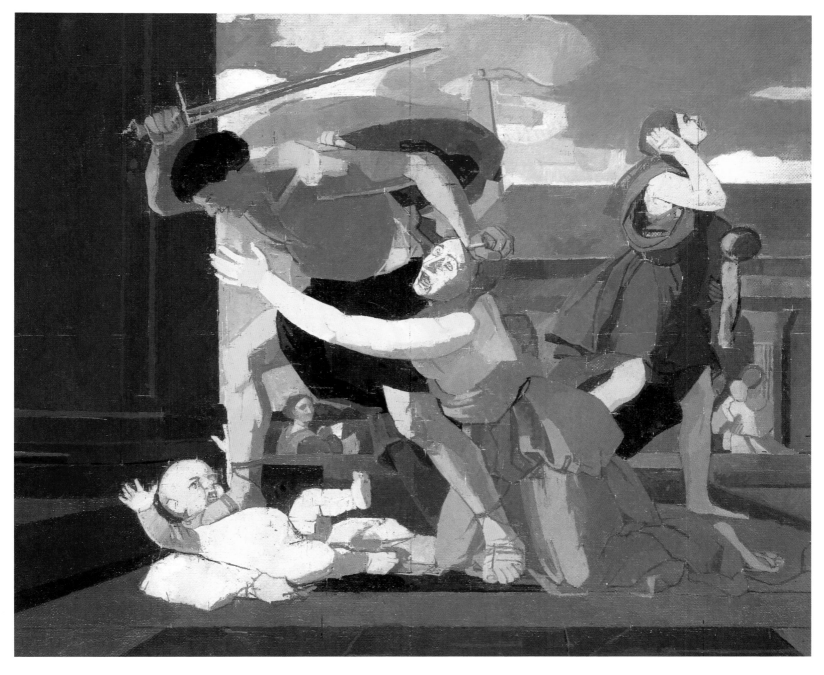

The relationship between *Nuria* and the Monet is oblique, but on previous occasions Uglow has been more engaged with the literal imagery of Old Master paintings. For instance, he has visited Chantilly in order to make measurements and drawings of Poussin's painting, *The Massacre of the Innocents*, there. He was allowed to measure behind the frame, for, as he points out, every book gives a different size and proportion, and, when he first began his transcription (**8**), he used a faulty reference and got the proportions wrong. His finished painting is a smaller version of the original, but made on the same ratio. Uglow has made same-size copies in the past – as a student he began, but never completed, a full-size copy of Titian's *Bacchus and Ariadne*. He also copied in front of another National Gallery picture, Poussin's *Cephalus and Aurora*, and Poussin's *Rinaldo*

how arms connect things across space. (In this respect, it resembles *Nuria*.) 'It's also about how marvellously Veronese draws. There's a whole lot of marvellous form in the back but I haven't tried to say anything about that.'

Uglow is drawn to this painting rather than to Veronese in general. In the same way, he says, 'I don't really like Leonardo but there are four pictures I think are marvellous – *Ginevra de' Benci, A Lady with an Ermine, The Last Supper* and *St Jerome*. Some of the drawings are marvellously explicit, so clear – like a good carpenter telling you how something works.' Uglow is not afraid to acknowledge the devotional aspect of looking at great art. He visited the London Tate Gallery's 1996 Cézanne exhibition for its duration every Sunday morning for an hour, 'like going to church'. He did not, however, make any drawings there, and indeed has never copied a Cézanne – 'I don't think that there's much to gain'.

Slices of Pumpkin (after Ambrogio Lorenzetti) (**10**) is so titled because when painting it Uglow was reminded of the little boats in Lorenzetti's exquisite small paintings *Castle on the Shore of the Lake* and *Town by the Sea*, both of which are in the municipal gallery in Siena. Much as he made the private visual analogy between a scooped-out half-lemon and the dome of the Volterra Baptistry in *Lemon* (1973), so he now makes a more public statement with a different fruit.

The question of Uglow's dependence on the art of the past is double-edged. Since his student days, Uglow has been visiting the National Gallery out of love, and regularly making pilgrimages to see individual paintings, such as the Domenico Veneziano in Bucharest. At the same time, he wants to see afresh, and make an image with a new resonance. 'At one time Pissarro said the whole of the Louvre should be destroyed. What he wanted us to have was pure innocent eyes. If you've got all that stuff there, you're bound to be influenced by it.'

Some commentators have thought it

9 Euan Uglow *The Way I See the Veronese*, oil on canvas, 45.7 x 45.7 cm, private collection

and Armida in Dulwich. And he has made many drawings after paintings in museums in London.

The point of making such a transcription from the Old Masters is simply 'to try and learn. It's a kind of osmosis – you do find out things: how Poussin organized and designed a picture.' Uglow sees it as a research programme. Even where he does not make as detailed a transcription as he did of the Chantilly Poussin, he continues to enjoy a strong relationship with past art: 'I wouldn't think of going to Florence without calling in to see

The Trinity by Masaccio at Santa Maria Novella. It would be like going past a friend's house a long way away, seeing the light on and not going in.'

Uglow recently painted an extraordinary statement of pictorial movement, *The Way I see the Veronese* (**9**). 'It's my thoughts about how Veronese meant me to read his painting *Allegory of Love I ('Unfaithfulness')* in the National Gallery. I knew I'd have a lot of trouble with it so I did it in oil paint so I could get rid of lines. But if you look carefully you can see there was a head on it once.' Visible also are the necks and shirts of two men on the central axis, but it was the movement through the picture that fascinated Uglow,

10 Euan Uglow *Slices of Pumpkin (after Ambrogio Lorenzetti)*, 1993, oil on canvas, 30.5 x 40.6 cm, collection of Mr and Mrs David Bowie

useful to categorize Uglow as a pupil of William Coldstream and an adherent of the Euston Road School. But Uglow has brought poetry to the hitherto rather prosaic recording of appearances familiar from the Euston Road method by introducing imagination and colour into his work. The early influences on his development include Coldstream as they do Giacometti, Piero della Francesca, Poussin, Chardin and Ingres. But, although singularly attentive to the art of the past, Uglow has followed the promptings of his own artistic instincts. The artist we see today is no mere acolyte but a self-created individual of considerable originality striving after pictorial truth, and sustained by a passion for the sheer beauty of the visible world.

Andrew Lambirth

Notes

1 All quotations are taken from interviews between the artist and the present writer, most of recent origin, others dating back over the past twelve years.

BOSCH

Christ Mocked (The Crowning with Thorns) about 1490–1500

NG 4744 Oil on oak panel, 73.5 x 59.1 cm

ACCORDING TO A passionately held belief of the Middle Ages, at a moment of great suffering Jesus Christ left humankind a true representation of his likeness. As she saw him pass by on the road to Calvary, St Veronica pressed a cloth to Christ's face gently to wipe away the sweat. When she withdrew the cloth, Veronica saw that his features had miraculously imprinted on the cloth to produce a 'portrait' of the Saviour, created not by human art but by

divine will. This 'true likeness' was kept as a precious relic at St Peter's in Rome, where pilgrims flocked to see it. From the thirteenth century images of it circulated widely throughout the Christian world. Thus Christians came to share a consensus that they knew what Christ looked like, with a thin face, long nose and flowing hair. Artists across Europe, and later around the world, referred to this shared image when they created their own images of Christ, firm in the conviction that they were referring back to a divinely sanctioned representation. Its absolute authenticity and accuracy superseded, but at the same time sustained, the facile artistry of which they themselves were capable.

Jerome (or Hieronymus) Bosch (1474–1516), too, drew on this tradition when he placed Christ at the centre of this small panel. The sacred features are recognisable from ten thousand other images, but the dark, questioning eyes Christ turns to the viewer are instantly arresting. The image shows him at a moment of the Passion before he met Veronica, when his tormentors, four of whom crowd around, prepared to crown him with thorns and to mock him as the King of the Jews. The gentle, indeed refined, face and features of Christ contrast with the caricatural figures who menacingly flank him. One of them, at lower right, threatens to rip away his cloak, while another, at upper left, prepares to force the crown of thorns on to his head. The man at lower left, as the crescent moon embroidered on his headgear establishes, is an infidel, while the studded dog-collar worn by the figure at upper right suggests that he is a brutal thug capable of perpetrating any indignity. Into such hands has the Son of God fallen, Bosch shows, because – and here the import of Christ's penetrating gaze is clear – of the indifference of those for whom he died, and to whom he had left his own image as a precious gift. Paintings such as this, which Bosch produced early in his career, demanded more than the viewer's contemplation; they called on the Christian to alter and improve his or her very life.

Christopher Riopelle

© Beth Herzhaft

B ILL VIOLA began working with video a year after entering the art school of Syracuse University in 1969. In 1971 he transferred to the department of Experimental Studios, where he made his first videotapes and came into contact with Nam June Paik and other pioneers of video art – a medium then still in its infancy. After serving as technical director at a video art studio in Florence (1974-6), he travelled extensively through the South Pacific and Far East, where he pursued his interest in the religions and philosophies that have substantially shaped his vision and the themes of his work.

Acutely conscious of the need to establish a standard of technical excellence for his medium, Viola has worked since the 1970s both on videotapes and on video/sound installations that bring a more physical presence to the images projected or shown on monitors. The relation between space and time as sculptural elements often intensify the viewer's experience as a participant in the work. Viola's long-standing dialogue with painting became more focused during the 1990s through references to art history, narrative, the human figure and portraiture. He lives and works in Long Beach, California.

BILL VIOLA

The Quintet of the Astonished 2000

BILL **VIOLA**

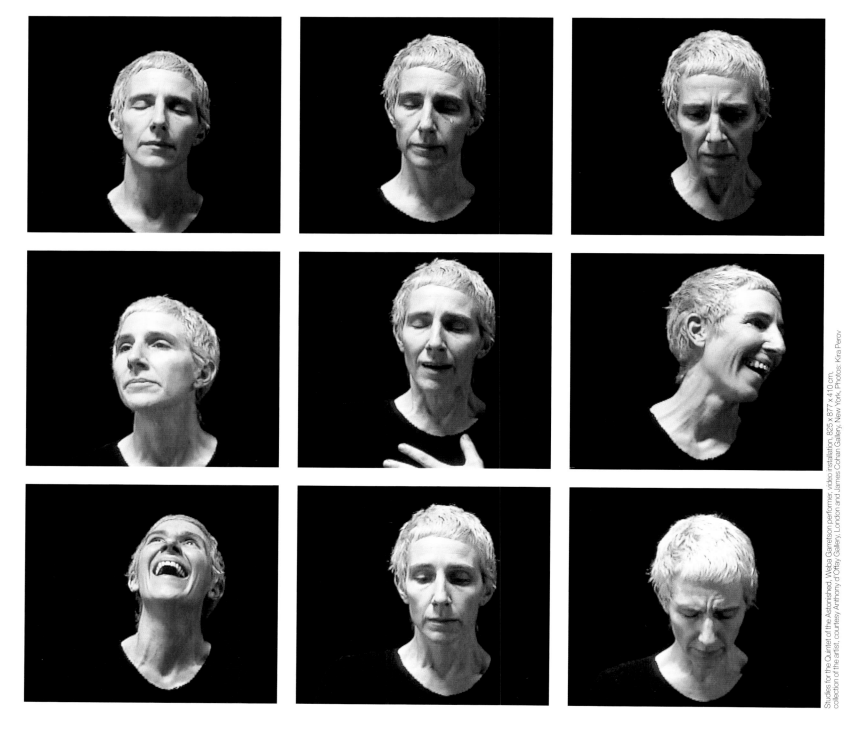

Studies for the Quintet of the Astonished, Weba Garretson performer, video installation, 825 x 877 x 410 cm, collection of the artist, courtesy Anthony d'Offay Gallery, London and James Cohan Gallery, New York, Photos: Kira Perov

I SEE AN IMAGE on the wall in a horizontal aspect ratio [landscape format]. There are five people very specifically placed relative to each other. They are at different heights, seen from the chest up. So we are already close to them and part of their world. And they are interacting in a very general kind of way, and in a peculiar way, because in fact your first impression is that maybe they are not directly acknowledging each other as often or as intimately as you would presume people standing that close together would. Something seems a little odd. They are also being shown to you in extreme slow motion, so the time has been extended, in the same way that the space they occupy has been somehow altered and obscured. The time extension allows most of the interaction that would normally be subconscious to be visible. You see unconscious gestures and little movements and nuances that normally are happening so fast in a conversation or engagement that you don't notice them.

'As you come in, right away you notice that these people have distinct emotional expressions. One person might be obviously visibly angry, another person very sad, another very distraught, another extremely calm and peaceful. So it causes you to have a set of assumptions about their relationships with each other. Then you get involved in the visual aspect of the image. What people are wearing is very important, the colours and the way the whole thing is composed looks very much like a painting, feels like a painting, and it is striking in some ways. So you get caught up in the image for a while and then you realise at a certain point that the guy who was very angry now is happy, and you couldn't really tell when he changed. And you're beginning to see that in fact all of these emotional expressions of these people are shifting, and they were in the process of shifting before you entered the space and after you leave they are going to continue to shift. And you never really get anywhere. There's never a conclusion, there's never an end result. It's a continuing shifting pattern of

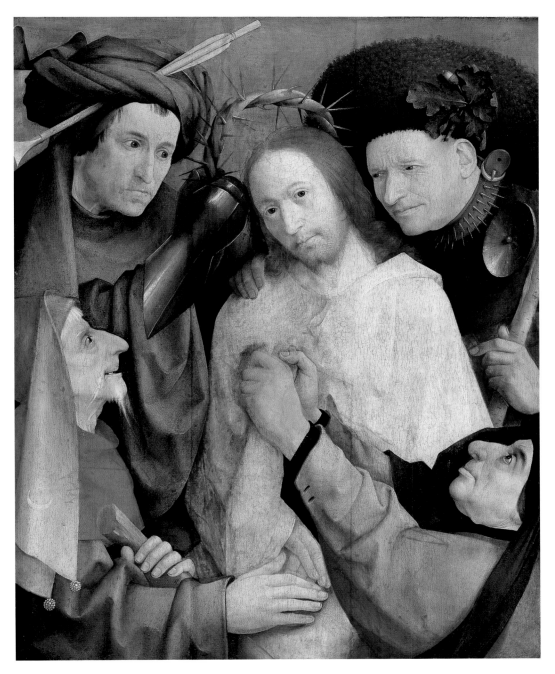

emotions that flicker across the field of faces in extended time, causing you to continually change your reading and assumptions of their relationship to each other.'[1]

This vivid visual description of Bill Viola's video installation for *Encounters* – the only work in the exhibition that uses a moving image and one of only two that is

Hieronymus Bosch *Christ Mocked (The Crowning with Thorns),* c.1490–1500

photographically based – is the artist's own, as he imagined it several months before he had filmed the work itself. This essay, which will go to press before the work is in production, is necessarily speculative even though it is

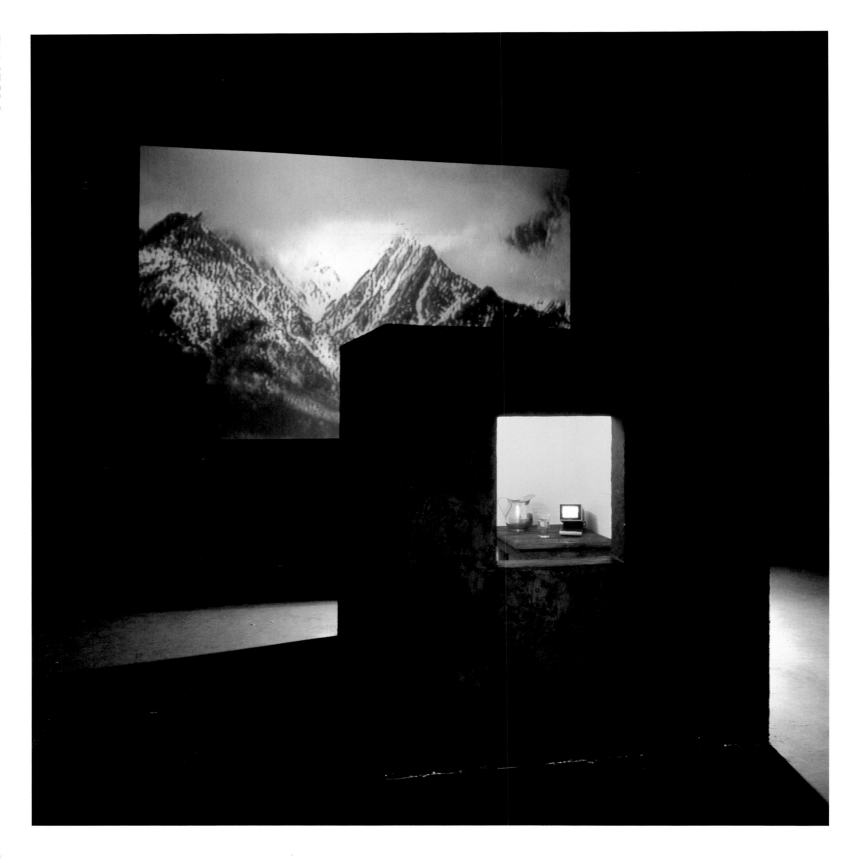

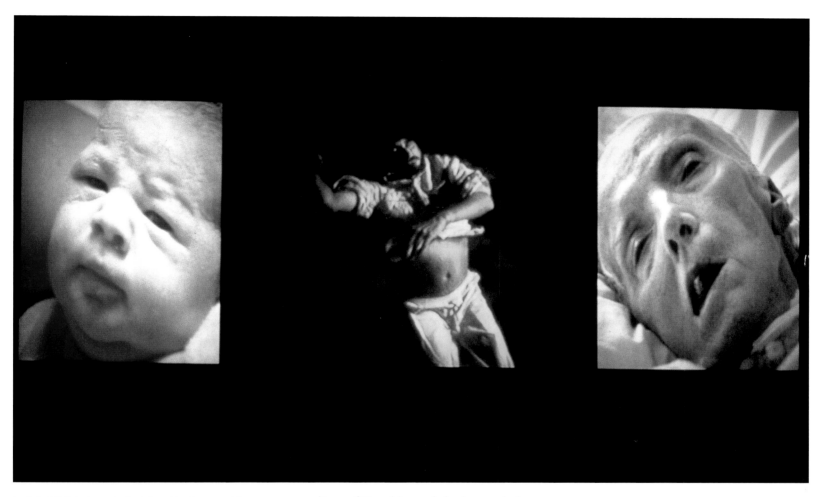

(Left) **1** Bill Viola *Room for St John of the Cross*, 1983, video/sound installation, 4.3 x 7.3 x 9.1 m, Los Angeles, The Museum of Contemporary Art. The El Paso Natural Gas Company Fund for California Art

2 Bill Viola *Nantes Triptych*, 1992, video/sound installation, 4.3 x 9.7 x 16.8 m, edition 2/2, Tate, London

based closely on the artist's intentions. As Viola is in the habit of changing the form of a work, sometimes quite drastically, in response to the process and the circumstances under which he is filming, the final video may look quite different from the way it is en-visioned here.

It is fair to ask why Viola should select as his starting point a religious painting with such a powerful theme of suffering, and why this particular one by Bosch: it was not always securely attributed to him, and it does not in fact conform to the popular conception of his art as fantastic and grotesque. The proto-surrealism of Bosch's work had appealed to him when he was young, and he had even quoted a Bosch-like detail from Pieter Bruegel the Elder in an earlier video.[2] But given that this painting hardly typifies the production of his fertile imagination, it would seem to be the actual painting, rather than its authorship, that attracted him. Since a large proportion of the paintings in the National Gallery Collection are of Christian subjects, one should be careful about drawing conclusions from Viola's choice of Bosch's *Christ Mocked*. Nevertheless, different reli-gions – Buddhism and other Eastern religions more often than Christianity, it has to be said – have been a constant touchstone in his art. Christianity has entered his art more overtly in recent years. This is most obviously the case in *Room for St John of the Cross* of 1983 (**1**); in the tripartite format reminiscent of altar-pieces of *The City of Man* of 1989 and *Nantes Triptych* of 1992 (**2**); and in *The Greeting* of 1995, with its undisguised echoes of the subject of *The Visitation*. These highly personal reinterpretations of Christian art and iconography must have helped prepare him for the new piece.[3] The essence of the new video, however, resides for him not in the specificity of the religious subject-matter, or even in one figure being tormented by others, but in the expression of emotions. As such, the Bosch painting acts as 'a visual template, not a content or subject issue'.

Late in 1999 Viola asked Philip Esposito, an actor who had appeared in several of his

works,[4] to make video studies of male and female actors expressing intense emotion. Viola was not looking for a one-to-one correspondence, in terms of physical resemblance, between the figures in the Bosch painting and the people he would be filming. Much more important was their ability to convey strong emotion through constantly changing facial expressions, and to do so very precisely on cue. The video footage, stills from which are reproduced here, struck him as

'primitive, grainy and expressionistic' and made him aware just how difficult this task would be, especially as his intention is for the five actors to be brought together only after they have prepared their roles in isolation. He cites the collaborative works of choreographer Merce Cunningham and composer John Cage, in which the dancing and the music were composed independently but presented simultaneously in the same space, to explain what he has in mind. He hopes that the impression of emotional interaction among people locked into their own worlds will give the work a 'strange, uncanny' atmosphere.

In an interview with National Gallery director Neil MacGregor in August 1999, Viola described Christ in the Bosch painting as the calm at the centre of a storm, a source of inspiration for the individual who can stand securely in whatever turbulent situation he may find himself.[5] He seems to have been attracted to the painting at least in part because of the way it expresses this state of being, having himself often proposed self-containment, even to the extreme of withdrawal from the outside world, as a prerequisite for self-knowledge. His sketchbook notes for *Room for St John of the Cross* also speak of a 'calm stability at the center of

3 Bill Viola *The Stopping Mind*, 1991, video/sound installation, 4.7 x 10 x 10 m, Frankfurt, Museum für Moderne Kunst

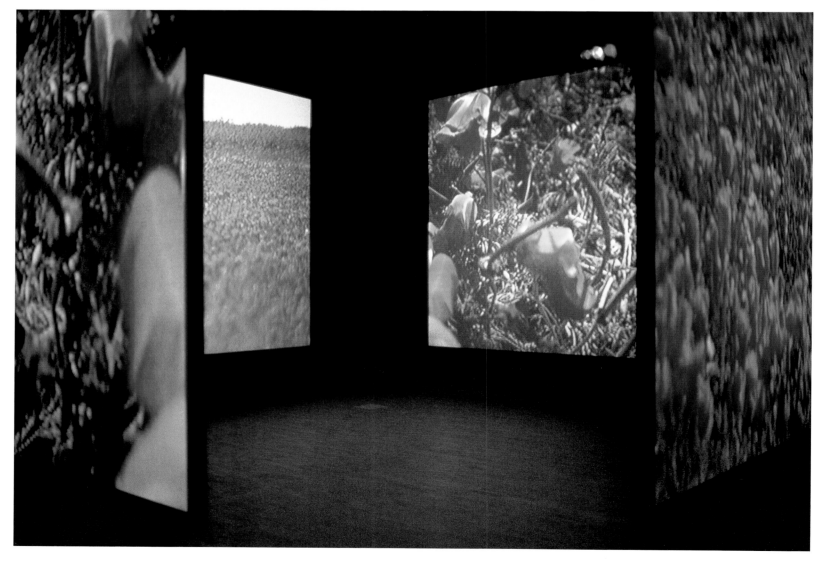

the storm', and of 'Inside, calm, serene, still' in relation to 'Outside, chaotic, turbulent.'[6] Viola explored a similar dichotomy, always with the suggestion of the centre being occupied by a human consciousness in a state of peace or grace, self-possessed, in *The Stopping Mind* of 1991 (**3**) and *Slowly Turning Narrative* of 1992 (**4**),[7] video installations which literally take the form of movement revolving around a still centre. In *The Stopping Mind* the protagonist is heard whispering but is not seen, and it is the viewer who (literally and physically) takes his place, standing still within a maelstrom of violent movement. Viola suggests that this is 'a very familiar experience for me in life', linked to his shyness as a child and to his tendency to retreat into his own world when drawing, relying on what was 'inside' him for sustenance. 'I did have the feeling that even if it was all happening out of

4 Bill Viola *Slowly Turning Narrative*, 1992, video/sound installation, 4.3 x 6.1 x 12.5 m, edition 1/2, Madrid, Museo Nacional Centro de Arte Reina Sofia

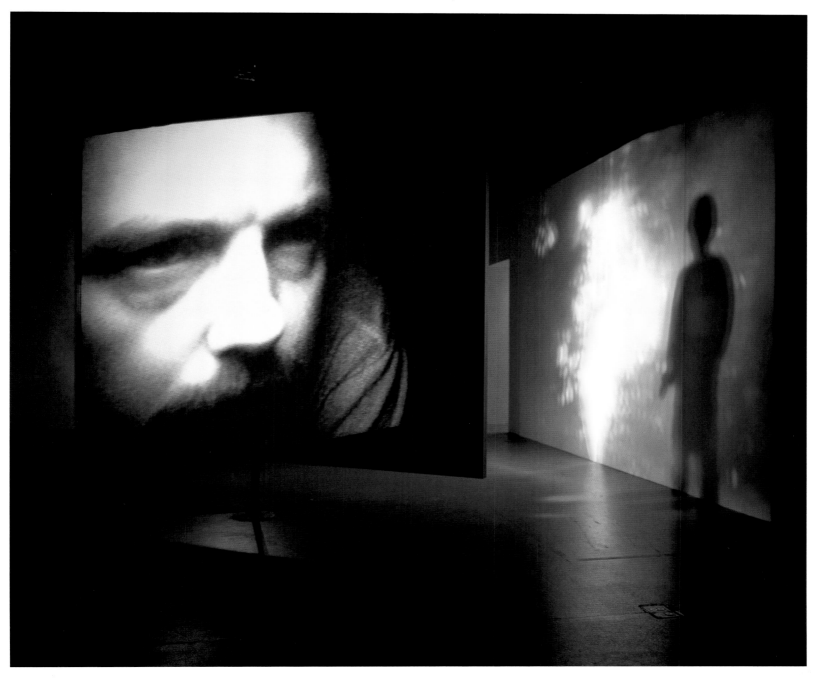

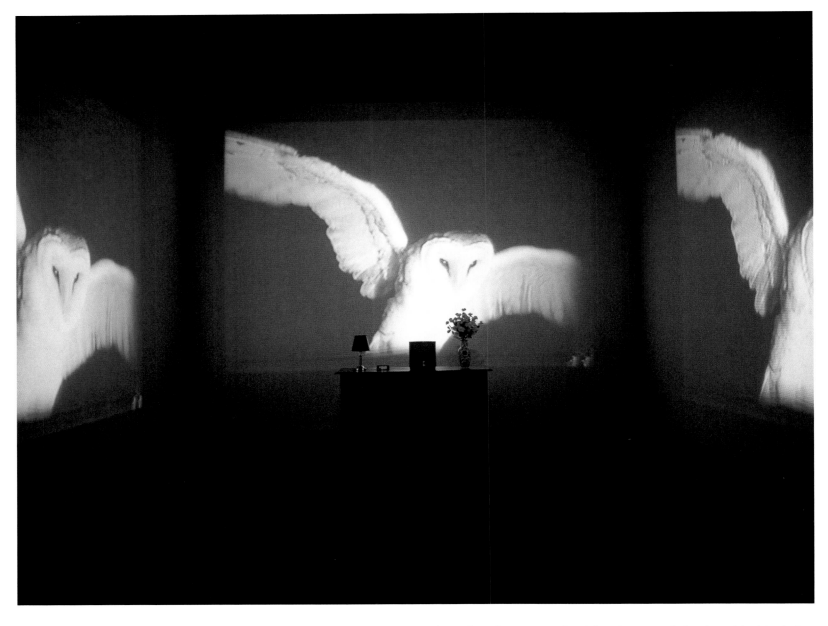

5 Bill Viola *The Sleep of Reason*, 1988, video/sound installation, 4.3 x 8.2 x 9.4 m, Pittsburgh, The Carnegie Museum of Art. Museum Purchase: Gift of Milton Fine and the A.W. Melton Acquisition Endowment Fund

my control around me, I could be very focused internally [and] then it would be okay.'

The Quintet of the Astonished – the title of which is derived from Persian poetry[8] – is not the first work by Viola to make such direct use of earlier art as a guide for the subject matter, composition and formal qualities. In *The Sleep of Reason* of 1988 (**5**) Viola made reference to Goya's 1797 etching from *Los Caprichos*, *The Sleep of Reason produces Monsters* (**6**), making the relationship explicit even in his choice of title. Although he had previously made reference to William Blake,[9] it is reasonable to regard that work as the first in which he openly reinterpreted an Old Master source. *The Greeting* of 1995 (**7**), however, provides an even closer precedent for *The Quintet of the Astonished* in being inspired by an Old Master painting, in this case by Pontormo's *Visitation* of c.1528–9 (**8**). This was prompted by a chance confrontation with a reproduction of the painting.[10] In *The Greeting* he was careful not to produce a kind of period costume drama, but to clothe the figures in such a way that they would be understood as of our time but also somehow timeless. This, too, is how he has initially conceived *The Quintet of the Astonished*.

6 Francisco de Goya y Lucientes *The Sleep of Reason produces Monsters*, 1797, etching, plate size 21.8 x 15.2 cm, London, Victoria and Albert Museum

The human figure entered strongly into Viola's art, much of which had previously been landscape-based, in 1992, in works such as *The Arc of Ascent*, which he describes as setting a path through the 1990s. In *Nantes Triptych* of the same year, in which he records the birth of a son in one 'wing' and the death of his mother in the other, the human figure is shown larger than life undergoing an extreme experience, a rite of passage. He had not, however, made a direct connection in his mind between these auto-biographical family pieces and his renewed interest in depicting people undergoing great emotion. As precedents for this aspect of *The Quintet of the Astonished* he cites instead several very early videotapes: *Tape I* of 1972 (**9**), *The Space between the Teeth* of 1976 (**10**), and *Silent Life* of 1979 (**11**): 'They all have to do with portraiture and the sub-surface, and emotional expression in some way'. He adds that a more recent video installation involving self-portraiture, *Nine Attempts to Achieve Immortality* of 1996 (**12**), may also be relevant.

Bosch painted several variants of *Christ Mocked*, and to see them together gives one almost the impression of static fragments of a narrative, like stills from a notional film. While aware of these paintings, however, Viola has decided not to make reference to them in planning his piece. As treated by Bosch, the theme is played out against a neutral background rather than contextu-alised by the setting, and the figures are pushed up to the front of the picture plane. Viola compares the setting in the Bosch to the 'studio backdrops' of photographers and film-makers. The space is claustrophobic, with the figures cropped around the four edges and pushed far forward with very little air behind them. A large part of the painting's emotional impact comes from that compression of space and from the

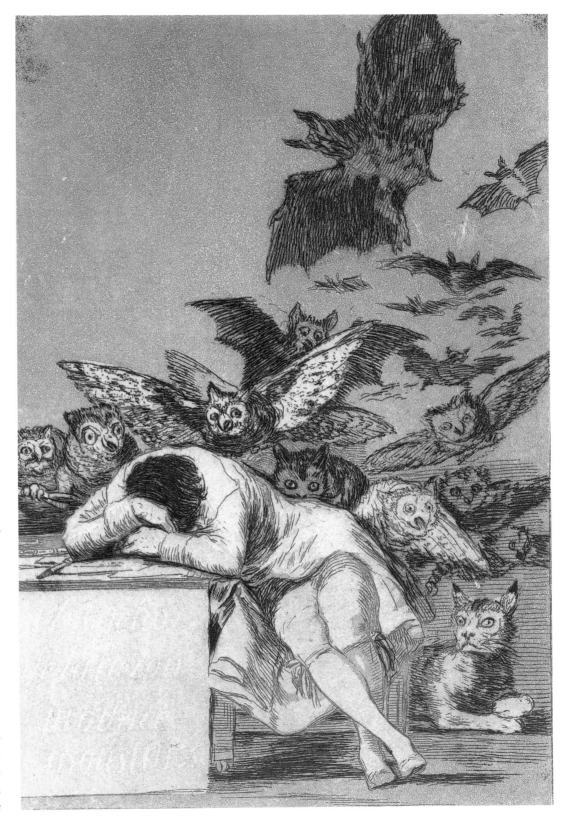

feeling of the four figures closing in on the central figure. By such means he achieves a confrontational relationship between Christ and his tormentors, on the one hand, and between Christ and the viewer on the other. Christ's plaintive glance intensifies the viewer's relationship with him. These are all aspects Viola is likely to highlight in his video work, although he does not intend to identify them so specifically as Christ and his torturers and may not even emphasise the centrality of one in relation to the other four.

The liberties Viola intends to take with the Bosch reveal the extent to which the painting is only a spur to the making of his work, rather than a source to be faithfully imitated. He cautions against making too literal a connection between the video and the painting. In fact, a Getty Museum painting of a totally different subject by an Italian artist, Andrea Mantegna's *Adoration of the Magi* of c.1495–1505 (**13**), may prove as important in the shaping of his vision. He has already decided that he will use the Mantegna's horizontal format, and perhaps something of its frieze-like disposition of figures, in preference to the vertical format of the Bosch.

Viola became interested in Mantegna's painting in 1998, while he was one of fifteen Scholars in Residence from very different backgrounds at the Getty Research Institute in Los Angeles, not far from his home in Long Beach, California. The period they spent there was focused on the topic 'Representing the Passions', and every week one of the scholars presented a seminar on an aspect of the passions and the representation of extreme human emotion. The theme interested him greatly as a challenge to 'represent the unrepresentable'. He was particularly taken with the theories of the

8 Jacopo da Pontormo *The Visitation*, c. 1528–9, oil on canvas, 202 x 156 cm, San Michele, Carmignano

seventeenth-century French painter Charles Le Brun on physiognomy, investigating how character can be conveyed through facial expression: the surface of the face as a window to the soul.

After he was approached to participate in *Encounters*, Viola realised that one of the many postcards he had collected and hung on his studio wall when exploring the passions was of a painting in the National Gallery collection, the Bosch *Christ Mocked*. He had been looking especially closely at Flemish fifteenth-century painting and had begun collecting photographs of works that touched him, including a *Mater Dolorosa* (**14**) by Dieric Bouts, which he had seen in the Art Institute of Chicago; an *Annunciation* of c.1450–55 by the same artist, his favourite work in the Getty Museum; and a *Head of St John the Baptist* by Dieric Bouts's son, Albrecht Bouts. All of these are likely to come into play in a series he is planning on the Passion, of which *The Quintet of the Astonished* will be the first. Viola refers to the Bouts *Mater Dolorosa* as 'the whole instigator of the project'.

Viola has not had the opportunity to study the Bosch painting, having seen it before and feeling 'That's an aura I don't need to contact right now.' He has instead worked from reproductions, just as Old Master painters often worked from engravings after other paintings. 'I think it is wonderful how paintings migrate off of their physical base and into other forms. I don't have any problems about having seen a picture in a book, and not having seen the real thing. Images have now been freed from their physical forms and are circulating as presences in our lives. And they come up on T-shirts and posters and in books, and these images maintain their power to inspire.'

Viola says there are good reasons why the paintings he has been looking at are almost all

from the fifteenth and sixteenth centuries. He believes that the huge changes in image-making occurring today, for example with computers and digital imaging, are comparable to those that took place then with the advent of printing from movable type and the

invention of perspective as means of representing space on a two-dimensional surface. It was also a time of great religious and political upheaval, with the challenge to Catholicism posed by the Reformation.

Since it will be projected rather than

9 Bill Viola, *Tape I*, 1972, videotape, 5:50 minutes

the filming itself. As in architecture, he points out, the ultimate determinant of scale is the human body itself. Another parameter unlikely to change concerns the duration of the piece. As he is planning to use a fixed camera and extreme slow motion, he is limited by the maximum length of film available on a single spool and by the fastest shooting and slowest projection speeds. At 300 frames a second, the actual shooting of 1000 feet of film will take 45 seconds. Slowed down to 30 frames a second, it would take seven and a half minutes to project, assuming that it is used in full, but it can be decelerated further electronically after being transferred to digital video. Since he will not allow any editorial cuts to interrupt the flow, it is only at the beginning or at the end of the film that any cuts can be made.

The 'conventional' aspect of this new work, closer to cinema than has previously been the case, seems rather daunting to Viola. The challenge is how to transcend these limitations, particularly as the problems will all have to be solved in the production itself – with the five actors and camera 'ramped up' in unison – since there will be no editing afterwards. At the time of writing, a number of very basic questions are

still under consideration. He is uncertain whether all five figures will remain in view the whole time, although this is likely to be the case. His instinct is to present them 'in a self-contained world', within the frame, as in the paintings of Giotto, as a means of intensifying their interaction. There is a question about whether they will all be men, as in the Bosch; he is tempted to use one of the actresses who featured in the video studies, although he hesitates to do so because of the different dynamics this would create. He is not sure, even, if the work will have a clear beginning and ending, as in the case of *The Greeting*, which was presented as a short

10 Bill Viola *The Space between the Teeth*, 1976, videotape, 10:50 minutes

narrative in a finite slice of time, or if it will be shown as a continuous loop. The latter solution is likely to prove difficult, as it would require a precise synchronisation of the five actors returning to the point of departure after expressing a gamut of emotions over a period of just 45 seconds. Such technical problems play a very important role in determining the nature and content of the work.

Painterly qualities have long been consciously exploited by Viola in the way he composes and frames his work and in his

shown on a monitor, the image can be partly masked and its shape changed, so that the artist is not limited to the standard formats. Viola plans to film on 35mm stock for its specific image quality and to transfer this on to Digital Versatile Disc (DVD), which he will project on to a vinyl front projection screen stretched on an aluminium frame. The size of the projected image is critical to the way that the viewer will relate to the figures, and to the intimacy of the experience, so it is a decision that has to be made in tandem with

11 Bill Viola *Silent Life*, 1979, videotape, 13:14 minutes

careful use of light and colour. Given the disembodied quality of the projected image, there are limits to how closely he can approximate the physical textures of paintings. A painting becomes visible through light, which it partly absorbs and partly reflects, while a video image itself consists of patterns of light projected on to a surface and made visible only when it strikes that surface. Of course there is a trade-off: with the filmed image one introduces elements of move-

ment, time and narrative action that in a painting can be expressed only by implication as possibilities held in suspension. As Viola points out, the moving image is only a century old, which is nothing compared to the long history of the still image, so the open challenge it presents remains immense. Yet his tendency to reduce the speed, sometimes to extreme slow motion, curiously plays against these properties and endows his images with the more static quality of paintings. One may

take this as another indication of his temperamental affinity with painting.

In the early days of photography, it was common for those using the camera to mimic aspects of painting, partly in homage and to a degree as a way of securing approval for the aesthetic potential of their medium. With works such as *The Greeting* or *The Quintet of*

12 Bill Viola, *Nine Attempts to Achieve Immortality*, 1996, video/sound installation, courtesy Anthony d'Offay Gallery, London

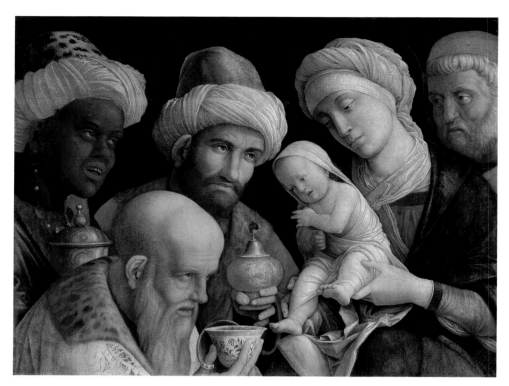

13 Andrea Mantegna *The Adoration of the Magi*,
c.1495–1505, distemper on linen, 48.5 x 65.6 cm,
Los Angeles, J. Paul Getty Museum

14 Dieric Bouts *Mater Dolorosa*, c. 1460, oil on oak panel, 38.8 x
30.4 cm, Art Institute of Chicago, Chester D. Tripp Endowment
Restricted Gift Fund, and through prior acquisition of Max and
Leola Epstein

the Astonished, both based explicitly on models in painting, Viola is operating in a similar way, that is to say, reinterpreting the aesthetic criteria of a more traditional medium and in so doing extending the possibilities of both the old and the new forms.

'When I took the Pontormo to do *The Greeting*, I shocked myself because I had never done that before so directly. I acknowledge that I'm influenced. I don't believe in originality in art. I think we exist on this earth to inspire each other, through our actions, through our deeds and through who we are. We're always borrowing. I think it's a beautiful, wonderful thing.'

Marco Livingstone

Notes

1 All quotations from the artist, unless otherwise noted, are from an interview with the author on 27 January 2000.

2 *I do not know What it Is I am Like* of 1986. For stills of this and all other works cited by Viola, see *Bill Viola*, the catalogue of his Whitney Museum survey exhibition, New York 1997. Every work is accompanied by a short text by the artist. In an e-mail to the author dated 15 February 2000, Viola explains that the most direct reference he had earlier made to the imagery of Bosch or Bruegel was 'in the night "scholar" section' of this work, 'where Bruegel's golden conch-shell treasure boat literally appears, a gift to the Christchild from one of the three wise men from the painting *The Adoration of the Kings*' in the National Gallery Collection.

3 In referring to Saint John of the Cross, there was no real history of representations to inspire him, to reinterpret or to react against. This meant that he was forced back more on his own devices but was also freer to invent. In representing the torment of Christ, by contrast, he has the weight of centuries of artistic interpretation bearing upon him.

4 Esposito, whose physical resemblance to Viola made him particularly useful as a stand-in, features in *Déserts* of 1994, *Interval* of 1995 and *The Crossing* of 1996.

5 Unpublished transcript of an interview for the BBC series *Seeing Salvation: Images of Christ in Art*, screened on BBC2 from 2 April 2000.

6 Quoted in Rolf Lauter, editor, *Bill Viola: European Insights*, Munich 1999, p. 260.

7 See Bill Viola, *Reasons for Knocking at an Empty House: Writings 1973–1994*, London 1997, p. 226, in which he says that *Slowly Turning Narrative* 'concerns the enclosing nature of self-image and the external circulation of potentially infinite (and therefore unattainable) states of being all revolving around the still point of the external self'.

8 As part of his research into narrative imagery he had looked at fifteenth- and sixteenth-century Islamic miniature painting illustrating epic poems. In an e-mail to the author dated 9 February 2000, Viola wrote: '*The Quintet of the Astonished* is the English translation of the *Khamsat al-mutahayyirin* by Mir Ali-Sher, the sultan's confidant and literary figure in 15th-century Herat, capital of the Timurid dynasty. It is a biography and tribute to his friend Jami, one of the greatest Sufi mystical poets of all time, and author of the epic poem masterpiece *Hawft Awrang*, or *The Seven Thrones*.'

9 *Ancient of Days* of 1979–81 referred to Blake's etching *The Ancient of Days* and *Songs of Innocence* of 1976 was inspired by the poem 'The Nurse's Song' from *Songs of Innocence*.

10 It appears on the cover of the large monograph published in New York by Abrams in 1994, *Pontormo: Paintings and Frescoes*, edited and with an introduction by Salvatore S. Nigro. Viola says that this reproduction was the first one he had ever hung up prominently on his studio wall, where he does his drawing, rather than just as part of his postcard wall. He had it there for about six months before he had an idea about how to use it.

STUBBS
Whistlejacket 1627–30

NG 6569 Oil on canvas, 292 x 246.4 cm

LARGELY SELF-TAUGHT, George Stubbs (1724–1806) established his artistic and scientific reputation with a suite of equine anatomical engravings. *The Anatomy of the Horse*, long in preparation and finally published in 1766, was based on the dissection and minute observation of horse carcasses and set new standards for the exact description of bone structure and musculature in the animal. Stubbs's anatomical investigations quickly attracted the admiration of wealthy and aristocratic patrons in whose economic, and imaginative, lives – as breeders, racers, gamblers and connoisseurs of horseflesh – the creature played a central role. Among them was the Second Marquess of

Rockingham, twice Prime Minister, whom Stubbs visited at his magnificent country seat, Wentworth Woodhouse in Yorkshire, around 1762. There he was commissioned to paint portraits of favourite horses and dogs, including Rockingham's most famous racehorse, Whistlejacket. The horse became the subject of Stubbs's largest and most audacious painting, one so unusual that a number of legends have clustered around it.

Whistlejacket was a pure Arabian stallion, foaled in 1749 and active at race meetings until he was put out to stud a decade later. Stubbs's powerful, life-size portrait is almost an advertisement for his services. Riderless and without harness of any kind, he rears and turns his tense head towards the spectator, orb-like eyes full of unbridled passion. Except for shadows cast by his rear hooves, the background of the canvas is a flat plane of colour, unmodulated by incident or detail, against which the animal seems to emerge into the viewer's space like an ancient bas-relief sculpture. The austere emptiness of the setting has led to claims that the painting must be unfinished, and that Stubbs had intended to add an equestrian portrait of King George III. There is no evidence to support such a contention. Moreover, other animal portraits that Stubbs executed for Rockingham, one of which also includes Whistlejacket, feature similar blank backgrounds. Perhaps the artist or patron appreciated the novel elegance of a solution which focused attention on the individualised physiognomy and fiery psychological presence of a much admired steed.

Another legend has it that Whistlejacket himself bolted with terror at the sight of the painting, rearing and stamping the ground. In fact, it seems that few animals can recognise two-dimensional representations. The story, however, belongs to an ancient trope of artistic encomium by which painted depictions of nature were hailed as visually indistinguishable from nature itself. As every artist knew, in ancient Greece Xeuxis had painted a bunch of grapes so realistically that the birds in the sky dived to peck at them. In modern times, what higher praise could be imagined for the greatest of British animal painters than the boast that a proud and passionate beast like Whistlejacket had been moved by his art!
Christopher Riopelle

JEFF **WALL**

born Vancouver, 29 September 1946

© Stephen Waddell

WALL STUDIED FINE ART at the University of British Columbia, followed by art history at the Courtauld Institute, London, from 1970 to 1973. From 1978 his interests in nineteenth-century French painting and in contemporary reality merged as he developed a particular kind of photographic art, the large-scale, back-lit colour transparency, shown in a wall-mounted lightbox. Using a form familiar from the advertising industry, Wall presents tableaux of modern life which he conceives, sets up and composes, calling on skills akin to those of painter, novelist and film-maker. Often seemingly matter of fact, the scenes he shows are set in such relatively unconsidered zones as the edges of conurbations, domestic interiors or the workplace. Through their careful detail his images, whether calm or dramatic, prompt the viewer to examine human relations and economic and social structures. Some employ digital technology to visualise entirely credible situations that are in fact contrived from numerous separate exposures. Wall's pictures range from representations of everyday reality to out-and-out fantasy or historical reconstruction, though these contrasting modes inform one another in varying degrees. He also creates portraits and still lifes. Since 1996 some of his work has been in black and white.

Wall lives and works in his native Vancouver.

JEFF WALL

325

A Donkey in Blackpool 1999

Transparency in a lightbox, edition of two, 195 x 250 cm, the artist, courtesy Anthony d'Offay Gallery, London

AT A FIRST GLANCE, Stubbs's *Whistle-jacket* and Jeff Wall's work in response could both be described as pictures in which nothing is happening. Each presents an outwardly very simple image of a single member of the genus horse that lived and worked in the north of England. Yet while each of these pictures is compelling, complete and satisfying in itself, each also rouses irresistible speculation as to what is not shown. Each image makes the context a part of our consideration – both the context in which the animal is found and the circumstances of the work's creation.

Wall has frequently depicted environments determined by the needs of work, whether manual (**1**) or cerebral. Stubbs, too, often represented the working environment; in his case there was almost always an association with horses (**2**). For both artists the presence of living creatures is important in a work; with Wall, even when they are not seen, their presence – usually human – is sensed. Here, in each picture, a single animal is set before us so vividly that at first nothing seems to come between it and the viewer. However, the Stubbs's exceptional size and featureless

ground bring swift awareness of the artist's brilliant contrivance. By contrast, Wall's very medium puts the viewer in the donkey's presence so directly as to make its image seem unmediated. Nevertheless, it would again be a mistake to see this work as uncontrived.

Wall's picture was, in fact, the outcome of six days' work in the location shown, the last four of which required some 160 takes before the final image was achieved. He had one assistant, whose previous work with animals proved vital. As with all Wall's lightbox works, important decisions regarding colour and tone were taken at the printing stage. The end result is a transparency (here in two visually seamless sections), mounted between sheets of perspex. The scene shown is in Blackpool, which was chosen only after a number of resorts in the British Isles had been considered and checked. The setting is one of the stables that house the donkeys that are hired for rides on

George Stubbs *Whistlejacket*, 1762

2 George Stubbs *Labourers*, 1781, enamel on Wedgwood biscuit earthenware, oval, 69.8 x 91.4 cm, Upperville, Virginia, Paul Mellon Collection

1 Jeff Wall *Untangling*, 1994, transparency in a lightbox, 189 x 245 cm, edition of two, courtesy Marian Goodman Gallery, New York

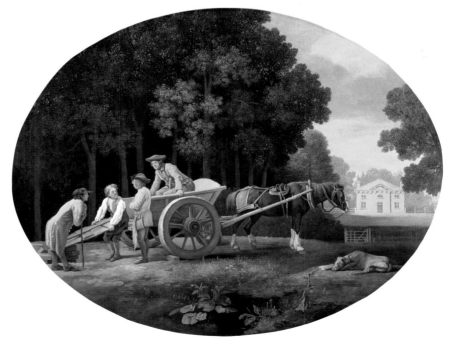

3 *Donkeys on the beach, Blackpool,* postcard

the nearby beach, a traditional feature of the English seaside holiday, of which the fore-shore at Blackpool is an archetypal site (**3**).

Not only in the amount and nature of circumstantial detail the work provides but also, above all, in the demeanour of its chief subject, Wall's closely observed stable scene with its occupant at one side could hardly be in greater contrast to Stubbs's portrait of a magnificent, rearing stallion placed centrally on the canvas, yet in indeterminate space. Despite the absence of a setting, the image of *Whistlejacket* associates the horse's power and impetuousness with the assurance and standing of the landed family and class which owned him and animals like him. It also reflects the concern of the aristocracy with breeding, in humans and thorough-breds alike.

When Wall visited the National Gallery after being invited to take part in this exhibition, the acquisition of *Whistlejacket* had recently roused much public interest. As he wrote later, 'I love donkeys and have wanted to photograph one for a long time … *Whistlejacket* seemed so regal; when I saw the poster … I immediately saw my preserved mental image of the donkey, probably in some shelter or shed. It seemed so precisely in contrast to the virility and dynamism of the great horse. I don't see the donkey picture as being in any way critical of the depiction in the Stubbs, it's

just another animal with another, equally valid world.'[1]

From the outset Wall planned to focus on a single donkey, at once as an individual within its species and as a worker. He wished to explore the function of donkeys today, not in those regions where poverty makes their use an economic necessity but in the developed world, where their more marginal role raises other issues. The location had to be Britain, in reference to Stubbs, but he wanted to avoid the pastoral associations of a country setting. Given the theme of the working life of donkeys, a seaside location seemed unavoidable.

The project forms part of Wall's ongoing examination of the daily life of populated centres, which ruled out smaller coastal resorts with more conspicuous charm. Indeed, the variety of the amusements for visitors to Blackpool highlights the tenuous role of the donkey in today's ever more sophisticated leisure industry. This industry, and the resorts themselves, may undergo change in the future. This led Wall to ponder the prospects for donkeys in western urban life, where their very existence hinges on the function not of maintaining life but of performing for human pleasure. He saw a parallel with the pathos of the anti-hero of John Osborne's play *The Entertainer* (1957). This,

too, is located in 'a large seaside resort'; it evokes the pathos of the end of the line for a certain tradition, its protagonists barely hanging on. Important scenes are set in 'a part of town visitors never see'. These parallels reinforced Wall's sense of the donkey as a small entertainer.

Wall pairs *Whistlejacket* with Champion, a female donkey who, at ten to fifteen years old, is relatively early in a working career that can extend from four or five to the age of forty. He found that each donkey's person-ality is distinct, and singled out Champion, quietly withdrawn and staying close to the far wall of the stable, for her facial expression and for her mannerisms. He is fascinated by donkeys' impenetrability and by their quality

4 Jeff Wall *An Encounter in the Calle Valentin Gomez Farias, Tijuana,* 1991, unique transparency in a lightbox, 229 x 288 cm, Basle, Museum der Gegenwartskunst

5 Jeff Wall *An Octopus* 1990, transparency in a lightbox, 182 x 229 cm, edition of two

of a certain remoteness. They occupy a psychic world in strong contrast to that of the alertness and excitability of horses. In donkeys' behaviour there is a seeming humility, but there is no element of irony in Wall's juxtaposition of *Whistlejacket* with Champion.

Wall had earlier explored relations between animal species in *An Encounter in the Calle Valentin Gomez Farias, Tijuana* of 1991 (**4**), and his still life subjects include *An Octopus* of 1990 (**5**). Currently he is working on an image of marine life on the sea bed, presented in an improbable setting (*Flooded Grave*). But the chief subject Wall explores in his work is human behaviour, motivation and experience, whether interactive or psychological. Even when a work's motif is landscape (urban or rural) or still life, part of its subject is the questions the image raises about the preceding formation or disposition by man of what we are shown. In the present work, too, this is powerfully the case.

Irrespective of the quality of the care they receive, the situation of working donkeys is as it is because of human needs and requirements. As much as the scene observed in **4**, the new work is about relations between species. It focuses the issue of human control over the rest of the animal world. Even though in the case of donkeys one result of this may be their very survival, the implication is that to a degree their existence is itself at human whim.

Such a perception is consonant with a significant theme in Wall's imagery, namely what people do to others, not always benignly as in the case of Champion. A number of his works represent disturbing acts of physical or psychological aggression. A still larger number show scenes in which, though no dramatic acts are being committed, figure and setting are so combined as to imply the guilt of authorities or society in making possible the human degradation we see or sense. Wall's works in progress in 1999 included his only sculpture, a memorial, to be sited in Rotterdam, to all those who sailed for America as *émigrés* through this principal continental point of embarkation for those forced to do so.

Wall's photographic works on such socially questioning themes are frequently set on the outskirts of conurbations, locations which interest him anyway as the point of encroachment of one type of man-made zone upon another. Such settings can also be read as a metaphor for marginality to the mainstream community, a further theme of importance in many of Wall's images of

6 Jeff Wall *A Villager from Aricaköyü arriving in Mahmutbey – Istanbul, September 1997*, 1997, transparency in a lightbox, 209.3 x 271.4 cm, edition of two

7 Jeff Wall *Cyclist,* 1996, black and white photograph, 213 x 295 cm

issues of social concern and relate to them only indirectly.

Wall's photographic images are frequently of interiors. While many of these are the setting for complex interaction between a number of figures, the present work is part of a sub-group in which the space itself occupies most of the image yet the single figure shown is crucial to the work's meaning. A work such as *Housekeeping* of 1996 (**8**) parallels the image of Champion's stable. In each case, the single figure is acting unassertively, yet is magnetic for the viewer. Each work also has the effect of opening to consideration a convention within the contemporary economic system that we take for granted. In common with some of these works, the image of Champion is also one of solitude.

The compelling nature of this work owes much to the realisation of the interior *per se.* Indeed, a further sub-group of Wall's pictures of interiors is of spaces with no-one in them.

8 Jeff Wall *Housekeeping,* 1996, black and white photograph, 203 x 260 cm

people, including ones set in city centres or workplaces. Wall's image of Champion in her stable can also be interpreted as a scene on the margin of modern Western life. It links with his themes of displacement (**6**) and even of abjectness (**7**) and can be related, in broad terms, to the implication in Wall's work as a whole of aspiration for a better life. As he said in 1986, 'The counter-tradition I'm interested in is not just an art movement, it is a whole political culture. And because its politics are based on the possibility of change, art plays a prominent role in it. It does so because it provides this complicated glimpse of something better'[2]

Wall's work is the more effective, even insistent, in this respect because of the understatement with which his images articulate their vital theme. The matter is complicated (or enriched) by the fact that a significant minority of Wall's works address interests in fantasy or in pure formal beauty that interweave with his examination of

9 Jeff Wall *Swept,* 1995, transparency in a lightbox, 174.8 x 216.2 cm, edition of two, Cologne, Johnen and Schoettle

One in particular, *Swept* of 1995 (**9**), shares several features with the image of Champion's stable. Like that picture, the new work depends on careful judgements of the precise extent of the image and the formal relationships between the shapes thus created. Also vital is the interplay between a wide variety of textures in the scene, many of which are individually close-knit. Here these include the open slats to left and right (and their shadows), the grid of the brickwork, the procession of inverted Vs running along the top, Champion's fur and especially the mass of golden straw on the ground. The two irregularly paired slatted structures (one of them partly gnawed) are paralleled by the pairing between a four-legged animal and a four-legged table. Key to the whole composition is the bold band of blue that divides its centre horizontally, even as it binds the various parts. The tips of Champion's ears just penetrate the blue. Quiet though the work may be, this stripe renders the whole visually dramatic, at the same time declaring in a single, simple stroke that the setting is institutional.

The internal rhythms Wall establishes are themselves one of the work's subjects. No less important is the surprising colour scheme, at once austere in the limitation of hues and rich in their fullness. The work is in the form of a photograph yet, as Wall stresses, many of the problems it addresses are common to those of painting and sculpture, with both of which the visual whole here has obvious affinities. These affinities are not only to some art of recent decades, not least aspects of abstraction, but also to art across the centuries. In common with most of his works, Wall's tableau has been carefully orchestrated and constructed.

While one could relate this picture to a wide variety of images from earlier eras, it is impossible to dissociate Wall's image of a donkey in a stable from Christian iconography in particular. A donkey carried Mary to the stable in which she gave birth. The importance of this animal in the story of Christ's life is reflected in images of the Flight into Egypt (not least that by Orazio Gentileschi in Birmingham, recently displayed in the National Gallery,[3] in which the donkey itself is exceptionally prominent) and of Christ's Entry into Jerusalem. In their clarity, detail, moral engagement and careful staging, Wall's lightbox works have a certain affinity with Pre-Raphaelite painting. This very frequently featured animals and there is a curious relation between *A Donkey in Blackpool* and a famous Pre-Raphaelite painting which also shows a lone animal, Holman Hunt's *Scapegoat* (**10**). Both the circumstances and the fate of Wall's donkey and Hunt's goat (the latter a metaphorical image of Christ) are in sharp contrast, yet each depicts an animal waiting to do something willed by others. While none of these associations formed part of Wall's concept for the present work, he does not actively disavow them, recognising the impossibility of cancelling from the mind iconography that is firmly established in the culture.

For all the resonance of Wall's image, its spatial structure (described by him as 'almost autonomous') has an interest of its own, and associates this picture closely with works such as *Diagonal Composition* of 1993 (**11**), which show neither people nor rooms. However compelling an image of a space may be pictorially, for Wall the presence in it of any living creature has the quality of an 'event'. But the absence of event can be positive in itself. Not only does the strength of the depicted space here make one speculate as to its effectiveness as an image without the donkey but conversely Wall's 'empty' spaces can be peopled in speculation.

Wall observes that 'more and more, I'm interested in the viability of either the presence or the absence of an "event" as a photographic situation'.[4] The theme connects the slightly mysterious character of the factual image of Champion in her stable

10 William Holman Hunt *The Scapegoat,* 1854–55, oil on canvas, 85.8 x 138.4 cm, Port Sunlight, Lady Lever Art Gallery

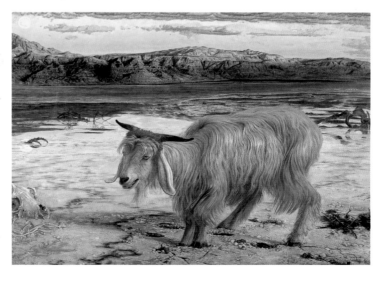

11 Jeff Wall *Diagonal Composition* 1993, transparency in a lightbox, 40 x 45 cm, edition of ten, Cologne, Johnen and Schoettle

with the 'spectral' mode in his art. Broadly, Wall alternates the two approaches (as he also alternates 'simple' images with ones crowded with detail). For example, his image of Champion was made in the middle of the longer process of creating the imaginary *Flooded Grave*, which shows life on the sea bed in the 'impossible' setting of a freshly dug burial plot. That task was more extended because, like many of Wall's works (though unlike *A Donkey in Blackpool*, which is a single exposure), *Flooded Grave* was made by digitally fusing a number of entirely separate photographs so as to produce what appears to be a single straight photograph of a scene that really existed. In Britain, perhaps the best-known example of this technique is Wall's *Sudden Gust of Wind (after Hokusai)* of 1993 (**13**), a re-creation of the famous coloured woodcut print (and the most explicit of Wall's reinterpretations of works by great masters of the past). Employing around 150 separately taken photographs, Wall's seemingly split-second picture required such complex direction over so long a period as to seem to him closer to film than to photography.

In the last few years Wall has increasingly favoured a realist, almost documentary approach. He aims not only to make underlying aspects of everyday reality apparent but also to foster closer scrutiny of the often unconsidered particular detail of what lies around us. As he told Arielle Pelenc, 'In photography, the unattributed, anonymous poetry of the world itself appears, probably for the first time. The beauty of photography is rooted in the great collage which everyday life is, a combination of absolutely concrete and specific things created by no-one and everyone, all of which becomes available once it is unified into a picture.'[5] *A Donkey in Blackpool* is a classic example of this truth.

The simple dignity of the subject and the directness of its realisation give this picture an affinity with the work of the German artist Stephan Balkenhol, on whose images of ordinary people, principally in carved and painted sculpture, Wall has written appreciatively.[6] Many of Wall's works imply outrage at inhumanity in the contemporary world, but one of the driving forces of his output is affection for people in all their individuality and vulnerability, an impulse which in his work for this exhibition is extended to the animal world.

It is, finally, the interplay between simplicity and complexity that gives Wall's works their strange power. Direct images of the observed contemporary world abound in our culture, not least in the form of photographs, but Wall's are unusual in the degree to which they make the viewer ask, 'What is going on here?'. It is far from a weakness of the works that the answer is not always readily apparent. Before Wall encountered *Whistlejacket* he had speculated on the possibility of making a work in response to the Gallery's painting by Velázquez, *Christ after the Flagellation contemplated by the Christian Soul* (**12**). As he observed, only the title tells the modern viewer the significance of the figure that personifies the soul.

What we see in any work by Wall is accounted for by a human, social and economic framework. Though not itself shown in the work, this determinant is powerfully implicit in the image and thus, in a sense, present in it. Wall's non-documentary work shows increasing interest in ghosts, a different kind of entity that is both present and absent at the same time. It is therefore curious that in Stubbs's riderless *Whistlejacket* he should have chosen a work that leads many viewers to imagine the presence of a supposedly intended mounted figure.

It is reasonable to speak of Wall's work as

12 Diego Velázquez *Christ after the Flagellation contemplated by the Christian Soul*, probably 1628–9, London, National Gallery

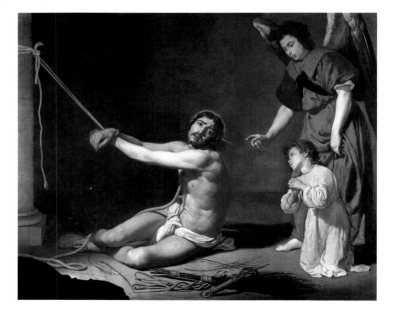

13 Jeff Wall *A Sudden Gust of Wind (after Hokusai)*,
1993, unique transparency in a lightbox, 229 x 377 cm,
Tate, London

having both a documentary and a spectral
side, but both kinds of work make us aware of
more than we are shown. Wall himself has
described his works as 'prose poems'. In the
fantasy of his 'spectral' works his imaginative
side is openly declared, but what draws the
viewer into his 'realist' pictures no less
strongly is a distinctive personal vision which,
while celebrating sheer observation, also
leads us well beyond it.

Richard Morphet

Notes

1 Letter to the author, 7 March 1999.

2 In Els Barents, 'Typology, Luminescence, Freedom,
Selections from a Conversation with Jeff Wall', in *Jeff Wall,
Transparencies*, Munich 1986, p. 104.

3 *Rest on the Flight into Egypt*, Birmingham Museums
and Art Gallery, shown at the National Gallery in the
exhibition *Orazio Gentileschi at the Court of Charles I*,
3 March–23 May 1999 (cat. 3).

4 Letter to the author, 3 October 1999.

5 'Arielle Pelenc in correspondence with Jeff Wall', in
Jeff Wall, London 1996, p. 22.

6 'An Outline of a Context for Stephan Balkenhol's
Work', in exh. cat. *Stephan Balkenhol*, Kunsthalle, Basle
(and tour), 1988–9, reprinted in *Jeff Wall,* 1996, cited
preceding note).

PHOTOGRAPHIC CREDITS

REMEMBRANCE OF ART PAST

1 © Museum of Fine Art Boston; **2** © Terra Foundation of the Arts, Daniel J. Terra Collection, 1992.51: Photo: Courtesy of Terra Museum of American Art, Chicago; **3** © Photo RMN J.G. Berizzi; **4** © Thomas Struth. Photo: Tate 2000; **5** © Succession Picasso / DACS 2000. Photo: Courtesy Helly Nahmad Gallery, London; **6** © The Estate of Roy Lichtenstein / DACS 2000. Photo: Tate 2000; **7** © David Salle. VAGA, New York and DACS, London, 2000. Photo: Courtesy Gagosian Gallery, New York; **8** © The Andy Warhol Foundation for the Visual Arts.Inc./ ARS, NY and DACS London 2000. Photo: Art Resource, New York; **9** © Malcolm Morley. Photo: Mark. K. Hatch. Courtesy of Sperone Westwater Gallery, New York; **10** © Royal Academy of Arts, London; **11** © Cindy Sherman. Photo: Courtesy of Metro Pictures, New York; **12** © Carlo Maria Mariani / VAGA, New York and DACS, London 2000. Photo: Robert Rosenblum, NYU; **13** © Alfred Leslie: Photo: Robert Rosenblum, NYU; **14** © Robert Colescott. Photo: Rose Art Museum, Brandeis University, Waltham, Massachusetts; **15** © Willem de Kooning Revocable Trust / ARS, NY and DACS, London 2000. Photo: NGA, Canberra; **16** © Succession Picasso / DACS 2000. Photo: Courtesy of the Musée national d'art moderne, Centre Georges Pompidou; **17** © DACS 2000. Zeppelin Museum Friedrichshafen. Photo: Toni Schneiders/Lindau; **18** © Estate of Francis Bacon/ARS, NY and DACS, London. Photo: Lee Stalsworth; **19** © Beth Philips, New York. Photo: Courtesy of Galerie Bruno Bischofberger, Zürich; **20** © Jake and Dinos Chapman. Photo: Courtesy of Saatchi Gallery, London; **21** © Mark Wallinger c/o Anthony Reynolds Gallery, London. Photo: Tate 2000.

USING THE COLLECTION: A RICH RESOURCE

1 © Claes Oldenburg. Photographed from the artist's book; **2** © Anthony Caro. Photo: National Gallery, London. Courtesy Barford Sculptures, London.

FRANK AUERBACH

Exhibit © Frank Auerbach. Photo: Marlborough Fine Art, London; Portrait © Photo: Julia Auerbach. Courtesy Marlborough Fine Art, London; **1** © Frank Auerbach. Photo: Tate 2000; **2** © Frank Auerbach. Photo: National Gallery, London; **3** © Richard Morphet; **4,5,6,7,8**: © Frank Auerbach. Photo: Marlborough Fine Art, London; **9,10,11,12**: © Frank Auerbach. Photo: National Gallery, London.

BALTHUS

Exhibit © Haroumi Klossowska. All rights reserved. Photo: Courtesy of Alex Reid & Lefevre Ltd, London (The Lefevre Gallery); Portrait © Photo: S. Martin Summers. Courtesy The Lefevre Gallery, London; **1,4,9,12,13**: © Haroumi Klossowska. All rights reserved. Photo: Courtesy of Alex Reid & Lefevre Ltd, London (The Lefevre Gallery); **2** © RMN, Paris. Photo: Arnaudet; **3,7**: © Haroumi Klossowska. All rights reserved. Photo: Electa Archive, Elemond, Milan; **5,10**: © Haroumi Klossowska. All rights reserved. Photo: Richard Morphet, London; **6** © Banca Nazionale del Lavoro, Rome; **8** © Haroumi Klossowska. All rights reserved; **11** © DACS 2000. Photo: Kunstdia-Archiv ARTOTHEK, D-Peissenberg.

LOUISE BOURGEOIS

Exhibit © Louise Bourgeois. Photo: Christopher Burke. Courtesy of Cheim & Read, New York; Portrait © Claudio Edinger 1988. Courtesy Violette Editions, London; **1** © Louise Bourgeois. Photo: C.E. Mitchell. Courtesy of Cheim & Read, New York; **2,5** © Louise Bourgeois. Photo: Peter Ballany. Courtesy of Cheim & Read, New York; **3** © Louise Bourgeois. Photo: Ben Schiff. Courtesy of Cheim & Read, New York; **4** © Louise Bourgeois. Photo: Rafael Lobato. Courtesy of Cheim & Read, New York; **6** © Louise Bourgeois. Photo: George Poncet. Courtesy of Cheim & Read, New York; **7** © Louise Bourgeois. Photo: Christopher Burke. Courtesy of Cheim & Read, New York; **8** © Louise Bourgeois. Photo: Allan Finkelman. Courtesy of Cheim & Read, New York; **9** © Louise Bourgeois. Photo: Louise Bourgeois. Courtesy of Cheim & Read, New York; **10** © Louise Bourgeois. Photo: Christopher Burke, Tate 2000. Courtesy of Judith Bumpus; **11** © Louise Bourgeois. Photo: James Hamilton 1992. Courtesy of Cheim & Read, New York.

ANTHONY CARO

Exhibits © Anthony Caro. Photo: John Riddy. Courtesy Barford Sculptures Ltd; Portrait © Photo: Hugo Glendinning. Courtesy Barford Sculptures Ltd, London; **1** © Anthony Caro. Photo: Tate 2000; **2,4,5,6,8,10,12, 13**: © Anthony Caro. Photo: John Riddy. Courtesy Barford Sculptures Ltd., London; **3,7,9**: © Anthony Caro. Photo: David Buckland. Courtesy Barford Sculptures Ltd, London; **11** © Photo: SCALA, Florence.

PATRICK CAULFIELD

Exhibit © Patrick Caulfield, courtesy of Waddington Galleries. Photo: Prudence Cuming Associates Ltd; Portrait © Photo:Janet Nathan; **1** © Patrick Caulfield. Photo: The Saatchi Gallery, London; **2** © National Gallery, London; **3** © Patrick Caulfield. Photo: Birmingham Museums and Art Gallery; **4** © Caroline Bugler; **5** © Patrick Caulfield. Photo: Richard Morphet; **6** © Patrick Caulfield, courtesy of Waddington Galleries. Photo: Prudence Cuming Associates Ltd; **7** © The Norton Simon Foundation, Pasadena, CA; **8** © Photo: RMN-A.Danvers; **9** © Patrick Caulfield. Photo: Tate 2000; **10** © Patrick Caulfield, Photo: Tate 2000; **11** © Succession Picasso / DACS 2000; **1** © Patrick Caulfield. Photo: Courtesy Colin St Wilson & Associates, London.

FRANCESCO CLEMENTE

Exhibit © Francesco Clemente. Photo: Courtesy of Anthony d'Offay Gallery, London; Portrait © National Gallery, London; **1** © Francesco Clemente. Photo: Beth Philips. Courtesy Sperone Westwater Gallery, NY; **2** © Copyright The British Museum; **3** © Francesco Clemente. Photo: Courtesy of Thomas Ammann Fine Art, Zürich; **4** © Francesco Clemente. Photo: Courtesy of Bruno Bischofberger, Zürich; **5** © Francesco Clemente. Photo: Courtesy of Anthony d'Offay Gallery, London; **6** © Copyright The British Museum; **7** © Board of Trustees. National Gallery of Art, Washington; **8,9**: © Francesco Clemente. Photo: Beth Philips, Courtesy Clemente Studio, NY.

STEPHEN COX

Exhibit © Stephen Cox. Photo: Centro Foto, Carrara; Portrait © Photo: Hugo Glendinning; **1,2,3,5**: © Photo: SCALA, Florence; **4** © Stephen Cox. Photo: National Gallery, London; **6** © Stephen Cox. Photo: Peter Inskip and Peter Jenkins Architects, London; **7** © Stephen Cox. Photo: Courtesy of the artist; **8** © Stephen Cox. Photo: Courtesy of the Henry Moore Sculpture Trust by H. Hardman Jones; **9** © Stephen Cox. Photo: Bruno Bruchi.

IAN HAMILTON FINLAY

Exhibit © Ian Hamilton Finlay. Photo: Antonia Reeve; Portrait © Robin Gillaneis. Photo: Courtesy of Ian Hamilton Finlay; **1,3,5**: © Ian Hamilton Finlay. Courtesy of the Artist; **2** © Ian Hamilton Finlay. Photo: David Paterson; **4** © Copyright The British Museum; **6,8,10**: © Ian Hamilton Finlay. Photo: Antonia Reeve; **7** © Ian Hamilton Finlay. Photo: Peter Davenport; **9** © Ian Hamilton Finlay. Photo: Stephen White.

LUCIAN FREUD

Exhibits © Lucian Freud. Photo: John Riddy. Courtesy Acquavella Galleries, New York; Portrait © Photo: Bruce Bernard; **1** © National Gallery, London; **2** © Lucian Freud. Photo: John Riddy. Courtesy Acquavella Galleries, New York; **3,4,5,6,7,8,9**: © Lucian Freud. Photo: Bridgeman Art Library.

RICHARD HAMILTON

Exhibit in progress © Richard Hamilton. Photo: Richard Hamilton; Portrait © Photo: Timothy Greenfield Sanders. Courtesy Anthony d'Offay Gallery, London; **1,10** © National Gallery, London; **2** © Rijksmuseum, Amsterdam; **3** © Succession Marcel Duchamp / ADAGP, Paris and DACS, London 2000. Photo, Tate 2000; **4** © Richard Hamilton. Photo: David Held. The Solomon R. Guggenheim Foundation, New York; **5,5a,5b,5c,7,9,**

ACKNOWLEDGEMENTS

The authors and the National Gallery would like to thank
the following for their assistance:

Eleanor Acquavella
Ian Barker
Heiner Bastian
Beatrice Behlen
Maria Brassel
Muffin Bruce
Margarita Burbano
Guy Cogeval
James Cohan
Daniel Congdon
Alexander Corcoran
Desmond Corcoran
Pat Cunningham
William Darby
John Erle-Drax
Gregory Evans
Walter Feilchenfeldt
Kathleen Flynn
Jerry Gorovoy
David and Ann Graves
Siri Fischer Hansen
Jan Hashey
Sarah Heaney
Margaret Heiner
Kathrin Henke
Nuria Homs
Richard Jacques
Bill Katz
Richard Kendall
Mr & Mrs James Kirkman
Karen Kuhlman
Haroumi Klossowska
Countess Klossowski de Rola

Sir Thomas Lighton
Matthew Marks
Rob McKeever
Zoe Morley
Anthony d'Offay
Lorcan O'Neill
Janet Nathan
Geoffrey Parton
Kira Perov
Dana Phan
Karen Polack
Tessa Quantrill
Karen Ratzel
Diana Rawstron
Nicola del Roscia
Adrian Rosenfeld
Richard Schmidt
Stephanie Sherman
Pia Simig
Stephen Stuart-Smith
Sarah Taggart
Joanna Thornberry
Belinda Thomson
Sarah Tinsley
Kirk Varnedoe
Anu Vikram
Robin Vousden
Susan and Lewis Manilow
Ivor Braka Ltd
Kunstsammlung Nordrhein-Westfalen, Düsseldorf
Tate, London
Kara van der Weg
Wendy Williams